MW00815232

ANDRÉ FU

LIBRARY OF
CONGRESS
SURPLUS
DUPLICATE

CATHERINE SHAW

ANDRÉ FU

crossing cultures with design

with 184 illustrations
including 22 original sketches

Cover, front: The second-floor reception sitting room at the St Regis Hong Kong (see page 29).
Cover, back: André Fu's original concept sketch for the second-floor reception sitting room at the St Regis Hong Kong.

Picture credits for pages 10–17, 265
10: photo courtesy of the Upper House, Hong Kong; 11, 13: sketches courtesy of André Fu; 14: photo akg-images/
Schütze/Rodemann; 15: photo courtesy of the Kadoorie Estate; 16: photo by Alistair K. O. Gough; 17: photo by
André Fu; 265: sketch courtesy of André Fu.

André Fu: Crossing Cultures with Design © 2020 Thames & Hudson Ltd, London

Foreword © 2020 Patrick McKillen

Preface and project introductions © 2020 André Fu

Introduction and captions © 2020 Catherine Shaw

Illustrations © 2020 the copyright holders; see page 268 for details

All Rights Reserved. No part of this publication may be reproduced or transmitted in any form or by any means,
electronic or mechanical, including photocopy, recording or any other information storage and retrieval system,
without prior permission in writing from the publisher.

First published in 2020 in the United States of America by Thames &Hudson Inc.,
500 Fifth Avenue, New York, New York 10110

www.thamesandhudsonusa.com

Library of Congress Control Number 2019940658

ISBN 978-0-500-02284-9

Printed and bound in China by Artron

contents

foreword

It's a very Irish thing to just visit people unannounced and, as I don't use email and feel that there is nothing better than saying hello in person, I simply arrived at André's office one day. I'm glad I did because, although I may have initially startled him, our unplanned meeting was the beginning of a wonderful friendship. Since then, we've had many opportunities to work together.

André listens deeply to his clients – which is rare. Then, within seconds, he starts sketching and produces magnificent watercolours that express the essential form and colour of his spaces. In these times of computer-generated imagery, I'm sad to say that I believe he might become something of a rare breed – perhaps even a national treasure – because of this natural ability to express his ideas.

Of course, André's understanding of space comes from his architectural training, but he also has a gift when it comes to furniture and materials, and this extends right through to the curation of artworks. I think this combination is unique.

As they say, it's all in the detail, and that is never more true than in André's work. I'm in awe at the way he details his floors and how it reflects on to ceilings. That is a lost art! His personal interest in lacquerware and ceramics is also clearly evident throughout his projects.

I really hope to continue to find great projects to work on together, not only so I can carry on surprising André by arriving at his door in Hong Kong unannounced, but also because it will mean even more memorable working dinners together, and the opportunity to share more of his fabulous spaces with our guests.

PATRICK MCKILLEN
hotelier, property investor and
owner of Villa La Coste

preface

Since I tend to experience each of my projects independently, I have rarely had the opportunity to consider how my work has evolved over the course of my career. However, creating this book has given me a fresh insight not only into the past but also into the future, by allowing me to reflect on the influences and development of my design language.

From when I first thought about this book I knew that I wanted to work with Catherine Shaw. She has known and written about my projects from the early days, and, even more importantly, she has experienced them on a first-hand basis. This is a very personal project, but we have a natural affinity so I was excited when she agreed to come on board. And just as I had anticipated, throughout the entire process she has challenged me with uncompromising questions: 'Why include this project and not that? What would I do differently now? Why do I recall this project with particular fondness?' The exercise has helped me to gain an interesting perspective on how I have responded to different situations, clients and briefs, and to realise how my designs have evolved with my own way of life.

I have always been reluctant to use any particular terminology to describe my aesthetics and design approach, especially since my work is a reaction to how lifestyles have changed over the past ten years. I think it is inevitable that luxury should become genuine and honest – in the world of hospitality, it is the essence of the experience that counts – and that can be boiled down to the notional concept, the thoughtfulness of the design and the deeper sense of comfort that I strive to express in my designs.

These are elements I have been thinking about ever since my first visit to the Park Hyatt Tokyo – one of the revolutionary 'sky' hotels, built on the top fourteen floors of a fifty-two-storey skyscraper in Shinjuku – when I was at university. I still remember vividly the bold proportions and modernist lines of the hotel's architect, Kenzo Tange, and its interior designer, John Morford. This was my first glimpse of how interiors could be infused with a sense of timelessness and feel gracious and sophisticated yet intimate and discreet. To me it was a sign of where hospitality might be heading, and to this day it remains one of my favourite hotels for its warmth and welcoming ambience.

I must also recall another defining moment: my first experience of one of the early design hotels, the Hotel Parco dei Principi, perched on the Sorrento cliffs, created by the Milanese architect Gio Ponti in 1960. It is an extraordinary hotel that perfectly encapsulates curated hospitality. From its signature, ocean-inspired cerulean-blue tiles and ceramic-pebble mosaics to its pure architectural geometry, the holistic manner in which Ponti designed the hotel is truly masterful.

In my own work, I aspire to create that same sense of intimacy and elegance, especially when it comes to such landmark hotels as the Upper House in Hong Kong and, more recently, the Waldorf Astoria Bangkok and the St Regis Hong Kong, where I was given the creative freedom to work with two of the most revered historical brands in establishing a sense of their new context. It was a delicate balancing act, but one that I particularly enjoyed.

Design is a highly organic, natural process and I prefer not to follow any formula or rules, so for that reason the projects we have selected for this book do not follow a chronological order. Instead, they are loosely grouped to reflect common themes, such as cultural filtering, relaxed luxury and modernity versus classicism. I hope each one expresses a slightly different aspect of my vision. I have never considered the possibility of a thread running through my work, but, in the end, I would choose to be remembered for evoking the essences of comfort and tactility, and for the way each experience embraces a sense of cultural nuance rather than a design label. There is no need to reinvent the concept of design; it is simply about creating memorable experiences for people.

While I cherish the diversity of the projects I have been fortunate enough to design and am curious about what the next ten years will hold, looking back over the past decade, I can see that the positive recognition and trust shown to me have been powerful incentives to innovate further. For that I am most grateful to my clients, who have entrusted me with this responsibility.

ANDRÉ FU

introduction

I remember exactly when and where I first met André Fu. It was in 2012 at a design-festival event hosted by Lane Crawford, in the earliest days of Wong Chuk Hang's transmogrification from a gritty industrial district into a creative hub. I had recently returned to Hong Kong after a decade of living in Tokyo – I'd been writing about Japanese architecture, design and art there – keen to rediscover what Hong Kong had to offer in creative terms.

It was excellent timing. Hong Kong was on the cusp of a very contemporary cultural revolution: it was to be Art Basel's first outpost in Asia, and the West Kowloon Cultural District was going ahead with M+, a new museum of the contemporary and visual arts with ambitions to become one of the world's great cultural centres.

Elsewhere on Hong Kong Island, historic buildings formerly known as Police Married Quarters were being revitalized as a mixed-use centre intended to help young creatives find a foothold in the prohibitively expensive Central district, while Tai Kwun, an entire block of 19th-century buildings comprising a police station, court and prison, was being painstakingly restored and adapted – with the addition of two dramatic new buildings by Herzog & de Meuron – to house an art centre, restaurants, bars and boutiques, as well as a museum. And across the harbour, planning for the new Victoria Dockside design district was just beginning. Hong Kong has always worn its heart on its sleeve, and there was a palpable sense of excitement of it carving out a new, creative cultural identity.

André had already acquired a considerable reputation as a designer. His groundbreaking project, the Upper House in Hong Kong, completed in 2009, had added a new dimension to the hotel scene, breaking away from typical opulent interiors with a fresh, new, contemporary mix of simple forms, as well as a geometry and symmetry that redefined the idea of modern luxury as sheer, unadulterated comfort rather than monumental, statement-making, marble-clad spaces.

Upper House was a challenging site for a designer's first hotel project, located on the upper floors of an occupied building

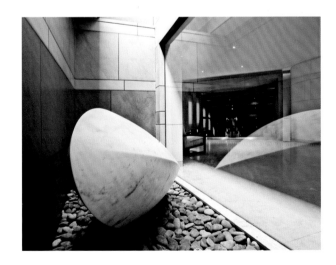

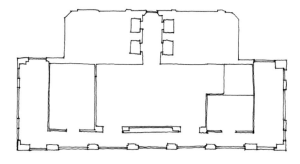

with a compact ground-floor entrance, a steep escalator and an awkward, oblong, low-ceilinged mezzanine reception area housing the elevators. André's bold concept introduced a dreamy yet glamorous palette and such architectural devices as camouflaging the escalator with a moody corridor of *torii* gates inspired by the architecture of Japanese temples. Guest rooms were generously sized, open and minimalist, conceived with cocooning comfort in mind.

I had already seen a few of André's other projects. In 2004 he had created two restaurants for the then twenty-three-year-old Hong Kong entrepreneur Yenn Wong, who had disrupted the local hotel scene with her Philippe Starck-designed JIA hotel in Causeway Bay – not only the city's first designer boutique hotel, but also Yenn's very first project. Yenn recalls feeling confident that André would be ideal for the project because his style was strong enough to match Starck's quintessentially quirky interiors.

André's quietly confident yet unassuming presence at the design festival alongside the effervescent musician and artist Pharrell Williams remains etched in my mind. It struck me then that he

was less interested in explaining who he was – a rare quality in today's starchitect-obsessed society – than in discussing design.

I remember making a note to keep an eye on André's new projects, which that year included 743 square metres on the seventeenth floor of the Robert Stern-designed 50 Connaught Road, Hong Kong, for the Parisian art dealer Emmanuel Perrotin, who has opened eighteen galleries in his life and knows a thing or two about what works and what doesn't. Emmanuel recalls that André listened attentively to his initial brief – and then literally turned the planned layout on its head, rearranging it along the dramatic, floor-to-ceiling windows to create a 30-metre corridor and window-sill seating to make full use of the spectacular harbour views and natural light.

André then divided the simple, rectangular space into a flexible series of smaller galleries, making use of every inch to showcase art, store large works and entertain guests in a private VIP lounge. André has gone on to design what Emmanuel calls 'dreamscapes' for him in Tokyo and Shanghai.

Then, in 2015, André collaborated with the Czech bespoke art-glass and lighting-installation specialists Lasvit on the design

opposite Fu introduces 'borrowed' scenery, a principle of traditional Asian garden design, by incorporating background landscape with a marble sculpture by the Taiwanese artist Cynthia Sah, in a small outdoor garden on the second-floor lobby at the Upper House.

above Fu's hand-drawn floor plan of the Perrotin gallery in Hong Kong presents a simple yet highly flexible arrangement of spaces that allows multiple exhibitions to be held at any one time.

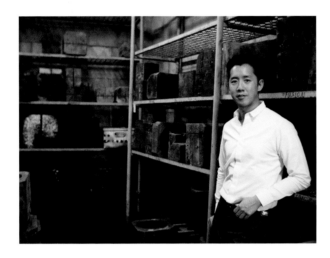

of a collection of lights. Such internationally known figures as Kengo Kuma, Zaha Hadid and Daniel Libeskind had already designed unconventional pieces for Lasvit, so I knew the creative freedom he would be given was likely to result in something distinctive. André and I had begun talking early on in the design process, instead of waiting for the project to be completed, and I was increasingly interested in the initial thinking that went into his designs. I therefore suggested that I shadow him for the duration, observing the entire creative process from start to finish, from the first concept-development meetings with Lasvit's founder, Leon Jakimič, to the collection's launch the following year during Salone del Mobile in Milan.

Leon believes the most innovative solutions emerge when designers and craftsmen work alongside each other, so André and I set off together for Prague via London, where a series of unforeseen flight delays resulted in us sharing a twenty-three-hour travel marathon and a new, easy familiarity. Writers and designers usually converse in concentrated snippets at interviews or perhaps over coffee or at most during a site visit, not for a week, so this experience was especially revealing.

And as Leon had predicted, the close interaction between André and the Bohemian glassblowers proved illuminating. Making and designing are too often far removed from each other, especially

since it is so easy to email a set of detailed design drawings to a craftsman or workshop in another part of the world and never actually meet them face-to-face. However, at Lasvit's workshop in Nový Bor, in the centre of the Czech Republic's traditional glass-blowing region, designing is a reiterative process that, by necessity, requires fine-tuning on the ground between the powerful glassblowers, who sweep poles laden with molten glass from 1,000-degree ovens to waiting moulds, and the designer, who directs the process.

It was a fascinating insight. André's appetite for investigating textures and forms was insatiable as he set about explaining his ideas and challenging the glassblowers to create a geometrical, architectural form celebrating modernism with a textured edge that would retain an artisanal quality. It also revealed how he deftly balanced his original concept and yet worked with others to make adjustments and achieve the best result. Lighting remains an important part of André's spatial meaning and form.

As time passes, I become more attuned to what makes André's designs so captivating. Despite his innate preference for privacy, he has been very open and frank in our conversations, and I have been able to observe at close quarters how he develops his creative vocabulary and refines the way he uses materials and light.

It is this aspect of his practice that first attracted me to the idea of a book that would share his inspirations and thinking. It is also why each project is presented in his own words, as told to me. You won't find a long list of room sizes or numbers of restaurants or details of where to source furnishings; instead, I hope to offer an insight into André's mind, a glimpse of the textures, spatial qualities and art that have informed his designs throughout his career.

Each project is presented alongside images and, in some cases, André's characteristic sketches. He sees the process of drawing as a means of thinking and of exploring his creative vocabulary, and so the sketches in particular beautifully illustrate his fascination with juxtaposing architectural elements, light, proportion and materials. My favourite is the fluid calligraphic drawing he made for Louis Vuitton Objets Nomades to express the swooping form of his contemporary conversation chair. Others depict guest rooms, conveying their refined luxury and space in a few simple strokes. In these sketches, the sense of a 'moment' or mood help inspire André's imagination.

Projects span different countries and periods – from early projects in Hong Kong to his visit to the Czech Republic, and more recent work trips to Kyoto, New York and London. We've deliberately selected a range that best expresses his thinking, from hotels and restaurants to pop-ups and furniture.

But first, some background, because no designer suddenly appears fully fledged with a ready-made creative vocabulary. André has always thought about design. He founded his eponymous studio in 2000, soon after graduating from Cambridge University with a master's degree in architecture, but even from an early age he recalls the joy of drawing. His mother, noticing this, engaged an art teacher to help the ten-year-old André learn pencil sketching, watercolour painting and Chinese calligraphy. Aged fourteen, he left Hong Kong for the United Kingdom to attend Malvern College and then St Paul's, where he was awarded an art scholarship and introduced to pottery, the fine arts and painting. Like many Hong Kongers who studied overseas, he feels as much at home in England as he does in Hong Kong.

André says he was always sure he would follow an artistic career and, as a scion of one of Hong Kong's most distinguished families with traditional Chinese values at the fore, the profession of architecture seemed a natural choice.

From his earliest days André was drawn to sculpture. As a university student, he became particularly interested in the understated, elegant lines and simplicity of Italian architect Carlo Scarpa's modernist architecture. He was also drawn to the great sculptural purity of pieces designed by another modernist,

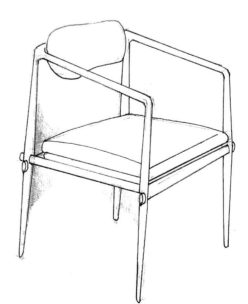

opposite Fu at Lasvit's Nový Bor archive, where the moulds are stored.

right Fu's hand-drawn sketch of a dining chair for André Fu Living demonstrates the interlocking architectural language he admires.

the pioneering Romanian sculptor Constantin Brâncuși, whose defiantly anti-realist bronze works André remembers seeing first at the Museum of Modern Art in New York, and which inspired some of the elemental sculptural forms in his own projects.

Exploring European design, André vividly recalls the impact of a visit to Le Corbusier's Villa Savoye in Paris, one of the Swiss-French architect's most important buildings and perhaps the best example of his efficient spatial planning and minimalistic aesthetic. It has been a lasting influence on André's appreciation of movement, especially between levels, and his concept of creating a journey with, for example, indistinct layers accentuated by sculptural elements.

Other defining influences include a visit to the 1986 reconstruction of the German pavilion designed by avant-garde architect Ludwig Mies van der Rohe and Lilly Reich for the 1929 International Exposition in Barcelona. Showcasing post-war Germany's new architecture, the main open-plan pavilion was raised on a 1.3-metre-high Roman travertine podium to make an elevated terrace, while inside all spaces flowed into each other, as if the building were a single hall. André recalls its spatial purity, spiritual serenity and timeless design language.

André often cites the Bauhaus as an influence, in particular the German art school's pioneering abstract geometric forms that are still part of Hong Kong's own architectural heritage, and which are captured in the romantic and elegant visual choreography of Chinese film director Wong Kar-Wai's 2000 drama *In the Mood for Love*, in which the glamorous lead couple, played by Maggie Cheung and Tony Leung, linger in the city's rainy streets.

After graduating André returned to Hong Kong, but his time abroad and exposure to European art, design and culture at such an impressionable stage in his life remain powerful influences to this day.

Although this has inevitably led some critics to categorize André's work as East-meets-West, such a label fails to recognize his individual and original outlook. His approach is not about combining styles; rather, it rests on an ability to navigate very different cultures and styles and to reflect contemporary culture not based on any one model, but on the inherent qualities of beauty. Hong Kong is perhaps the ideal place to develop this cross-cultural approach. Indeed, André often credits his hometown as central to his success, both at home and on the international stage, and it is certainly one of the few cities in Asia where the concept of beauty draws as naturally on European principles of geometry, based on the square and the circle, as it does on oriental qualities.

For André, it is the nuances of these multiple dimensions that help to express a sense of tension and therefore create spaces that

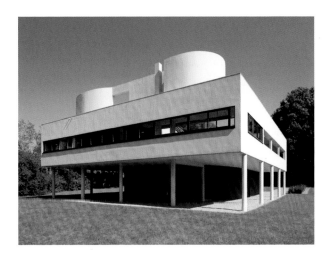

left Located on the outskirts of Paris, Le Corbusier's Villa Savoye has had a lasting influence on Fu. The modernist villa features a series of ramps leading from the lower level to the rooftop garden that are intended to maximize the experience of movement between spaces.

opposite Designed by Lord Lawrence Kadoorie, the Round House is one of eighty-six Bauhaus, 1930s-style houses on the Kadoorie Estate in Hong Kong.

are more than just beautiful or stylish. This is perhaps the way in which his work has had the most impact on interior design in Hong Kong and throughout Asia, where he had already completed multiple projects, including five hospitality projects along Hong Kong's waterfront.

This is not to say that André ignores the power of conveying cultural values in various aspects of his work, from the treatment of space and light to landscape, especially in his projects in Japan and at the Villa La Coste in Provence. But this is less for purely decorative reasons and more to give meaning to the experience of a space.

At HOTEL THE MITSUI KYOTO, located in front of the ancient capital's Nijo Castle, André took great care to consider Japanese traditions, respecting the art and craft of kimono but adding his dimension with avant-garde hand-woven wall coverings. I especially like the oak *torii* slanted at an unexpected angle that frame some of the passageways and provide a different perspective on the traditional gate at the entrance to Japanese temples. Every space, surface and object in the hotel is carefully considered to create an intriguing composition that expresses contemporary design while retaining traditional Japanese simplicity and comfort.

At Villa La Coste, André expresses the unfettered spirit of Provence's famed bright light and dry landscape through a simple but visually arresting refined rusticity composed of natural stone, rough-edged timber and an earthy palette, adding a glass pavilion reached by a path of flagstones across a pond. Here, his understanding of architecture comes to the fore with a consistency of thought that reflects the mood of each space.

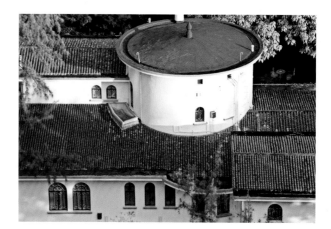

There is a fine line between spectacle and subtlety, but André's delicate interplay of spaces is defined by an airy, streamlined and refined style that creates a flowing sequence – an emotional connection that is a world away from architectural showmanship.

More often than not, André is thought of as minimalist because of his sleek, restrained forms and silhouettes. To me, however, it is his careful layering, opulent textures and materiality – mixing colours, patterns and periods to create a cohesive look – that makes his work so interesting and complex. This is more difficult to achieve than it sounds: the ability to incorporate an eclectic mix of design styles and still create spatial clarity, a feeling of warmth and comfort, comes from an instinctive sense of balance and of what works together. A restaurant interior in André's hands is romantic, warm and elegant, but his approach will always have been precise and exacting.

André sees the worlds of product design and interior architecture as a natural fit, an opportunity to extend his design sensibility into something tangible. When I asked him once if he thought design was more interesting than architecture, he looked surprised, replying that, for him, they are both the same – that architecture is about the interaction of space and a person and everything in between.

This may explain why his favourite projects are those where he also contributes custom-designed furnishings and sources decorative pieces, and why it felt like a natural progression to launch the André Fu Living brand in 2016 to showcase his lifestyle collections created in collaboration with highly skilled artisans. One of the most recent is 'Modern Reflections', a 150-piece range of homeware and decorative accessories that includes cashmere throws, bed linen, porcelain tableware and modernist-inspired tables and chairs. The range also offers an intriguing insight into how André translates his architectural perspective into a different realm, one that, instead of creating an environment, immerses you in it, using materials that arouse the senses while still retaining his understated style.

For André, every detail must be considered before a space feels complete. Not all of them are immediately noticeable, and they often seep slowly into your consciousness as you start to notice, for example, that the lacquer doors in the Andaz Singapore guest rooms are the exact colour of a ripe mango, or that the subtle

curved pattern on an Art Deco-inspired bronze screen in the lobby of Waldorf Astoria Bangkok reflects a Thai dancer's hand movements. André is drawn to this sense of discovery, surprise and finesse, to the idea that the smallest detail – even a bronze door handle, leather trim on an armchair or custom-designed coat hanger – conveys a tacit connection to time, place and mood.

His eye for choosing materials is excellent: their beauty and essential tactility, their history, and the artisanal skills used to fashion them are evident in all his projects, from K11 ARTUS' intricately woven, Persian-inspired wall panels to the simple bamboo box that holds his signature Fargesia unisex scent, its textural, grey interior suggesting concrete. Detailed research and experimenting underpins many of these unusual finds, which escalate the experience.

Nature is important to André. I'd noticed his use of moss and plain but striking topiary and succulents in some of his projects, but it still came as a surprise when he admitted that, had he not become an architect, he would have trained as a landscape designer, and that his dream commission would be to design a park. In his projects, nature is not just to be seen and touched, but a subtle connection with the seasons and settings. Even his first office, tucked away on Hong Kong's Duddell Street, looked out on to a leafy terrace with a forest of camphor trees and palms beyond. The studio recently relocated to an airy new open-plan office on nearby On Lan Street, with unusually high ceilings and a lofty feel within a minimalist envelope.

above Fu uses natural materials extensively in his work. At Perrotin Shanghai, he chose a richly veined Iranian marble to add a touch of glamour.

opposite Fu's photograph of a sculptural moss garden at Tofuku-ji Temple in Kyoto provides inspiration for adding texture to interiors, such as the monogram moss installation at Louis Vuitton Objets Nomades.

For projects that call for landscaping, André draws on a variety of cultural influences, including traditional English, Japanese and Chinese gardens. He cites the Classical Gardens of Suzhou as an important influence in an elegant marble moon gate on an outdoor terrace at St Regis Hong Kong. He is also inspired by the refined rigour of Japanese gardens, and often employs their traditional devices of 'borrowed' views and *torii* gates and the subtle blurring of indoors and outdoors, combining different elements to create such innovative landscapes as the Moroccan-inspired garden on K11 ARTUS' pool-side terrace. For the pop-up he created for COS, Japanese moss predominated, softening the crisp, geometrical architectural forms.

Elsewhere André uses such organic and mineral materials as bamboo, stone, agate, marble and mud plasters to remind us of

our connection to nature. His collections of rugs for Tai Ping vividly evoke the natural world within an urban context, while at Louise, a restaurant for Yenn Wong's JIA Group in a heritage building in Hong Kong, the connection with nature is made through the use of such tropical motifs as sage-green accents, woven rattan and a staircase enveloped in vivid, jungle-like floral wallpaper. In the St Regis Hong Kong, a more recent project, André has introduced water flowing gently over a low, gleaming-marble sculptural form.

Art is one of André's favourite, more subtle ways of connecting to the elemental character of a landscape and culture. His personal interests and tastes are eclectic, ranging from Chinese ceramics from the Sung dynasty – which he appreciates for their pure silhouettes and simple, elegant proportions – to contemporary paintings, vintage architectural sketches by Le Corbusier, and sculpture. Some items he buys from galleries, while a great deal is collected on his travels. In his projects he sees art as part of the architecture, adding creative energy – as demonstrated, for example, by a bold visual accent at the base of a sweeping staircase at St Regis Hong Kong, or a dramatic, kimono-inspired ceiling installation in Kyoto. More importantly, perhaps, André lives as he works: his Hong Kong home and office contain pieces that reflect both calm elegance and focused energy with a strong overall sense of spatial connection and careful detailing, yet it is also relaxed and shows no sense of deliberate curation.

It is a decade since André's first major project, the Upper House, and therefore an opportune moment to reflect formally on his philosophy, exploring the themes and connecting the dots between the wide range of work he has created. André is not much given to analysing his work, but he and I have spent a great deal of time considering and discussing the motivation and thinking behind each richly complex project. By necessity this process is reflective, but it has also been forward-looking and, as I see him continuing to forge his own way, exploring and reinterpreting his views on lifestyle with an impeccable sense of rhythm, it feels like the start of an exciting new chapter.

the projects

st regis hong kong

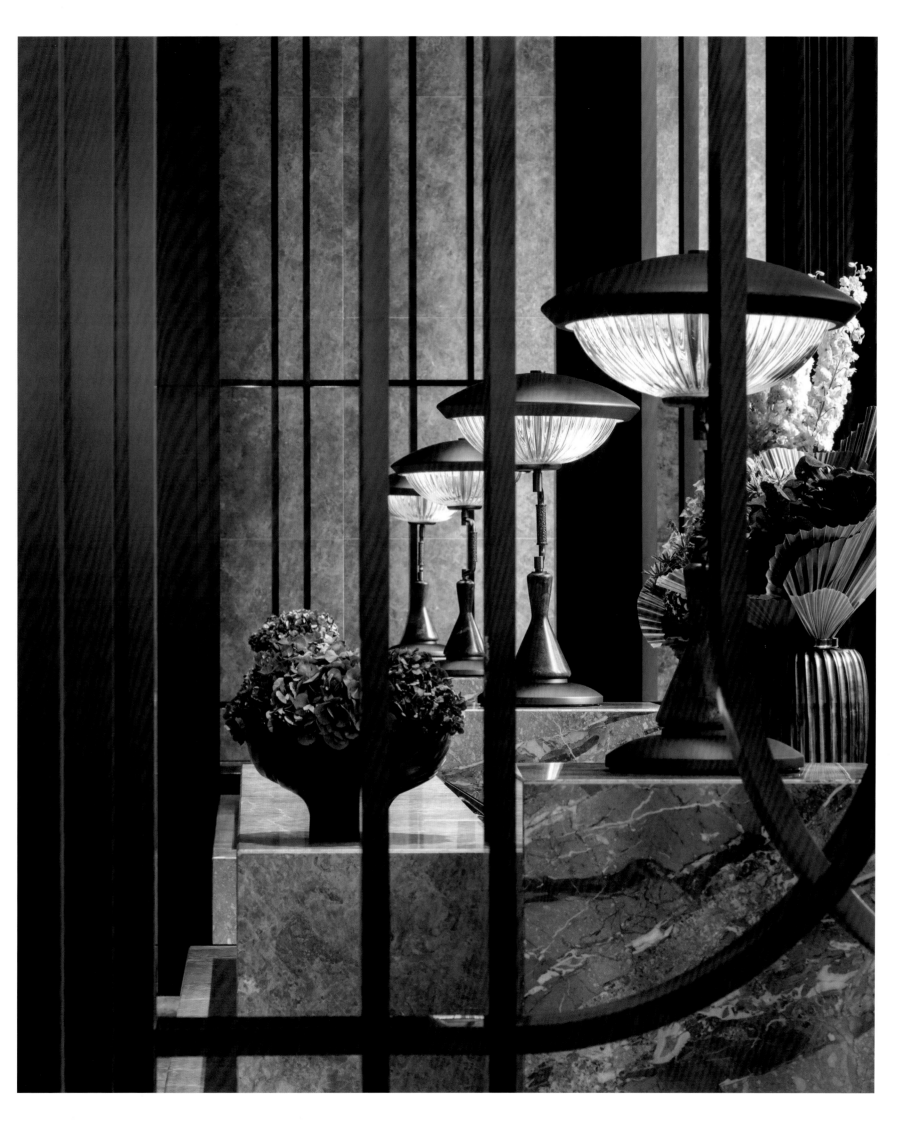

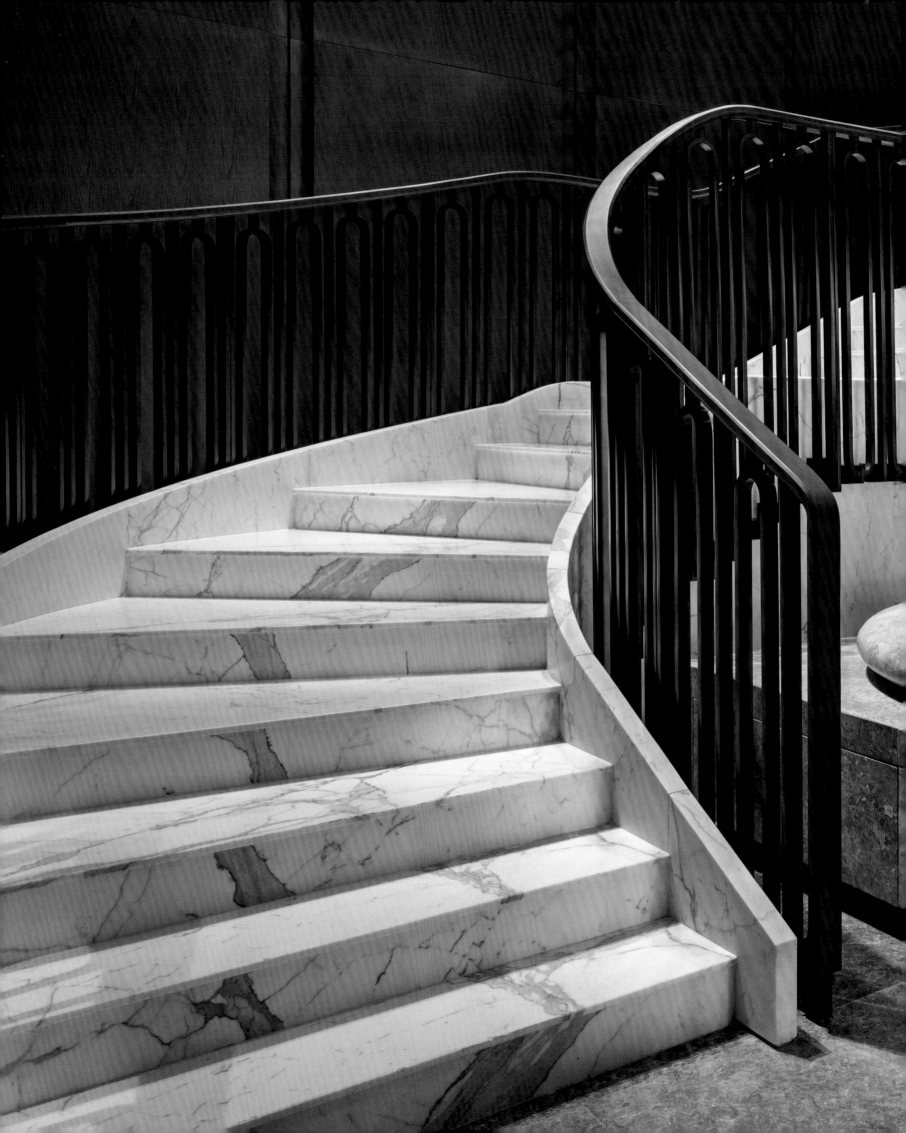

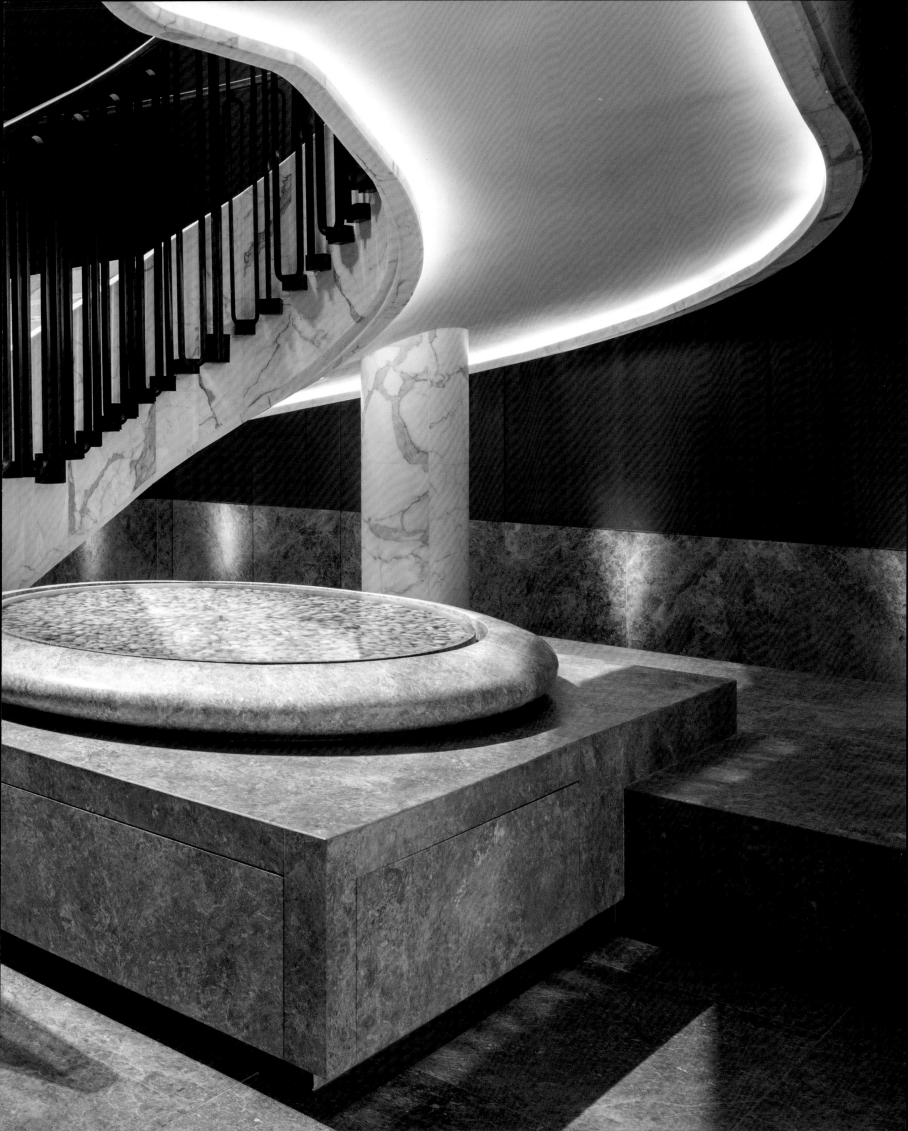

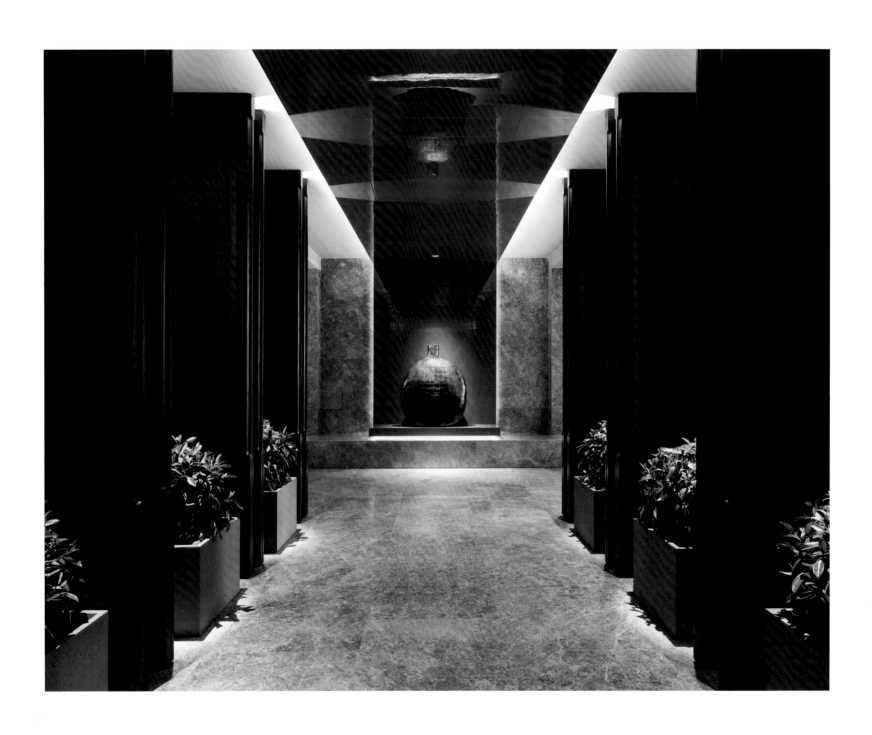

St Regis New York is such an iconic hotel – I especially recall its stately elegance and home-like feel when I first saw it as a child – so when I was asked to design St Regis' first hotel in Hong Kong, I knew that we had to capture the same special qualities that has made St Regis New York somewhere people want to gather and be entertained. It was originally the place where the Astor family would entertain New York society, yet to me it felt like a private mansion, so I wanted to replicate the essence of this duality, of the spirit of the original.

At the same time, I felt that it was very important to reflect the essence of Hong Kong, and for me it felt very natural to draw on the city's distinctive historical architecture and culture. I also had in mind the wonderfully romantic *In the Mood for Love*, a classic drama by the Hong Kong film director Wong Kar-wai. I admire the poignant *flâneur* qualities that he brings to the film, and I wanted to express this feeling by juxtaposing the past and present in a very fluid way throughout the hotel.

The hotel is conceived as an urban mansion, and I like to think that it is imbued with a very modern Hong Kong sensibility that still retains the essence of classic sophistication. The two are not contradictory to me: the colour and material palettes are very refined and subdued with grey, white and earthy tones, and this is offset with dramatic, geometric architectural forms, such as monolithic tables in simple linear and cantilevered shapes, glossy lacquered panels in milk tea, jade and terracotta colours, and very stylish light oak screens. One of my favourite places is the outdoor terrace, where a 2.5-metre-diameter moon gate in Galassia Verde Italian marble adds a touch of Carlo Scarpa and yet still makes reference to a traditional architectural element found in Chinese gardens.

Artisanal details such as discreet bevelled edges, curved elongated shapes and mouldings on walls, doors and furnishings are very subtle, but I think they add a softer, more elegant finish that speaks of true luxury. I designed all the furnishings myself, and, although these are generally contemporary, I've added vintage shapes and forms to evoke mid-century glamour. It is not overtly Asian, although there are hints in such pieces as the interlocking motif on the massive marble slabs that engage to create monolithic desks.

To me, lighting is absolutely essential in creating warm and welcoming spaces. At St Regis Hong Kong, cut-glass pendants reminiscent of the 19th-century Rochester-model gas lamps on Duddell Street – where I had my studio for many years – also reflect the sculptural and geometric architectural language. I really like the way the double layer of glass with a fluted inner chamber refracts light to give a soft glow.

From the start, I envisaged St Regis Hong Kong as an immersive, layered visual journey, where guests pass through a space to encounter something special, such as a magnificent contemporary artwork or a dramatic triple-height atrium, as they do arriving at the Great Room on the second floor. This progression not only adds a structural rhythm, but also highlights the striking contrast in proportion and creates a sense of surprise.

I see the guest rooms and suites – and especially the Presidential Suite – as elegant, contemporary Hong Kong homes, a tribute to the city's past and present. The interiors are lavish and glamorous yet restrained. Nostalgic, yet also very contemporary, which for me is what a refined Hong Kong home feels like.

page 21 Brushed-bronze lamps and sculptural screens at the entrance of the hotel reference Hong Kong's distinctive historical silhouettes and architectural details. These familiar shapes and the tactile relationship with materials are continued throughout the interiors.

pages 22-23 A striking, white-marble spiral staircase with bronze railings leads up to L'Envol, the hotel's French fine-dining restaurant. To the right of the staircase is a sculptural water feature, evoking a sense of serenity as well as Fu's conception of an urban oasis.

opposite Guests enter the second floor through an elegant, oak-panelled passageway beneath a cantilevered lacquer ceiling. The large ceramic vase, a play on traditional forms and contemporary textures by the Chinese artist Cao Yuan Hua, heightens the sense of discovery and transforms the 'in-between' space.

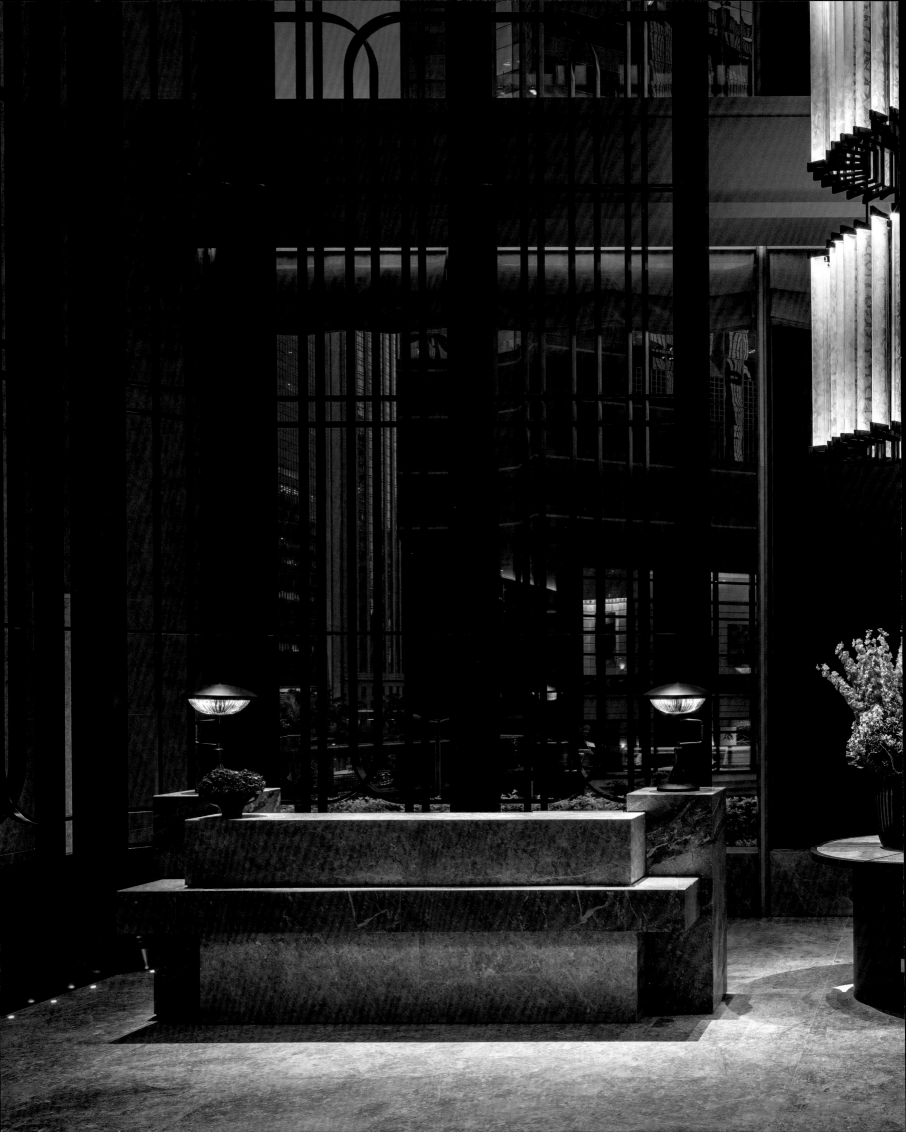

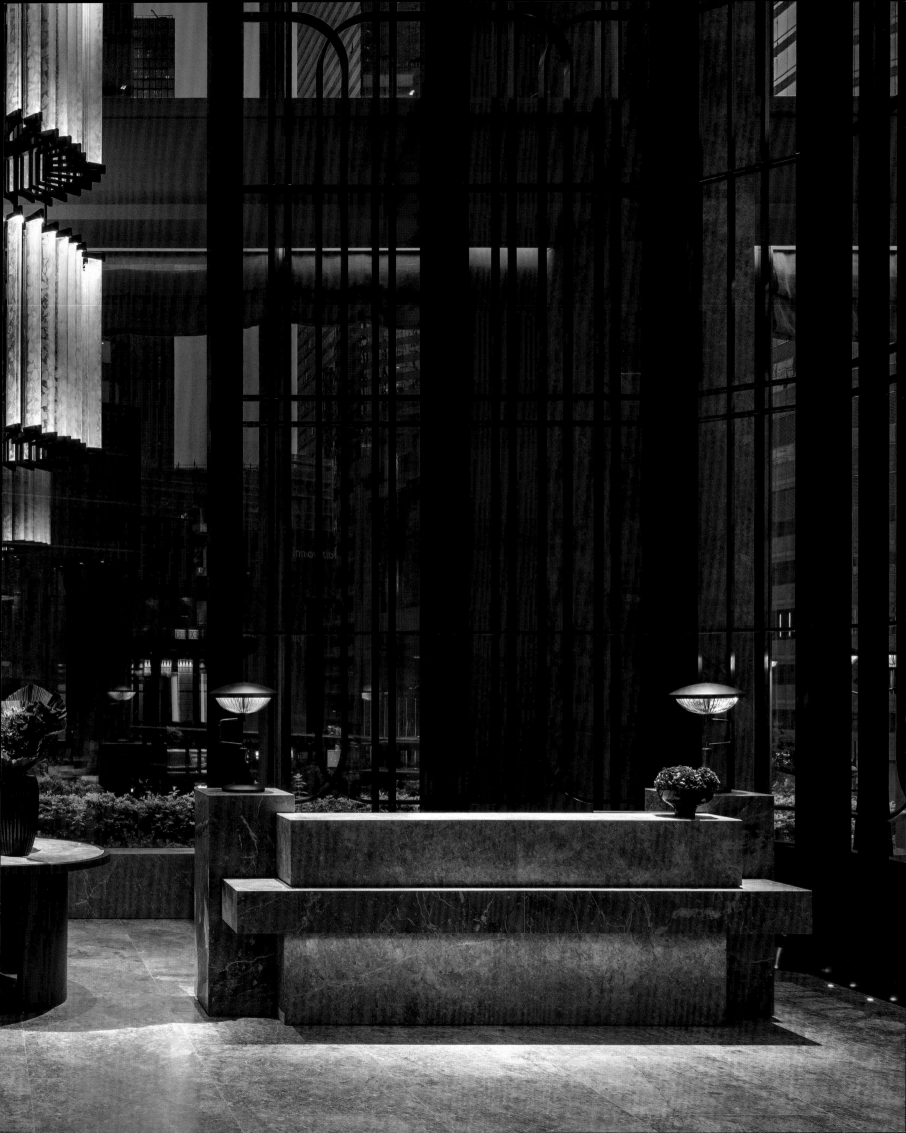

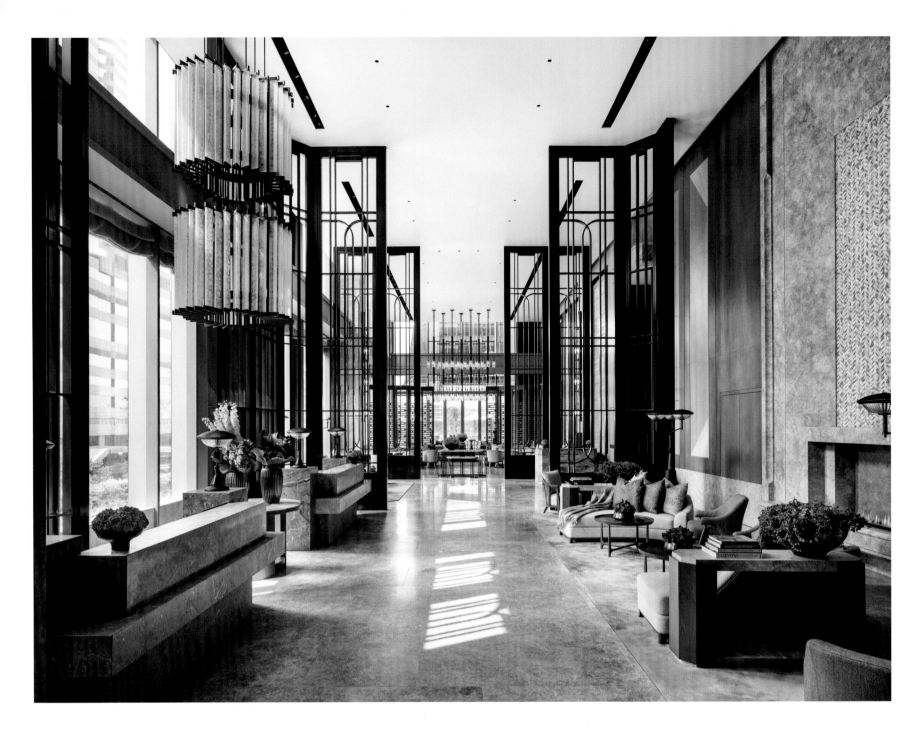

pages 26-27 Fu's modernist-inspired chandelier, featuring his 'TAC/TILE' custom-designed, hand-blown glass pendants produced by the Czech lighting manufacturer Lasvit, provides a dramatic, theatrical centrepiece. A pair of silver-grey-marble reception desks adds symmetry and balance to the soaring triple-height Great Room.

above View from the entrance of the Great Room and reception desks towards the terrace. This is the hub of St Regis' public area, providing a harmonious balance between intimacy and theatrical scale and symmetry through a series of open-plan lounges where guests can relax.

opposite The second-floor reception sitting room features a fireplace set in an opulent marble wall panel with a woven appearance. Seating is arranged to create informal, intimate conversational areas.

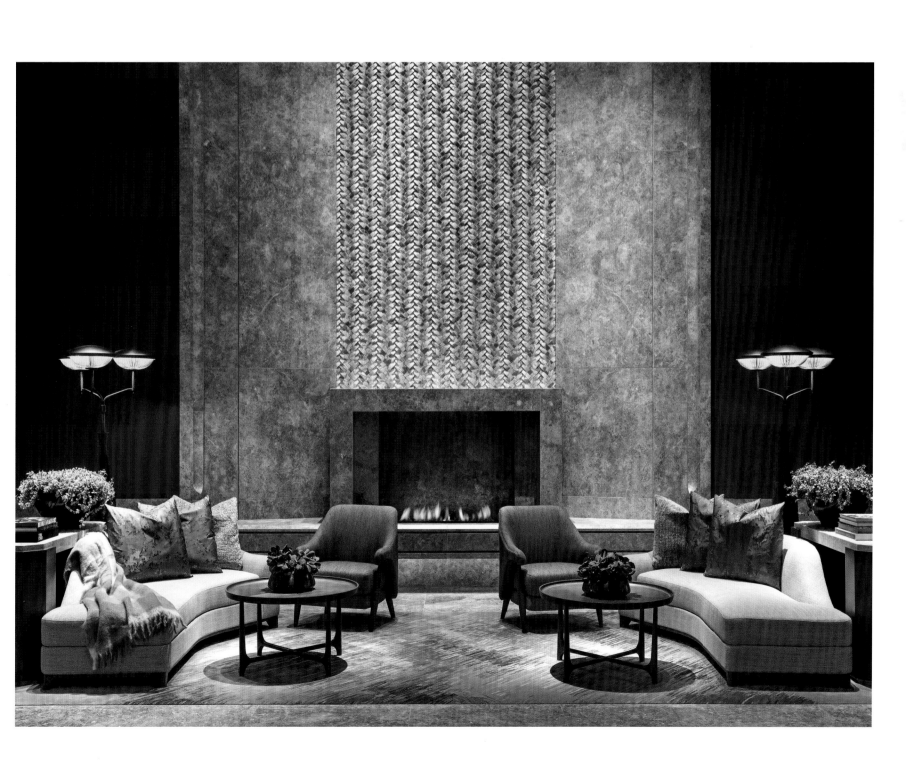

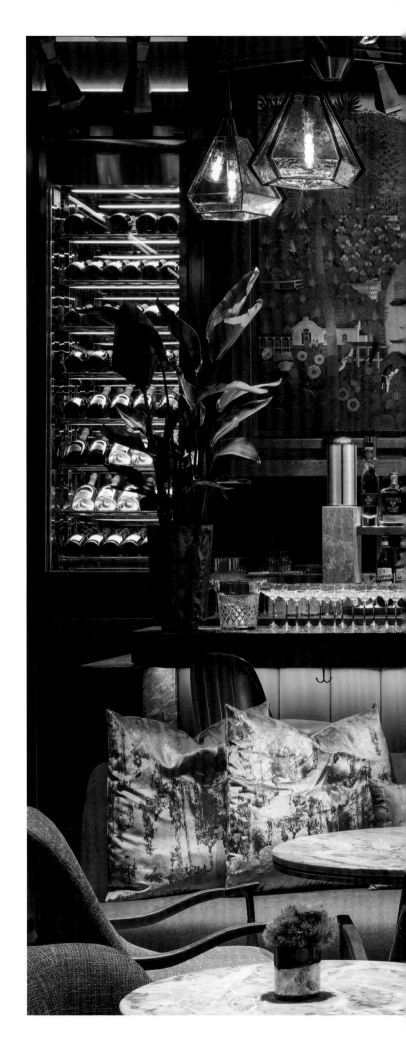

right The St Regis Bar's specially commissioned whimsical mural depicting Hong Kong landscapes and architecture is by the Beijing-based artist Zhang Gong.

page 32 Bronze frames incorporate the designer's signature geometric architectural language. Translucent double-layered lantern shades cast a soft glow.

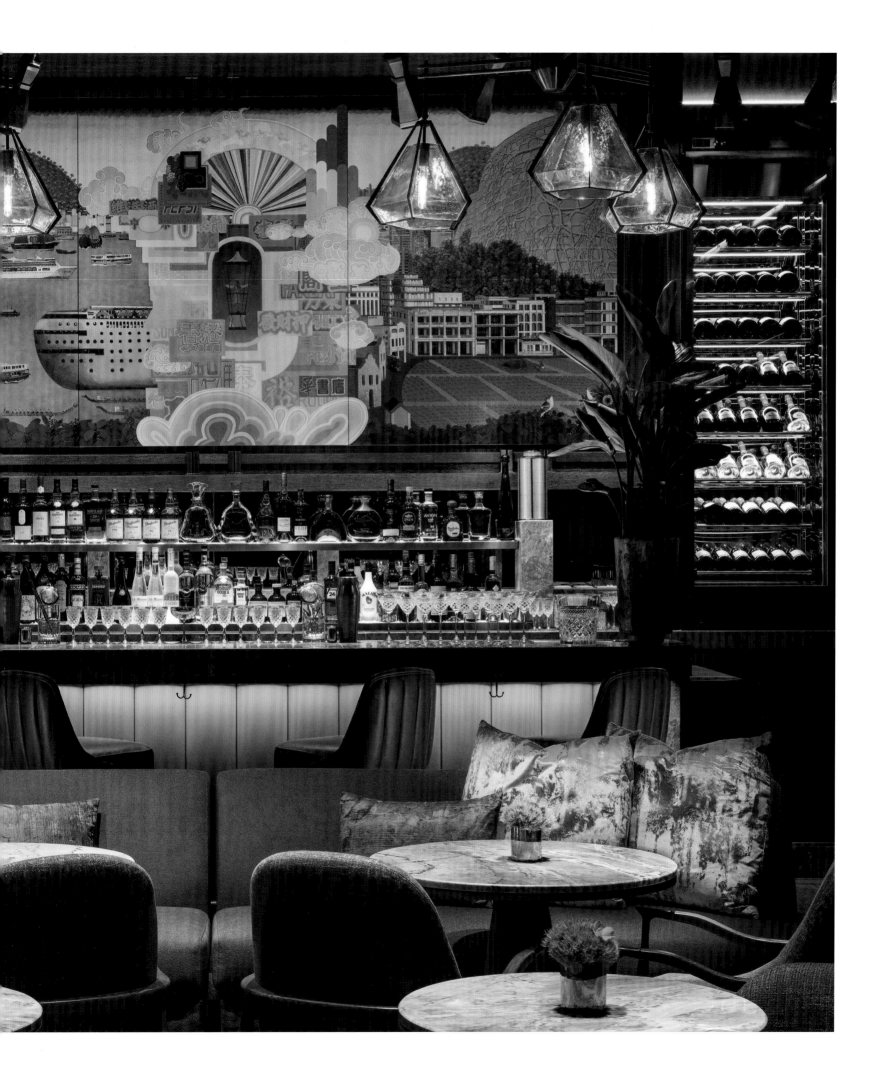

I think a very simple palette allows
objects in the space to evolve and breathe.

ANDRÉ FU

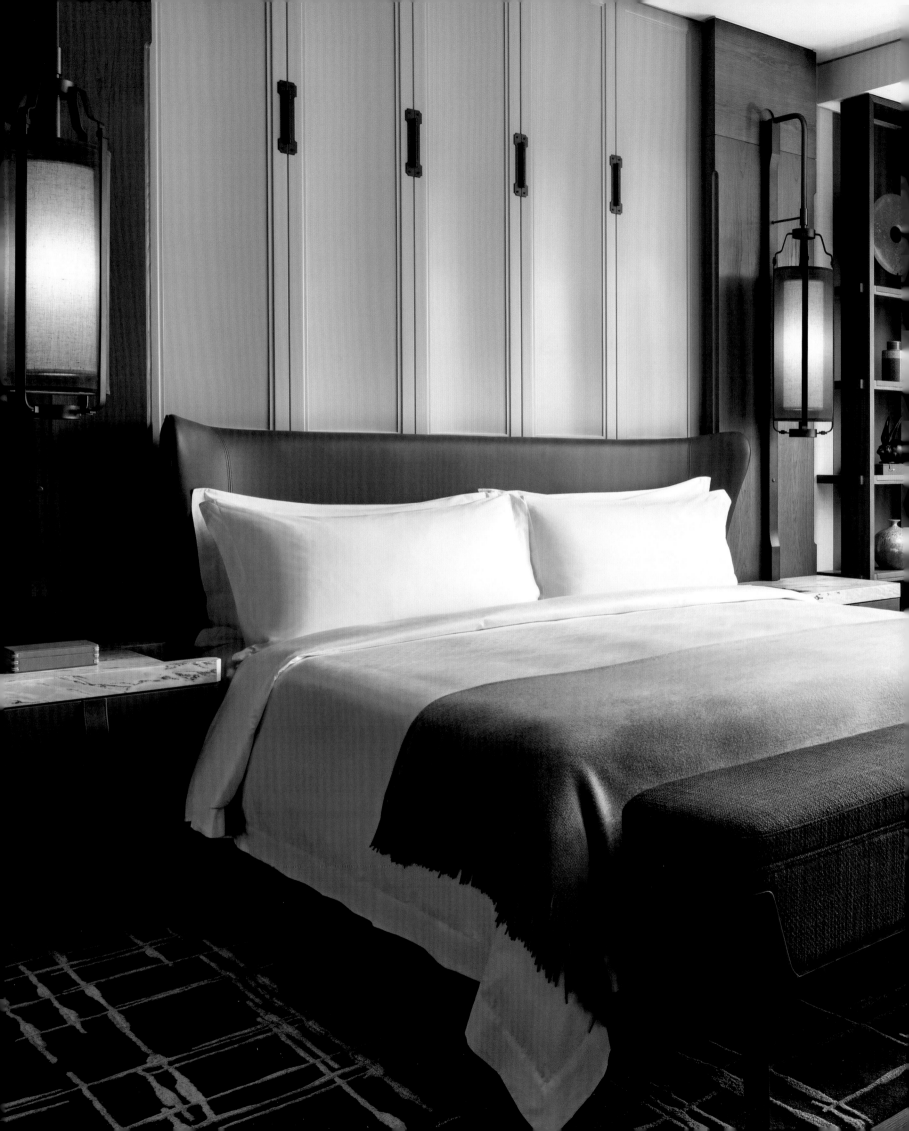

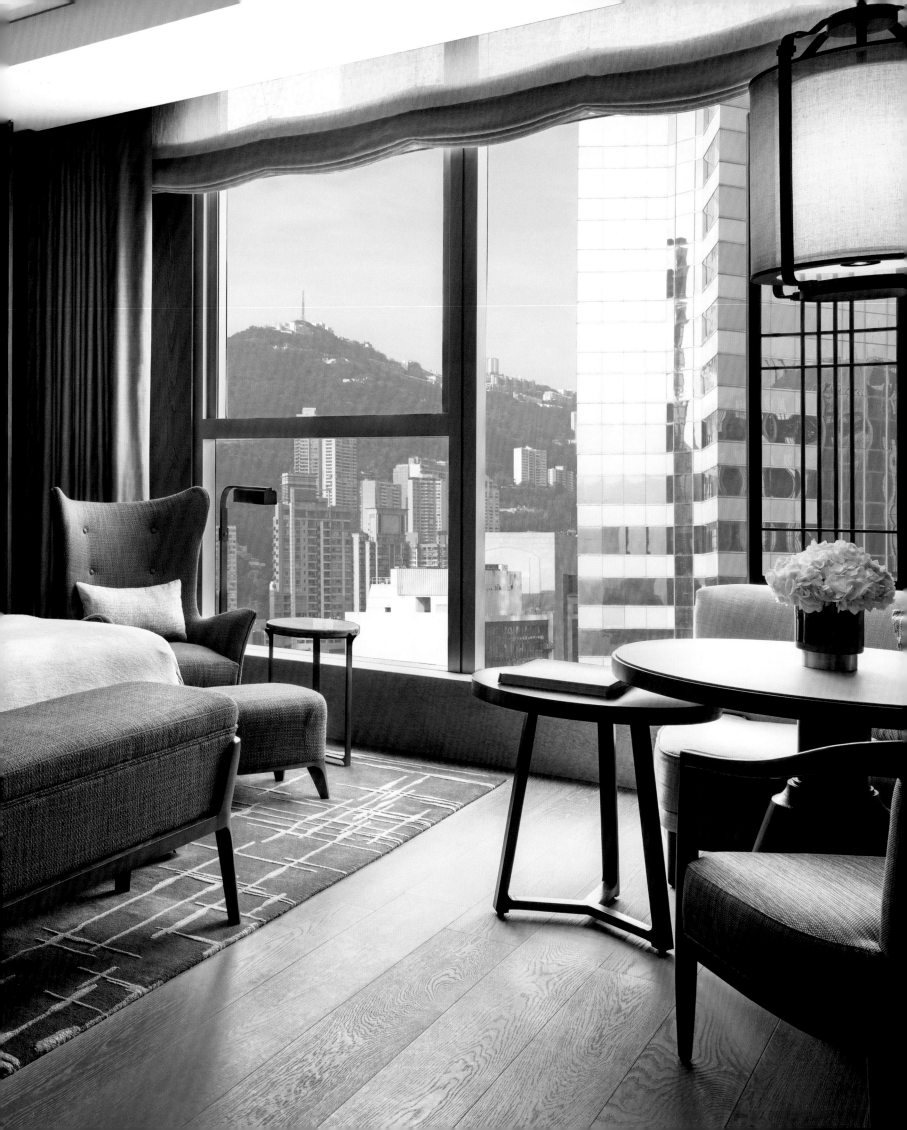

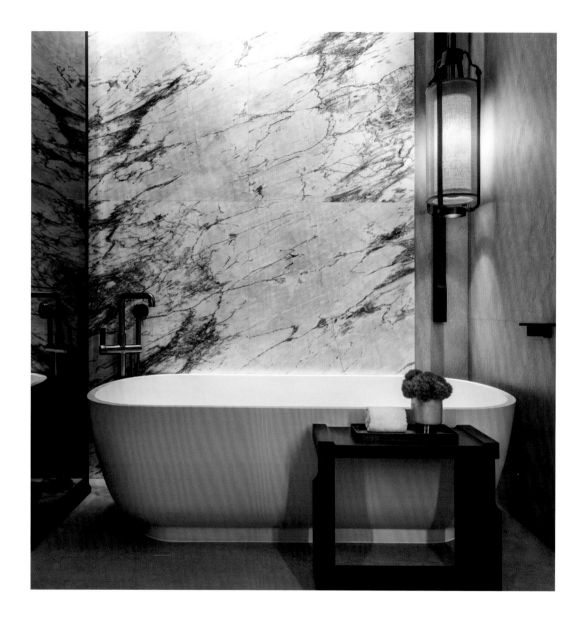

pages 34–35 A gently curved, winged headboard in soft leather adds form and texture. The tea-coloured lacquer panels recall traditional Hong Kong shutters.

above The freestanding bath and Kallista bronze taps complement the striking marble pattern with a contemporary aesthetic.

opposite Fu sourced an eclectic collection of decorative artisanal objects and ceramics from his network of artists and his travels to increase the residential ambiance.

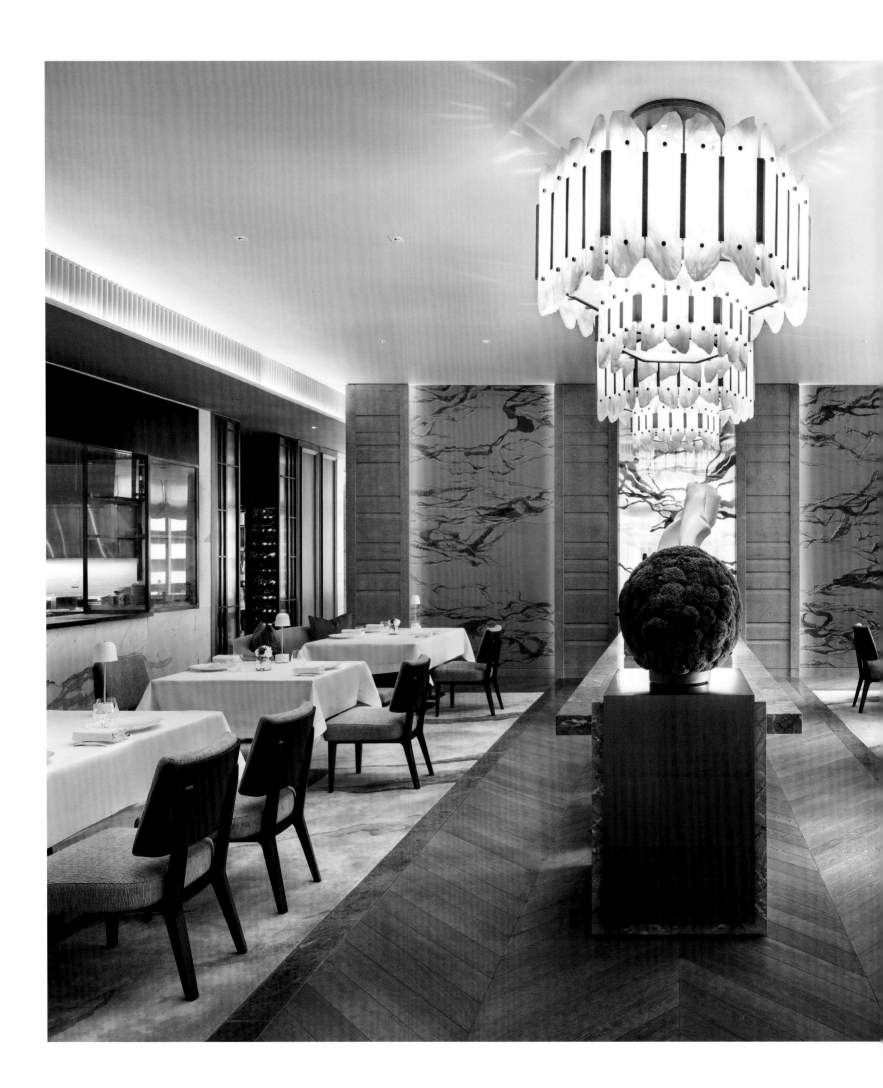

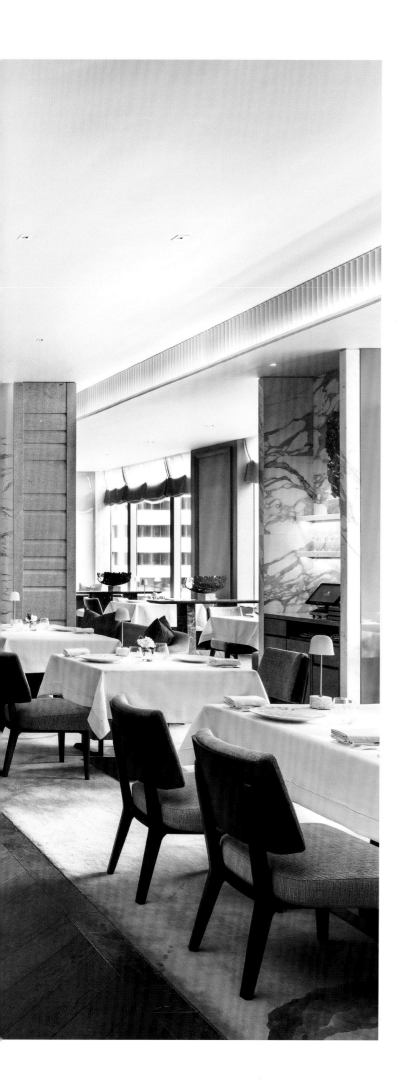

left A chandelier of natural-form ivory agate adds a luxurious sculptural touch to L'Envol.

pages 40–41 Drawing on traditional Chinese tea-pavilion architecture, this 110-square-metre freestanding abstract pavilion in pale oak is completed by a rug with a delicate, smoke-inspired pattern that evokes classic Chinese ink paintings.

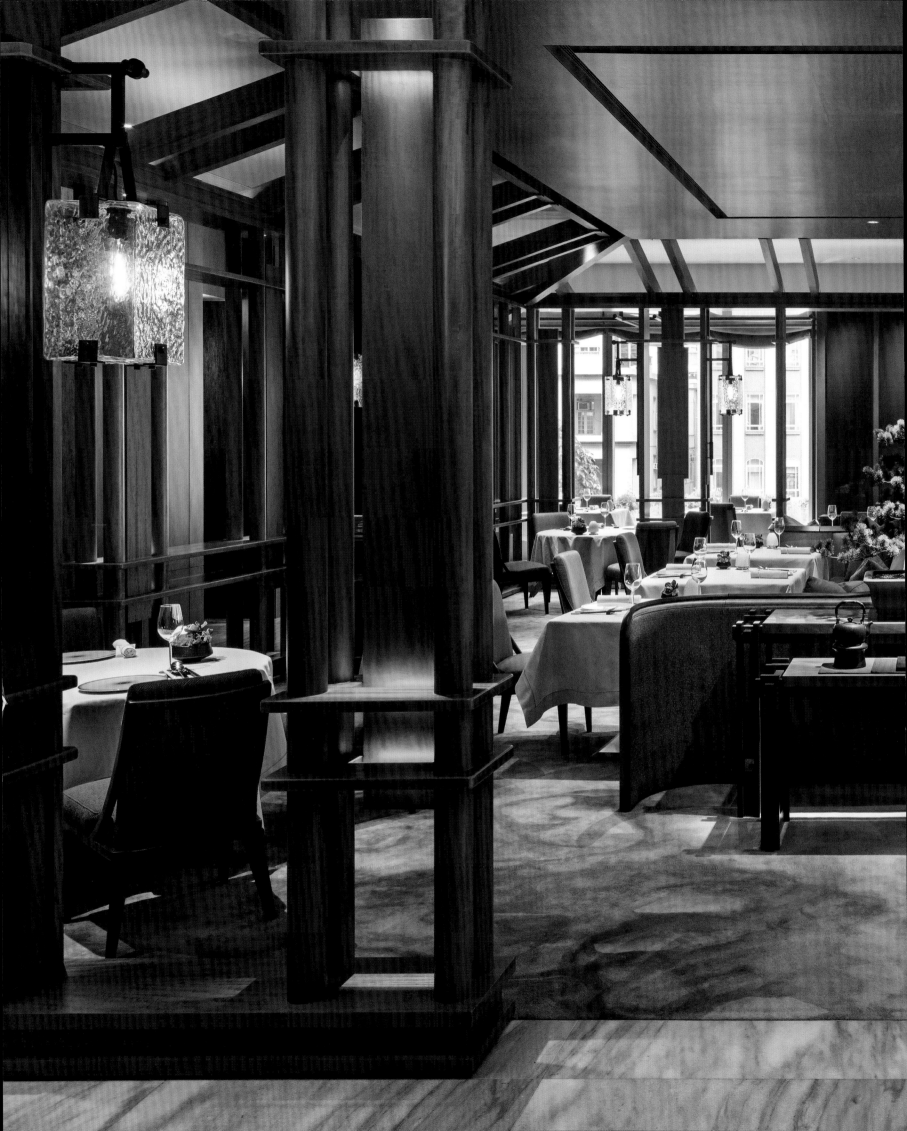

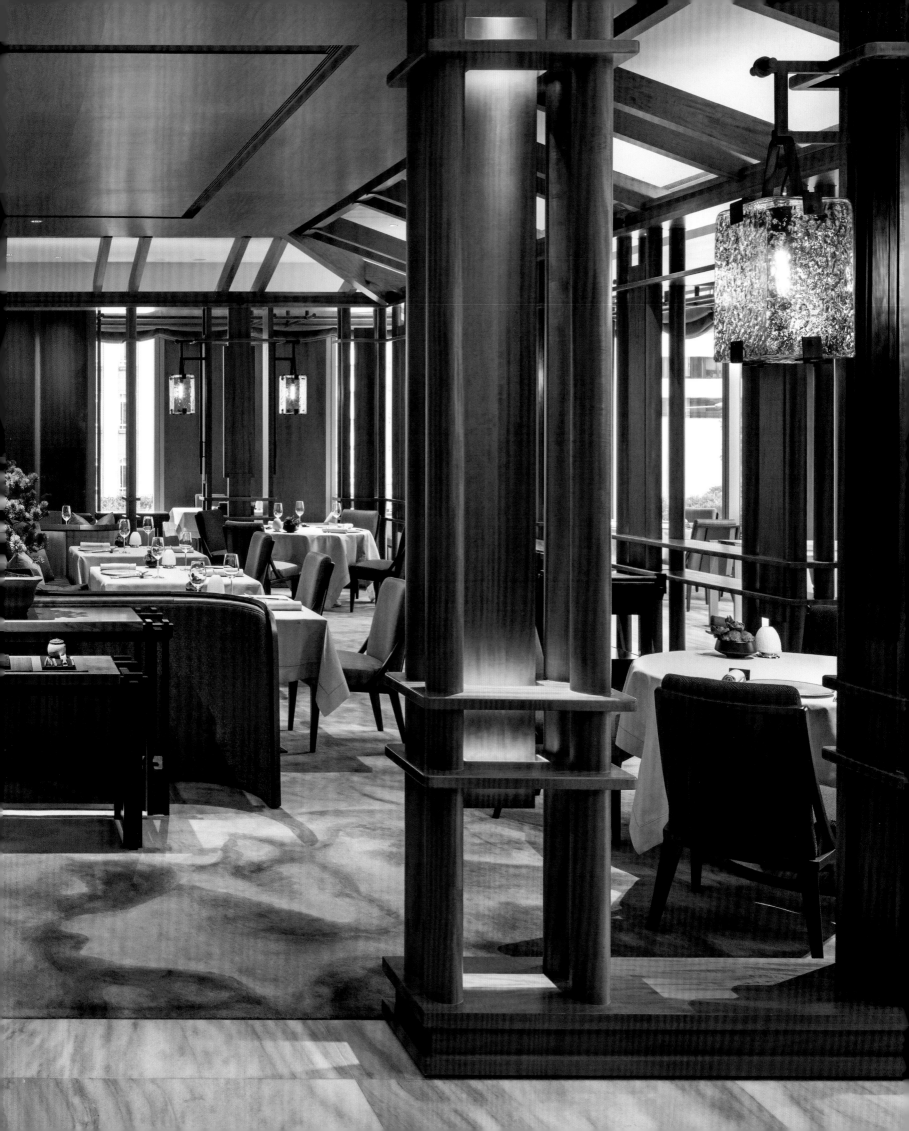

pavilion suites the berkeley, london

London is a very special market for high-end, 'aspirational' suites, but in 2017, when I was commissioned by The Berkeley, most hotel suites fell within two camps: decadent and opulent classic, or uber-modern and high-tech. I wanted to create something quite residential that would fit The Berkeley's contemporary spirit of innovation, so I thought very carefully about what makes a beautiful home, adding a fully fitted kitchen that would make the suite ideal for entertaining, and simple, appealing details throughout, like a stunning bathtub that has a sculptural marble pillow.

I wasn't really thinking about Asian aesthetics; instead, I wanted to translate the sense of innovation that I had experienced in Asia's fast-growing hospitality market while also embracing the classic elegance of London's Hyde Park and the chic, fashionable vibe of Knightsbridge. So the interiors that emerged were more about an elegant and streamlined international feel with quintessential British touches like brushed brass and rustic flamed marble, which feel very London to me.

Then, a few years later, Maybourne asked me to help create two glass penthouse pavilions in the same property. I was intrigued by the challenge of inserting glass boxes into an existing building, especially since I've always admired and thought of Philip Johnson's perfectly proportioned and simple Glass House as the ultimate expression of modernism.

One very rarely has floor-to-ceiling-height windows in London, and it is also unusual to have so much daylight in a residential setting. This proved to be a challenge because although I wanted to celebrate the abundance of light and panoramic windows, they also take away a lot of the intimacy.

Both penthouses face Belgravia so have a residential setting. They are quite different to each other in the experience they provide, even though they are equally large and each features a large terrace. The Crescent Pavilion Penthouse measures around 214 square metres and is conceived very much as a glamorous yet welcoming open-plan home dedicated to the art of entertaining. There is a dining room that seats eight, a bar and two spacious living rooms arranged in an L-shape looking on to a wraparound outdoor terrace. The glass doors slide back completely so that the

indoors and outdoors feel like one seamless space. It was conceived very much as a place to host friends or special events.

The Grand Pavilion Penthouse is quite different. It is not a single space like the Crescent Pavilion; here, the glass box is divided into two: the living room and the bedroom, which creates a much more intimate, personal ambience, even with both rooms enveloped in glass on three sides. I imagined someone waking up in the morning and raising the window blinds to look out at the panorama of Belgravia. We deliberately placed the bed close to the glass to create a feeling of being in the sky.

Designing the pavilions was a revelation, because I realized that it was not just about creating an indoor and outdoor space, but about integrating them to create an engaging experience. They need to be more than just beautiful, and to still feel cosy and warm despite being surrounded by glass. The interesting thing is that the interiors seem to extend outwards, so you design to the very outside edge of the terrace and account for different perspectives, such as what the interiors look like from the outside looking in. To address these issues, I incorporated sheer Roman blinds and landscaping on the terraces. The Crescent Pavilion's terrace has two separate areas for dining and relaxing and feels like an English garden with delicate flowers and lush plants that provide a beautiful backdrop for any kind of entertaining – especially with views of St Paul's Church – whereas the Grand Pavilion's terrace is sculptural and rustic with cypress and olive trees and an open firepit.

I also looked for ways to infuse softness into what is otherwise a very architectural expression. The colour palette is soft, with pale greys, sage and in-between colours like dusty burgundy and mineral teal. Texture is also important, and one of my favourites is a Fromental wallpaper with hand-painted, gilded raindrops – a whimsical tribute to English weather. The rugs are all by Tai Ping, so super plush, and the custom bronze lighting is a nod to traditional English streetlamps, with vintage-style tungsten spiral bulbs for a touch of nostalgia and to create a soft glow. It feels very contemporary, but at the same time in the wood wall panels there are hints of classic Britishness that I feel celebrate London today.

opposite Pavilion suites dressed in an understated, earthy palette complemented by such luxury finishes as the elegant marble in walk-in dressing rooms evoke Fu's take on modern Britishness.

45

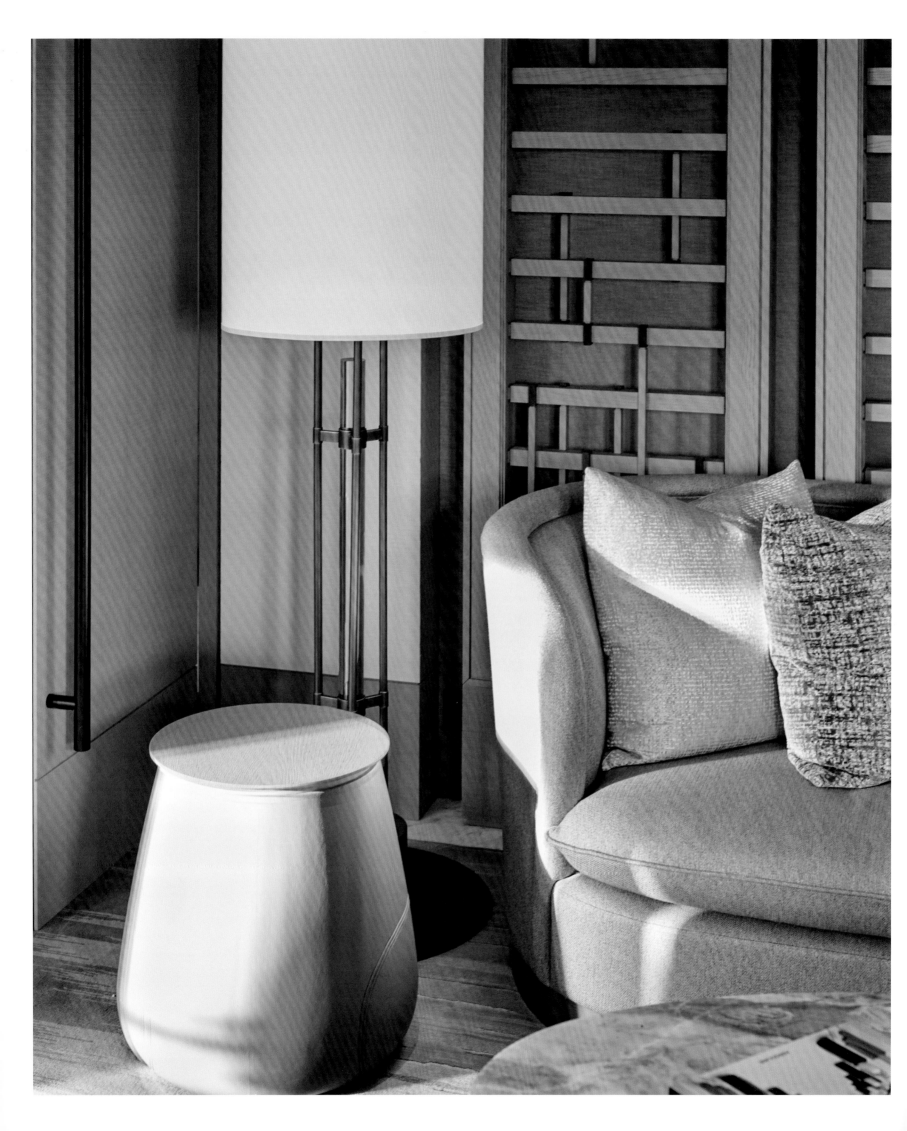

opposite Here, the pale-oak flooring and the soft silhouettes of the custom-designed tufted rugs combine to focus on comfort.

above A muted colour palette of pale greys and sage blends with rich, tactile natural woods and warm metals.

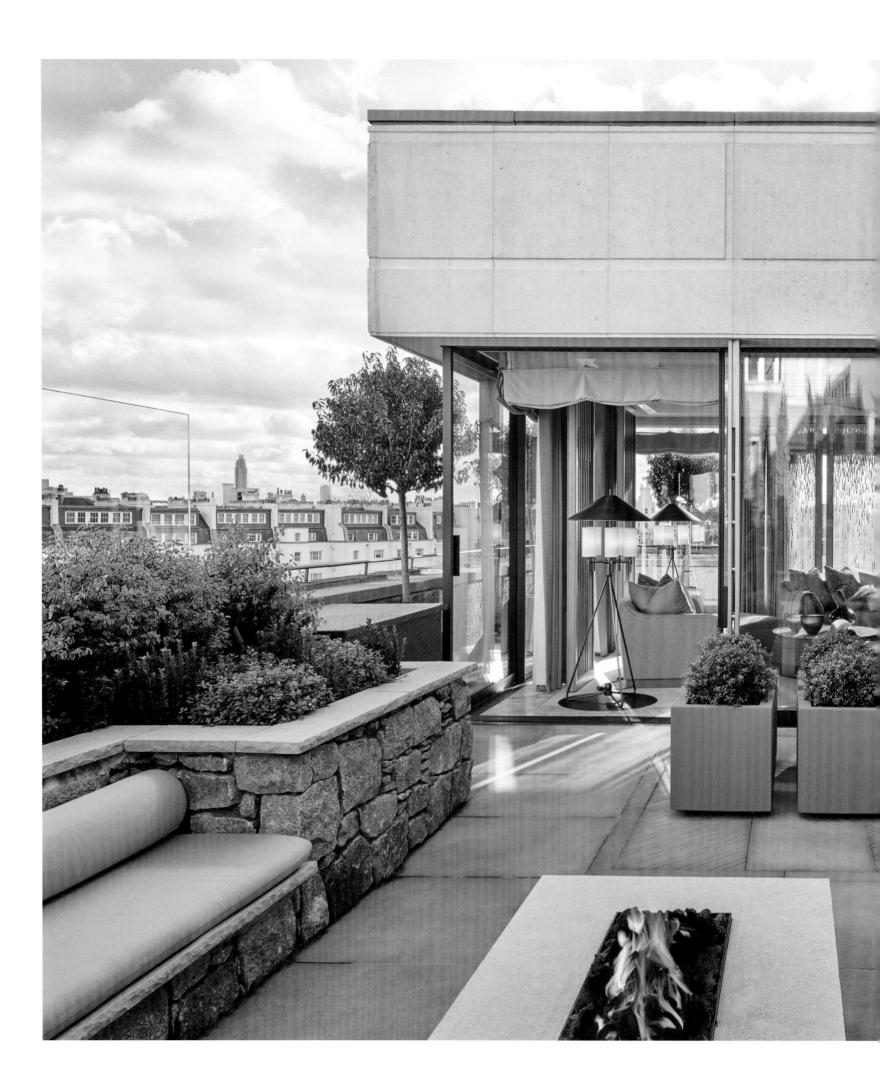

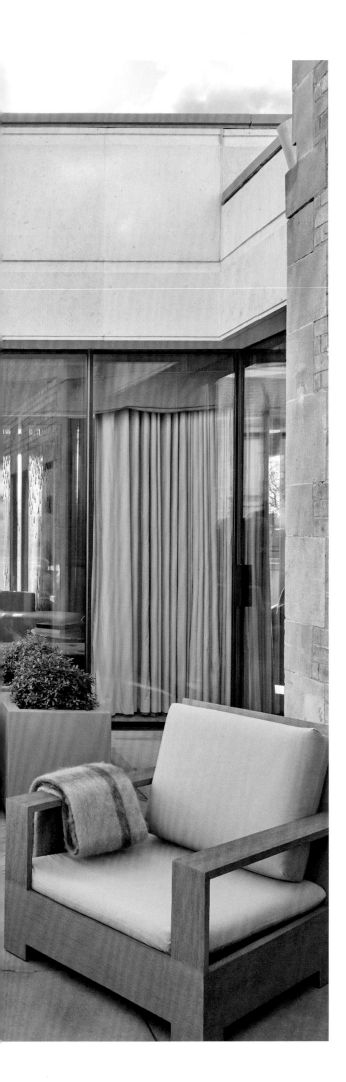

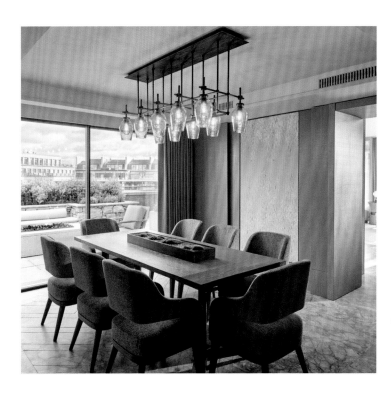

left Fully retractable floor-to-ceiling windows and doors blur the boundary between indoors and out. The terrace's centrepiece is a striking contemporary fire pit with rustic stone planters.

above The dining room opens on to the terrace and has panoramic views of the London skyline.

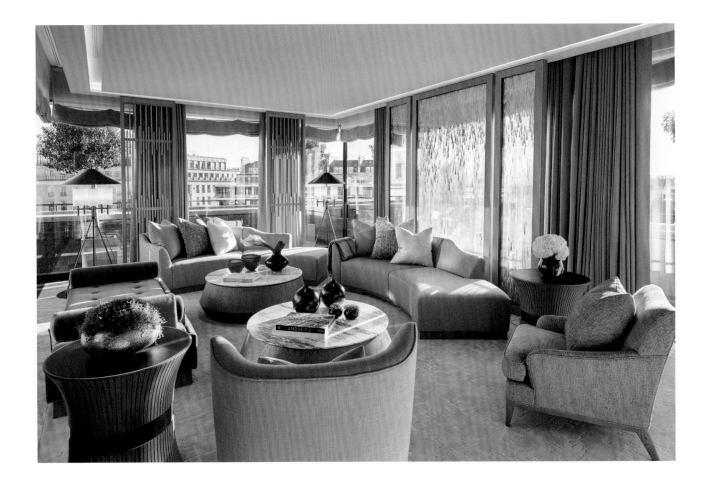

above The living room is designed for relaxing and entertaining, with comfortable sofas, generous armchairs and dramatic views.

opposite Hand-painted, gilded raindrops are Fu's tribute to English weather and luxury.

pages 52–53 The master bedroom of the 214-square-metre, two-bedroom Crescent Pavilion Penthouse infuses quintessentially contemporary British style with a Zen-like tranquility.

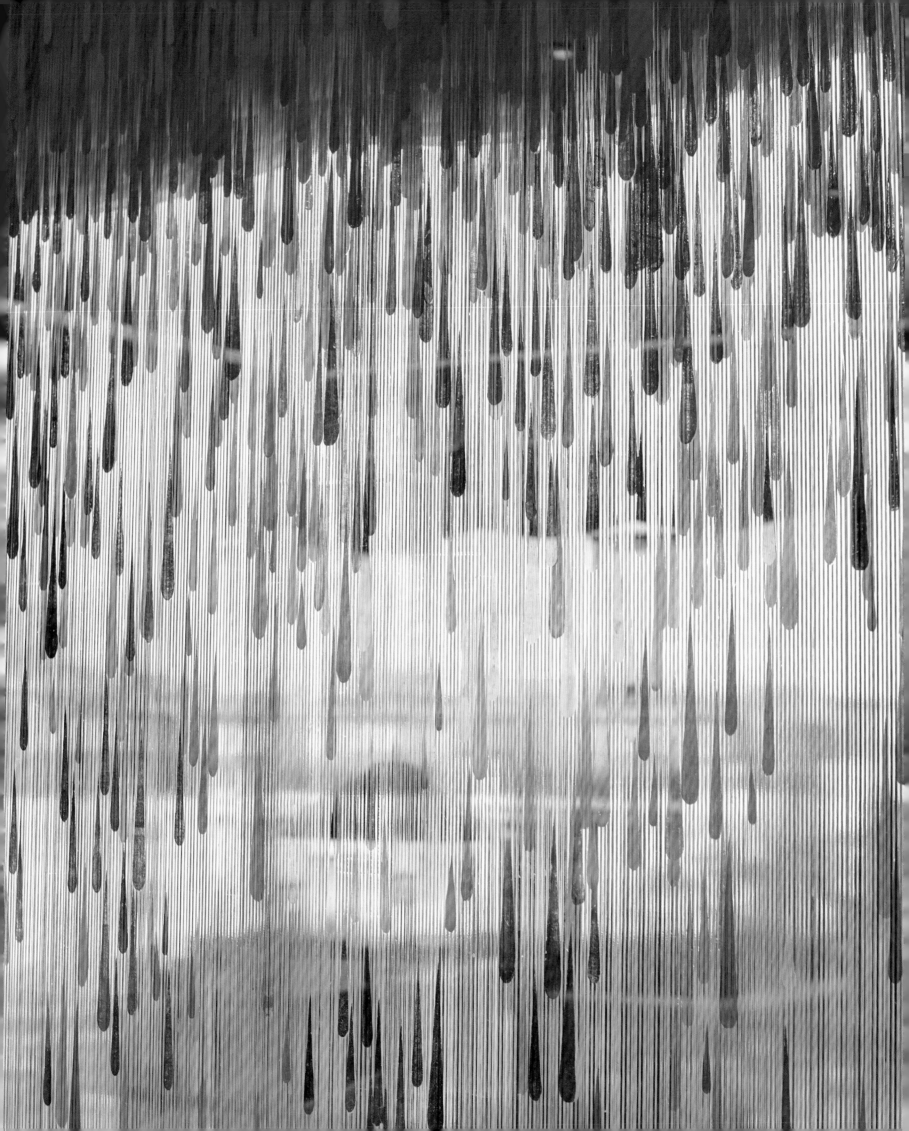

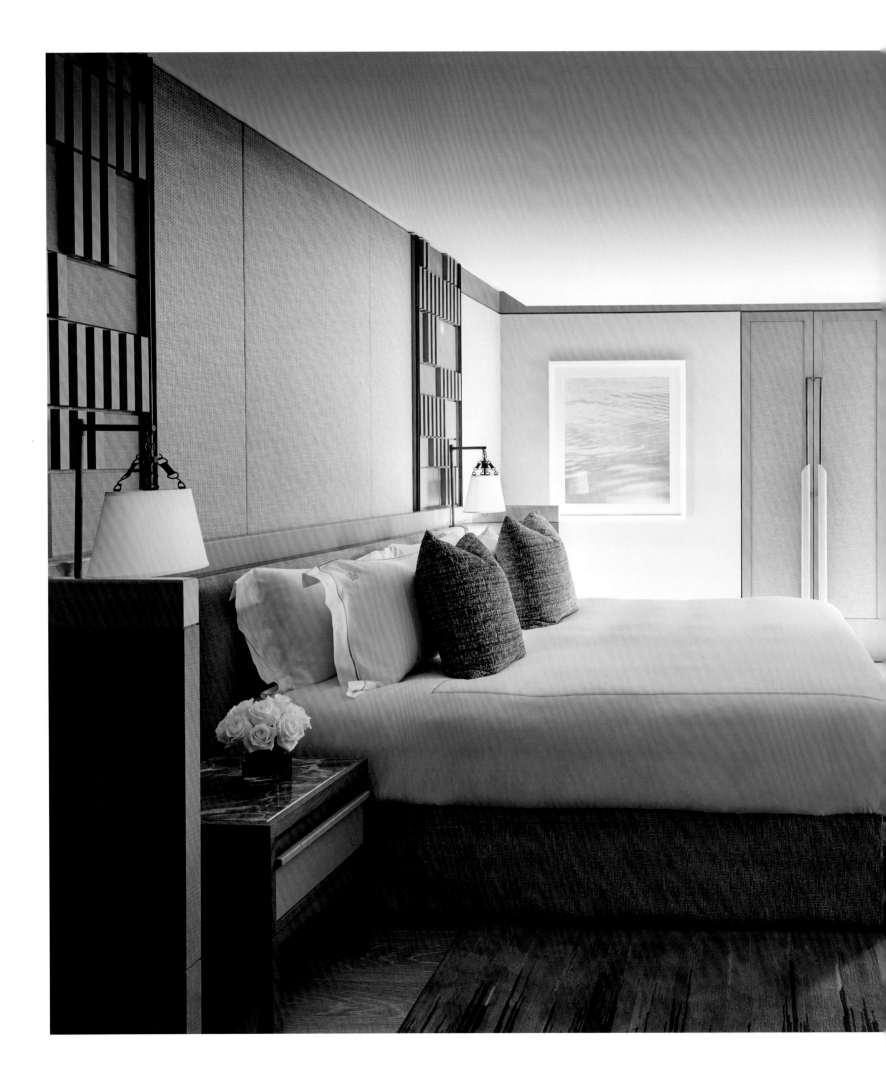

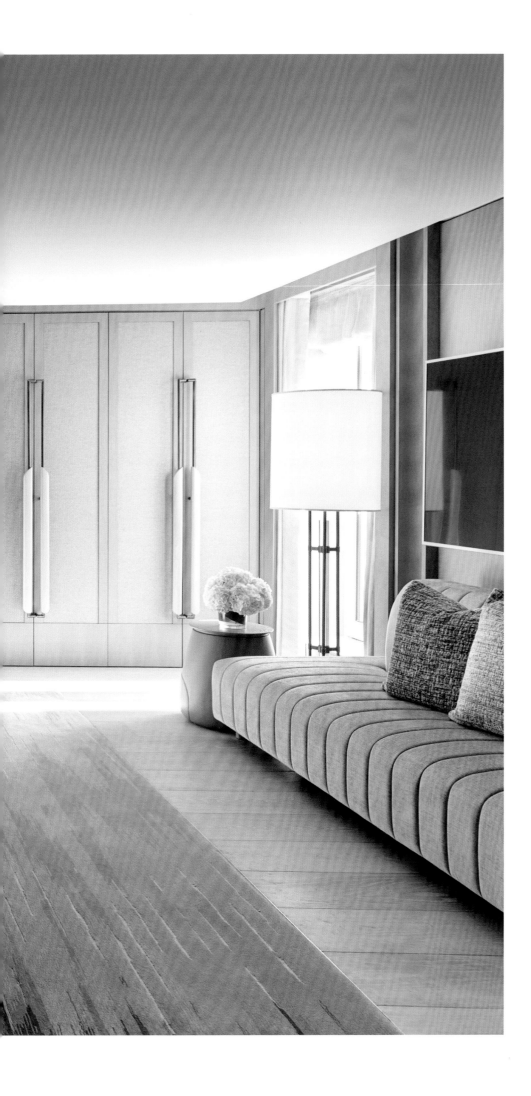

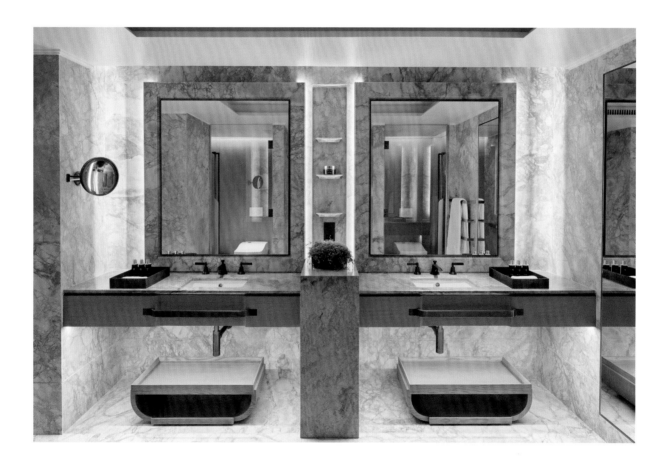

above Silver-grey marble and a freestanding bathtub create a cosseting, spa-like feel in the bathroom of the Grand Pavilion Suite.

opposite The distinctive, sculptural marble veining that extends to the walls and floor complements the soft curves of the island bathtub.

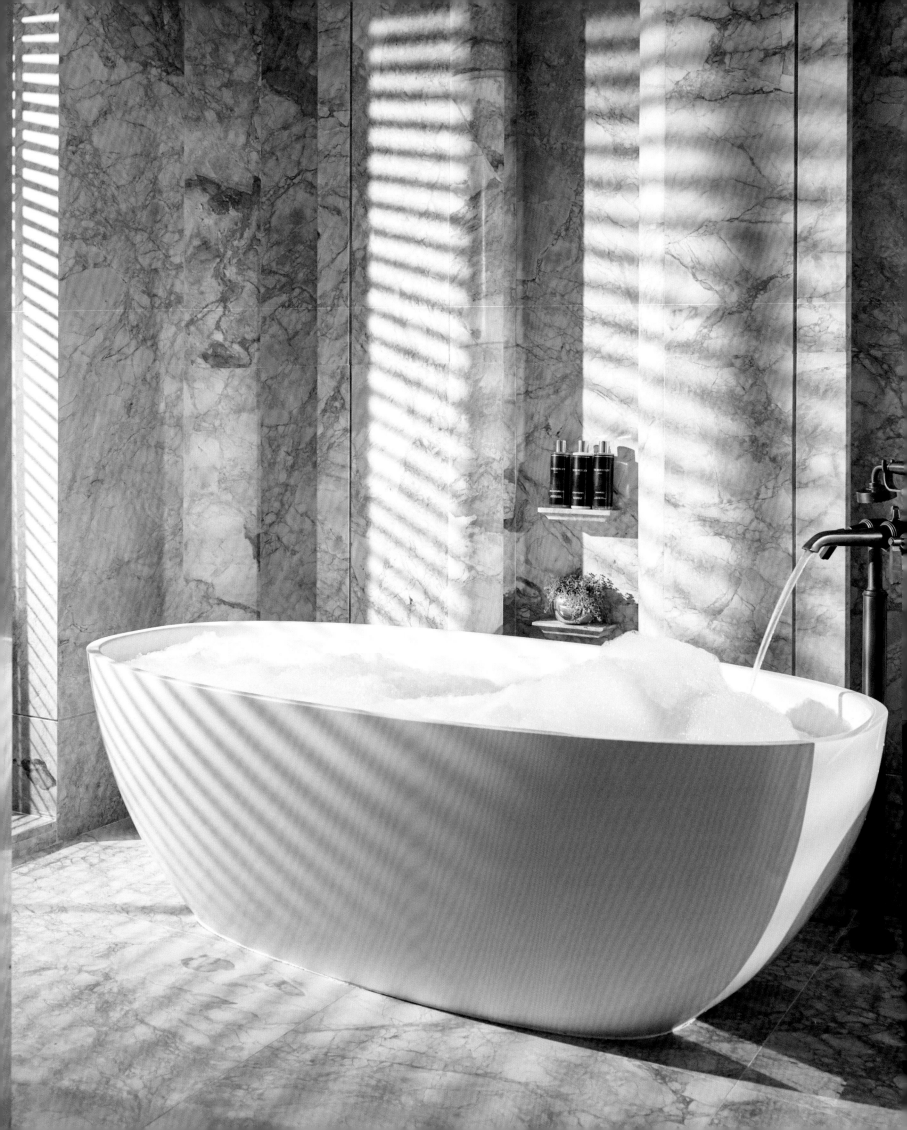

waldorf astoria bangkok

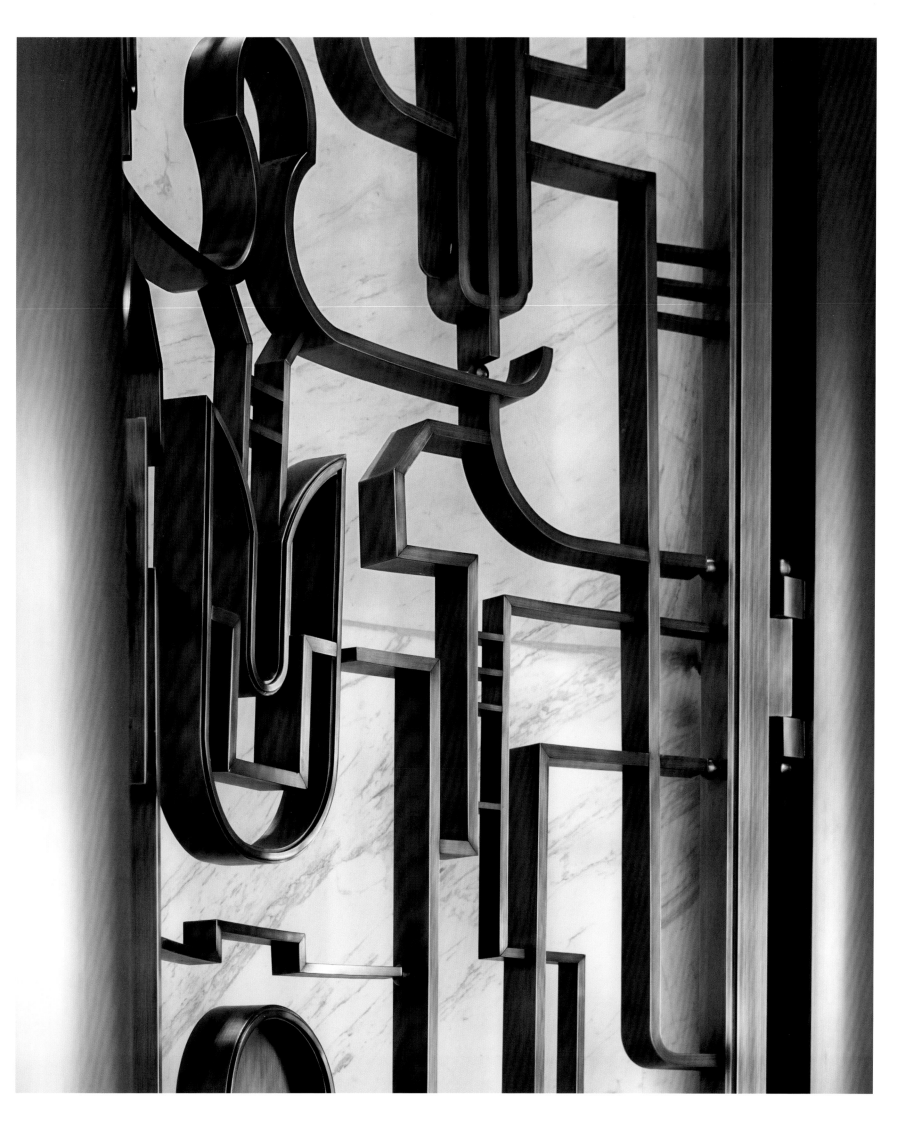

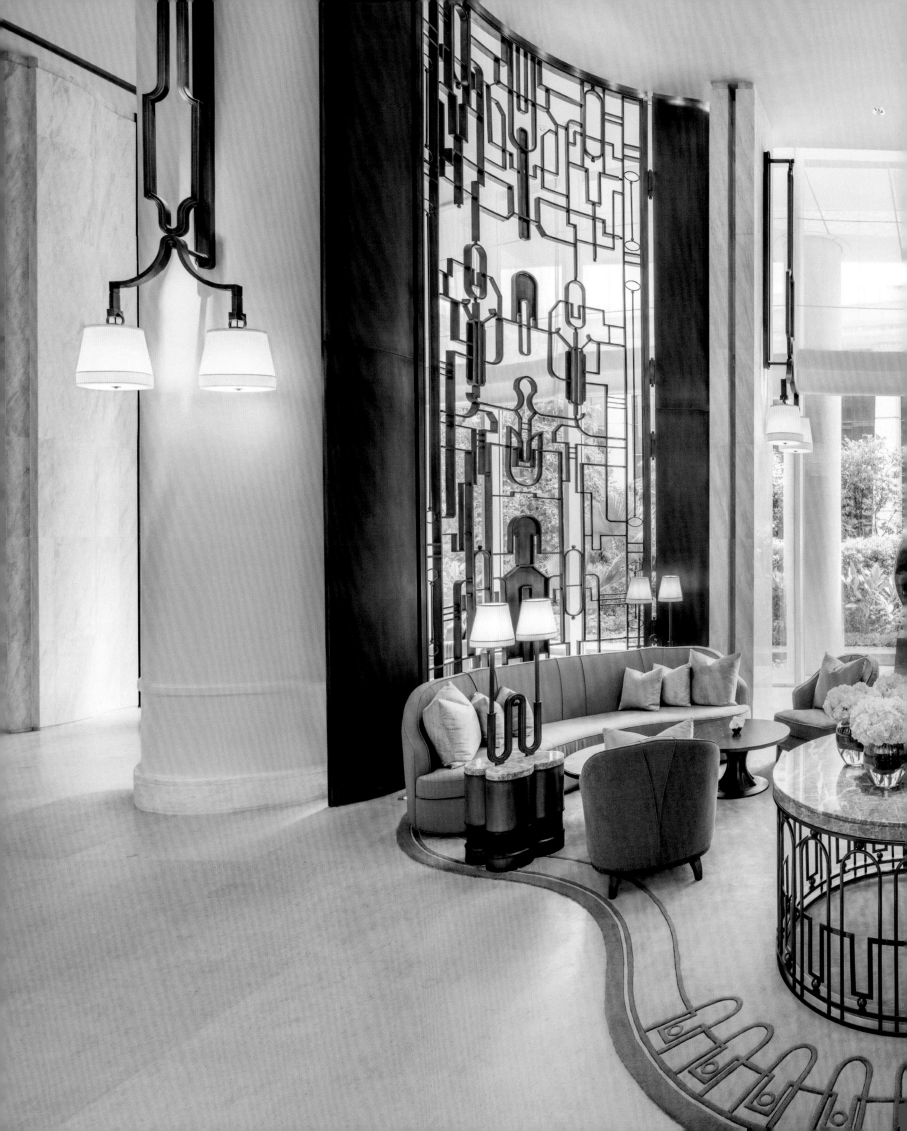

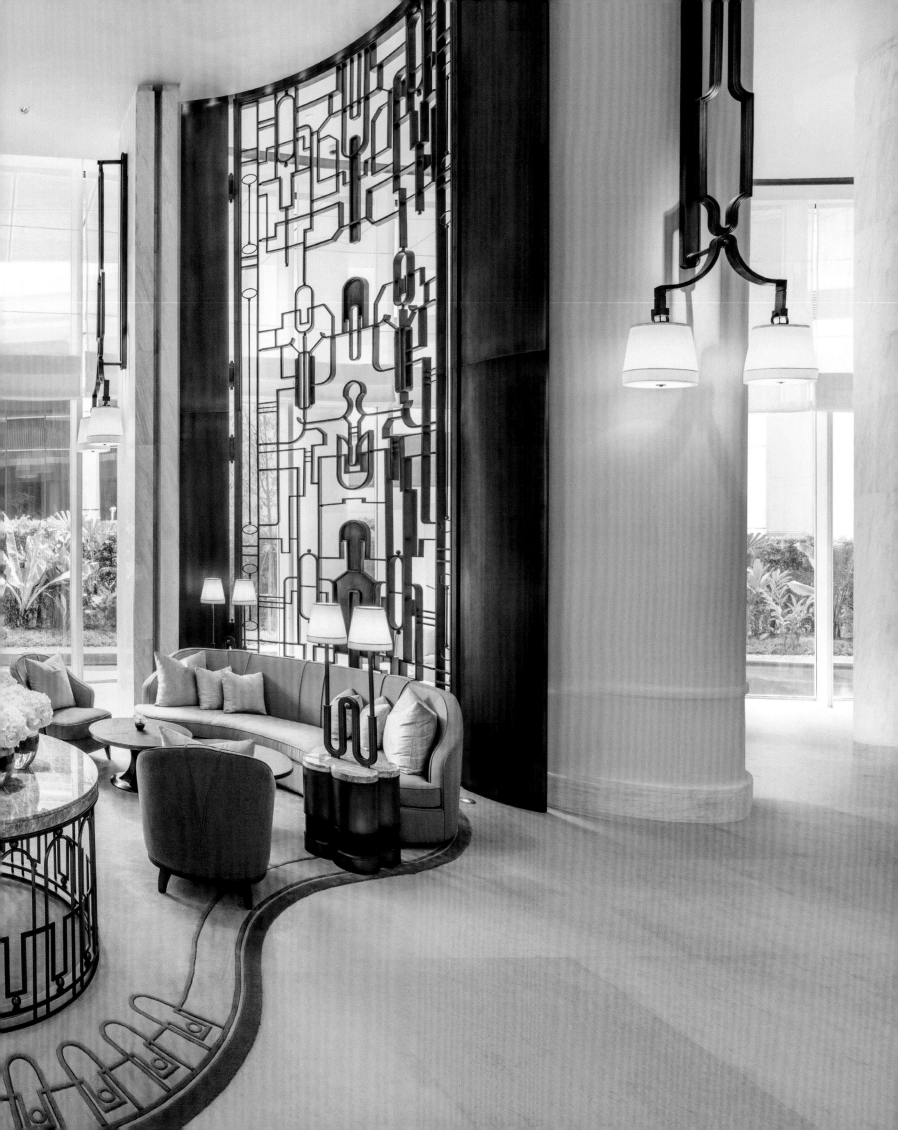

To me, the Waldorf Astoria as a brand has always felt majestic and formal with a layered approach to its interiors. I especially remember the impression that the Waldorf Astoria New York's powerful formality and many Art Deco motifs had on me as a teenager, so I was very intrigued by the proposition of having a legendary historical brand within a contemporary, futuristic-looking building in Bangkok – a complete opposite to the quite rectilinear and geometric form that I associate with Waldorf Astoria. That is one of the key reasons why I wanted to take on the challenge of creating a unique experience of Waldorf Astoria within a contemporary Thai context.

Bangkok is a fast-changing city, especially over the past ten years, but generally its hotels have tended to be either classic or contemporary. The Waldorf Astoria Bangkok is different because it marries a classic historical spirit to a strong contemporary sensibility. Most importantly, it embraces Bangkok today.

I felt that it was especially important to create the strong sense of a journey through the hotel. From the time you arrive at the entrance and you see a pair of 6-metre-high bronze screens, there is a very careful curation in the visual sequence as you move through the hotel. The organic flow is partially in response to the challenge of the building's narrow, long yet organic shape. This sense of fluidity is very different to the original Waldorf Astoria hotel, but is a wonderful homage to Bangkok as it evokes the sense of a magnolia flower and petals unfolding one after the other. That impression is further extended to many of the carved marble tables, artworks and even some of the walls that imbue spaces with natural sensuality and fluidity. One of my favourite moments is the passageway leading into the spa. It is quite a long corridor, but we elevated the experience by lining the walls with gently curved white lacquer panels illuminated from below, like a line of dancing petals. It is a subtle touch, but creates an incredible glow.

We also suspended many pendant lights – and wall-hung candleholders designed like a bronze ribbon to celebrate the notion of fluidity – that create a soft glowing halo of light and subtly orchestrate guests' movement around the hotel.

I am not thought of as a designer who works with Art Deco – I am better known for modernity – so the opportunity to explore the motifs from that era within the unique DNA of the Waldorf Astoria brand also appealed to me.

The best example of how these motifs are expressed is in the different screens throughout the hotel. In the ground-floor lobby, for example, the pair of welcoming screens has a very subtle pattern that is inspired by the elegant hand movements of Thai dancers. I wanted to translate that sense of movement, articulating a sense of 'Thai-ness', but not in an obvious way. The design and shape of these screens are also a response to the dramatic architecture of the building, which was inspired by the magnolia flower, while their Art Deco-inspired metal frames with subtle tweaks to the profile evoke classic Thai motifs. Nothing is obvious; these details are almost subliminal.

Thai culture is also expressed in the smaller details, such as the cast-bronze room numbers. These were handcrafted by a very talented Thai graphics artisan. It is essential to me that even the smallest font should be consistent with the holistic language we use in the hotel.

On the other hand, the proportions of the hotel's public spaces are especially dramatic and the material palette is very bold and quite masculine, with softer, curved furnishings and accessories. I especially like the dramatic stone wall panels carved to create simple curvilinear forms. It is a fascinating play on a solid material expressed in a soft, tactile way.

I personally find the juxtaposition of classic and modern quite intriguing. Some people say that they find it is not a classic hotel, but it's not a modern hotel either. This is really about fusing the two elements so that it feels like an authentic reflection of the vibrancy and the strong culture of Bangkok today. For me, that is the most interesting part.

page 57 A bronze screen at the hotel entrance celebrates a feeling of place through an Art Deco motif with a hint of Thai dancers' hand movements.

pages 58–59 Interiors are a harmonious blend of classic Waldorf Astoria and contemporary Bangkok.

opposite Sensuous, undulating marble wall panels reflect a sense of sculptural fluidity throughout the hotel.

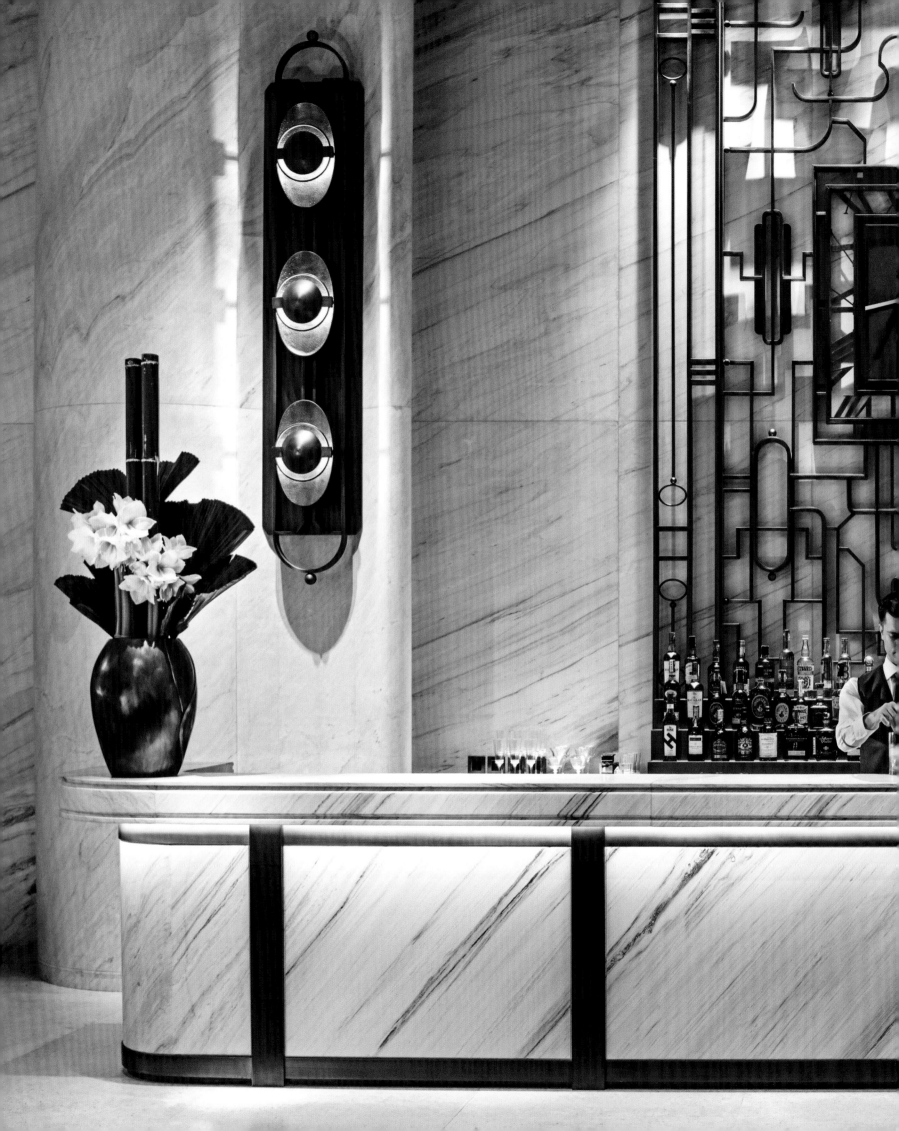

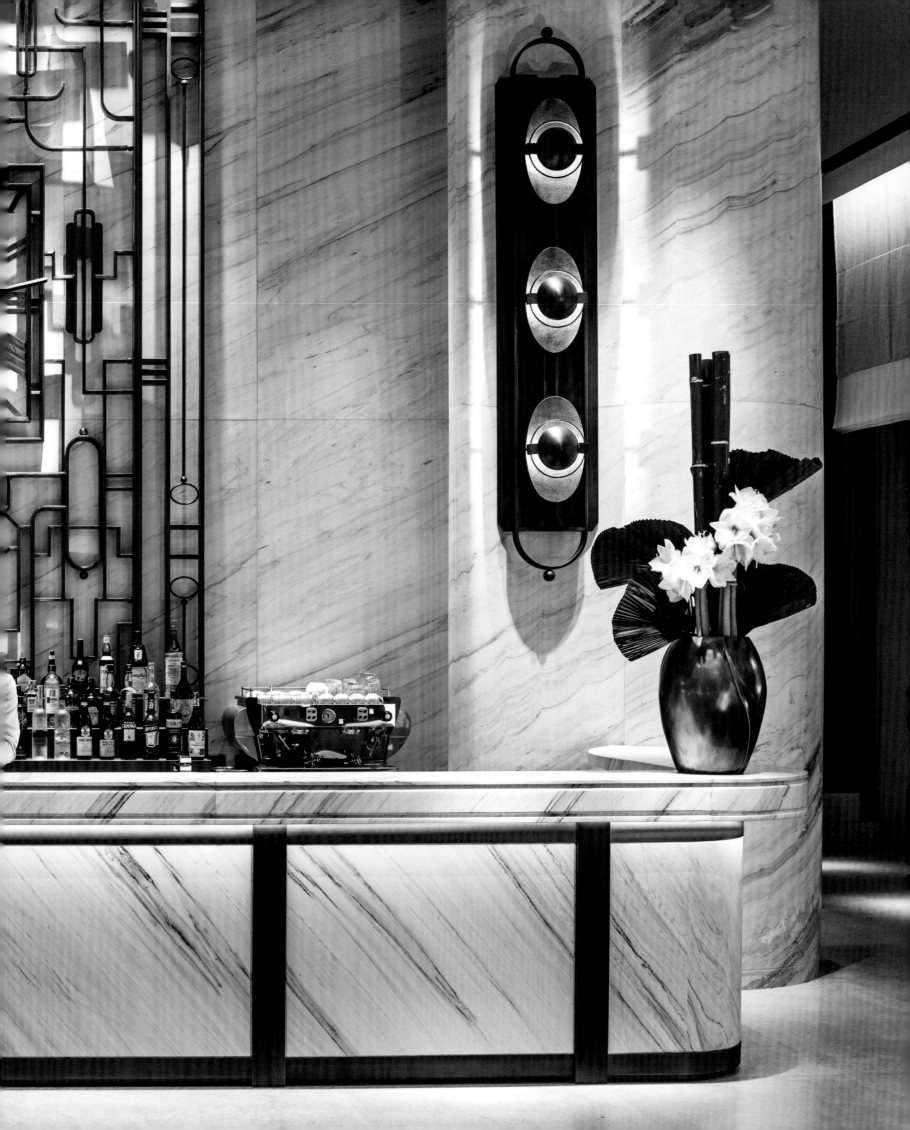

pages 62-63 Inspired by the grand centrepiece clock on Peacock
Alley, the walkway that connected the original Waldorf and Astoria hotels
in New York, Fu's striking backdrop comprises signature curving forms,
custom sconces and a decorative bronze screen on the feature wall.

right A beguiling sculpture in Bianco Carrara marble by the British artist
Louise Plant adds a spectacular yet clean, minimalist twist to the base of
the Grand Staircase.

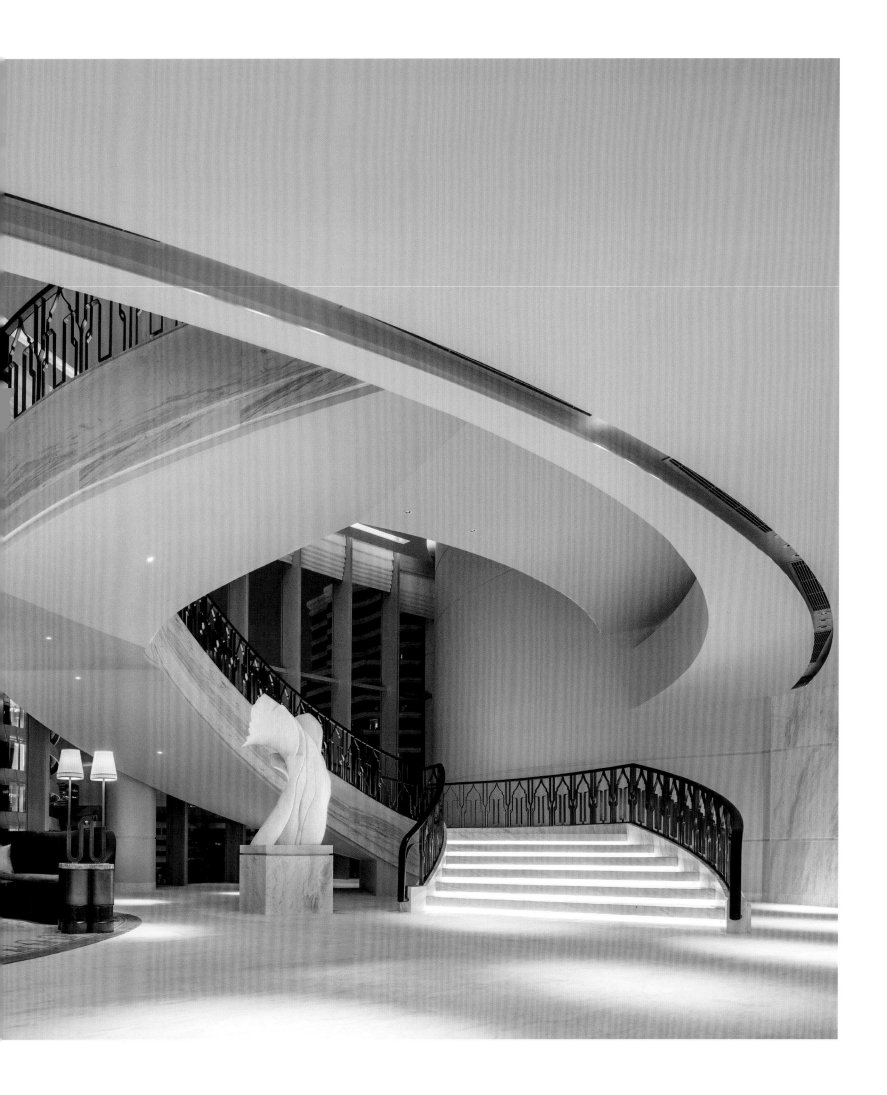

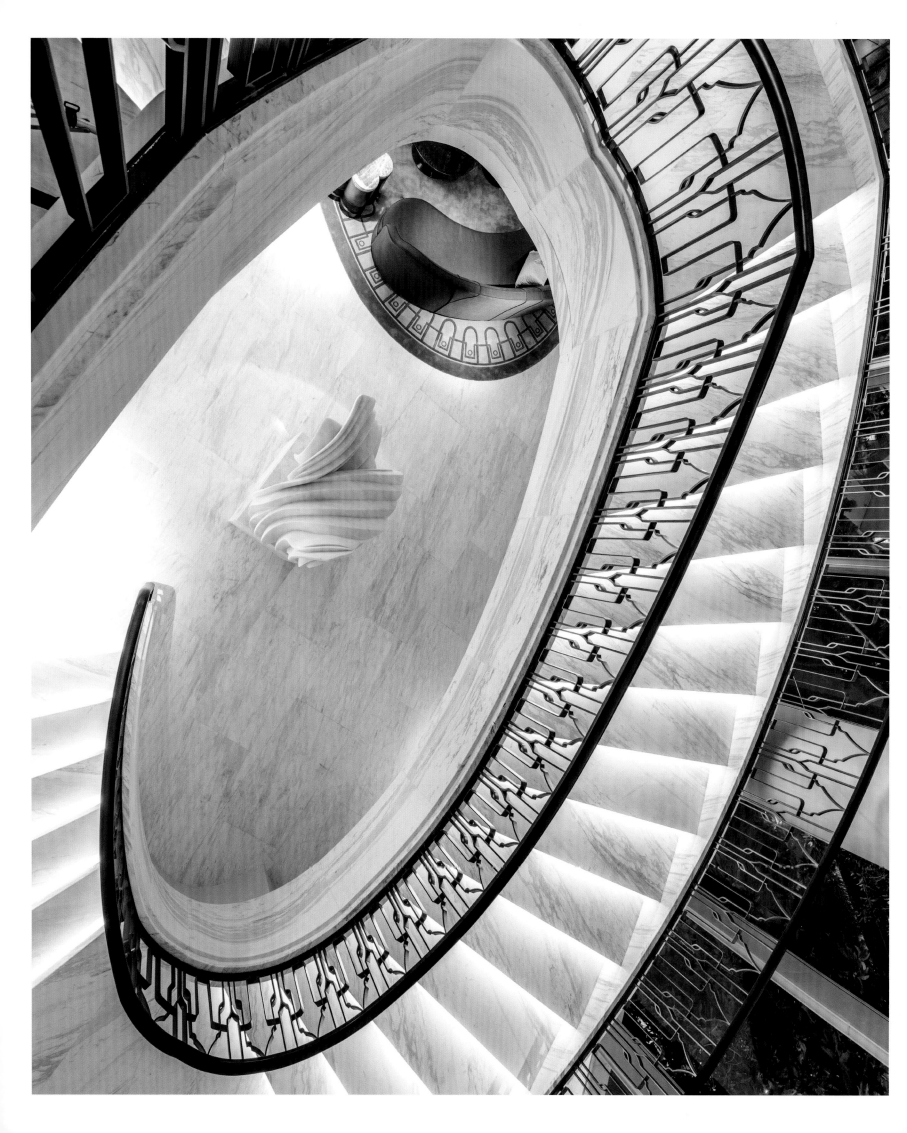

opposite View down the Grand Staircase towards the elegant
marble sculpture by Louise Plant (see pages 64–65; detail shown
above). The sculpture's organic profile is a visually powerful feature
at the base of the staircase.

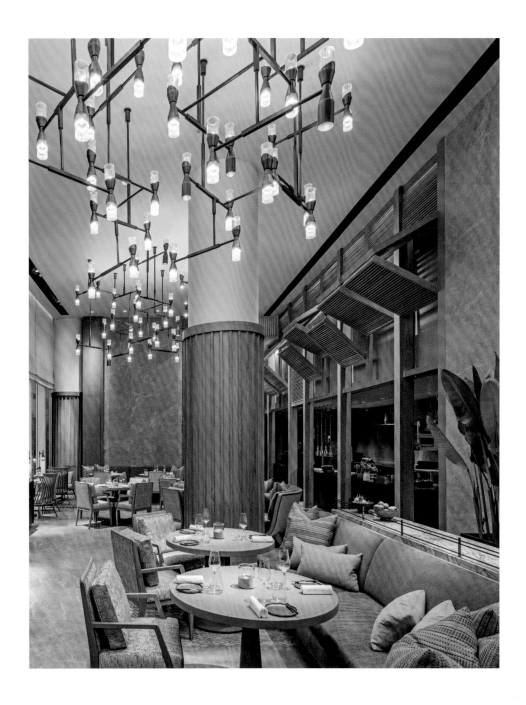

above and opposite In the Front Room, which serves Nordic-Thai cuisine, Fu took inspiration from Thai heritage and culture to create a kaleidoscope of suspended lanterns, evocative of the Thai floating lanterns used during the Loy Krathong festival. The shutters above the open kitchen reinterpret traditional Thai shophouses

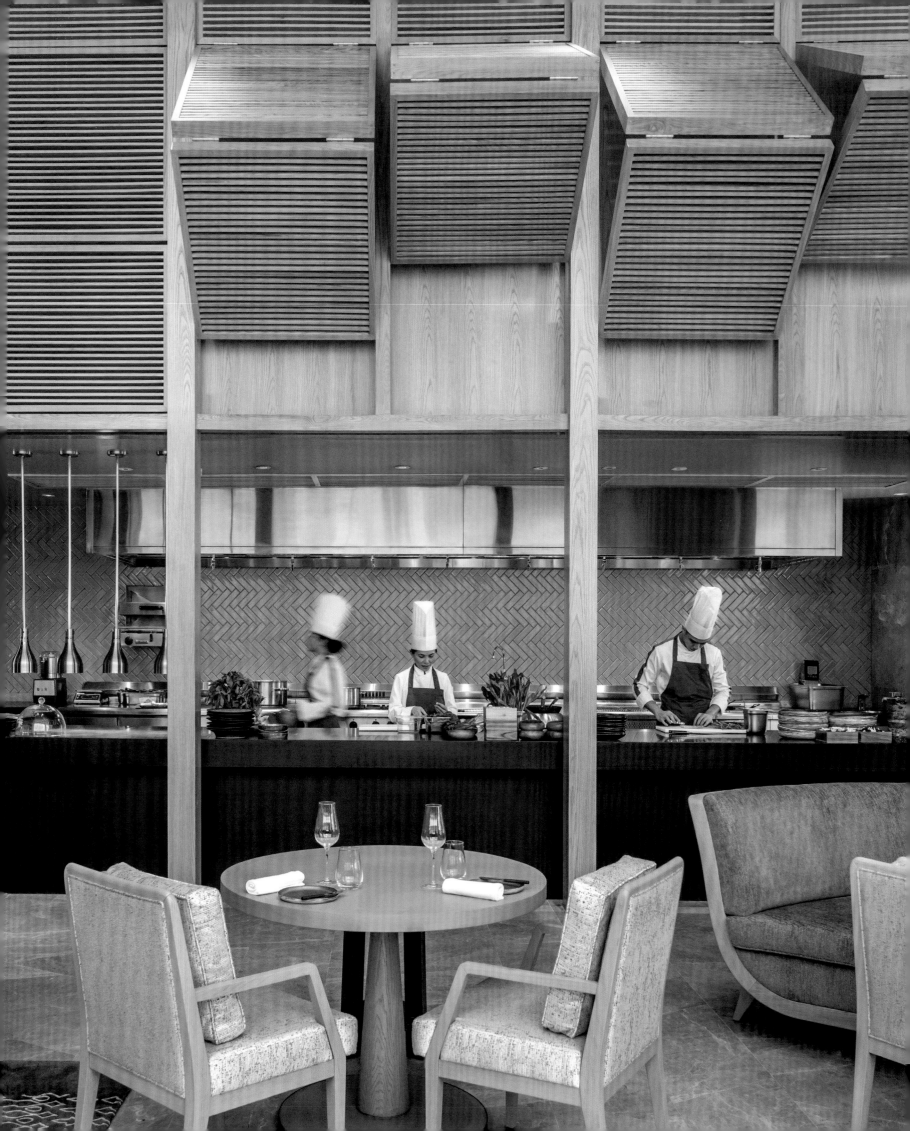

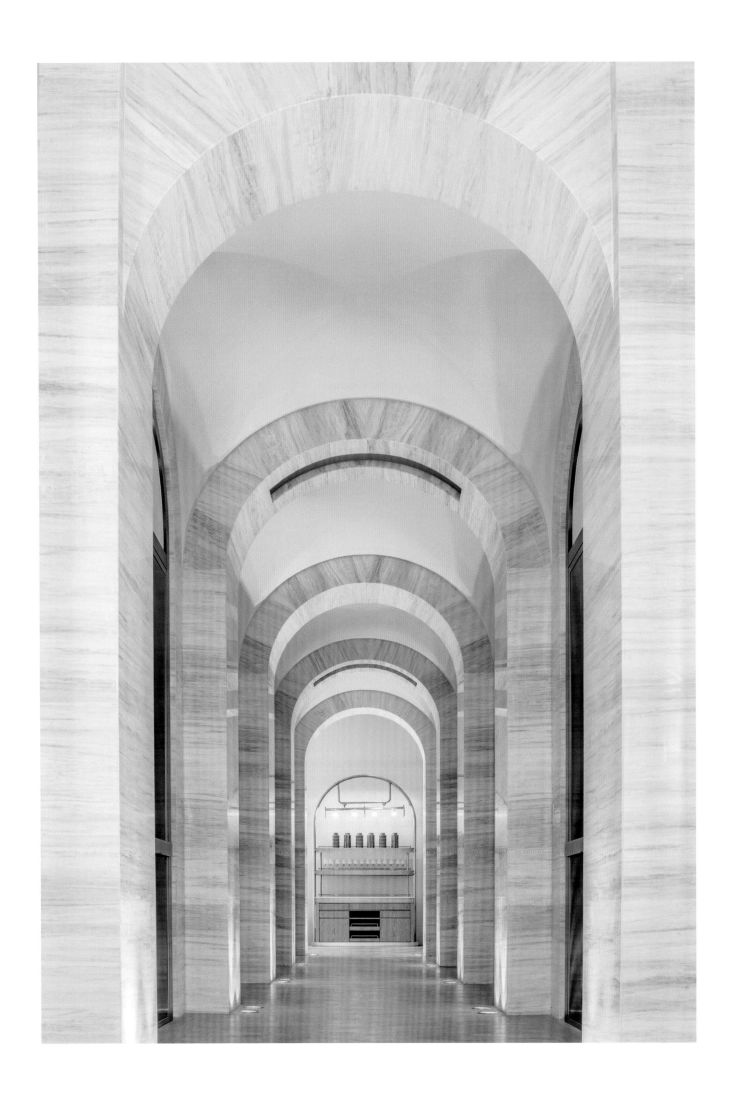

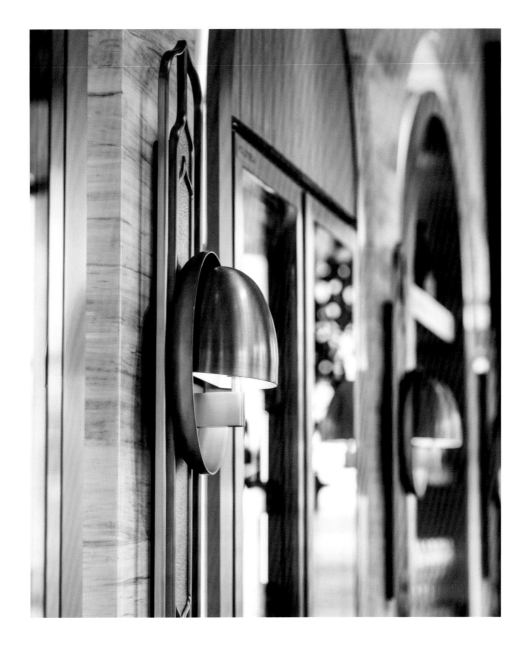

opposite The arched marble hallway leading to the Brasserie
pays tribute to the original Waldorf Astoria's famed colonnade.

above Fu designed all the lighting in the hotel, including this
brushed-bronze sconce with a subtle Thai motif in the Brasserie.

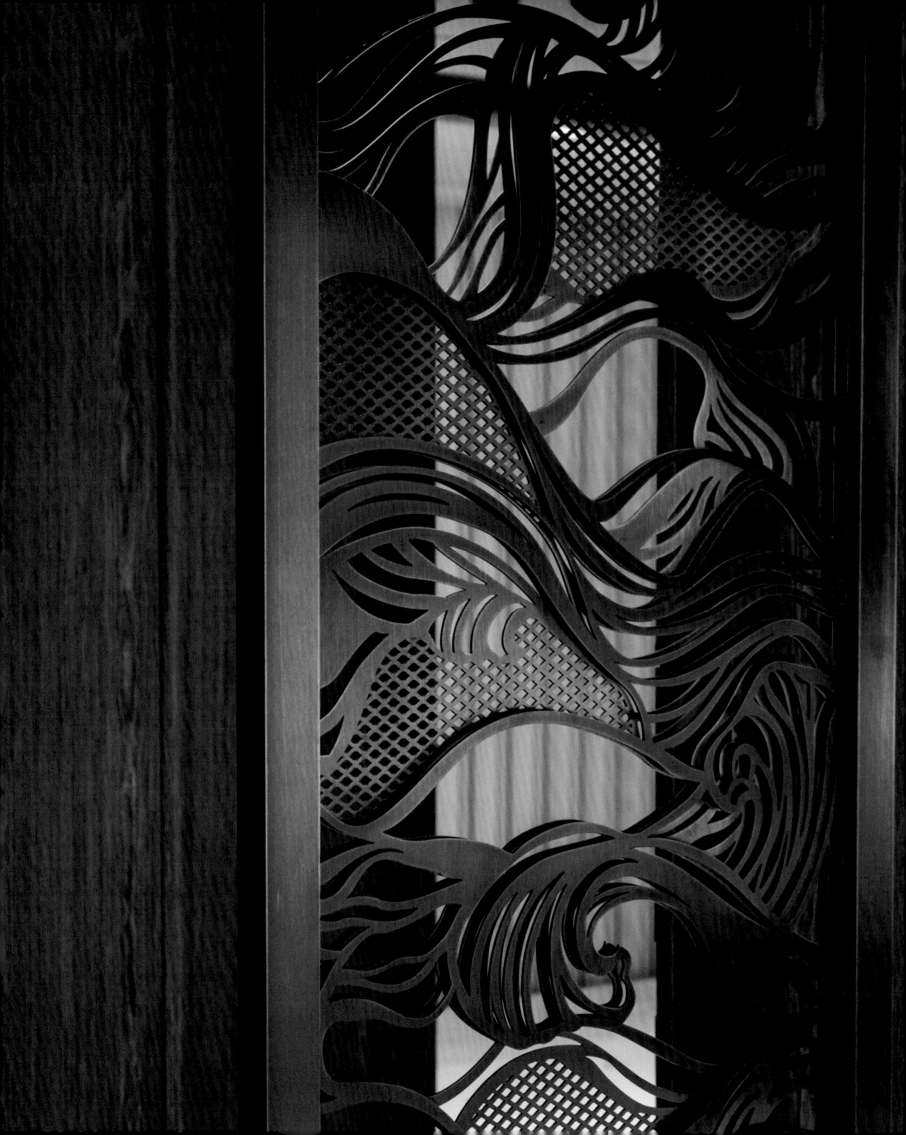

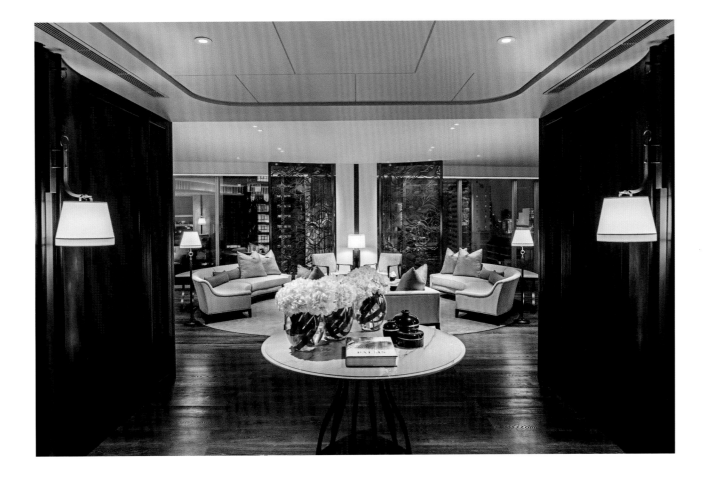

opposite The pattern of this laser-cut bronze screen is reminiscent of traditional Thai lace.

above Entrance to the Royal Suite living room.

pages 74–75 The sculptural rooftop pool deck is decorated with Fu's understated, contemporary outdoor furnishings in natural, earthy tones.

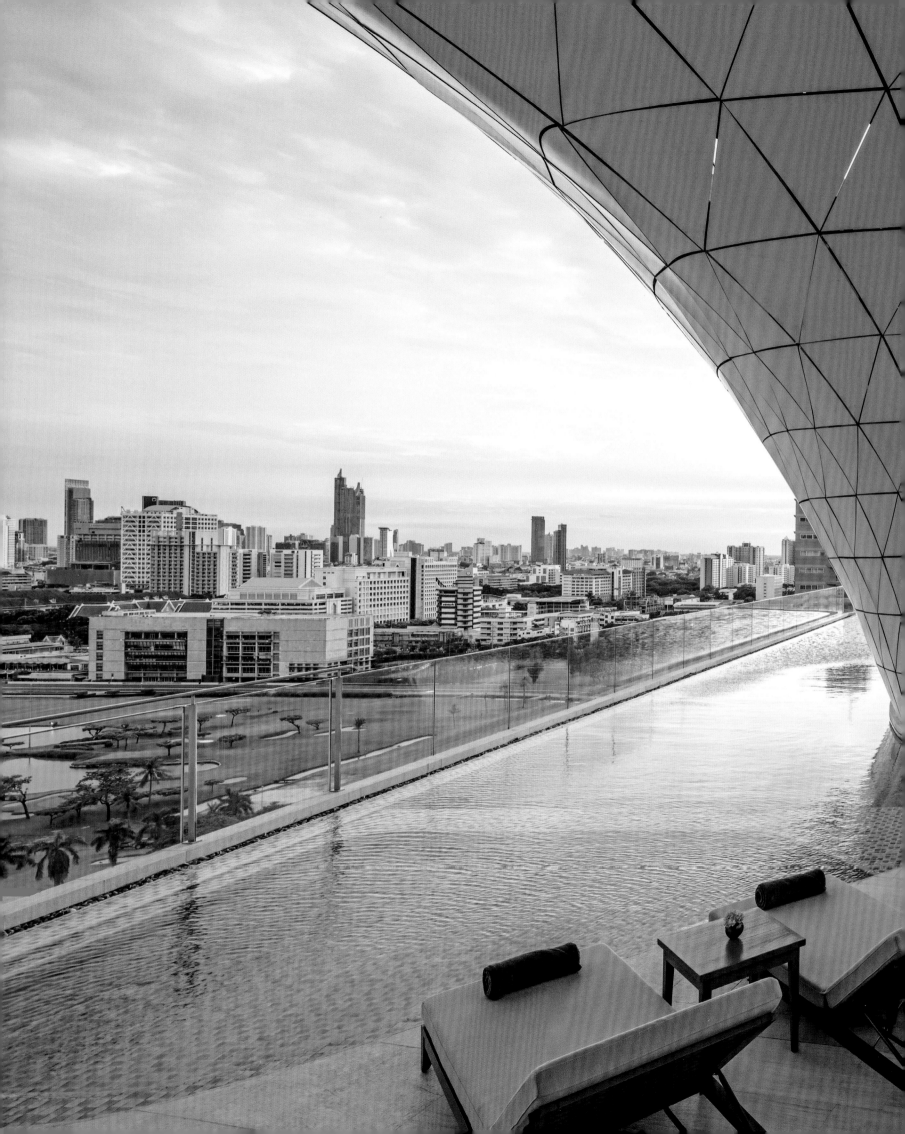

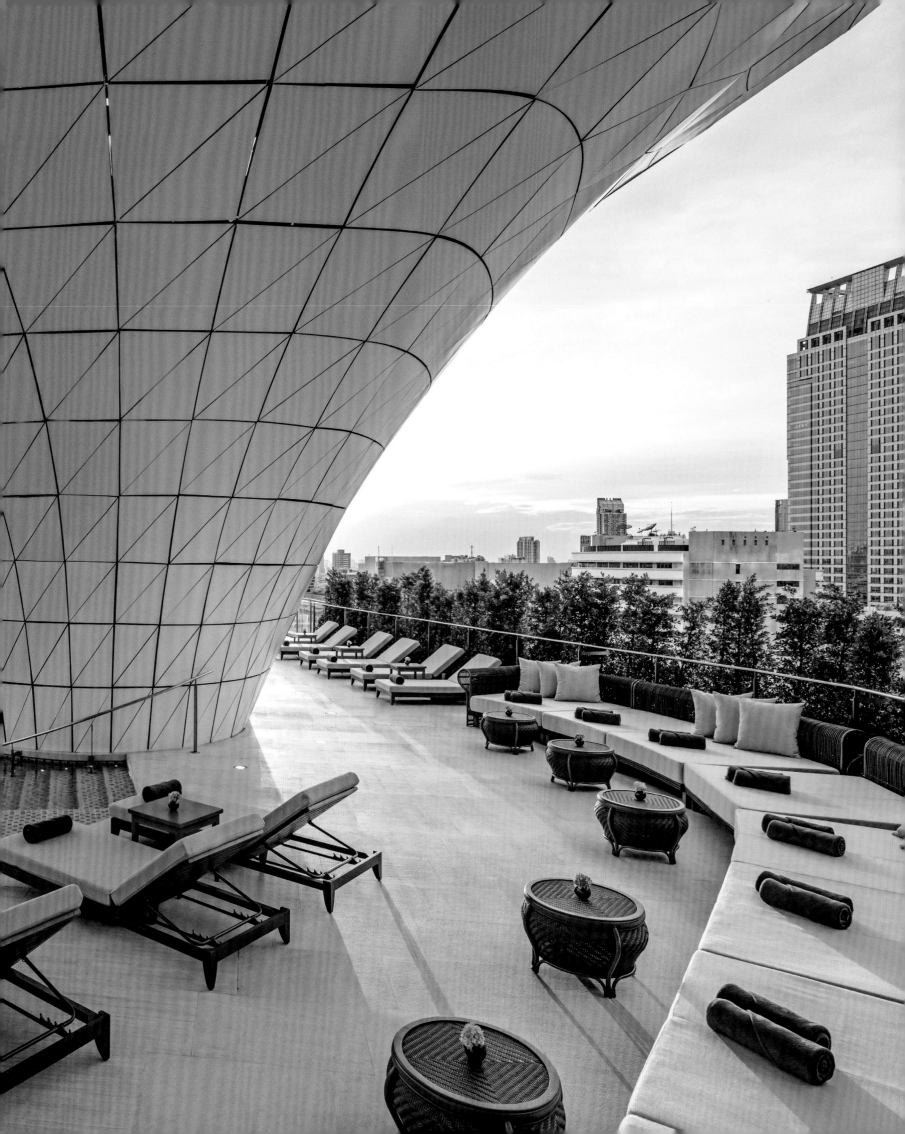

lasvit tac/tile

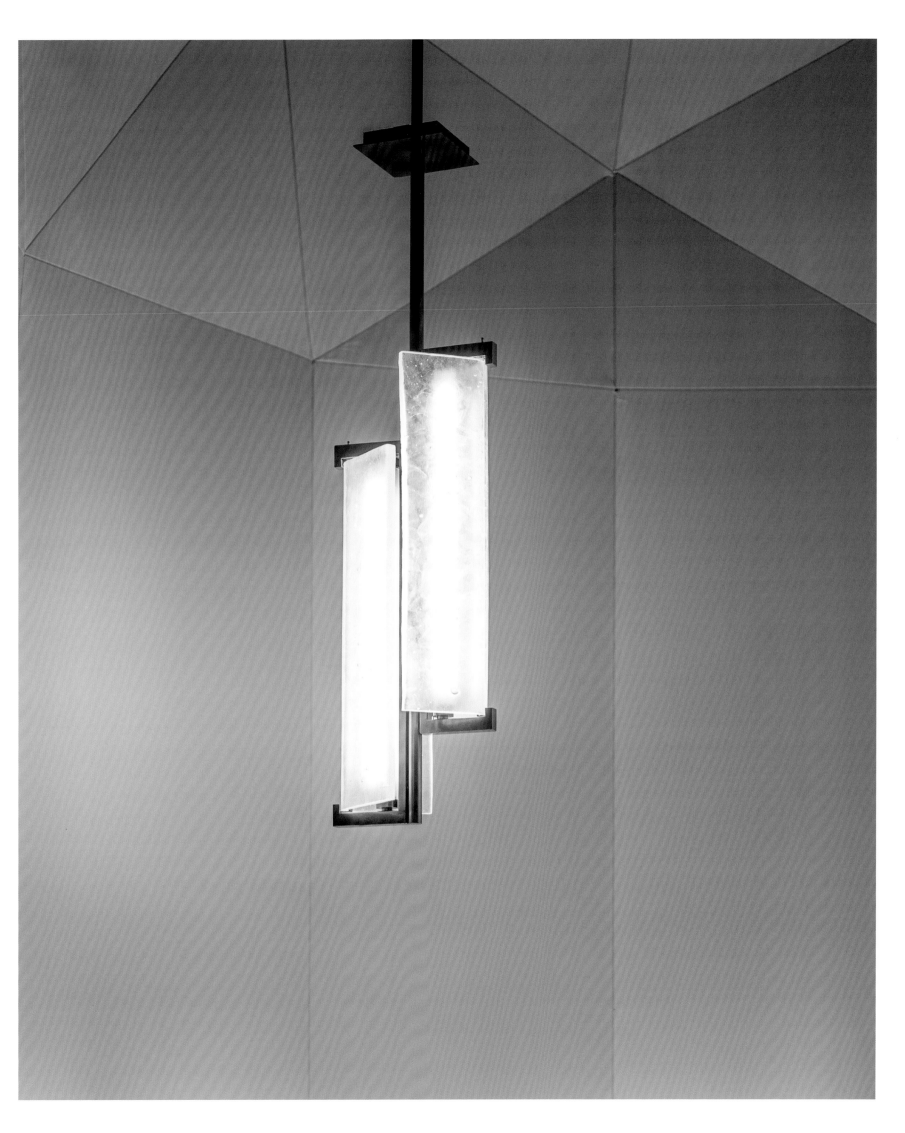

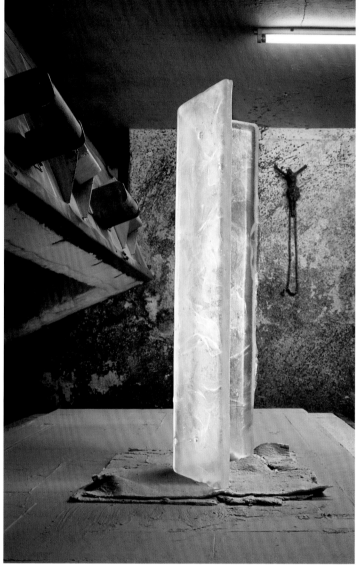

It was when I was designing lighting for ballrooms for several hotel projects in Asia that I first started thinking about the qualities of glass as a building surface and how a cast-glass brick's strong tactility allows it to be utilized as an architectural form. It made me think much more deeply about the qualities of glass and how I could explore new ways of designing with it.

The Czech glass manufacturer Lasvit was a natural choice for me. I knew that they were formidable on the technical side. Although they are famous for their spectacular artistic installations, they were open to my thoughts on creating something that people would use in their daily life, in their homes.

I had designed a lot of lighting for my projects, but even so, when we started the process I wasn't fully aware of how challenging it would be to create something that looks so simple, with such a raw, rough beauty.

It was also not a case of creating an idea and sending off a technical drawing. In fact, it took us a year to design and make the pieces before launching the TAC/TILE collection of table and floor lamps and suspended pendants at Salone del Mobile 2016.

From the very start I knew that I didn't want to design something purely decorative. I wanted to create a new way of thinking about glass that was more than just about illuminating a room. This is where the idea for a simple, folded, 23-millimetre-thick glass tile paired with a minimalist, matt-bronze frame emerged. It felt like a return to my architectural roots, because I was inspired by the 1932 Maison de Verre, Czech metropolitan passageways and traditional Chinese tiled roofs, as well as by modernist glass blocks.

I tend to be associated with exploring the natural, tactile quality of materials, especially softer, luxurious kinds, but TAC/TILE is more instinctively organic and crafted with a contrast between the raw beauty and purity of the bronze frame – which is almost Brutalist in spirit, yet highly articulated – and the glass. It is the juxtaposition between these two worlds that is interesting to me.

The design process involved visiting the oldest glassblowing workshop in the Czech Republic, where craftsmen still use traditional materials and equipment, like long-handled wooden poles, to transform molten glass with their breath. It was invaluable to be there on the ground so that we could push the boundaries together.

The tile shape is deceptively simple, although it required an extremely complex technical process to mould the glass under very precise temperature control. Because you can't control the process completely, each piece is unique.

Creating a collection around a single, distinctive element like a glass tile was not a mutation of a design. From the start we considered how the different forms would work, whether you were looking up at a pendant or at a desk lamp right in front of you. Balancing functionality with each different volumetric quality was crucial, and I kept coming back to the geometric simplicity of modernism devoid of unnecessary frills. It is not the glamour and intricacy of what glass can produce that makes all of these details essential, but more the experience and how it affects us, so getting the brushed champagne gold and anodized bronze exactly right was as important as the glass tile.

A conscious effort was made, for example, to keep the glass component free from visible fixings: the metal frame functions as a bracket to clip the tile so that it can be displayed in its most natural way, while LED technology allows the glass to glow evenly without a highly visible light source.

The biggest challenge throughout the process was not to lose sight of my original concept while being shown so many different ways of doing things. Collaboration takes many forms – directing and questioning and trying to find a solution together – but, most importantly, I wanted the team to understand that it wasn't just about finding a texture for the glass to make it interesting, but about creating a natural quality that makes something not feel too perfect. I especially enjoy the tactility of the finished tile. Its opaque transparency and bubbles suggest a handcrafted aesthetic. If it were completely perfect and polished you wouldn't have that sense of how it is made.

page 77 The curved roof tiles of traditional Chinese architecture and 20th-century modernist buildings inspired the TAC/TILE collection.

opposite Left: In the final part of the production process, the glass tile is cooled down to room temperature over a metal mould to create a curved shape. Right: The 23-millimetre-thick seamless fold of glass.

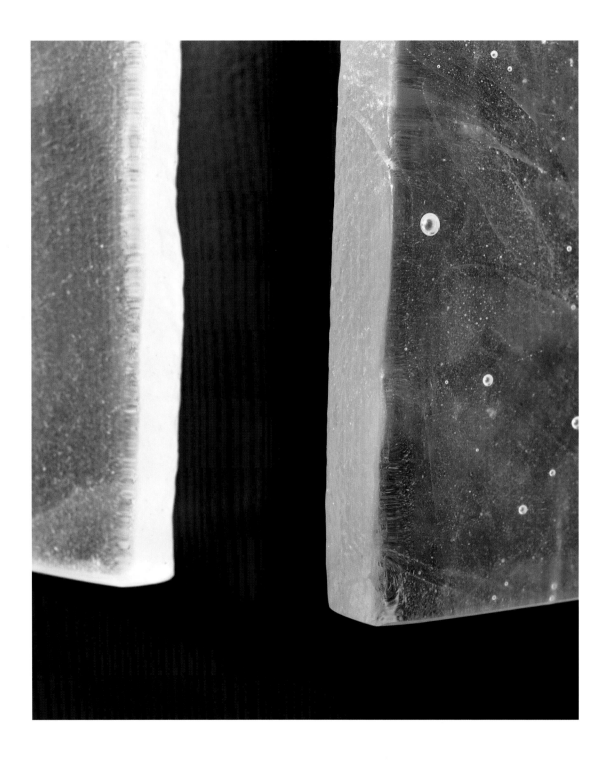

above and opposite The traditional hand-blown glass process creates a minimalist linear volume, yet retains a hint of natural texture.

page 82 TAC/TILE was launched as part of an exhibition at Milan's Palazzo Serbelloni at the Salone del Mobile 2016.

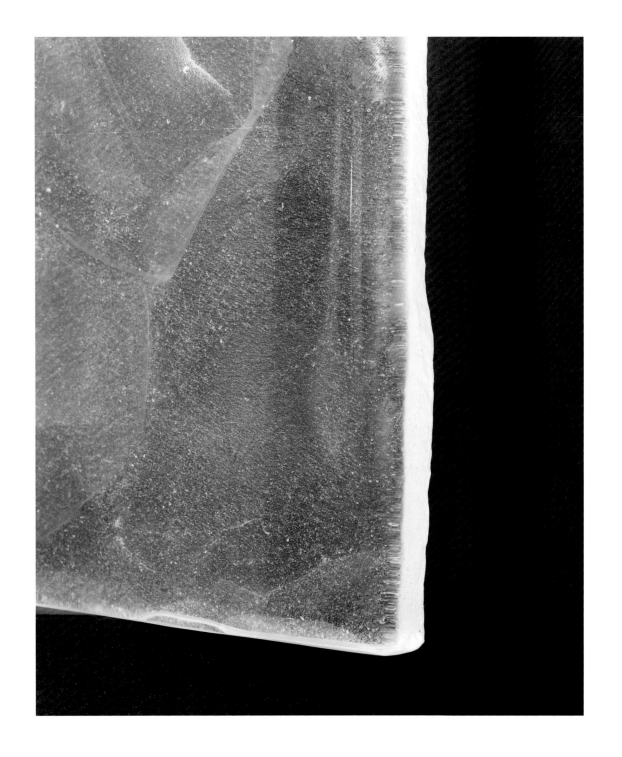

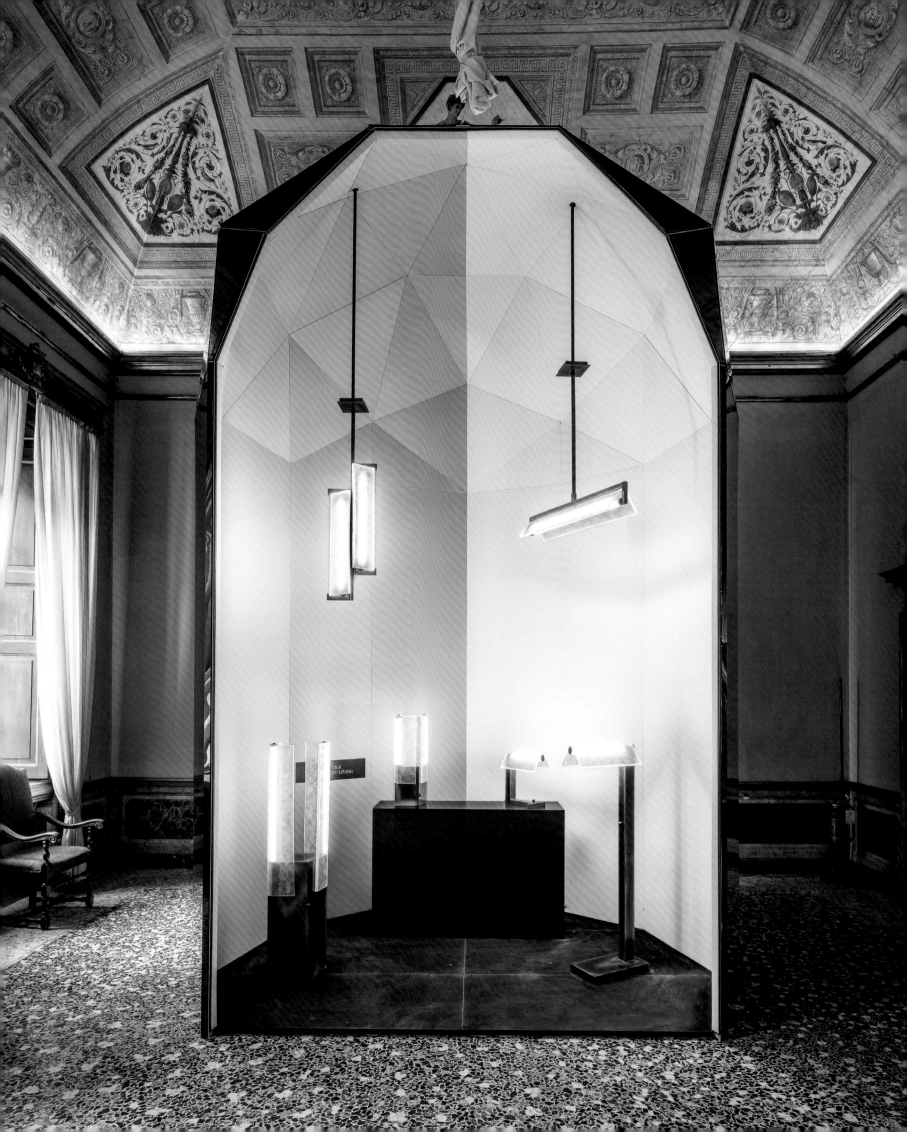

André's simple, rustic-edged modernist form is so
unlike anything we have ever made at Lasvit, yet it feels like
a perfectly natural mix of old and new. The greatest surprise
has been how incredibly versatile the deceptively minimalist
shape is because we've discovered how easily it can be
repeated and grouped as a family or enlarged to
create different-looking lights and chandeliers.

LEON JAKIMIČ
founder and owner of
glassmaking company Lasvit

perrotin shanghai

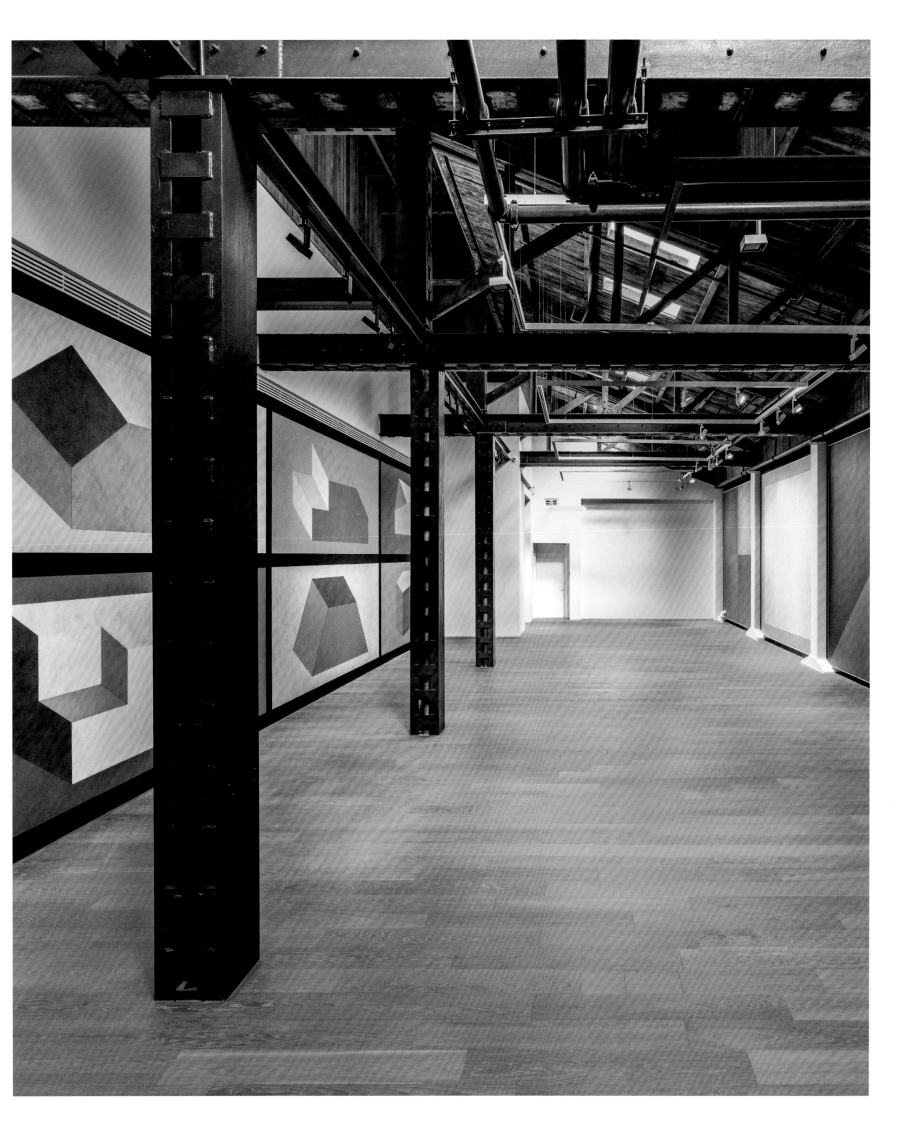

I had worked with Emmanuel Perrotin on his gallery in Hong Kong in 2012, and then in Tokyo five years later, so when he asked me to design his first space in China I already had a good idea of what he expected. His artists include painters and sculptors, and some like Paola Pivi and Xu Zhen who produce large, complex installations, so the interior needed to accommodate a wide range of works, with flexibility to schedule more than one show at a time – and still have plenty of storage.

To me, a successful gallery must also express the spirit of its culture and context. I wanted to frame the experience of this historic brick warehouse building that had been built in 1937 and used by the Central Bank of China during the Republic. There are four salons on the fourth floor of the building, with a lounge, terrace, dining facilities and office space upstairs on a mezzanine level. When first saw the building's distressed timber roof, I was struck by how the exposed beams give the space a distinctive character and personality.

The galleries are very different in size, personality and experience. Some are classic art spaces with a pure-white ceiling and minimalist feel, while others have exposed beams, windows on one side or a dialogue with another room, so the challenge was to ensure it all acts as one space with a sense of integrity.

Emmanuel likes visitors to his galleries to be immersed in the art immediately. He always says, 'The first impression has to be the art, not a person,' so the main entrance leads directly into a generous reception space that acts as a central hub, creating a transition between the galleries.

The scale of the lower level is big, and it becomes the volume that holds the transition between each gallery. The middle space, which holds up the heart of the gallery, is especially interesting for me because it allows us to divert different experiences and create a continuous loop, like a museum going from one space to the next.

Creating an intuitive journey through the 1,200-square-metre space was an important objective. I also wanted to express the original fabric of the building, so retained and restored the original distressed truss ceiling in the main gallery and introduced different parquet floor patterns in each of the four exhibition spaces, while metal window frames add a hint of French Concession-style windows. I feel as though these evoke a traditional Shanghai residence.

The distressed wooden ceiling was a challenge because in a gallery, designers usually focus on creating the most flexible light system. With a pitched timber ceiling and natural light from large windows, this is harder to achieve. However, honing the balance lends a warmth to the space and adds to the experience of the art.

The greatest design challenge was in defining the hierarchical and visual demarcation between the distressed, heritage raw timber and high beams that give the place character and the new, contemporary, open white box 'insertion' that offers movement and flexibility. It is not intended to replicate traditional vernacular, but instead is conceived as a modern art space that reflects on its historical context through an immersive experience

Upstairs on the mezzanine level, accessed via a new internal staircase, there is a comfortable lounge with my own-design furniture where guests can relax. It features two large windows that provide a bird's-eye view over the gallery below and an outdoor terrace with lush greenery. It really is unlike anything else in the city.

page 85 The gallery is located on the top floor of a French Concession-era building on Shanghai's historical Bund, and has a 6-metre-high ceiling. The local vernacular is expressed in a modern architectural language.

page 86 The fourth floor of the gallery contains four large salons, some with pure-white ceilings and others with exploded beams and windows that enrich the spatial experience.

pages 88-89 The contemporary galleries retain a sense of the building's history and provide an unusual backdrop to the works on display, such as these colourful wall drawings by Sol LeWitt, exhibited in 2019.

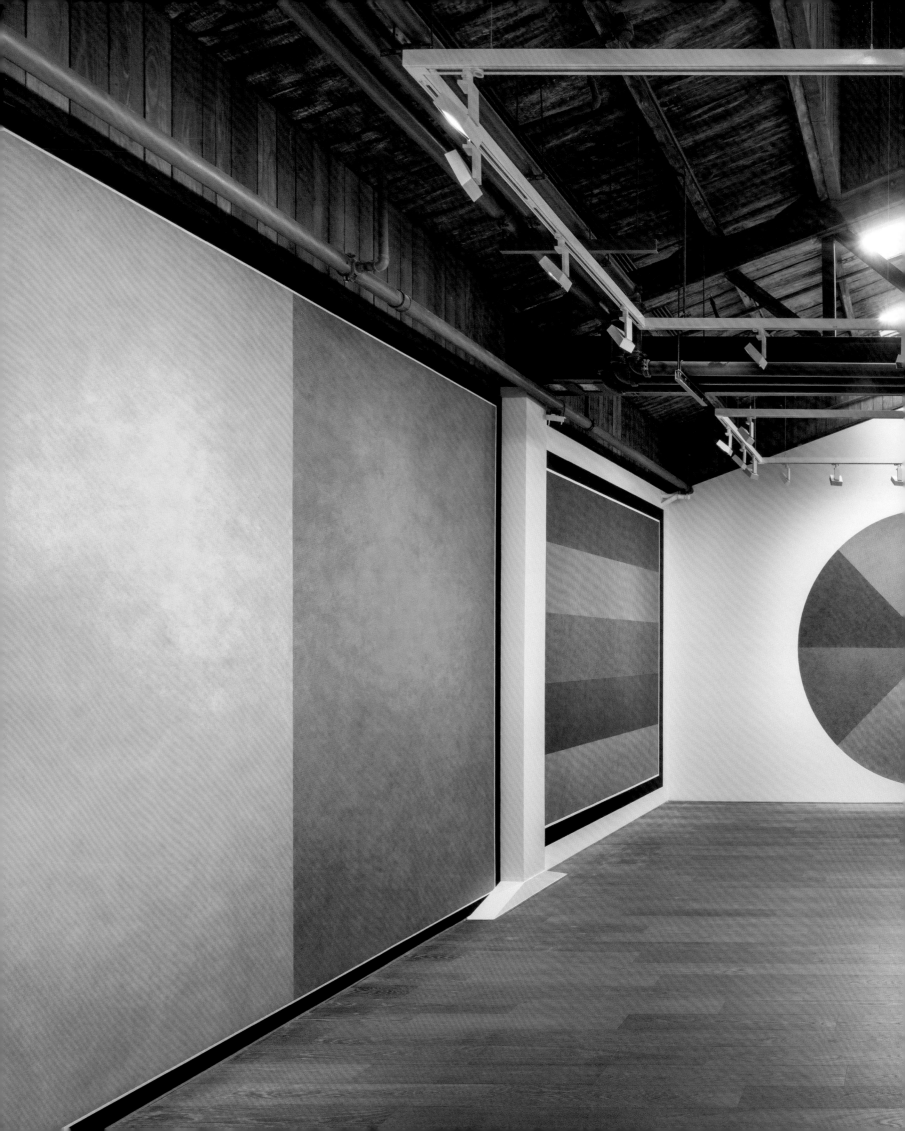

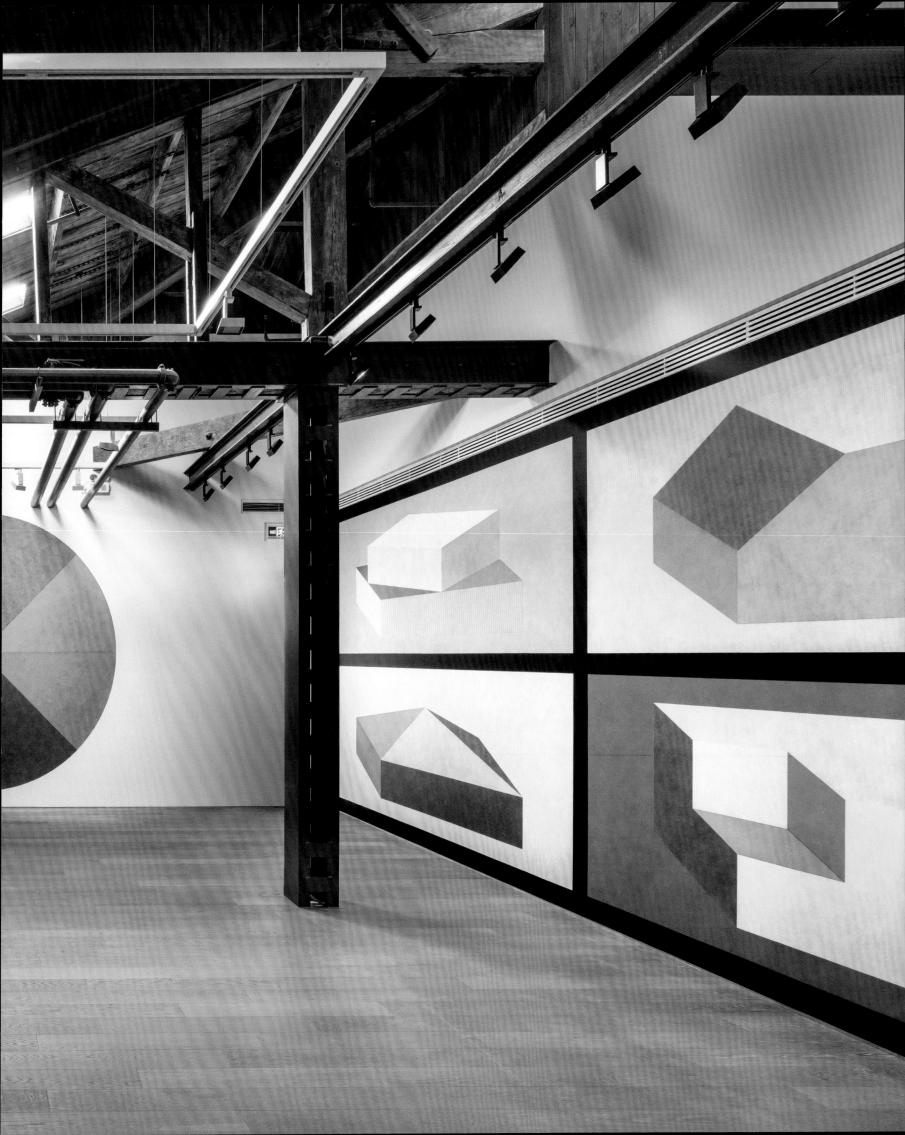

above and opposite Each gallery features a different parquet floor pattern – a bespoke tribute to the Concession mansions formerly on the Bund, as well as to craftsmanship and artistic flair.

We don't want to do what everyone else is doing
so the spirit of this gallery is very different to anything
else in Shanghai. It's ambitious – not just for us,
but for our artists too. I like that because it is
always good when we provoke artists
to confront a space.

EMMANUEL PERROTIN
founder of Perrotin Art Galleries

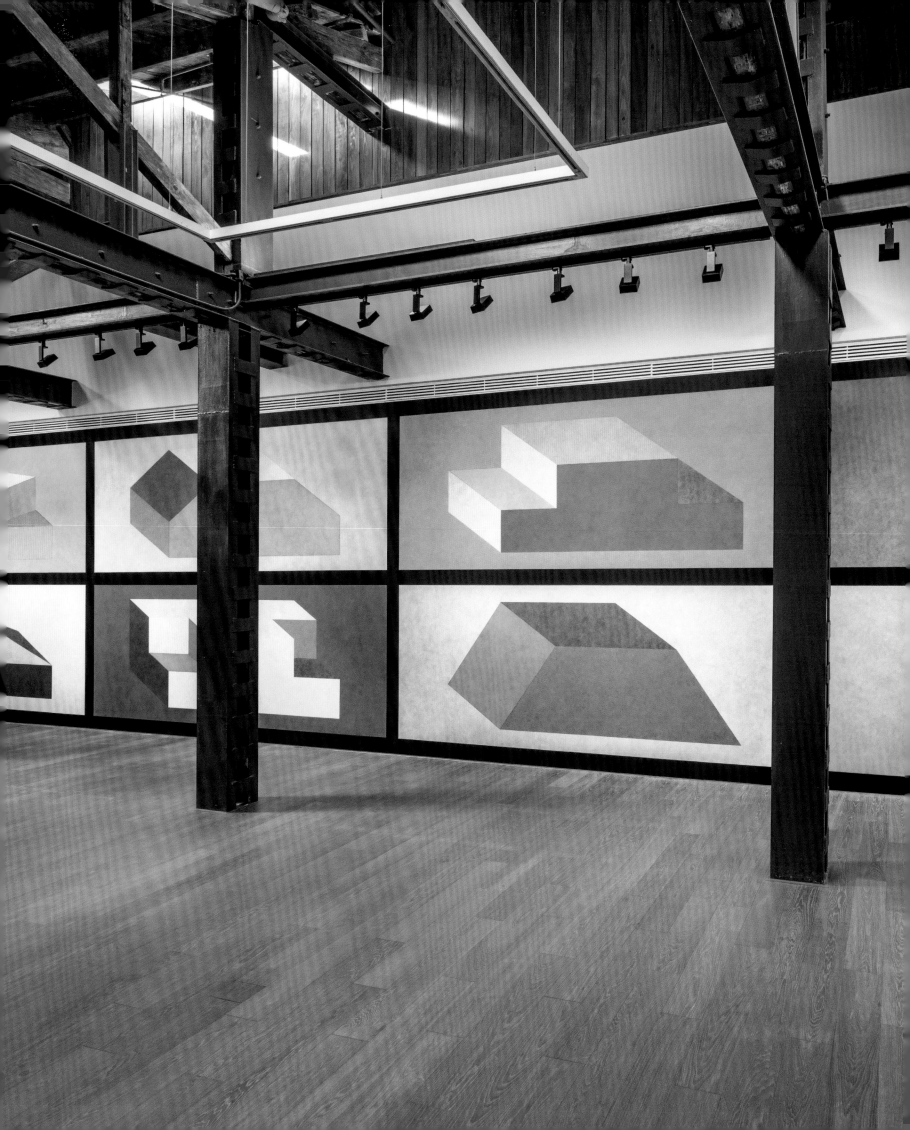

page 93 Original timber beams and columns encased in steel add an interesting, industrial quality to the gallery.

opposite Belgian neo-conceptual artist Wim Delvoye's Gothic filigree sculpture on the gallery's outdoor terrace.

above The mezzanine has a private lounge with brushed-oak floors. The doors on the right open on to an outdoor terrace with views over Shanghai.

louise hong kong

Louise is all about nostalgia, from heritage architecture to interiors and the casual French cuisine. It's a wonderful location – a classic colonial building within the enclave of historic buildings now known as PMQ, home to creative studios, workshops and boutiques. But unlike all the other buildings on the site, it is a standalone two-storey house with floor-to-ceiling windows that open on to a terrace upstairs and a garden on the ground floor. It faces Hollywood Road, which is lined with beautiful Banyan trees.

I've known the restaurant owner, Yenn Wong, for many years. In 2005 I designed two restaurants for the Jia Hotel, her very first venture, so when she asked me to re-imagine the interiors for a new restaurant with the Michelin-starred chef Julien Royer at the helm, I thought it would be interesting to do something very fresh and different.

I was especially intrigued by the idea of creating a setting that would feel as though you were stepping into the private home of someone charismatic – a sybaritic city dweller with a highly original personal style and take on life. 'Louise' is an old French name that, while it may seem simple, exudes tradition, integrity and a subtle elegance.

It felt like a very personal project – more than just a decorative theme – like designing a residence, and I felt strongly that the interiors should reflect the Grade II-listed building's character, recreating the earthy warm mood that embodied the eccentric yet sophisticated style of the late 1960s and 1970s. I wanted to reflect the life of an unconventional spirit and the exotic curiosities and memorabilia of a storied past – adding a dash of tropical Hong Kong.

So I imagined the restaurant as a fictional home with spaces defined as rooms that would arouse the senses and trigger memories. I like to think of the person who would live here as someone with a glamorous, relaxed outlook on life, and the home should reflect this in maximalist style with joyfully clashing patterns and colours and lavish decorative pieces. I wanted to introduce interesting moments and a familiar nostalgic materiality that would create an emotional connection.

I envisaged the ground floor as a tropical greenhouse with a verdant, multilayered lounge decorated in sage-green with rattan furnishings. Jewel-like 1970s colours work beautifully with the geometric play of curves and straight lines overlaid with a strong graphic element. I particularly like the hand-brushed zinc entrance gates because they feel quintessentially Hong Kong and set the scene for the interiors while retaining their individual quality. There is dining space for around sixty people, and the centrepiece is a semi-fluted green-Brazilian-marble bar with a striking fish-scale, jade-green background. We paid a lot of attention to getting the details right, with custom, vintage-inspired lamps with terracotta glass bulbs and 1970s luxe textures such as lacquer and velvet. The carpet continues the natural theme with a jungle-like pattern. There is also a private dining room with an exotic mural that stretches across the length of the wall and a pair of 1950s sconces.

The staircase that leads to the second-floor restaurant is especially eye-catching. Its walls are dressed in a wildly fanciful botanical wallpaper from Cole & Son, while the staircase carpeting is a dramatic, contrasting geometric vintage pattern in a salmon pink and teal. Both add a seductive pop of individual style to the interiors and evoke the inventiveness and flair of times past. I like to think that moving upstairs through such a transitional space also adds a sense of mystery.

Upstairs feels very much like a private boudoir in a glamorous palette of ivory and mustard yellow with plush velvets, frosted lamps and vintage sconces juxtaposed with dark parquet flooring. The materials, including Iranian golden onyx for a series of consoles, are deeply luxurious. There is seating for around fifty people at tables and at a long, plush banquette that stretches along one wall. The intricate, geometric-patterned rattan ceiling is very striking and perfectly offsets the wood-panelled walls. Other materials are an interesting combination of brass and glass, and there is a crafted feel to the finishes. This room leads on to a balcony where furnishings are in natural materials and offer a connection to the surrounding landscape.

I am associated more with the naturals and neutrals of modernism, so this project struck a fresh chord for me. I enjoyed experimenting with nostalgia, keeping a sense of glamour and luxury – and playfulness – without descending into kitsch. Louise is an extraordinarily lovely place to spend time in: it is comfortable, fun and has all the charm and attitude of yesteryear.

page 97 A staircase clad in a whimsical, richly patterned botanical-print wallpaper makes the transition to the upstairs restaurant an immersive, sensorial experience.

opposite Original concept sketches. Top: Upstairs, the dining room is decorated in ivory with warm, mustard-yellow accents that harmonize with the lush natural setting. The graphic rattan ceiling has a geometric pattern. Bottom: The ground floor is envisaged as an inviting, casual lounge bar with an adjoining private dining room and bar.

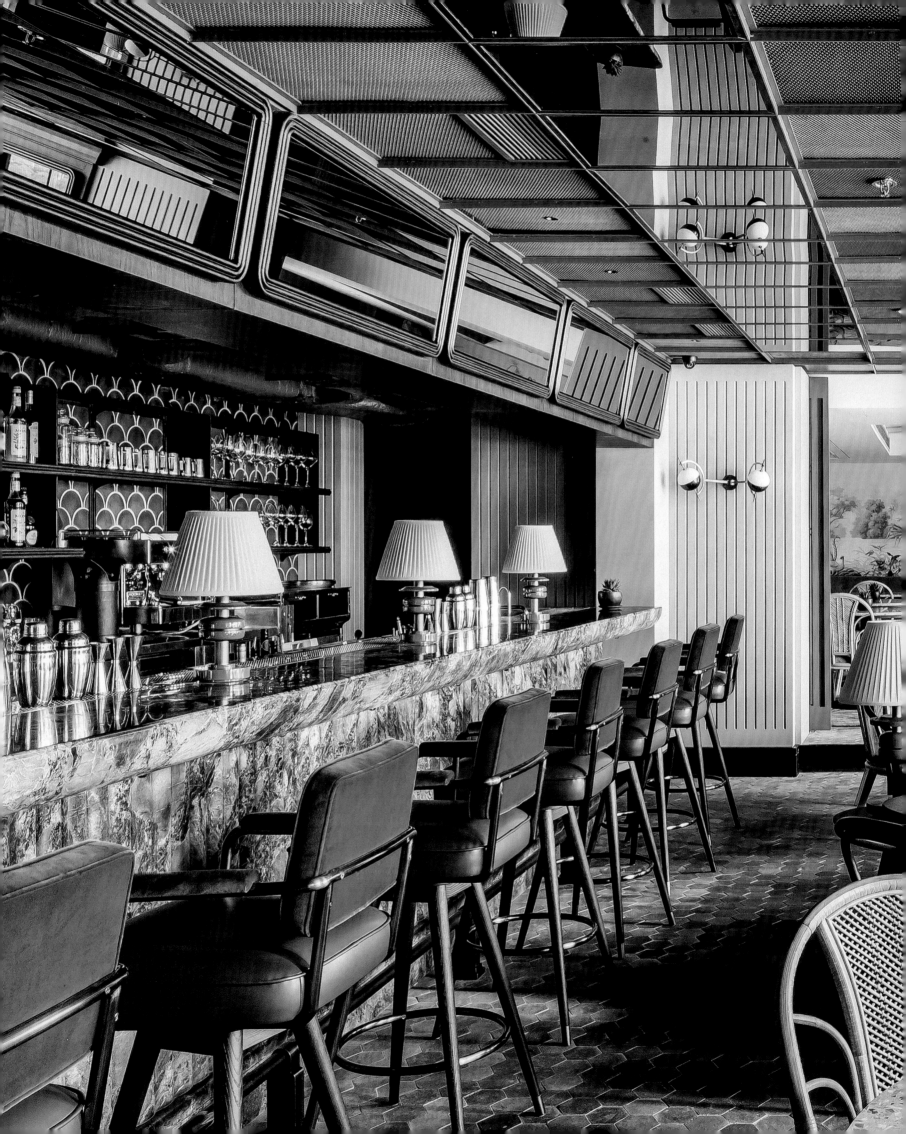

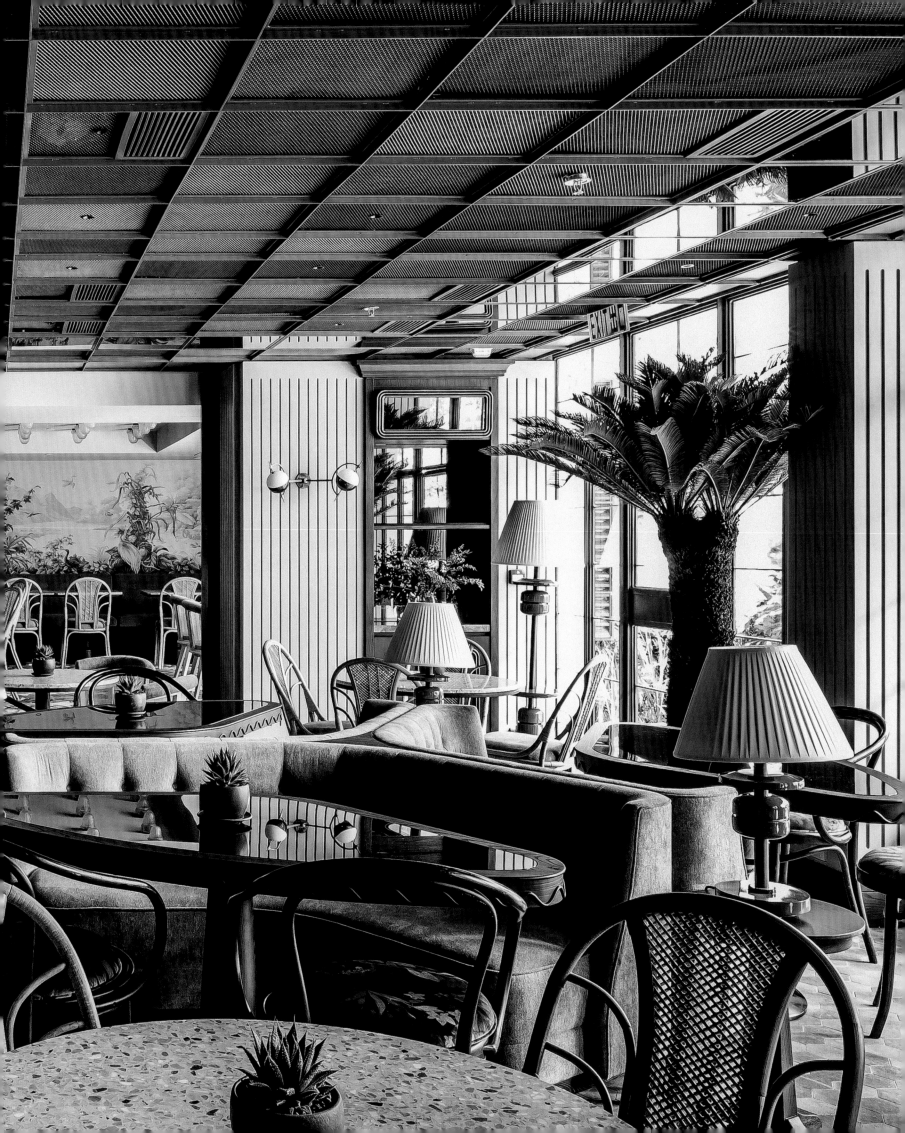

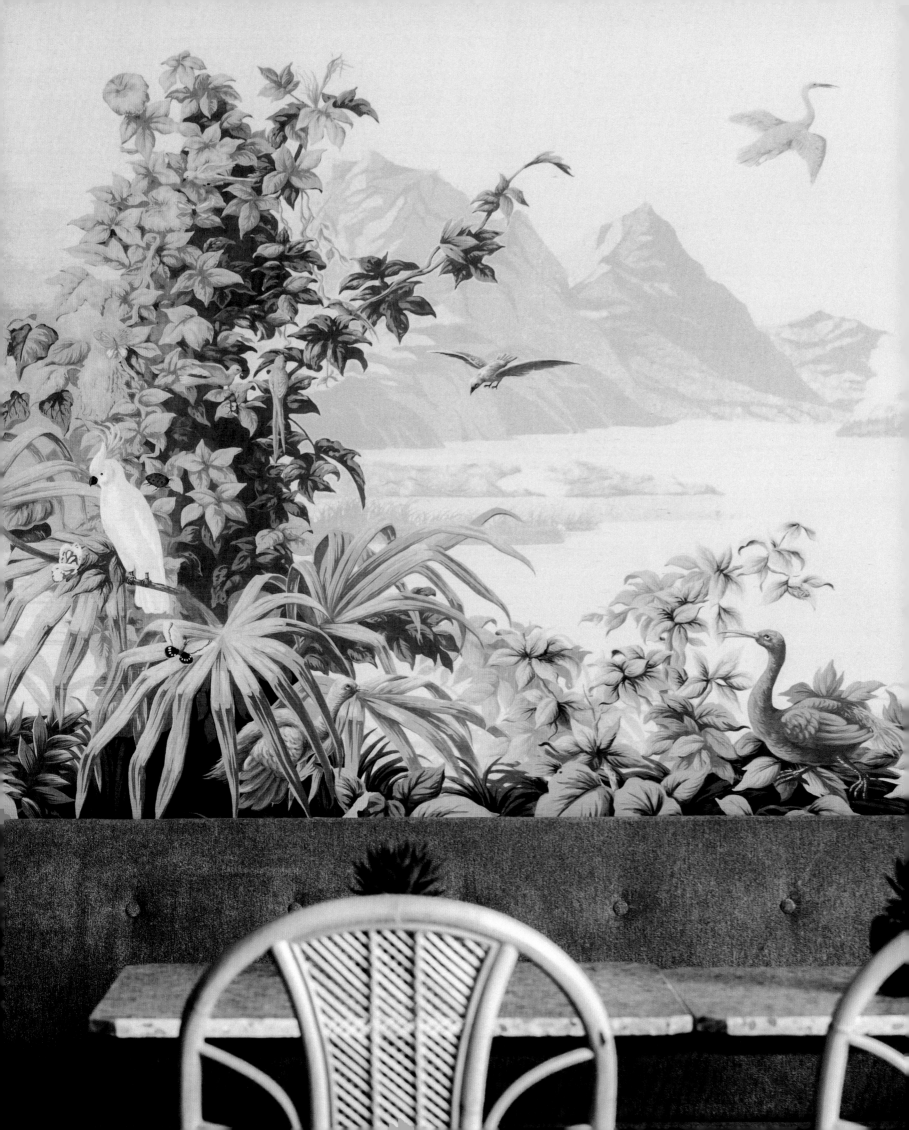

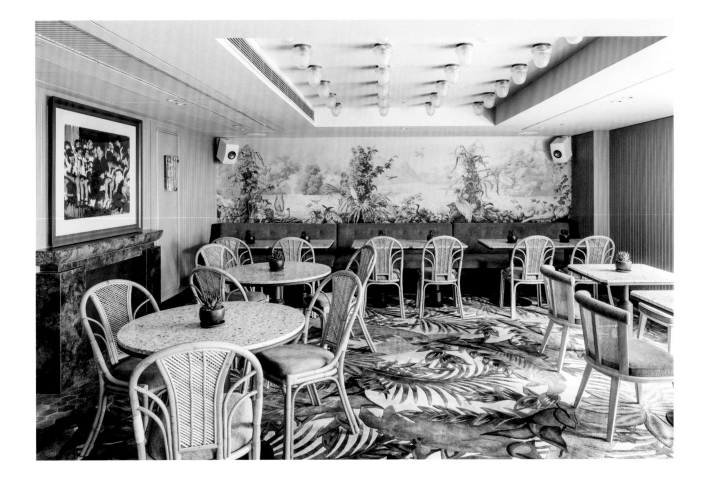

pages 100–101 The ground-floor open-plan interiors centre on the bar, and combine luxuriant plants, vintage lamps and furnishings in sage-green and mud-orange with a palette of velvet, lacquer and marble. To the rear is a vibrant tropical mural on the feature wall of a private dining room.

opposite and above The private dining room, with its authentic rattan furnishings, offers a relaxed, tropical greenhouse setting.

page 105 A vintage sconce against a handmade, Italian, jade-green ceramic tile pays tribute to the heritage of the area.

pages 106–107 The upstairs dining room and alfresco terrace overlook a leafy corner of PMQ, a collection of repurposed historic buildings formerly known as the Hollywood Road Police Married Quarters. The natural, light-infused ivory palette and succulent plants offer a dramatic counterpoint to the tropical ground-floor parlour, adding distinctive personality inspired by Louise's 1950s architecture.

We have opened a lot of restaurants and know how important it is to think about how a guest will feel when they are sitting in a space. We take design very seriously, but it is not just about creating an interesting design narrative. It is about each guest's personal experience, and at Louise we wanted to do something very different. André instinctively understood this and thought very deeply about what we wanted.

YENN WONG
restaurateur, CEO and founder of JIA Group

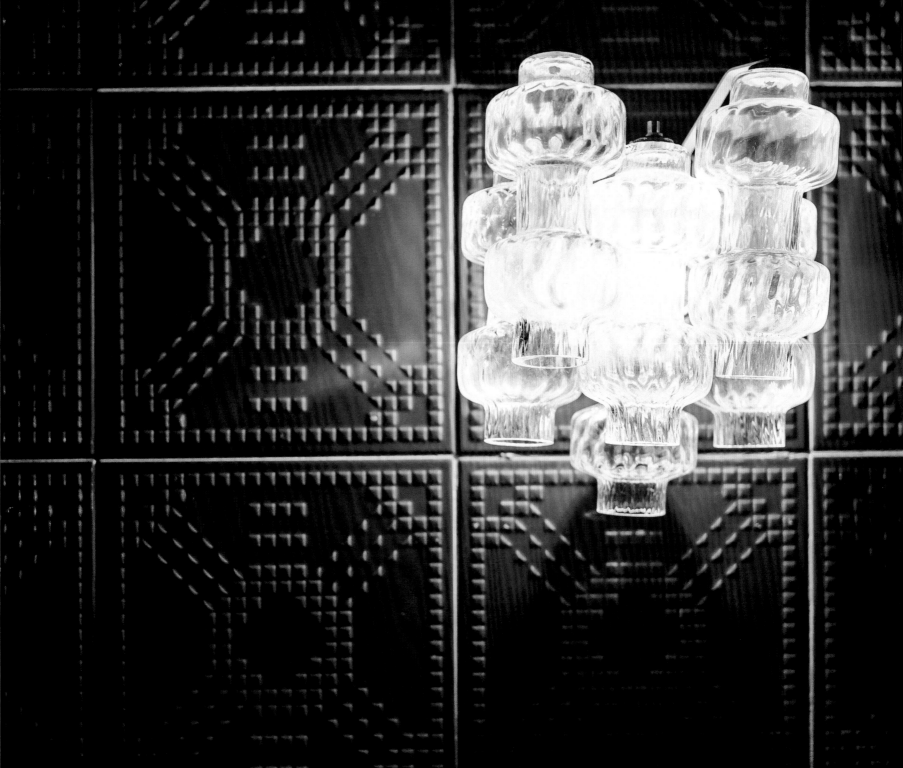

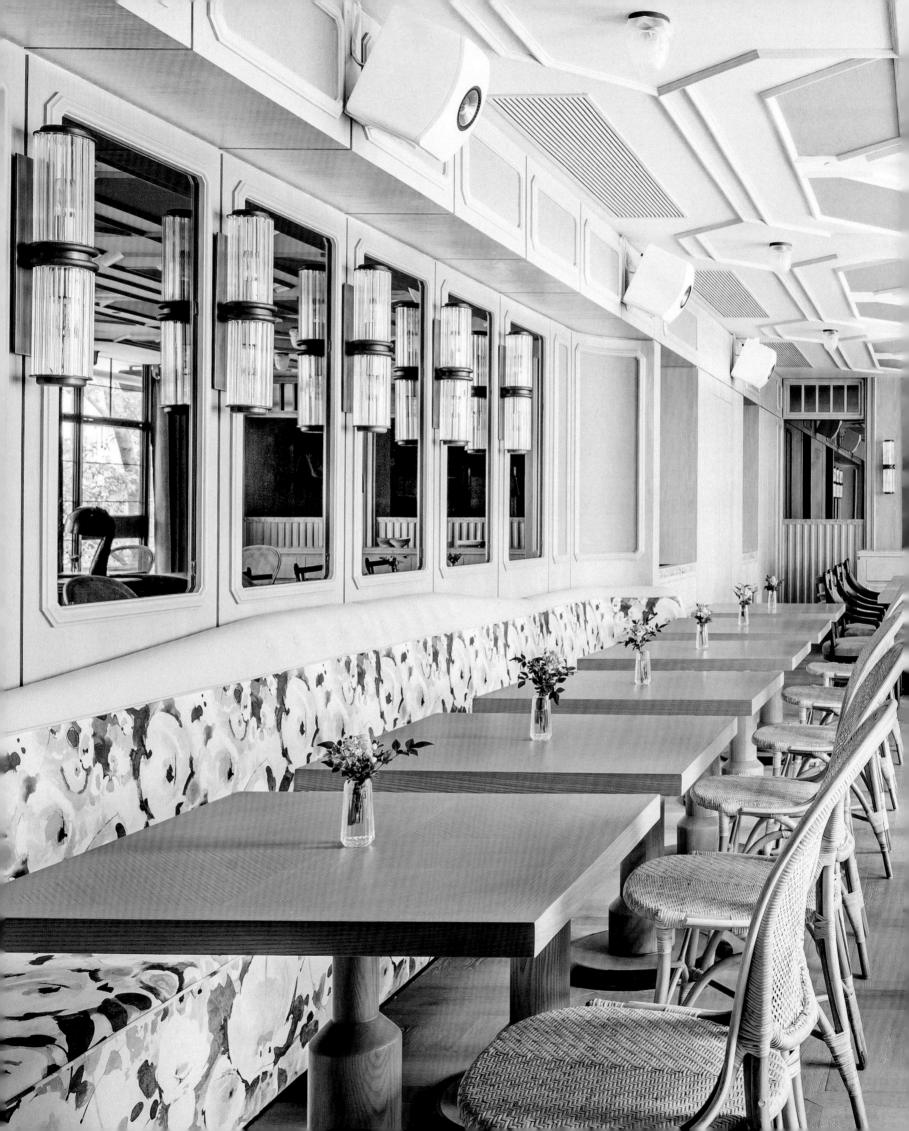

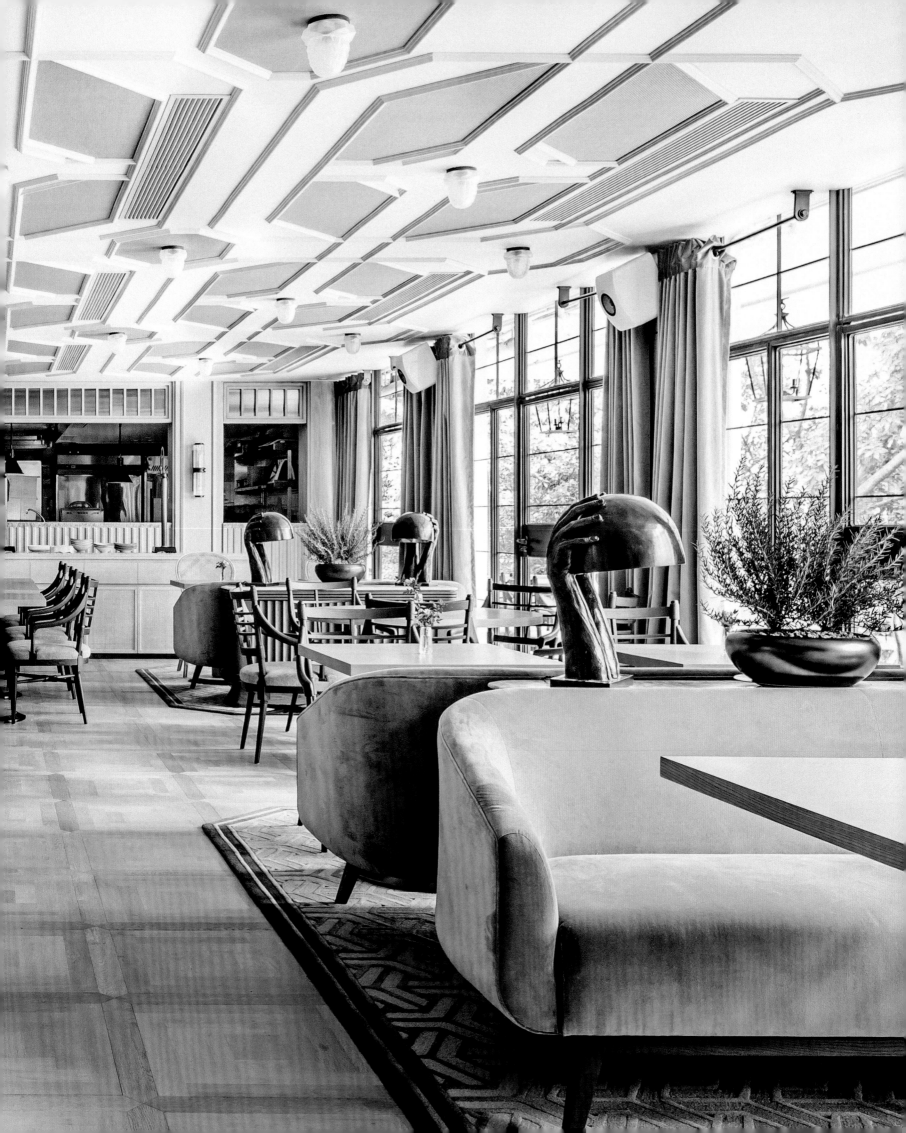

akira back, four seasons seoul

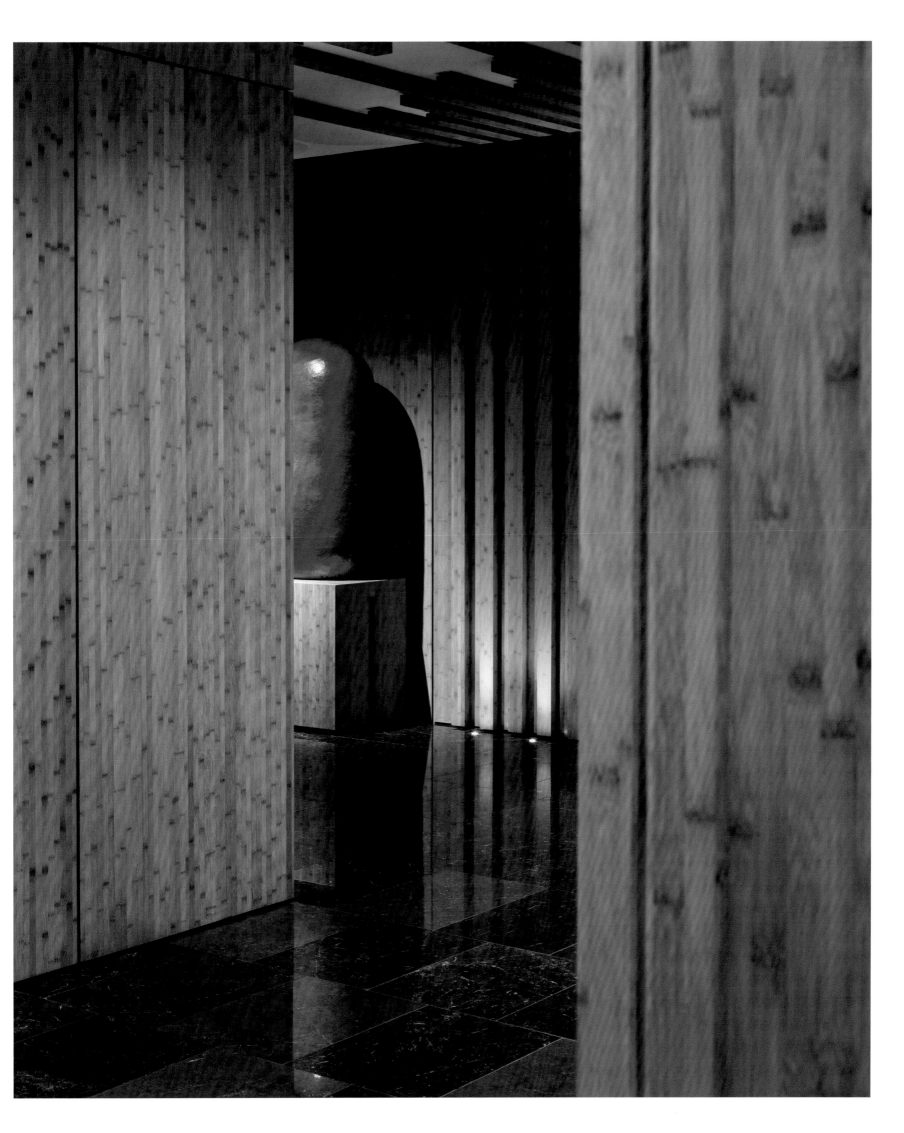

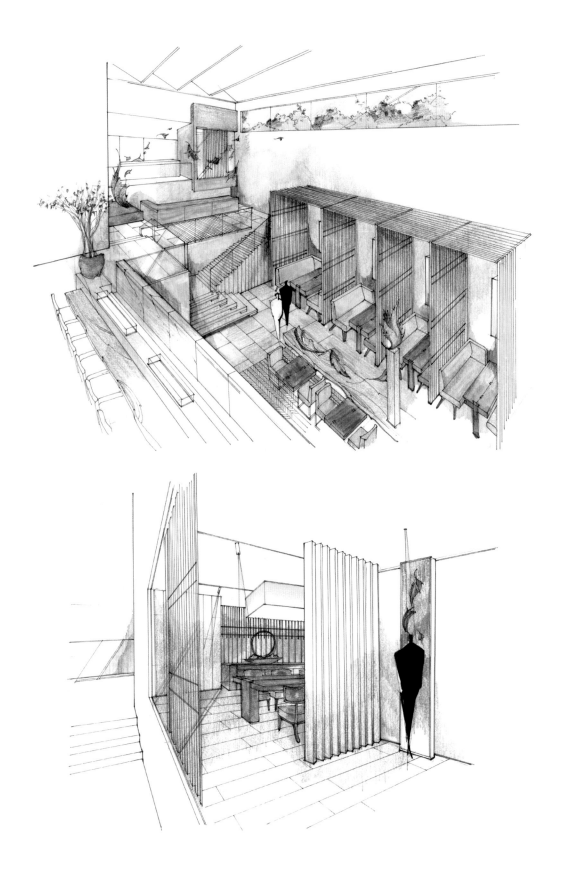

My design for this contemporary Japanese restaurant at the Four Seasons hotel in Seoul was inspired by the idea of a modernist bamboo theatre that embraces the spirit of contemporary Japan. I wanted to avoid the idea of luxury as something glamorous and opulent and explore it in a more nuanced, understated way. At the core, however, it was very much a response to the volume of space – a total of 511 square metres – and a cavernous, double-height room with a dramatic, 7-metre-high ceiling.

At the same time this allowed me to think about how the different moments and 'scenography' could unfold freely. There are three distinct levels. Guests enter upstairs, and dining and drinking are arranged over two floors and a mezzanine, so it was important to consider how their perspective worked from every angle, whether looking down at the tables or across the room. It is a striking space but enclosed with a line of skylights in the ceiling so it felt very much like a theatre to me. I was thinking about setting the stage for an experience.

The palette is very subtle and subdued, taking its cues from traditional theatre, with mud orange and cool mineral grey complementing the natural, tactile materials, such as bamboo, sand and volcanic charcoal stone. Some are kept in their raw state, and all have a timeless quality. Bamboo is a particularly strong theme throughout the space.

I think that when you have such a dramatic volume, you need to think especially carefully about the entrance. Here, the dimly lit hallway embraces the Japanese theme, and is lined with sculptural bamboo posts that are inspired by traditional *torii* gates, which are typically made up of layers of vermilion gates, to create the sense of entering an ancient Kyoto shrine. It is very simple and almost meditative in its quality. At the entrance there is a bold ceramic

work by Jun Kaneko that I feel anchors the sense of arrival. The hallway leads guests to the first dining area with an 11-metre-long sushi counter carved out of solid-pine timber trunks. Diners seated here have a dramatic view over the main dining room, yet the feeling is still very simple and elegant because the bar runs parallel to the double-height volume and looks through a linear window to maple trees. It is all part of providing guests with a continuing sense of discovery, and creating strong visual connections as they move from space to space.

On the mezzanine floor I created a sake tower in Gailo Louis marble. Guests have a bird's-eye view of the entire restaurant, which is reminiscent of a traditional theatre, here expressed with dramatic layers of bamboo screens and glowing, postmodern lantern shades.

Art is always an integral part of my interiors, and here the standout piece is by the Japanese sculptor Muramoko Shingo, who created a collection of mud-orange polished-lacquer maple leaves that appear to float through the restaurant. Their fluidity contrasts with the restrained, almost formal masculine interior and completes the delicate palette. They give the effect of moving or dancing across the dining theatre, and this evokes a very special energy. It is an Asian touch, but I have given this, and other elements like the traditional lacquered wall panels offset by monolithic stone blocks, a modernist twist that reflects a sense of purity.

The feeling of a bamboo theatre comes from the arrangement of rafters, screens and poles that I used to frame and create layering throughout. It is not just a decorative device: their elegant geometry contrasts with the bold volume, and also with the delicacy of the food served. It is a simple yet calm backdrop.

page 109 A bold ceramic artwork in traditional red, by Jun Kaneko, marks the entrance.

opposite Original concept sketches. Top: Bamboo screens create intimate dining booths. Bottom: The sleek, 11-metre-long sushi-bar counter is carved out of solid pine.

pages 112–113 Suspended postmodern lanterns cast a soft glow over the booths.

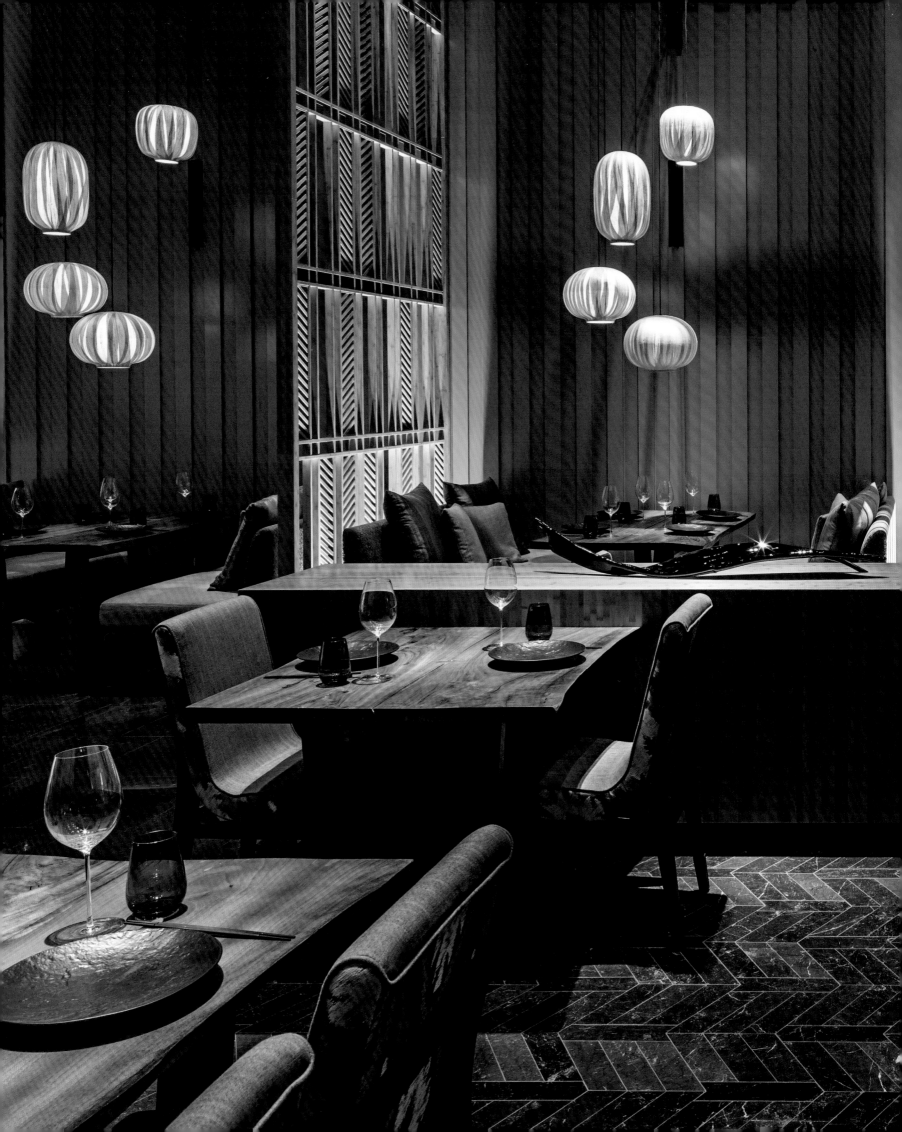

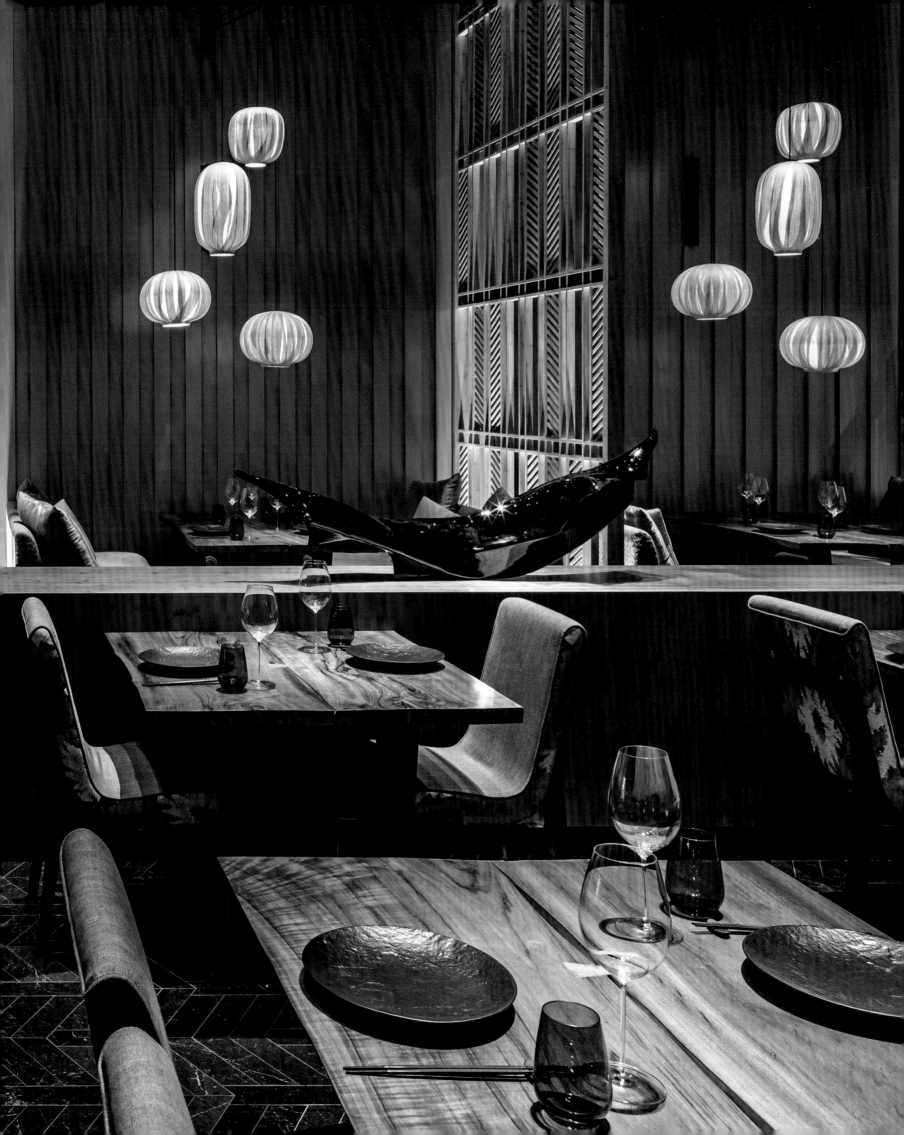

I'm interested in the physical experience of being
in a space, rather than just how it looks. I think that is much
more meaningful, especially in a restaurant, when the
interiors shouldn't be the star of the show; it should be
all about the food and sharing that experience
with friends and family.

ANDRÉ FU

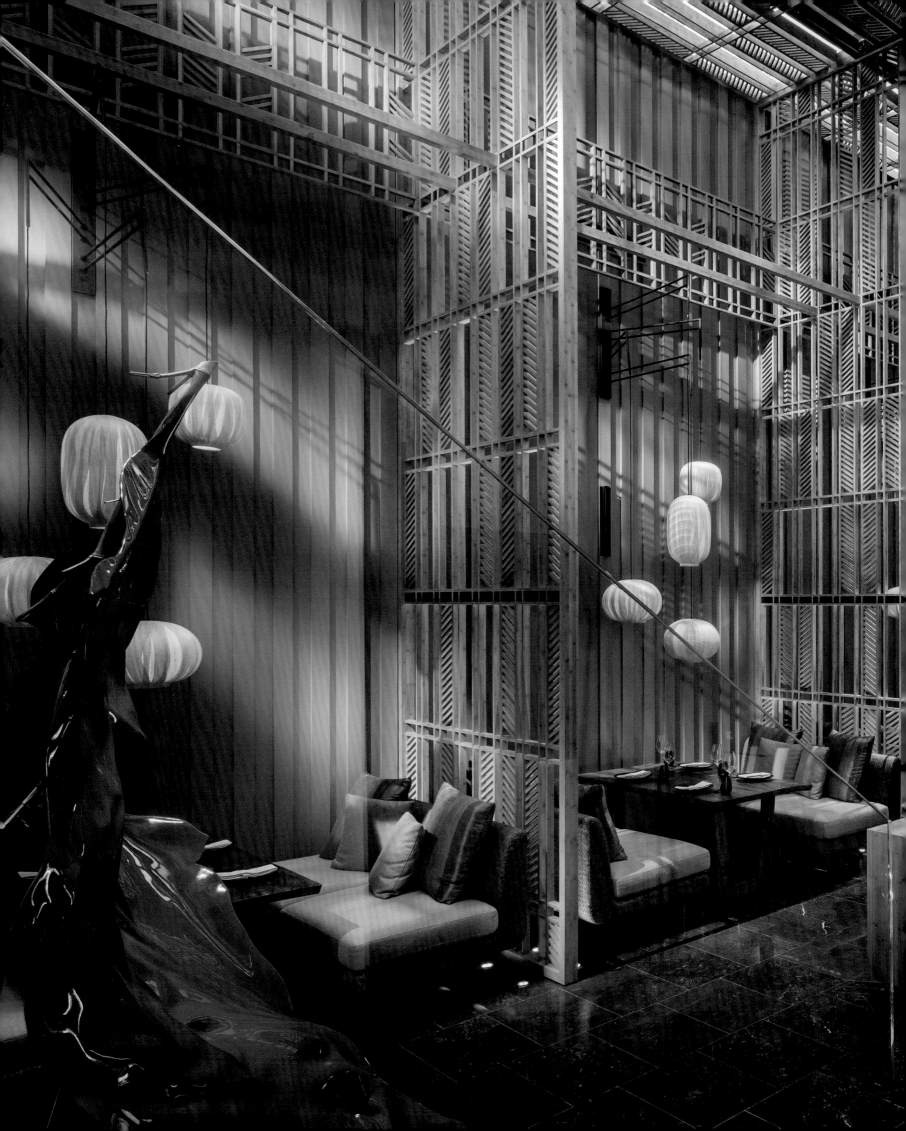

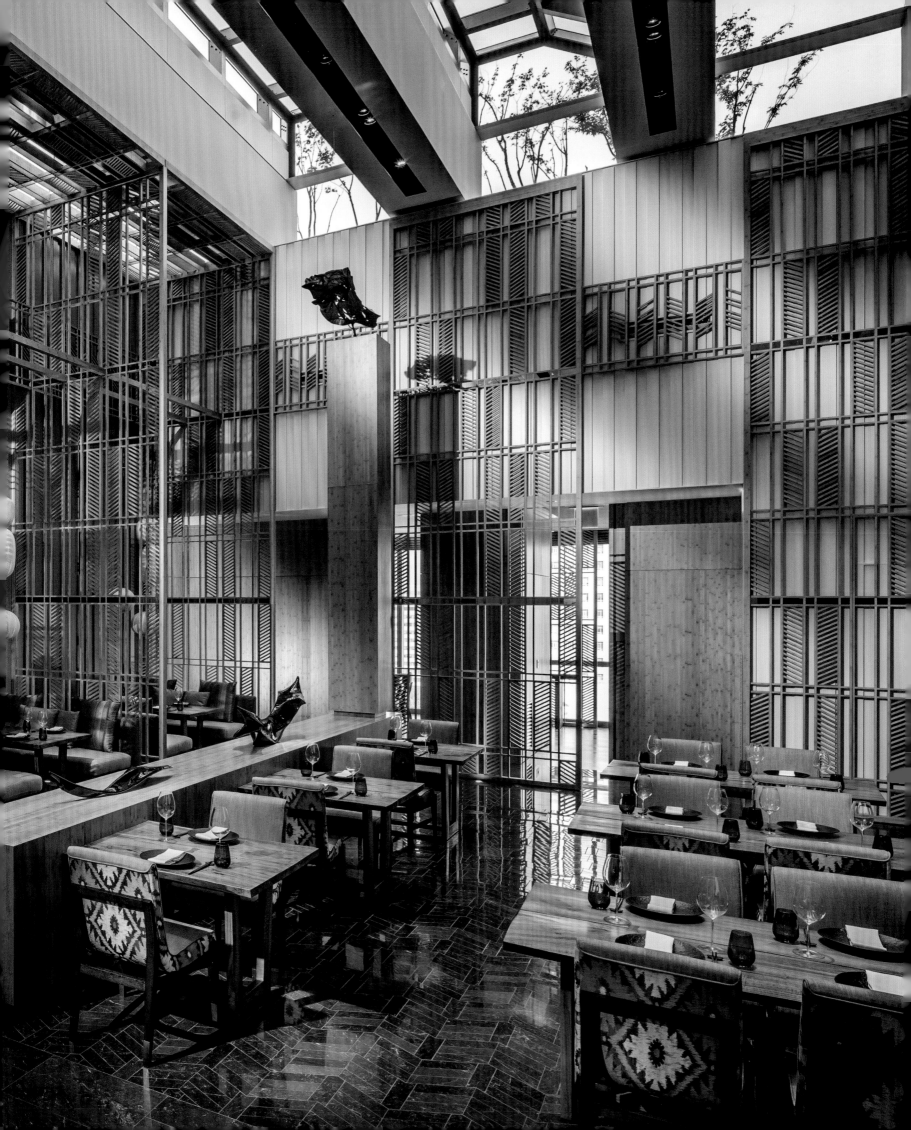

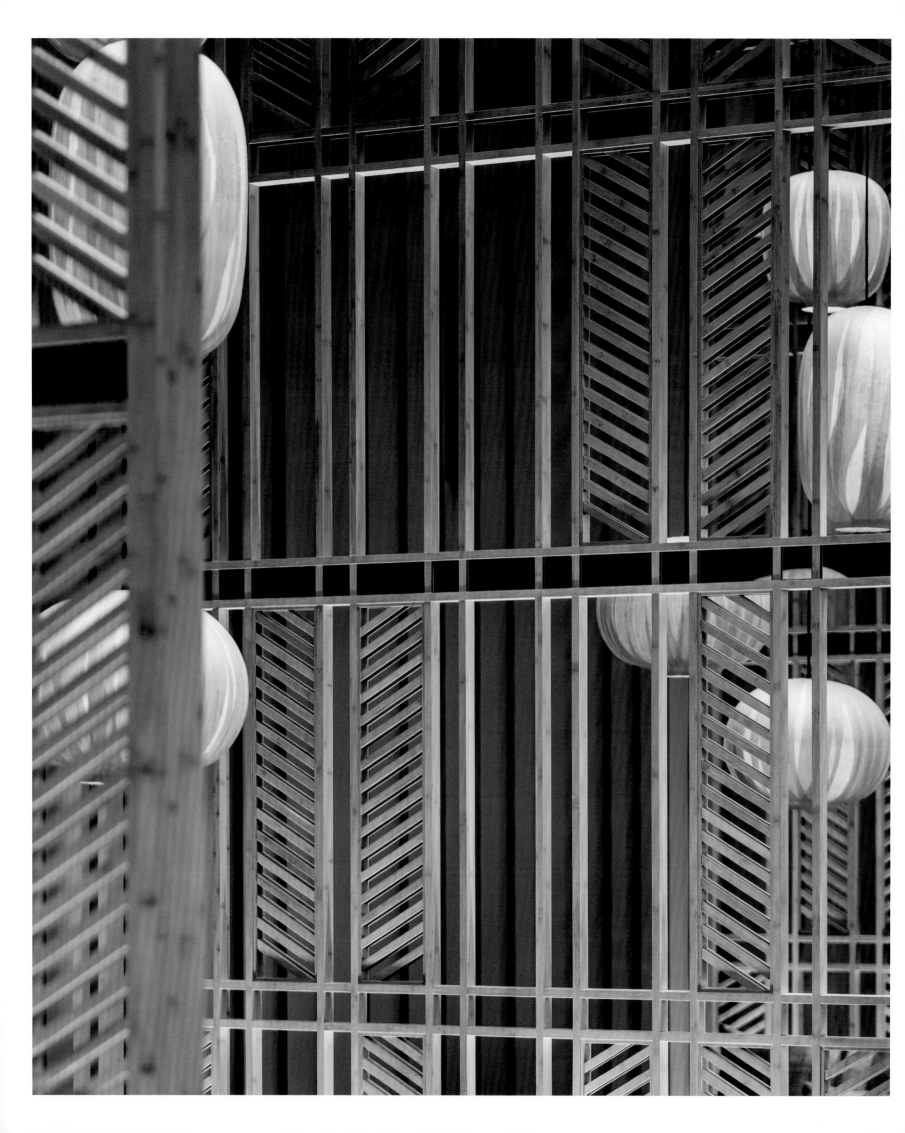

page 115 Simple, solid-wood tables and rustic tableware in earth tones harmonize with the contemporary Japanese aesthetic.

pages 116–117 The restaurant is spread over two levels. Fu commissioned the Japanese artist Muramoko Shingo to create the sculptural leaves – in traditional mud-orange urushi lacquer – that appear to dance across the dining room.

opposite Bamboo screens create a sense of intimacy within the booths without detracting from the drama of the space.

above The Sake Tower's bamboo wall displays a selection of special sakes.

tai ping scenematic

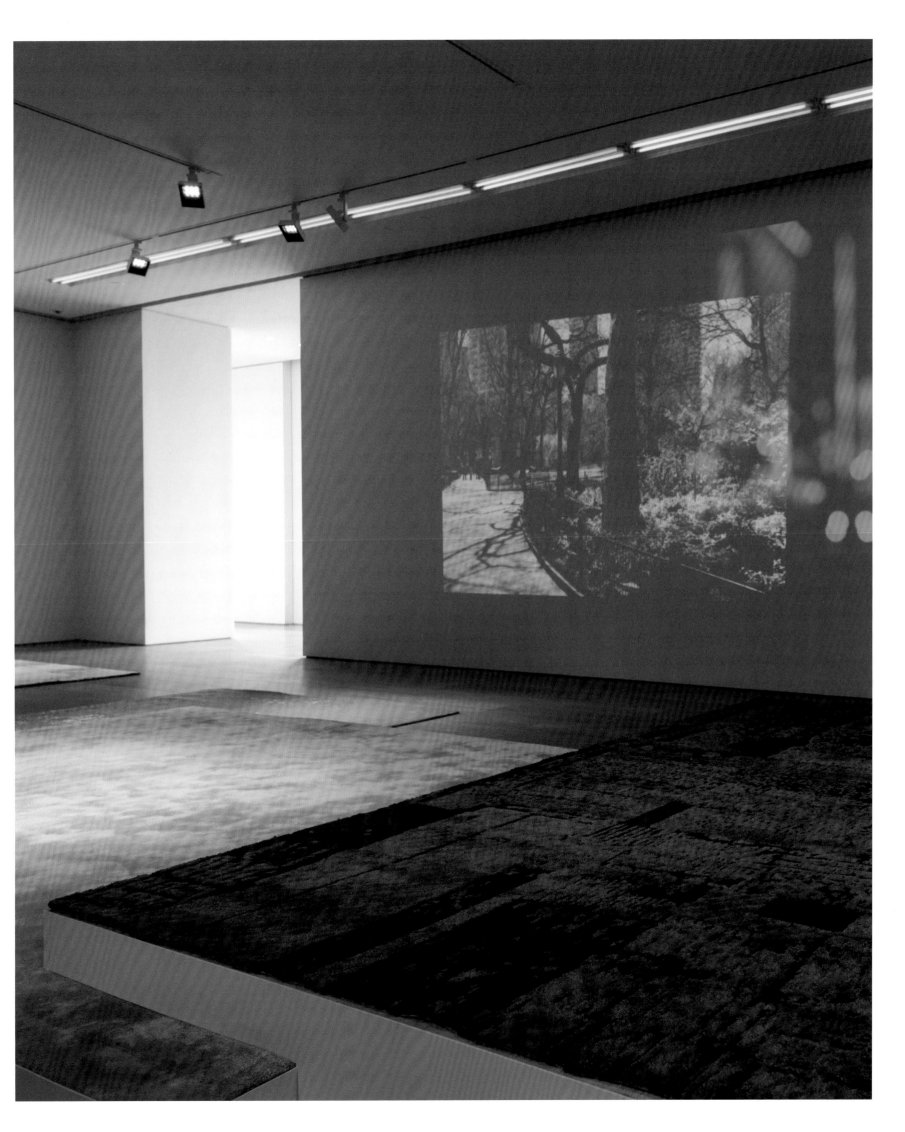

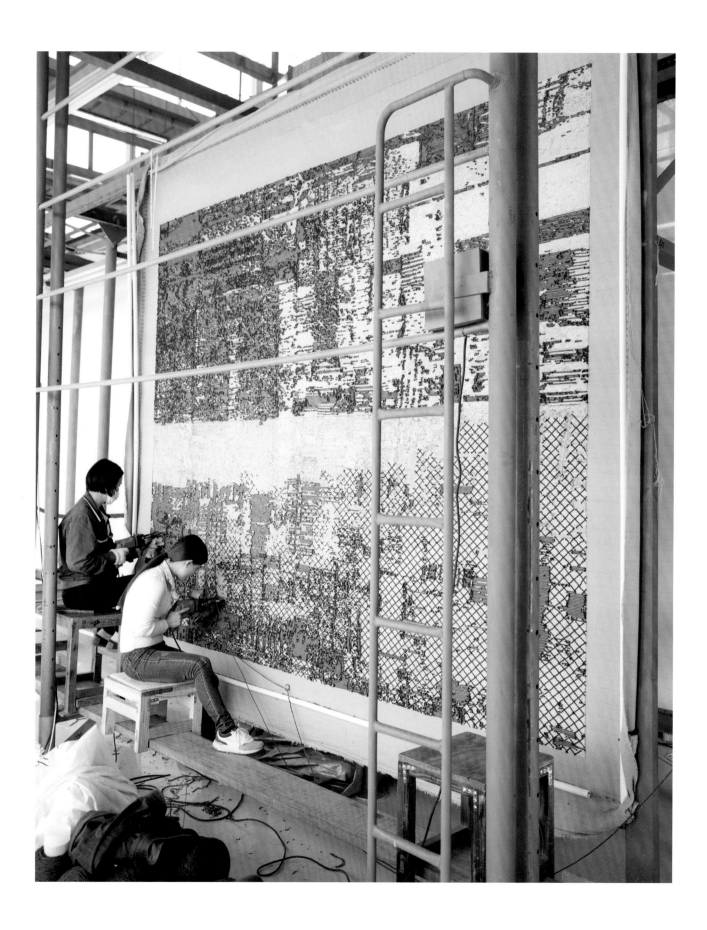

I have designed many rugs for my projects, but this collection is especially close to my heart because it was so effective in capturing the very sensual, subliminal experience that comes from being immersed in the silhouettes, lights and reflections of an urban landscape – whether in Paris, London or Shanghai – from dusk to dawn.

This collection is not about any single element of a particular city. I actually see it as a collage of sceneries that co-exist in our subconscious or as faded memories of the city.

I particularly wanted to explore the pixelated quality of modernistic architecture and the reflective cityscape on water, and to translate this image of cinematography into an artisanal range of carpets.

In 2011 I designed a collection of rugs for Tai Ping that introduced a series of subtle abstract designs inspired by a modern Asian sensibility, and in 2016 I presented a collection of whimsical, urban-toned 'Edition 2' geometric rugs that play on the concept of tracing contours of furniture.

'Scenematic', however, called for a very refined and intricate colour palette, ranging from delicate romantic pastels that hint at water and trees to darker tones combined with intense shades of blue and teal. The carpets reinterpret the urban landscape through a complex range of textures and pile heights, with cut and looped, felted or semi-worsted wool, Steele, and Tai Ping's newly developed, ultra-durable Glosilk thread.

The collection is divided into three main themes: 'Sensory Dusk' is reminiscent of the soft light of dawn and dusk, and reveals a complex layering of subtle shadows hinting at a glimpse of etched reflections of forest green and mineral yellow in geometric and linear to pixelated forms.

'Immersive Sunset' has deep, earthy tones of cinnabar and burnt reds infused with dusty pink to capture the city's reflective mood as night begins to fall.

The 'Urban Nightfall' theme has a highly textured, seductive, dream-like painterly quality. Intuitive elements of the city's powerful urban form at night hint at a touch of wanderlust, with shades of midnight blue and grey offset by warm beige and presented in a subtly fading rhythm.

This is the first time that Tai Ping has mixed hand-tufting and hand-knotting in a bespoke carpet collection. It called for an exquisitely detailed level of craftsmanship and an extremely complex compositional process with an interesting variation of textures and yarns to create shimmering graphic patterns or deeper, complicated overlays that emphasize softness and sophistication. The results are extraordinary at every level. I think it is this combination at play that makes the collection unique.

In one rug, 'Sublime Mineral', the design recalls the shimmering silhouettes of water and rain reflected on windows. The natural palette extends from an intense layering of peat-grey and brown with tones of mineral blue and green in Steele, to soft, pastel ivory, faded caramel and blue-grey tones in wool.

With 'Skyfall I', the graphic quality of modernist skyscrapers reflected on water is expressed in a subtly pixelated range of hand-tufted ice-blue and ivory wool, felt, Glosilk and Steele. Other versions of this rug feature hand-knotted hues of faded plum and dark ivory, or render the design in saturated teal and mineral browns in wool, felted wool, Glosilk and Steele.

The carpets' names reflect the feeling I wanted to evoke. 'Quiet Dusk', 'Line Dance', 'Sublime Mineral', 'Rhythmic Shadow' and 'Midnight Escape', for example, all have a quietly poetic resonance.

I think the carpets express a *flâneur* quality too. 'Quiet Dusk', for instance, is a reflection of the urban streetscape, with its ephemeral quality of cobbled pavements and worn concrete represented in a delicate fading of darker shades of charcoal, ivory, and hints of icy jade and stone in wool, felted wool and Glosilk. 'Urbanist Rays' is a particularly evocative interpretation of shards of light and reflections of curtain walls through an intricate, graphic arrangement of lines that combine rich earthy tones and rustic cinnabar red in wool and Steele.

page 121 'Nighttime Streetscape II' is part of Fu's collection of rugs inspired by the cinematic qualities of the city. The rugs suggest a subliminal memory of the patterns formed by cobbled streets through an abstract arrangement of rich red and orange wool, felt, and Glosilk.

opposite Highly skilled artisans hand-tuft complex layers of silk to create 'Quiet Dusk I' at Tai Ping's workshop. This technically demanding pattern is a reflection of an urban streetscape, with worn concrete represented in pale ivory with hints of icy jade and stone.

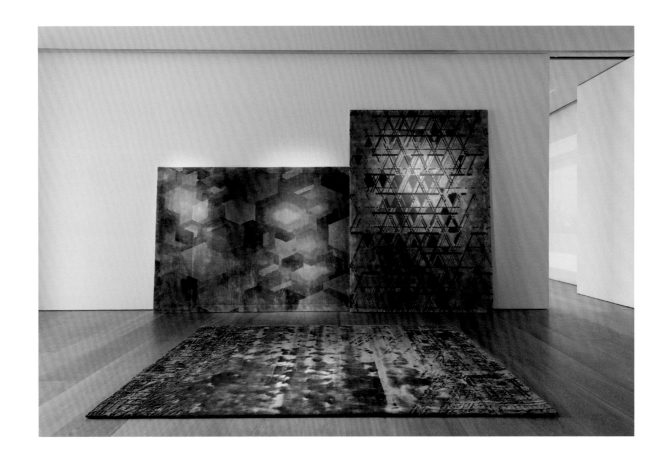

above The 'Sublime Mineral' rugs are reminiscent of shimmering water and rain on windows. The natural palette is extended by intense layering.

opposite This close-up of 'Skyfall III' reveals a complex interplay of both cut pile and high- and low-loop pile with dove silk, felted wool, wool, Glosilk and Steele.

pages 126–127 Prompted by images of the city at night, 'Midnight Escape' mimics a cobbled street, its textures and forms represented by a saturated abstract effect – fading teal, midnight blues and steely grey-blue in Glosilk, wool and felt.

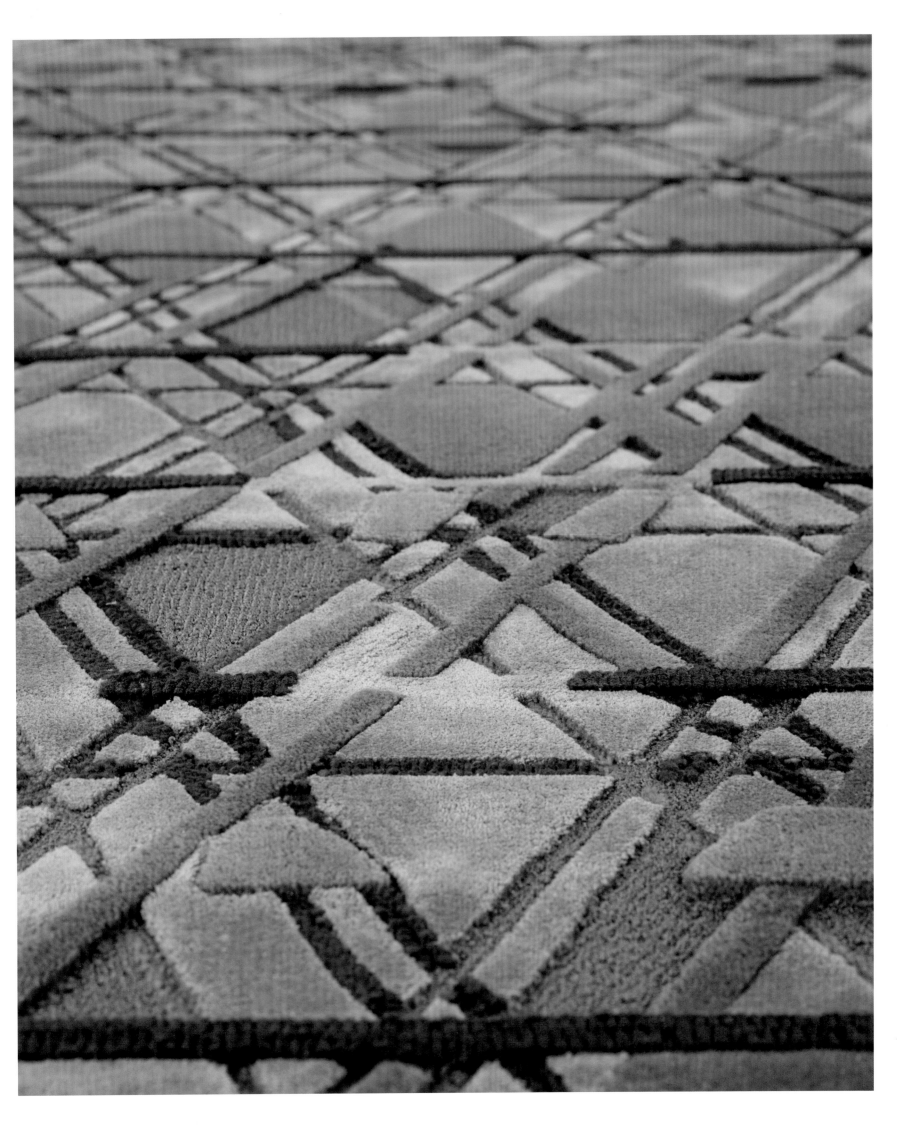

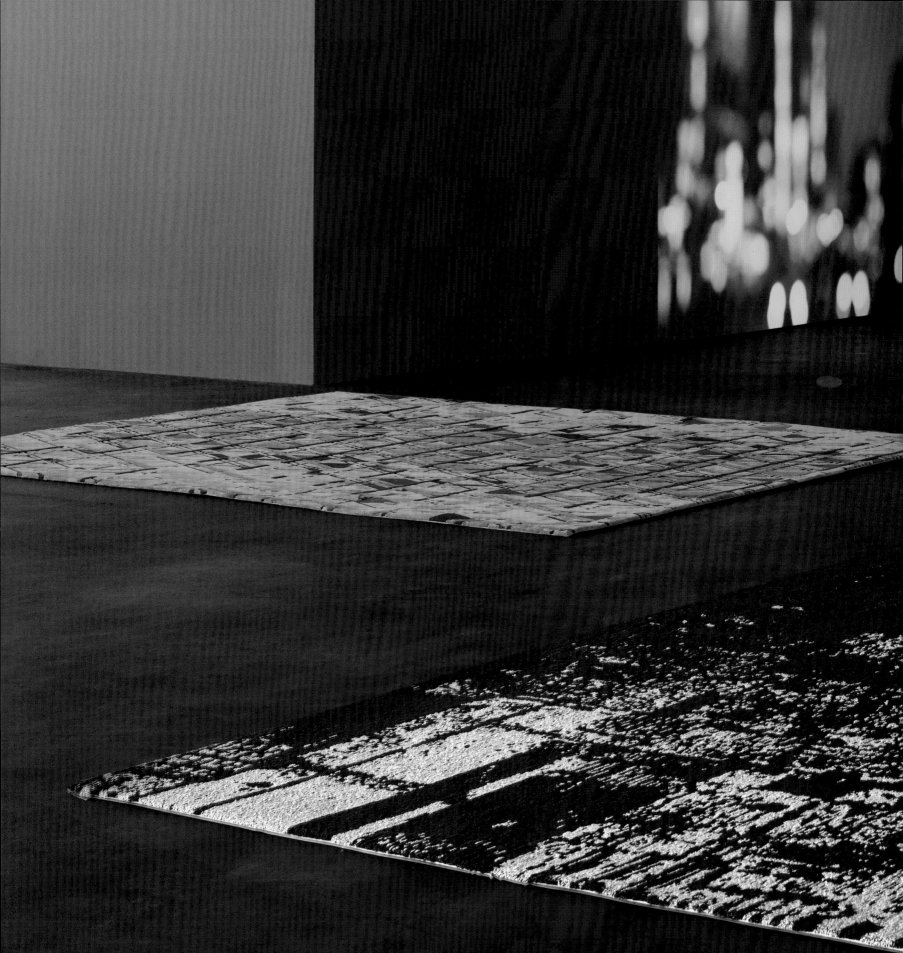

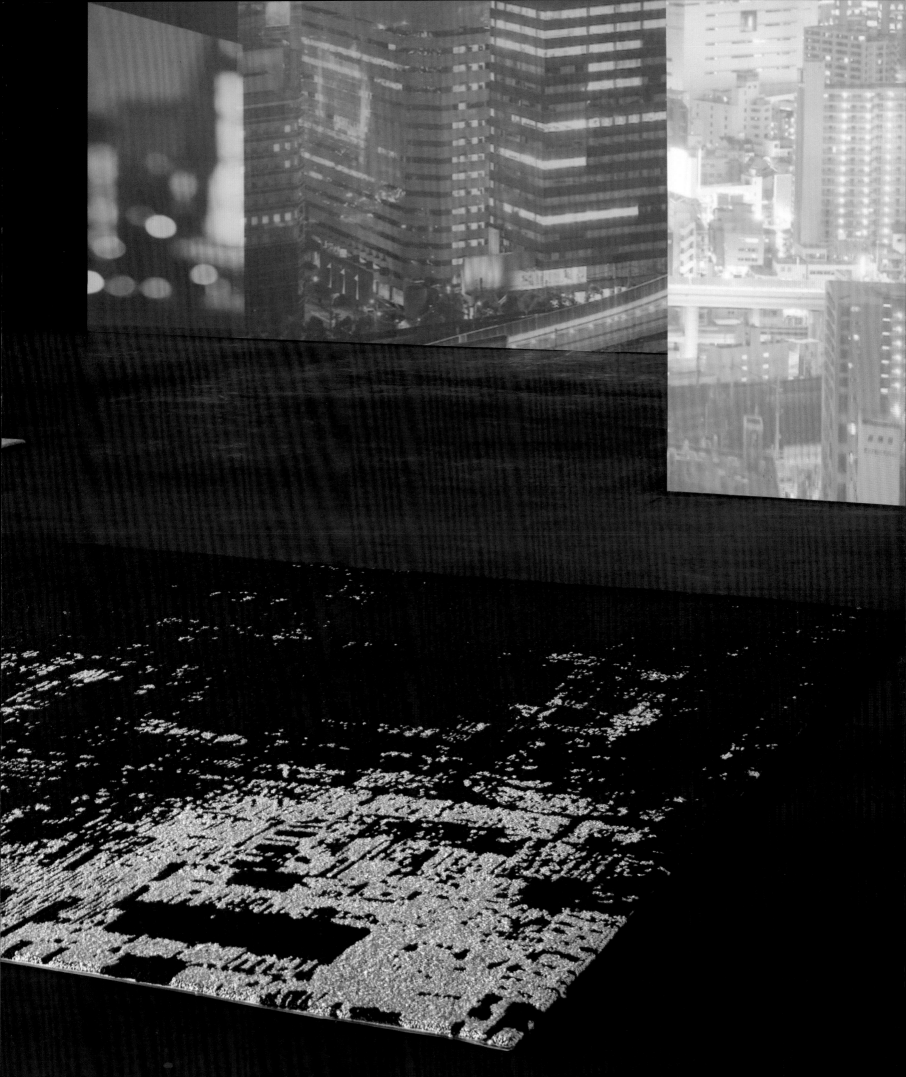

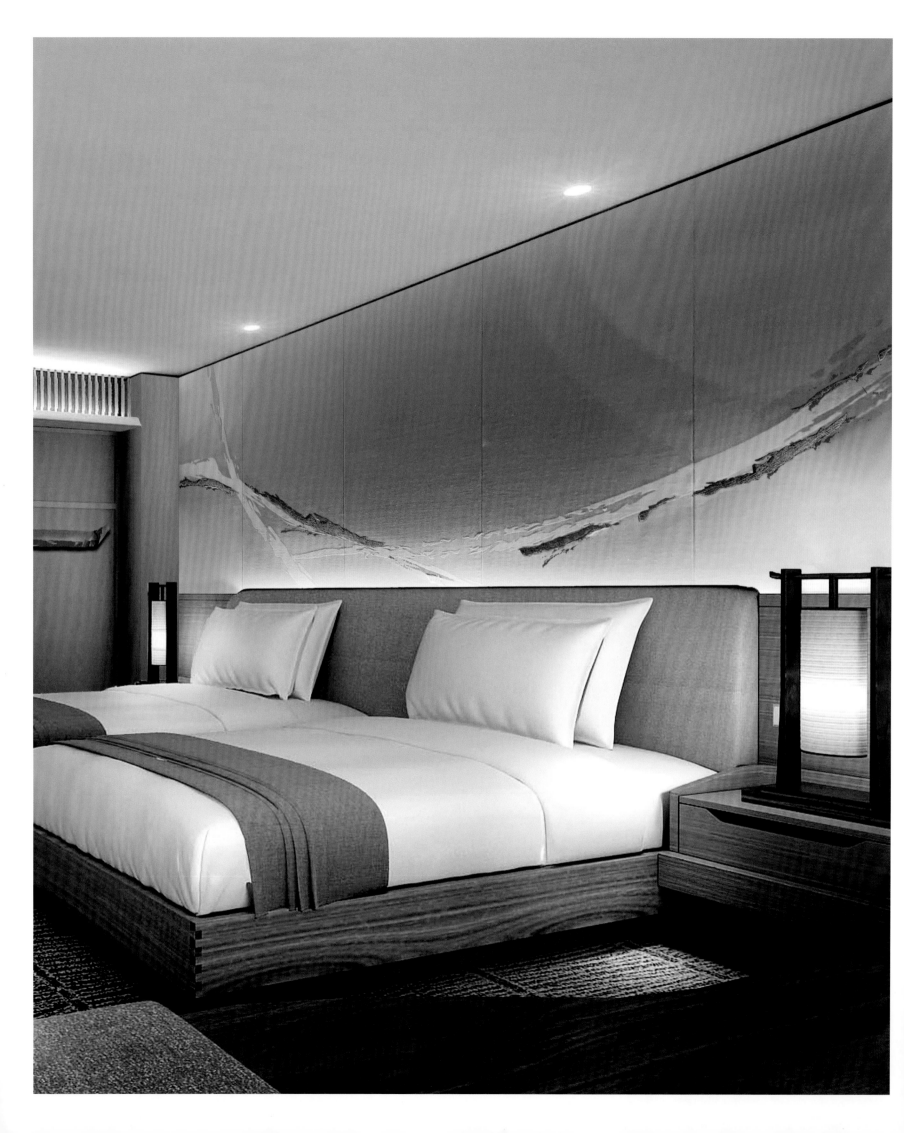

hotel the mitsui kyoto kyoto

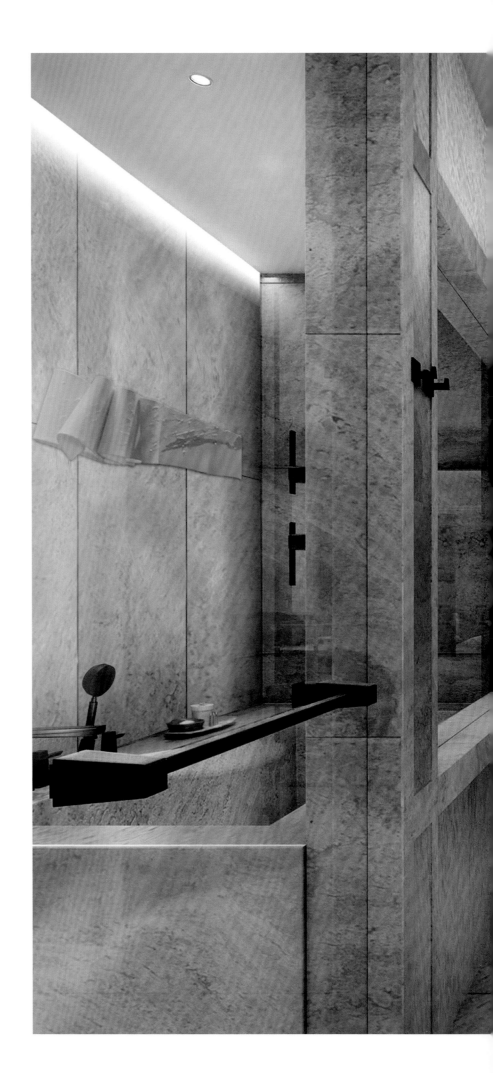

page 128 A custom-designed, hand-stitched wall panel by the modern kimono artisan Jotaro Saito indicates Fu's signature brushstroke. The natural palette is an unusual combination of walnut and local cedar.

right The deep marble tub features a built-in seat. Interlocking forms salute the city's architectural elements.

page 132 Traditional Japanese materials and seamless interlocking forms, including a floating desk made from a rough-edge solid timber plank, are interpreted with Fu's trademark contemporary sensibility.

pages 134–134 The Lobby leads on to an immaculate courtyard garden. Inside, the suspended installation was inspired by the traditional kimono – raised to unveil the garden – and is a tribute to the Mitsui family's history trading kimono fabrics.

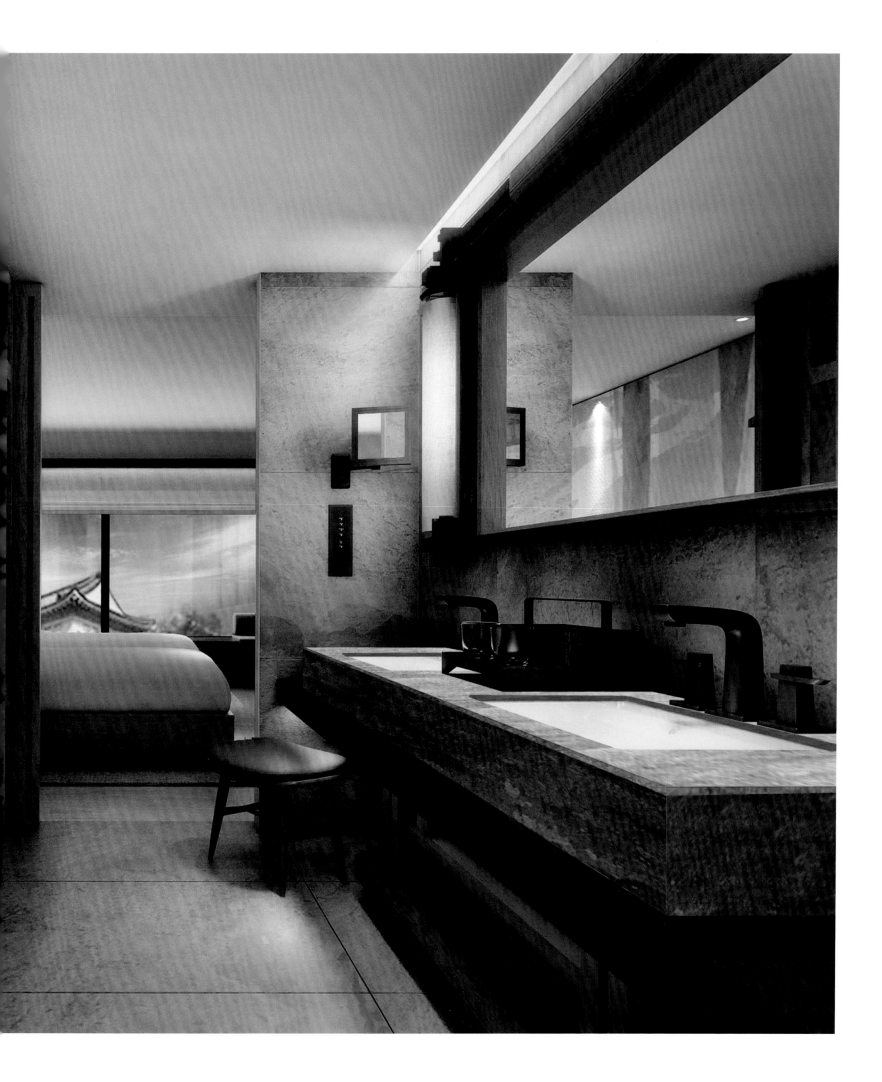

I always feel a great sense of responsibility when taking on a new project, but it was especially so with this recent, 130-room hotel in front of Nijo Castle in central Kyoto. The castle is not just a very important UNESCO World Heritage site; it was the Mitsui Kitake family residence for over 250 years from the end of the 17th century. I have spent a lot of time in Kyoto, but as a non-Japanese, I felt a special duty to reflect the poetic character of the ancient capital and pay homage to the family in a nuanced, authentic way. The city has always had a mystical quality for me.

At the same time as celebrating the hotel's unprecedented sense of place and capturing a contemporary sense of luxury, I hoped to bring a fresh, international perspective that would add something unexpected. Although it is very much a contemporary hotel experience, the soul of the hotel revolves around the experience of landscape and hospitality as if they were one – centred on a series of sublime artisanal gardens that suggest an alternative way of understanding what traditional Japanese hospitality, architecture and culture mean.

As with many heritage sites in Japan, the density of the surrounding area is quite low. The Mitsui is arranged around an internal courtyard garden, over four floors above ground with another level below, so it has a very seductive, intimate feel. We worked very closely with Kyoto artisans to infuse the interiors with a sense of true local craftsmanship. This is especially so at the entrance, where a pair of 300-year-old timber entrance gates from the original Mitsui residence welcomes the guests into a lush, bamboo forest-inspired garden, the first within the property. The gates' beautifully weathered wood was painstakingly restored and is now a dark grey. I see it as an artwork in its own right.

Inside the lobby there is a wall of angular timber slats, an abstract tribute to the nearby bamboo forest and a modern interpretation of traditional Japanese architecture's placement of a bamboo hedge as a spiritual and functional barrier. An enormous shoji lantern that measures 5.5 by 4.5 metres is suspended from the very low ceiling, and the walls are lined with cherry wood. The centrepiece is a large ceramic sculpture by the Japanese artist Yukiya Izumita set in finely raked sand. Inspired by the transient qualities of time and place, the installation gives a sense of depth to the space while reflecting Japanese qualities of antiquity and modernity, fragility and strength, vulnerability and resilience.

The entrance has such a quiet beauty that the change of scale as one enters the soaring double-height lobby lounge next door is very dramatic. There, floor-to-ceiling windows lead on to the traditional courtyard garden and a particularly beautiful cherry tree. A sleek open fireplace carved out of a monolithic block of stone symbolizes the lounge as a gathering place. Suspended from this ceiling is a hand-painted bamboo installation reminiscent of flowing kimono fabric. The pattern evokes a silhouette of water, reflecting the water feature in the garden outside and giving a visual and tactile connection to both inside and outdoors.

Japanese design is often perceived as being all about crisp geometries and perfection, but I find it is also very much about textures and wabi-sabi [the Japanese philosophy of embracing imperfection]. Moss, rocks and wood at temples like Tokuji in Kyoto are imbued with this textured materiality and offer a mesmerizing glimpse of the Japanese relationship with nature. I took inspiration from this for walls sheathed in woven textiles created by the kimono designer Jotaro Saito, whose family have long been Kyoto kimono-dyers, and whose innovative style shares the classic and contemporary sensibilities that perfectly encapsulate the ambience at the Mitsui. I don't usually work with clay, but here it adds a wonderfully rustic quality, especially with this deep, mud-red colour.

Kyoto landscape master Shunsaku Miyagi's immense knowledge of Japanese gardens was integral to creating the garden landscapes, especially the courtyard garden that acts as a visual focus for the lobby and brings a touch of the theatrical to the tea lounge. The garden has two parts: one is a tribute to the original traditional garden, and the other, closer to the lobby, a contemporary garden. Both transform during the seasons. This theme continues inside through beautifully crafted interlocking joinery and understated custom furniture. In the guest rooms, traditional Japanese teahouse interiors and such materials as solid, natural-cut walnut, tatami and kimono fabrics are re-interpreted in a fresh, modern manner.

It's difficult to get a perfect balance of what feels genuine without being constrained by it, so I focused on imbuing the interiors with a sense of luxury through honest materials and avoided the temptation to over-perfect details, especially lighting. I wanted to create a subtle atmosphere and didn't want it to feel too glamorous or urban. The *washi* [traditional handmade paper] lampshades, handmade by local artisans, add pools of light-glow without unnecessary theatre, yet with a strong sense of authenticity. This was also the case with the oak *torii*, slanted at an angle to give an interesting perspective to the passageways.

There are some cities where you have to search for the story that informs your design, but Kyoto's story is so strong – you simply have to fit inside it.

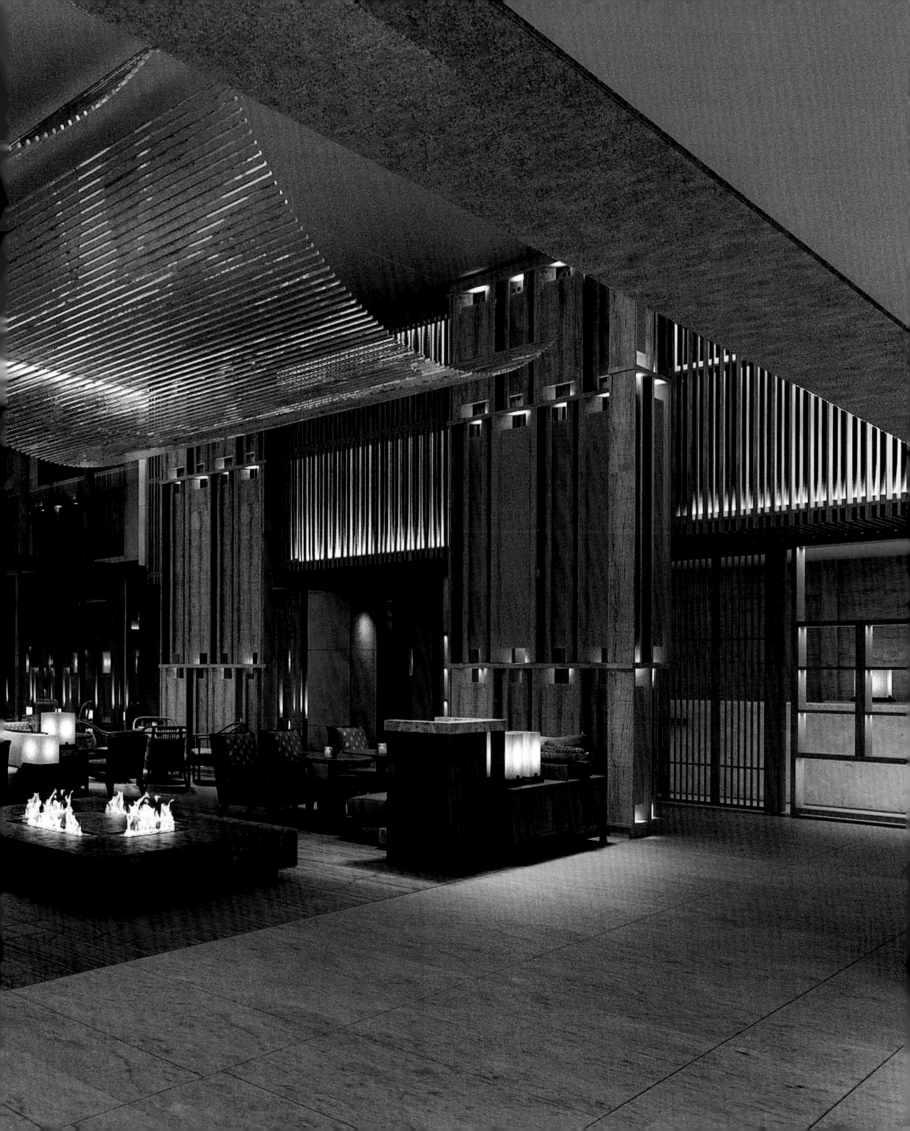

k11 artus hong kong

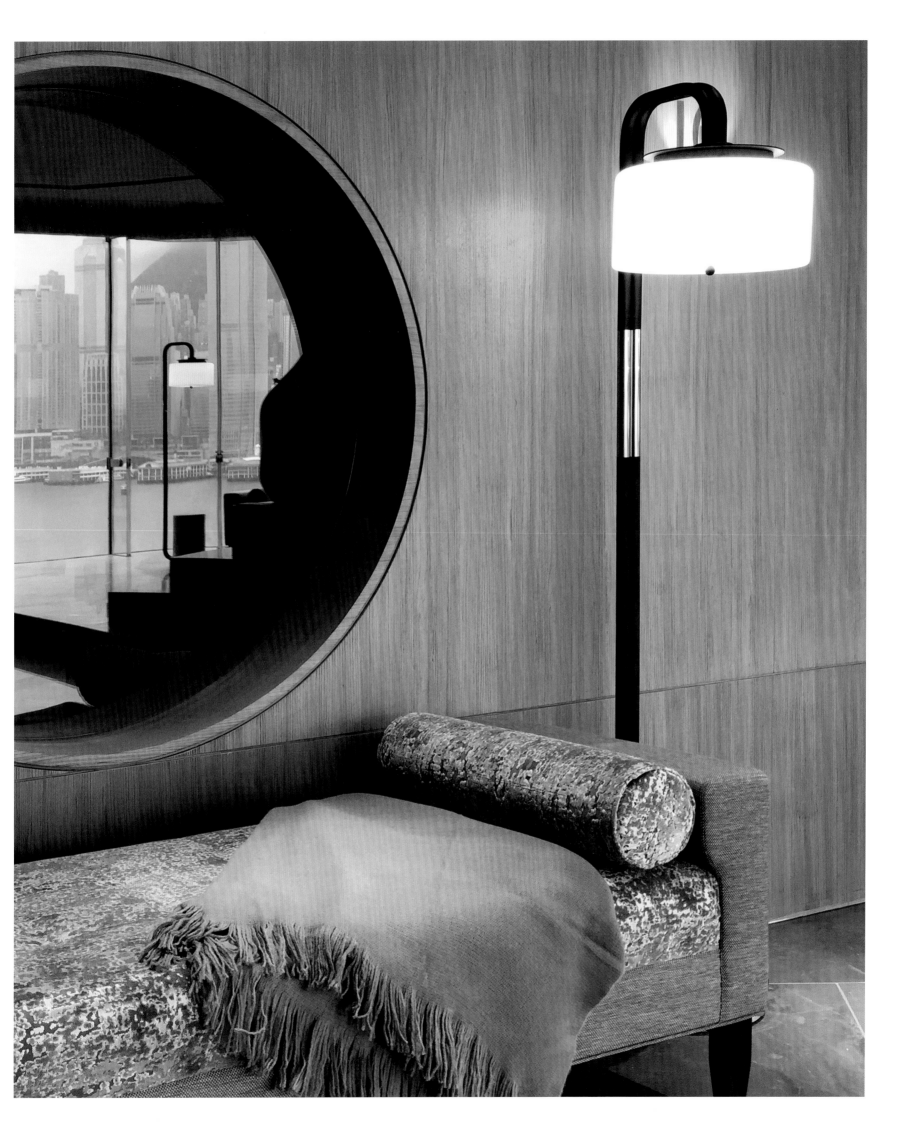

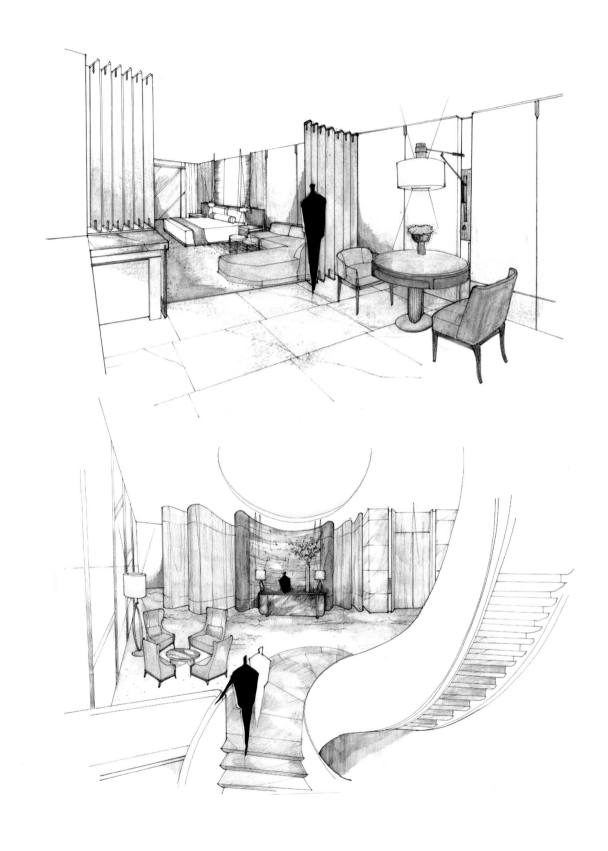

The name given to this K11 project, ARTUS, is a compound of 'art' and the Latin word for home, 'domus' – which perfectly encapsulates K11 founder Adrian Cheng's mission to create a new luxury residential lifestyle concept around a community with shared tastes in art and literature.

I was intrigued by how this and his artisanal movement could be expressed in a relaxed, unpretentious way that is not about an attitude or curating art in a residential context, but focused on creating a space for people who embrace a certain way of life that epitomizes relaxed luxury. The K11 brand is already very well-established in the retail and art worlds in China and Hong Kong, and I felt that a lively and stimulating private salon with a hospitality experience presented as a private apartment or pied-à-terre would best express its underlying philosophy and style.

It needed to be a highly contextual response because the property, which was once known as Holt's Wharf and bought in 1971 by Adrian's grandfather to develop into a retail/hotel/residential/office complex called New World Centre, is right on the edge of Victoria Harbour. The distinctive, curved, ribbon-like façade means every guest room is a slightly different shape. They each have a private continuous balcony and panoramic views across the harbour towards Hong Kong Island. There really is nothing like it in Hong Kong, and I paid particular attention to internal layouts that would make the most of those views and the natural daylight.

There were certain things I wanted to avoid: I felt there was no need for obvious 'wow moments', nor did I want to present East-meets-West tropes. I felt it called for a more nuanced approach that would reflect the cultural duality that is very much modern Hong Kong, so accommodation is designed to feel very intimate, intuitive and discreet with a strong focus on solid and thoughtful details that make it feel like a home. Within each suite there are open-plan living and dining spaces and a very well-equipped kitchen with laundry facilities as well as storage rooms. That means you could just as easily stay for an extended period and feel comfortable about entertaining friends or even colleagues without sacrificing your privacy.

In some of the suites we've created a study off the living room that can be enclosed by oak screens to create a second bedroom, and there are very generously sized storerooms, walk-in dressing rooms and dressing tables with good lighting. The upper levels have their own private elevator access, which very much emphasizes the feel of a home. The earthy and natural material palette is offset with bold, deep navy-blue and terracotta accents in some guest rooms, and mustard yellow and earthy peach in others.

All the rooms are decorated with handcrafted items that I sourced from around the world, and these fit well with other artisanal touches, such as richly textured woven fabrics, glamorous bespoke finishes and glossy lacquer, leather and brushed brass. There is also a play on Persian and ethnic patterns that embrace the artisanal spirit, and bespoke lighting and furnishings that evoke a mid-century feel and reflect the bold, confident community I had in mind.

Timber and stone panels engraved with an architectural diagrid that I created specially for this project also express my perception of K11's artisan spirit.

The tenth floor, with four dining and lounge spaces, is very unusual compared to typical hotel public spaces because the entire, 1,200-square-metre space is loosely expressed around four cultural themes that pay tribute to Hong Kong's favourite cultural pursuits: calligraphy, literature, string instruments and chess. I conceived it as an extension of one's home, so while each of these spaces has a different atmosphere, making them feel friendly and engaging in a shared work and living environment was especially important, as was maximizing the 3-metre floor-to-ceiling windows with harbour views. There are several museum-quality contemporary sculptures and a triple-height library that doubles as the reception area. It was a challenge to create an expansive yet intimate environment that is both refined and relaxed, but I feel that the subtle layered sequence unfolds very naturally.

page 137 Fu's fondness for geometric forms is expressed in the Bauhaus-inspired circular window that displays views of Victoria Harbour and fills interiors with natural daylight.

opposite Original concept sketches. Top: An open-plan, one-bedroom studio. Bottom: Curved wall panels and a sinuous staircase link the shared social spaces over two floors.

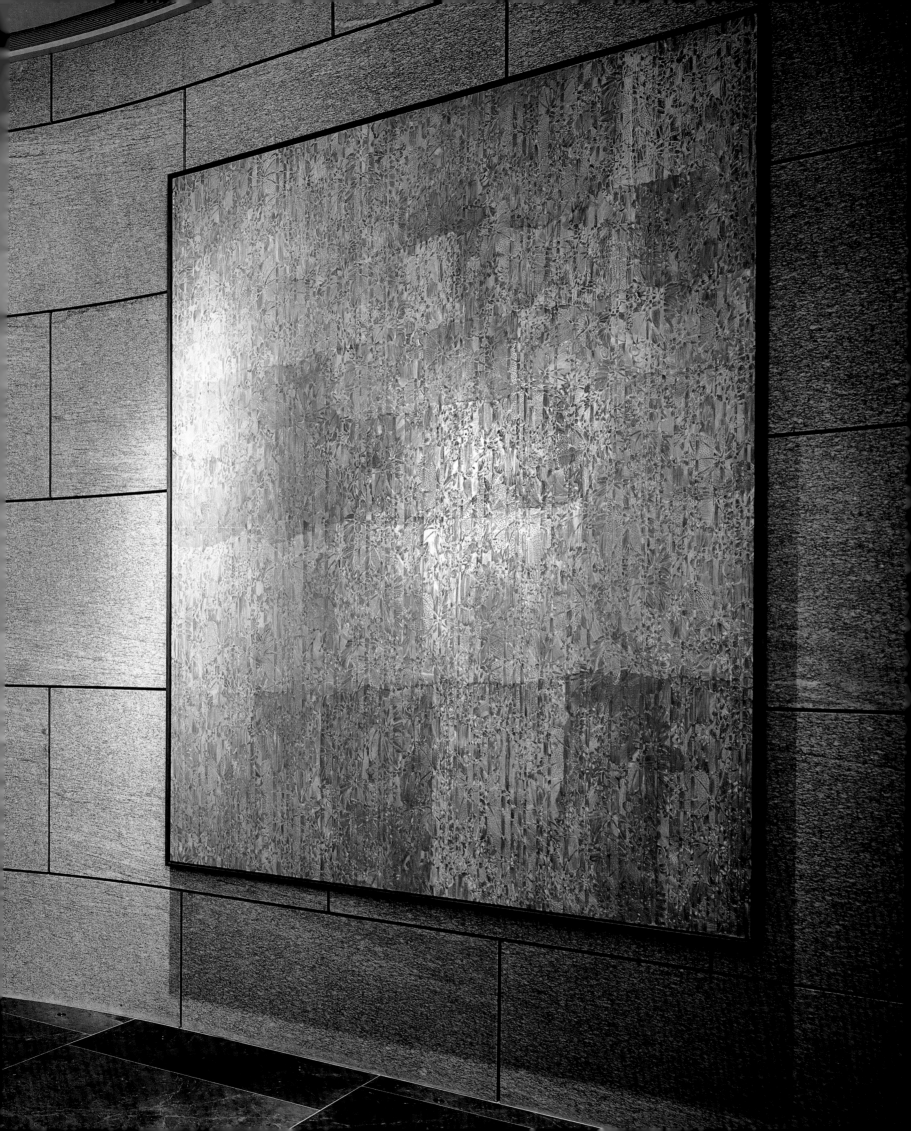

pages 140-141 An ethereal oil painting by Liang Yuanwei and a concierge desk with monolithic, interlocking, curved marble forms in the west entrance lobby.

above A detail of an intricate metal landscape sculpture by Kenou Ho Kwun Ting, highlighted by Fu's custom lighting inspired by a traditional magnifying glass.

opposite The west entrance lobby, decorated with eclectic *objets* and succulents, creates the feeling of entering a private home and marks the departure from the city beyond.

page 144 A trio of minimalist reception desks anchors the impressive, 7-metre-high library, which contains a collection of books on art, design and architecture selected by Fu. A geometric floor pattern leads to the guest-room elevators. Smaller, more intimate areas in which to sit and relax are arranged next to the floor-to-ceiling windows.

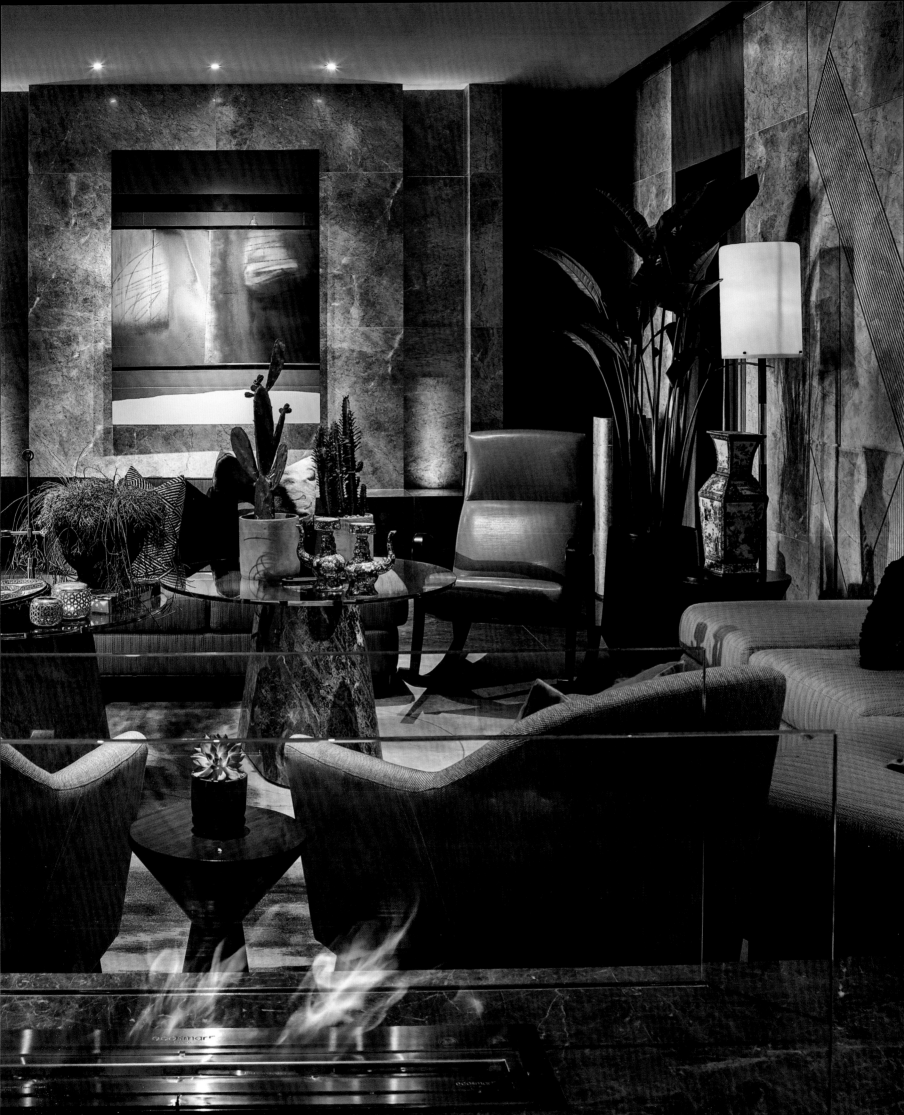

'In the past decade or so I've worked very closely,
and spontaneously, with a lot of world-class architects
and designers. Obviously each project is different and
each with a certain culture, aesthetic and ideology
that I'd like to convey, so I first share the grander vision
with the creatives to see if our visions align.
I see my role as playing devil's advocate in order to get
the best out of someone. André has a particular philosophy
and that means his work is very layered, so our
creative collaboration really helped to push the boundaries
to create a very intense experience, where each
time you visit you discover something new.'

ADRIAN CHENG
executive vice-chairman of New World Development
and founder of K11 Group

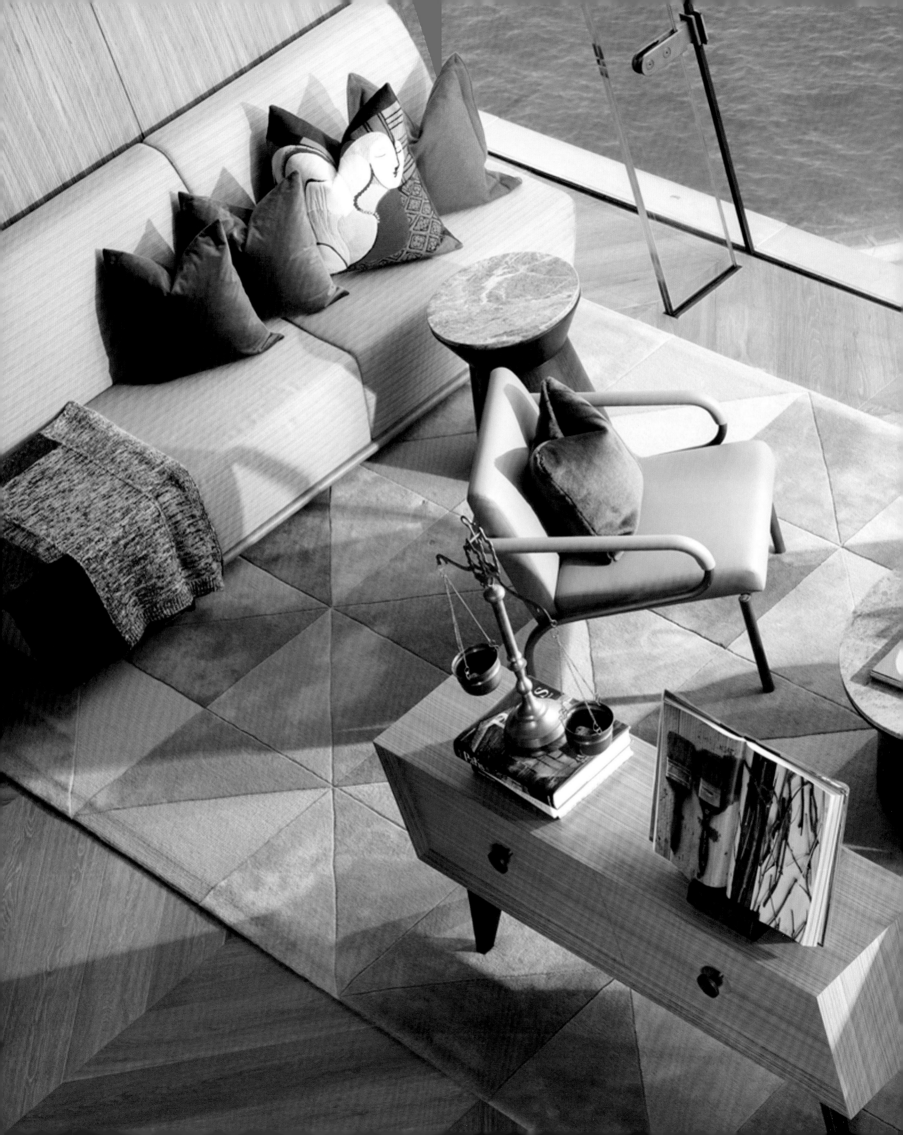

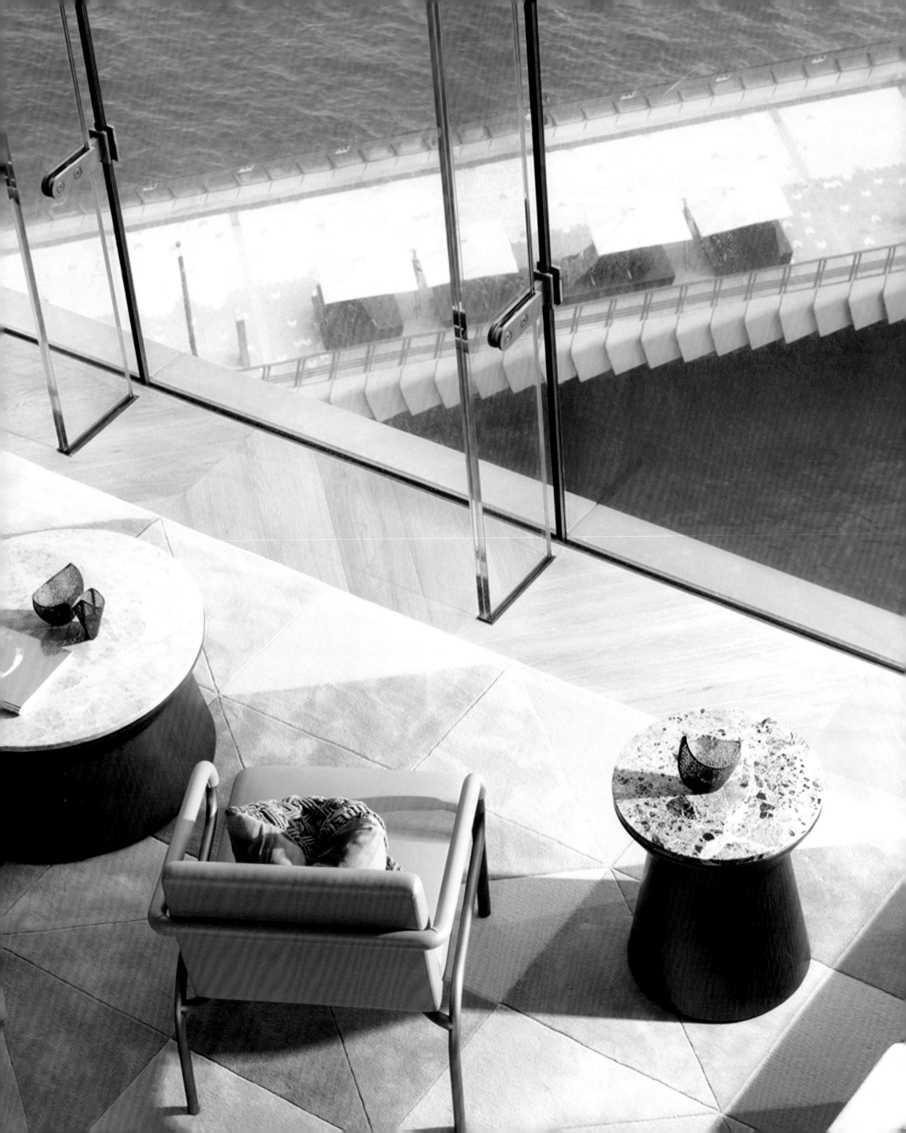

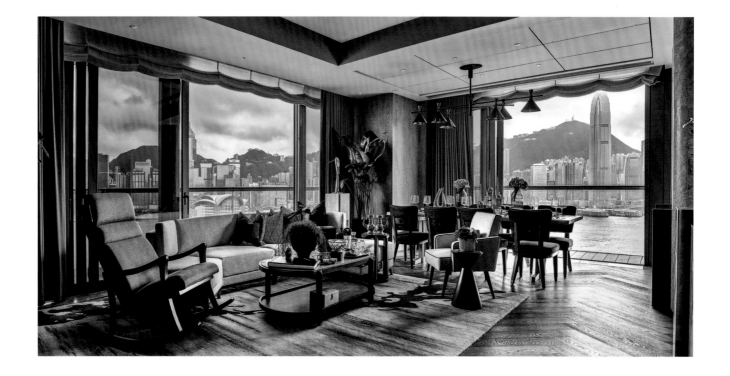

pages 146–147 A bird's-eye view of the library looking out to Victoria Harbour and the Avenue of Stars. The subtle palette of calm neutrals with mineral accents and rich textures reflects the seascape.

above A three-bedroom corner suite with a wraparound balcony and panoramic views of Victoria Harbour, decorated with gently curved furnishings and handmade artefacts that create an inviting atmosphere.

opposite A master bedroom designed for long-term stays is dressed in a rich palette of wood and textiles. Slender timber fins between the bed and walk-in dressing room create a sense of privacy while retaining an open-plan feel. The intricate, Persian-inspired textile mural and vintage-look wall lamp add to the residential aesthetic.

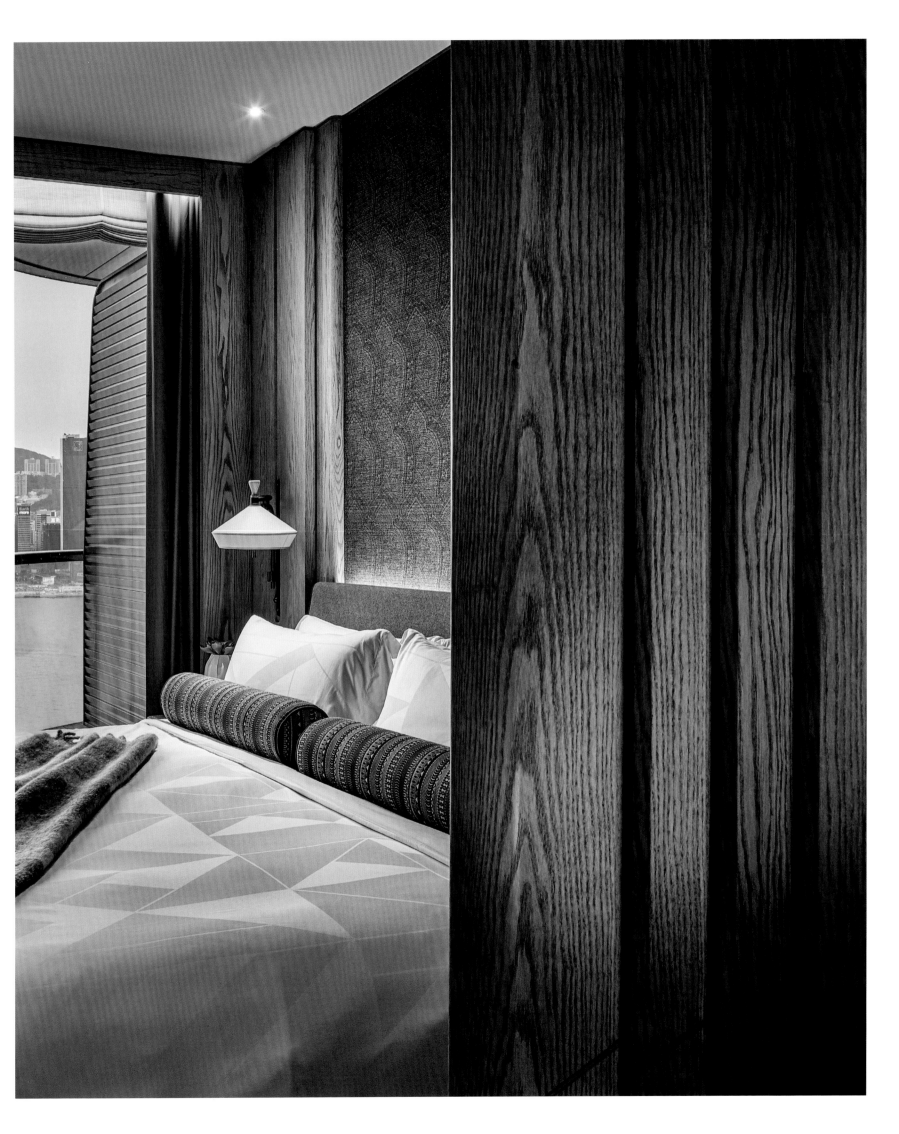

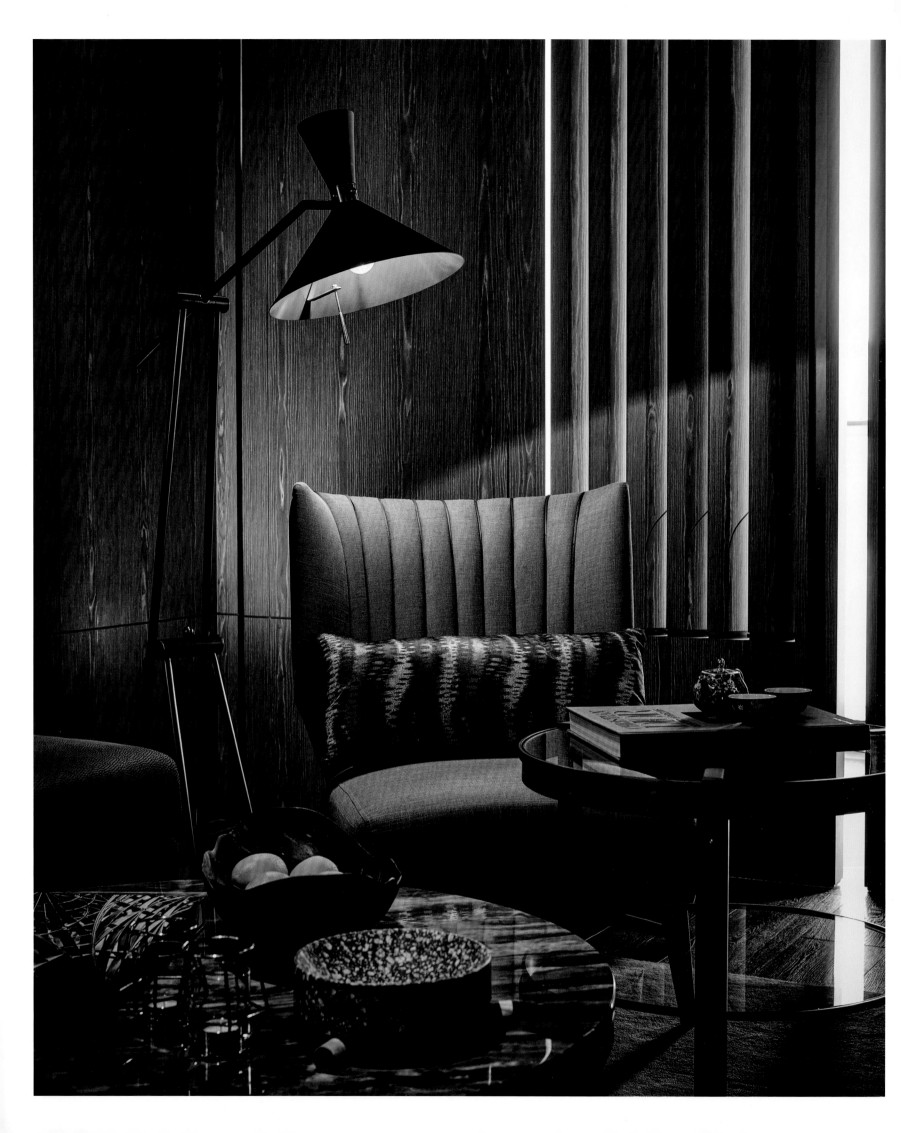

opposite A seating area in a one-bedroom suite with vintage-inspired custom-made furnishings.

above Museum-quality art includes *Spiral*, a 2014 bronze sculpture by the British artist David Nash. The dramatic geometric backdrop in solid marble highlights the sense of drama.

pages 152–153 The building's unusual, organic, wave-like façade and continuous balconies make a distinctive, rippling architectural statement in dialogue with the harbour.

cos urban landscape, hong kong

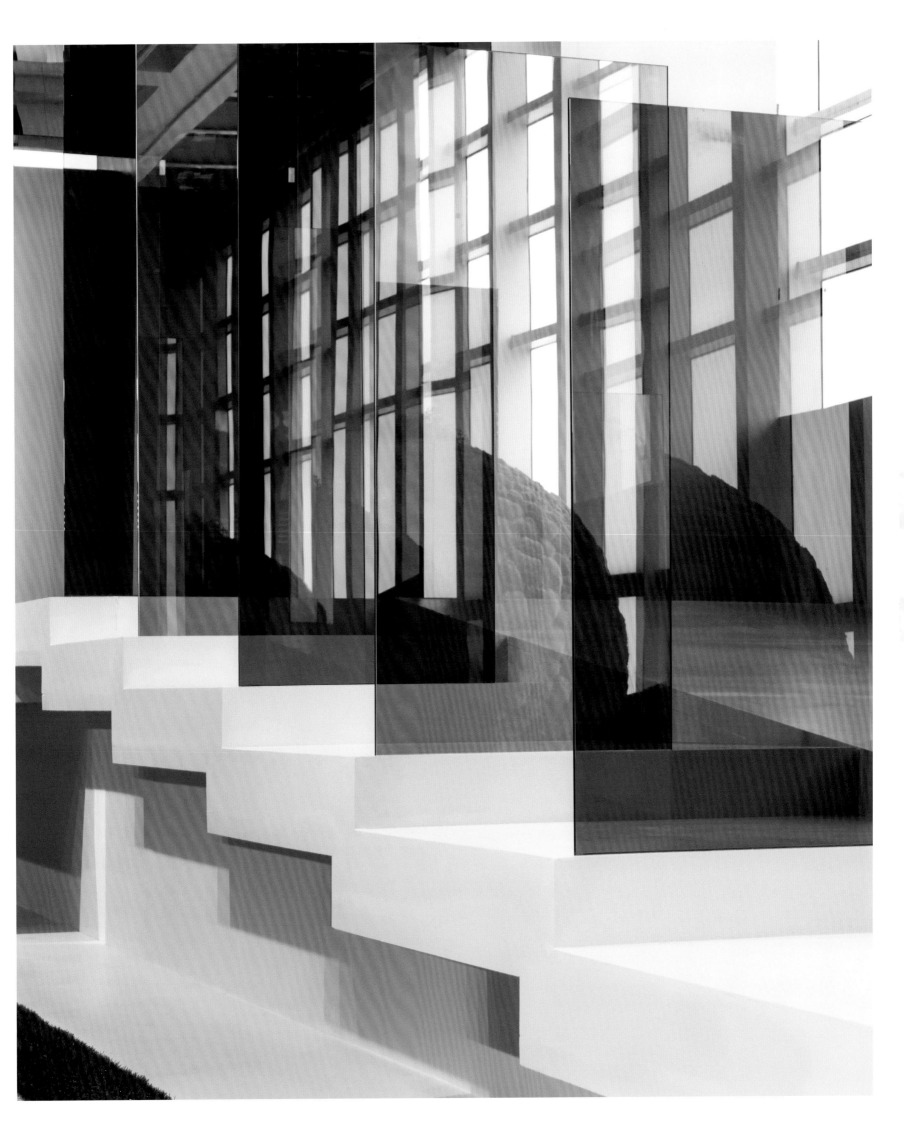

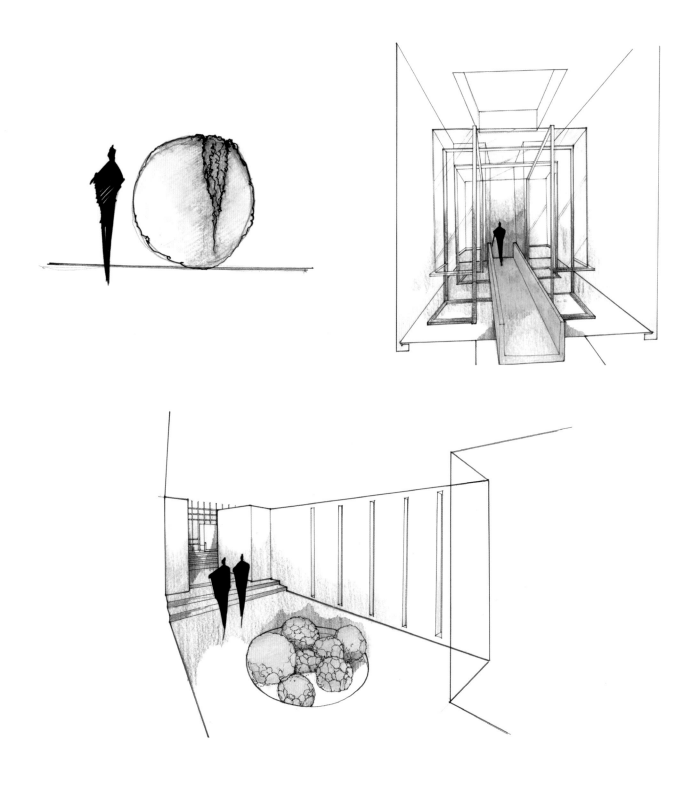

Temporary installations, such as this one-night-only pop-up on the Hong Kong Star Ferry Central Pier for Swedish fashion brand COS, offer enormous creative satisfaction, despite their fleeting nature. COS embodies a feeling of fashion going forward and I wanted to explore this along with the notion of urbanity. A pop-up sounds simple but this project took forty people more than forty-five days to install. The structural and decorative elements had to be fabricated, assembled and tested off-site, which is a big undertaking for any brand.

I have long admired COS's down-to-earth, approachable style to fashion, and was intrigued that this should be their first fashion show in seven years. They usually rely on word-of-mouth and social media, not the traditional catwalk.

My design brief was very open: I was invited to embrace the spirit of Asia within the context of the Hong Kong Star Ferry Central Pier, an extraordinary structure on Victoria Harbour.

We had the entire upper deck, which measures about 2,000 square metres. Like most piers, it is long and narrow, and in this case the lower deck was still operating, ferrying passengers to Lamma Island.

The interiors were not a neutral space; there were several significant building challenges to address, such as different ceiling heights and existing infrastructure. This was why I used an architectural approach to create clarity and simplicity within the existing context, without hiding what it was.

I wanted to avoid a typical, mono-directional fashion show where the viewer is a static part of the overall experience. Instead, my idea was to create an immersive, shared experience that would reflect modern Asia's distinctive cityscape. This emerged through a sequence of ultra-modern, minimalist conceptual spaces to stimulate visitors' senses yet remain a holistic experience.

The palette throughout was a sensual dove grey, which is the COS brand colour, but it is also very natural and peaceful and reflected my interpretation of COS as pure and tactile.

The entrance was conceived as a prelude with 'the Cube', an ultra-contemporary, 3.5-metre-high glass-and-steel cube that visitors crossed on a forest-green lacquered bridge. I see the cube as embracing the spirit of cities, so to my mind it was a natural start to the design narrative.

Further on, I contrasted glimpses of the building's working industrial infrastructure with a more serene transitional space, where a 2-metre circular sunken garden of moss-covered spheres rested on white pebbles. I especially liked the way these spherical shapes – the first encounter of greenery inspired by the idea of nature in architecture – engaged and interlocked to evoke a very still and peaceful aesthetic, but with a sense of drama.

The path led to a dramatic terraced stage of ramps and interlocking steps, where COS models showed the Autumn and Winter 2015 collections of voluminous silhouettes inspired by Japan's mono-ha art movement's interpretation of the relationship between nature and modern industrial materials. The 'catwalk' was a cantilevered bridge connecting two enormous cubes – one mirrored and one entirely of glass – set against panoramic views over Victoria Harbour.

I think of this pop-up as my first landscape installation. The most interesting thing for me was its experiential quality that elevated the senses to a different level, like walking into a show by the American artist James Turrell where architecture, light and space are all one. It never feels static because the ultimate experience comes from being able to interact with the space in a much more natural and organic way. It was very important to me that it should not feel like an installation or a façade, but rather conceptual with all elements in visual dialogue.

page 155 Fu conceived the pop-up on a long, narrow pier on Victoria Harbour as a tribute to city life, inserting infinity glass panels to give multiple reflections and create a sense of tension within the geometrical setting.

pages 156–157 The circular sunken landscape of moss-covered spheres resting on white pebbles is a prelude to the light-infused main installation.

opposite Original concept sketches illustrate the sequence of experiential spaces.

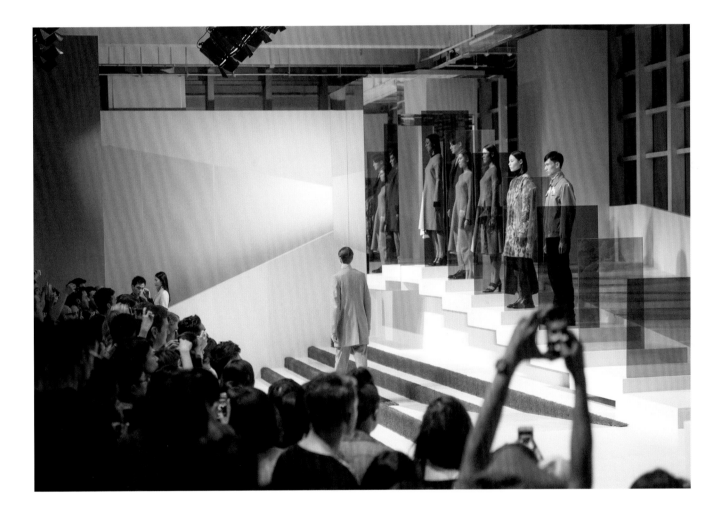

opposite Models pose against reflective glass panels.

above Structural and decorative elements made and assembled off-site offer a powerful interplay of form and texture.

page 163 The pure-white and glass geometrical forms are offset in dark moss-green, with the city providing a dramatic backdrop.

pages 164–165 The installation included a terraced walkway on which models showed the COS collection.

I think of this pop-up as my first landscape installation. It just felt like a natural fit to mix such calm and peaceful natural elements with an urban setting.

ANDRÉ FU

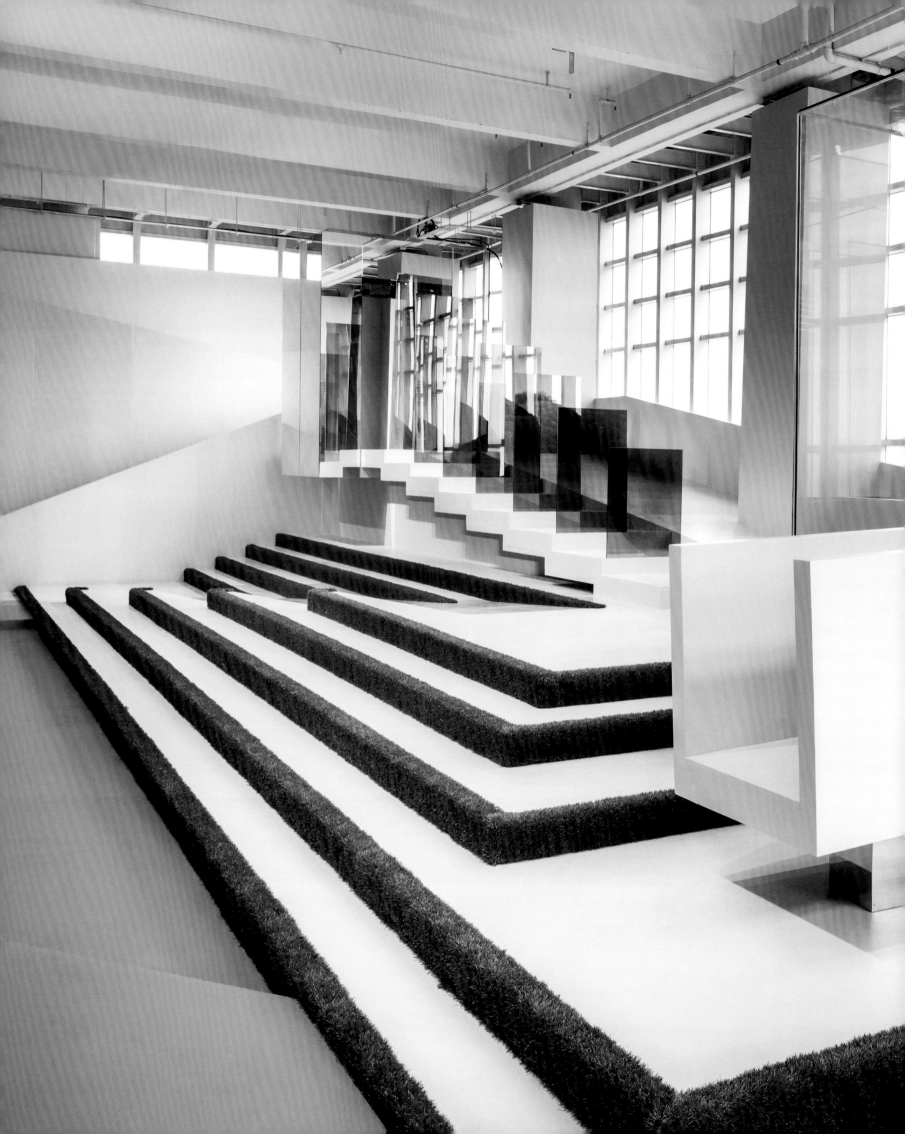

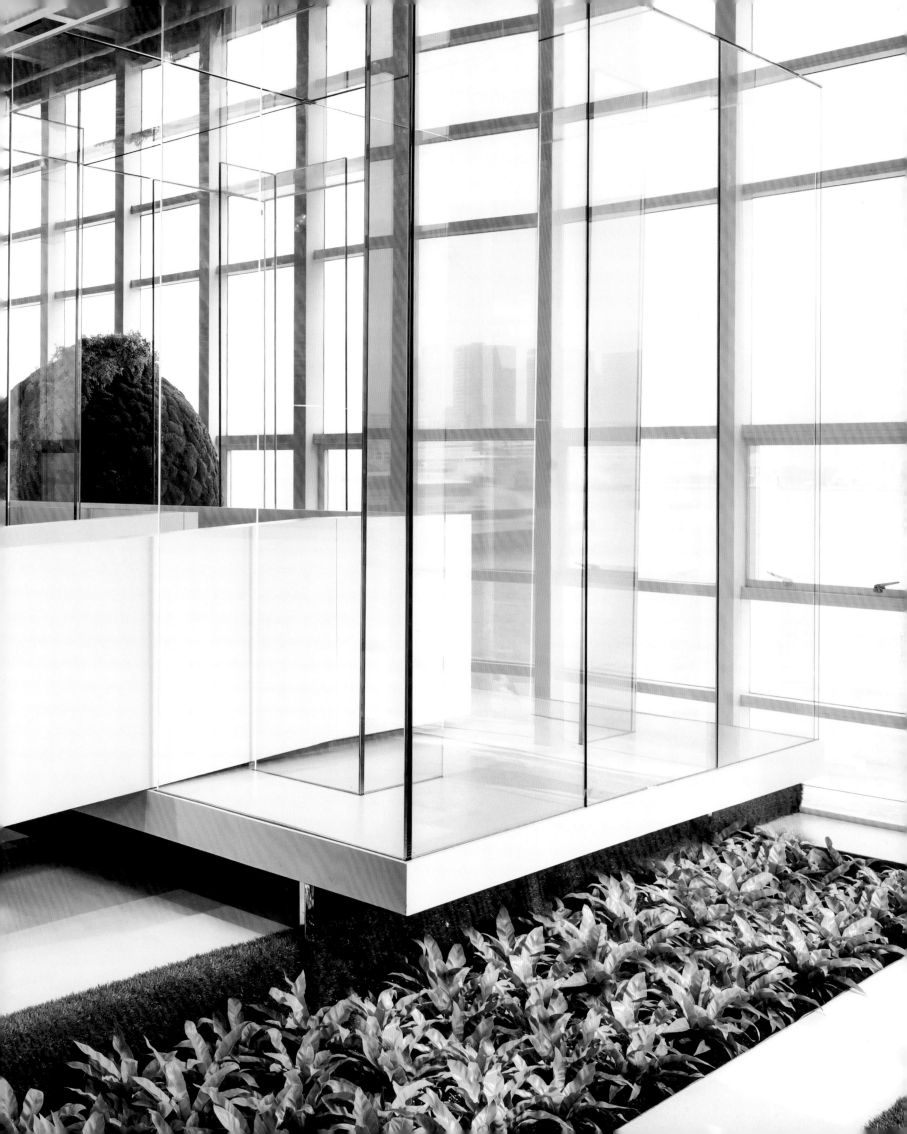

andaz singapore

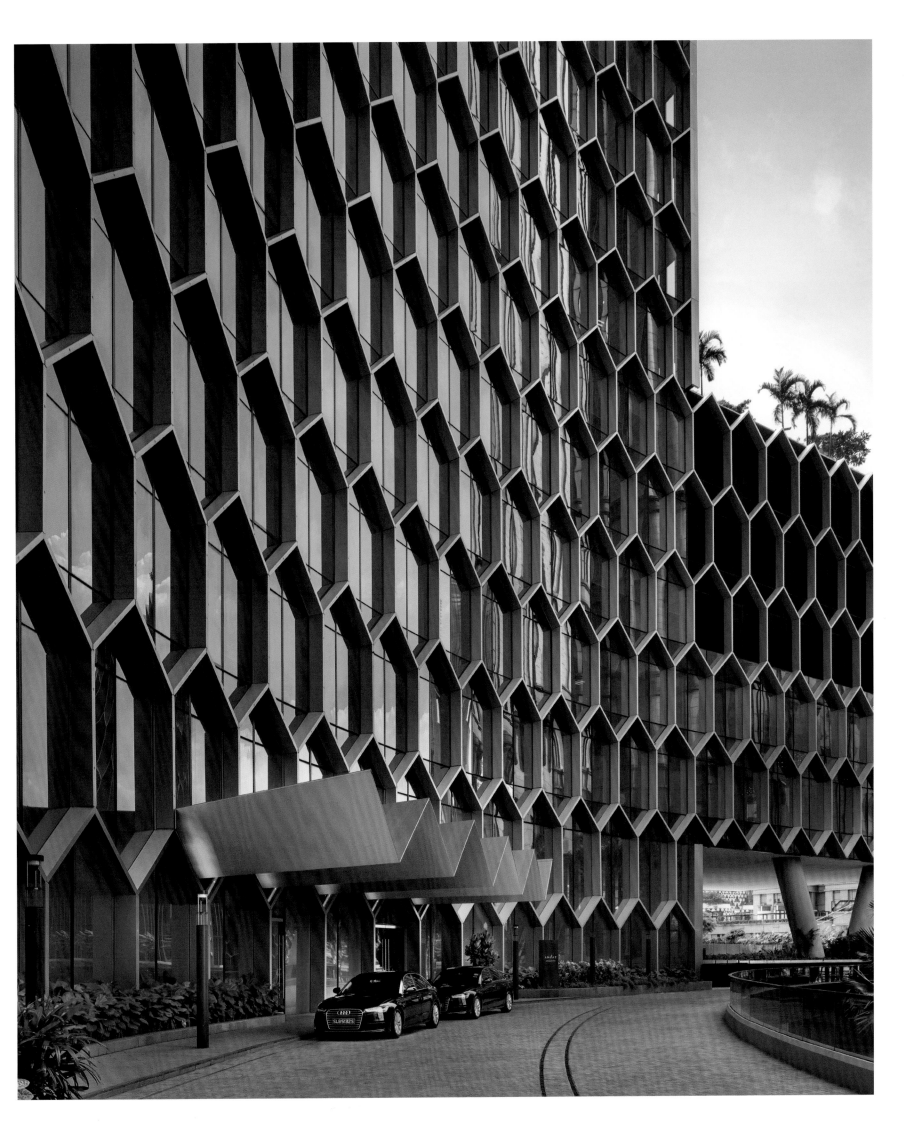

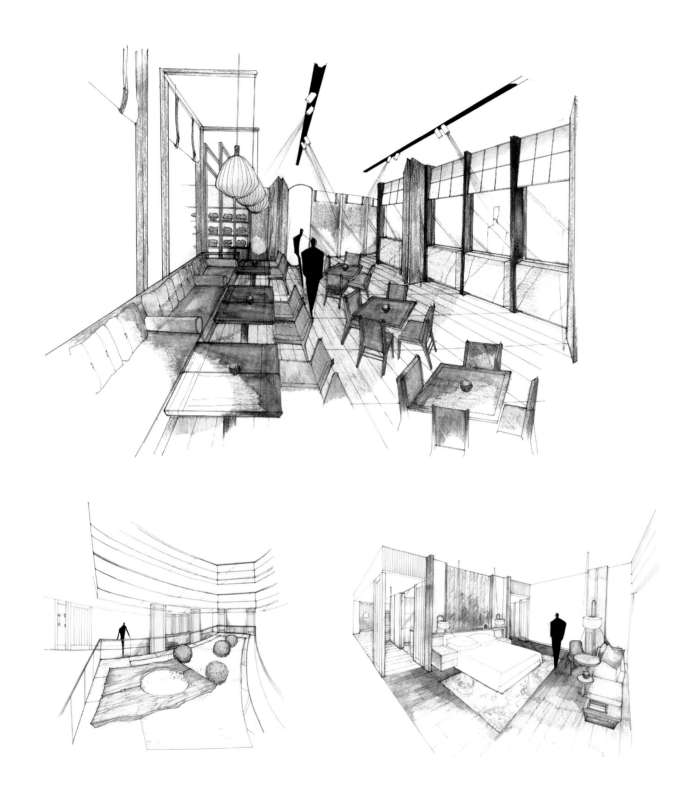

This was my second hotel in Singapore, and I felt strongly that the design should not be about heritage, as it was with the Fullerton Bay, but about finding a new way to tell the story of the past, present and future of the city.

I wanted to tell a story that reflected the Andaz brand, which is playful, young, and about bringing the neighbourhood in, so the first thing I did was to explore the surrounding Kampong Glam district. It is a cultural area with many traditional shophouses that are now local restaurants, cafés and boutiques.

I didn't want to simply replicate or transplant the traditional shophouse concept to the hotel. For me, it was about capturing the spirit of meandering through the district's alleyways and the sense of discovering intriguing little places. This is expressed at Alley on 25, where we have a cluster of seven restaurants and bars conceived as an alley around the core of the building. The routing through these multiple dining destinations expresses the spirit of Kampong Glam, but with a sense of authenticity, tapping into a deeper expression of culture and sense of place, rather than just for its decorative appeal.

The restaurants also reflect the best of Singapore: the hawker centres where each hawker is dedicated to one speciality. The dining venues on the twenty-fifth floor are similarly dedicated to one technique, and the interiors reflect this. They are driven not by cuisine but by a specific cooking technique, and I think that elevates the whole experience in a natural way. Here, you'll find one shophouse dedicated to wok and steam while another focuses on dishes made from an authentic cast-iron oven, so there is a sense of Singapore's culinary culture that guests can enjoy.

The public spaces have a relaxed, local feel about them too. The lounge is like a greenhouse, with a ceiling that has a traditional pattern – a modern interpretation of houses that are typical of Singapore's elaborate Peranakan architecture, which is sometimes referred to as Chinese Baroque.

The lobby is like a courtyard with a tropical garden surrounded by a glass shophouse, a delicate play on the whimsical balanced with clean geometry and solid architecture. There is a lot of landscaping inside, and interwoven and interconnected spaces.

The arrangement of these shophouses and the lobby courtyard around the core looks simple and intuitive but was very challenging to design because there are so many different dining components, which each required a very complicated matrix of back-of-house support. The skyscraper complex, designed by the German architect Ole Scheeren, has a most unusual, obscure trapezium shape so the design works both with it and against it to create a tension.

The bungalow-inspired guest rooms also express Singapore's urban spirit, with guest-room doorbells set into customized post boxes, mango-yellow, shophouse-inspired folding doors between the bedroom and the bathroom, lamps that reflect a hint of the city's traditional street lamps, and rugs with a faded, ethnic batik pattern. I think that even the smallest details make a big difference to the overall sense of a space, so we spent a lot of time on adding very tactile and rich woven textiles to furnishings and cushions, and on such custom items as clothes hangers in bronze and thick, solid walnut.

Greenery is very much part of the design language too. The outdoor roof terrace, which has a very tropical-looking bar, is landscaped and dotted with private teepees. They feel very lively, fresh and relaxed – which reminds me of Singapore.

Even the clothing for the staff has a local feel; it comes from a ready-to-wear collection by a local designer. This emphasis on colours in the interiors and the clothes is very much about creating experiences and making the team feel part of the indigenous spirit within the hotel.

page 167 The bold, curvaceous façade by Büro Ole Scheeren provides a dramatic sense of arrival, and is a prelude to the hotel's contemporary interiors.

page 168 Original, hand-drawn concept sketches echo Fu's sense of the spirit of the hotel's nearby neighbourhood.

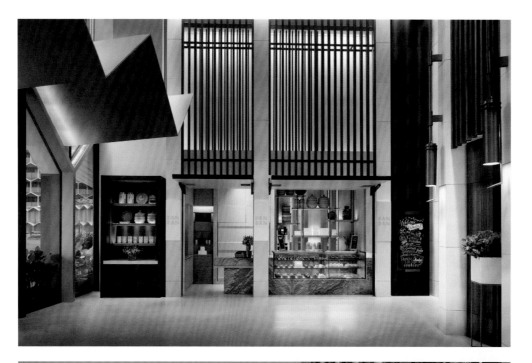

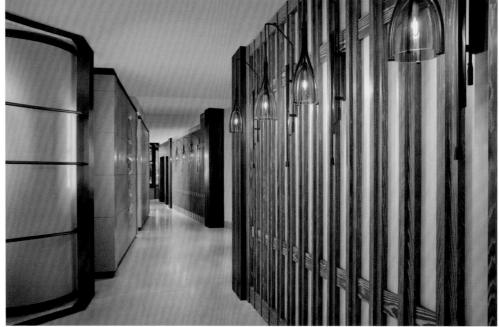

above In the entrance lobby, a Pandan cake shop has its origins in traditional Singaporean shophouses, and adds to the arrival experience by relieving the triple-height ceiling with its intimate proportions. Below, a meandering alley reflects the local neighbourhood.

opposite Lanterns flanking the elevator lobby are an abstract expression of the Bugis neighbourhood's traditional street lamps. The bold sculpture of a face is by the Brazilian artist André Mendes.

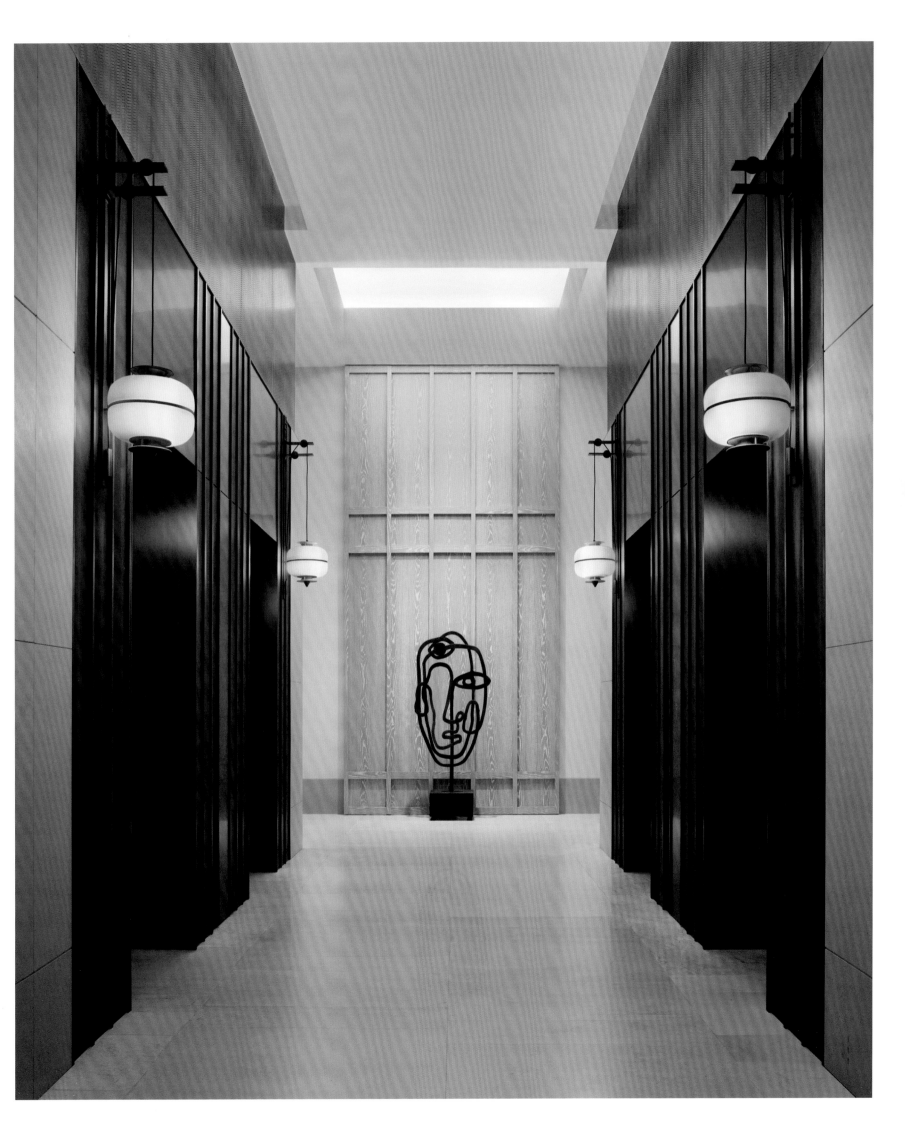

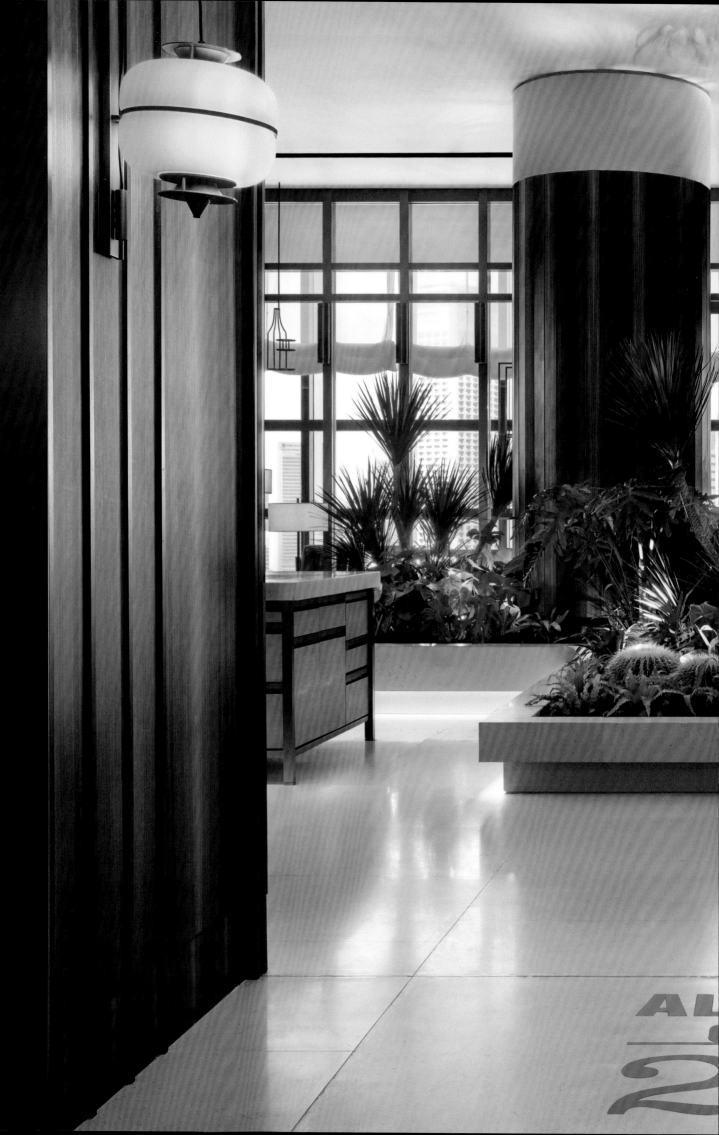

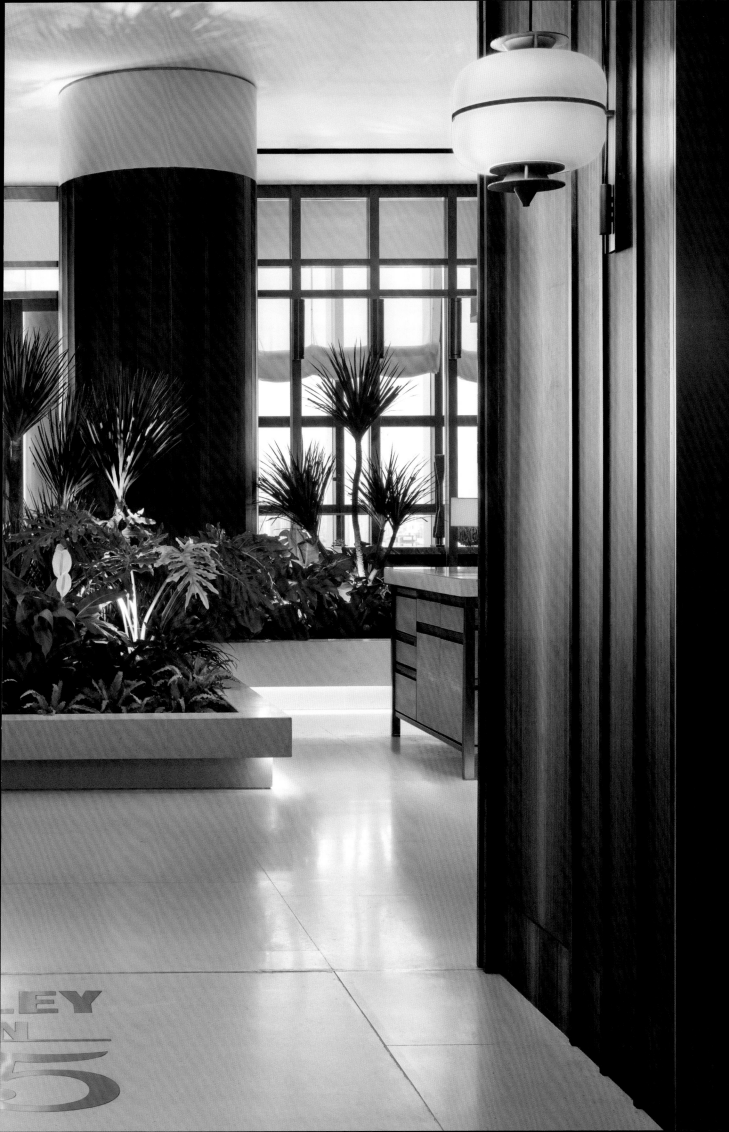

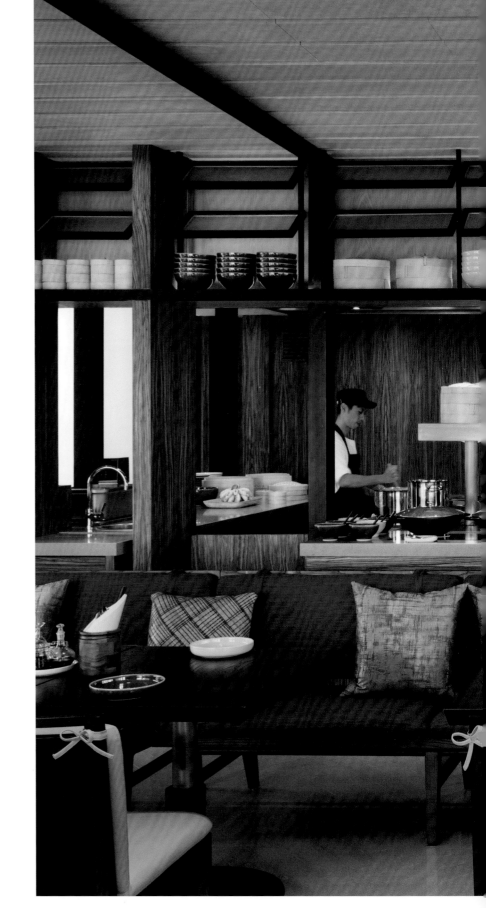

pages 172–173 Guests check in at an informal reception area with a tropical garden on the twenty-fifth floor of the hotel. Conceived as the hub of Andaz Singapore, it is furnished with comfortable sofas and armchairs. Seven restaurants and bars and an outdoor terrace with a pool are on the same floor.

right Aunties' Wok and Steam restaurant is a nostalgic but contemporary take on Singapore's *zi char* home-cooked food culture, with a bold urban palette accented in olive green and mango yellow.

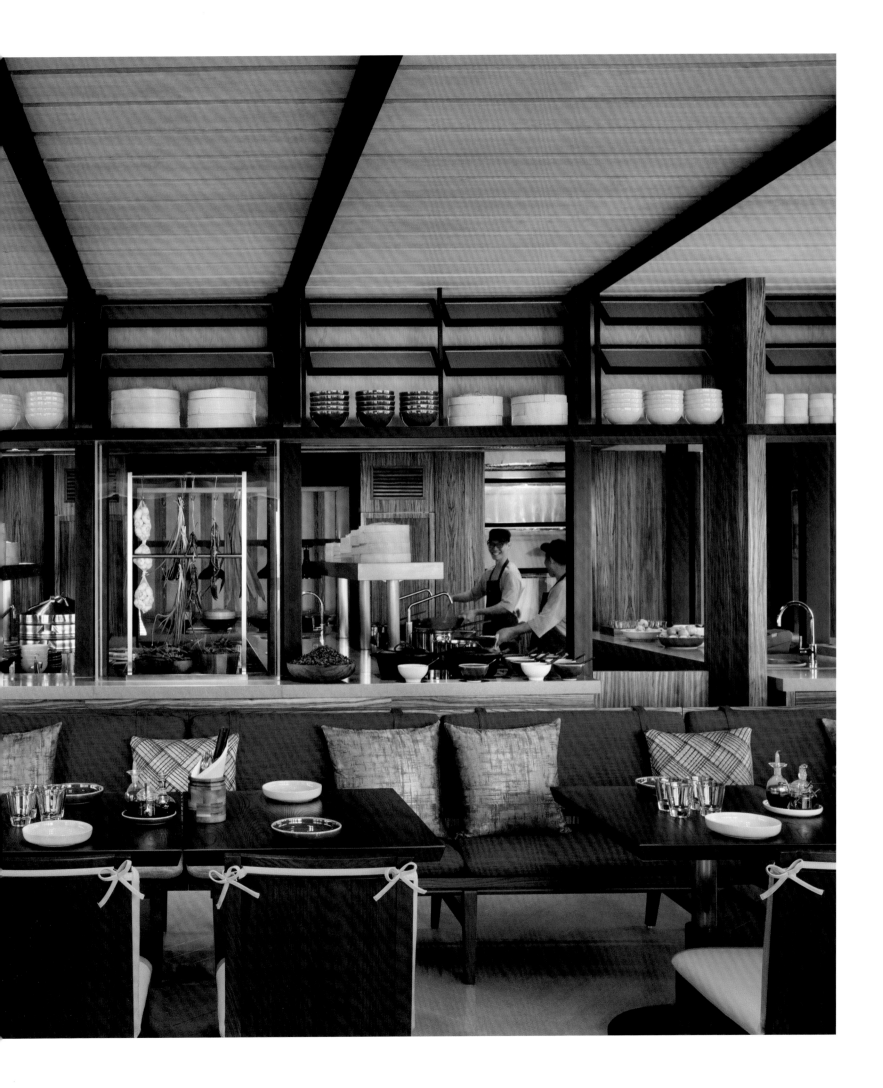

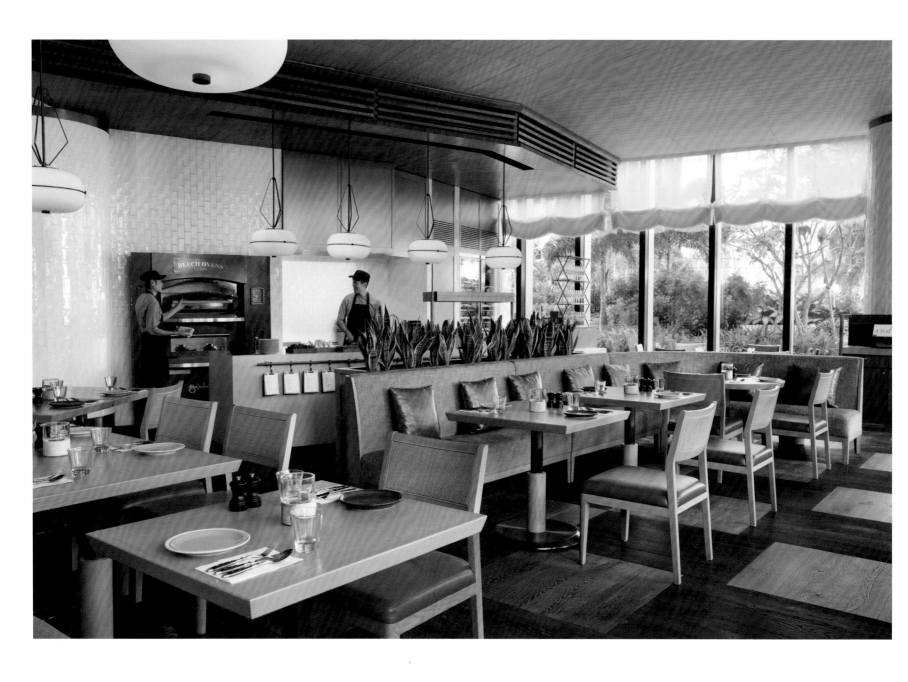

above Fu selected tableware for all the dining and bar areas to convey their diverse range of cuisines.

opposite Bar Square is designed to create a personal interaction between guests and mixologists. The communal bar runs the length of the room and is juxtaposed at a 45-degree angle against the façade, echoing the building's unusual polygonal architecture.

pages 178–179 The Sunroom, adjacent to the reception, is influenced by traditional Singaporean Peranakan architecture and includes Fu's modernist interpretation of the city's architectural heritage in a detailed oak ceiling.

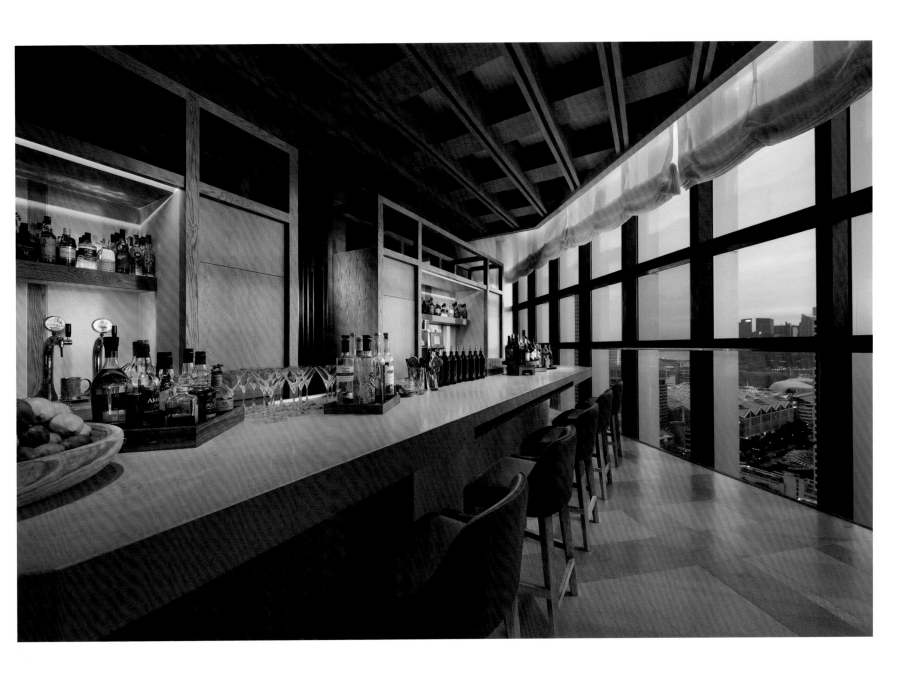

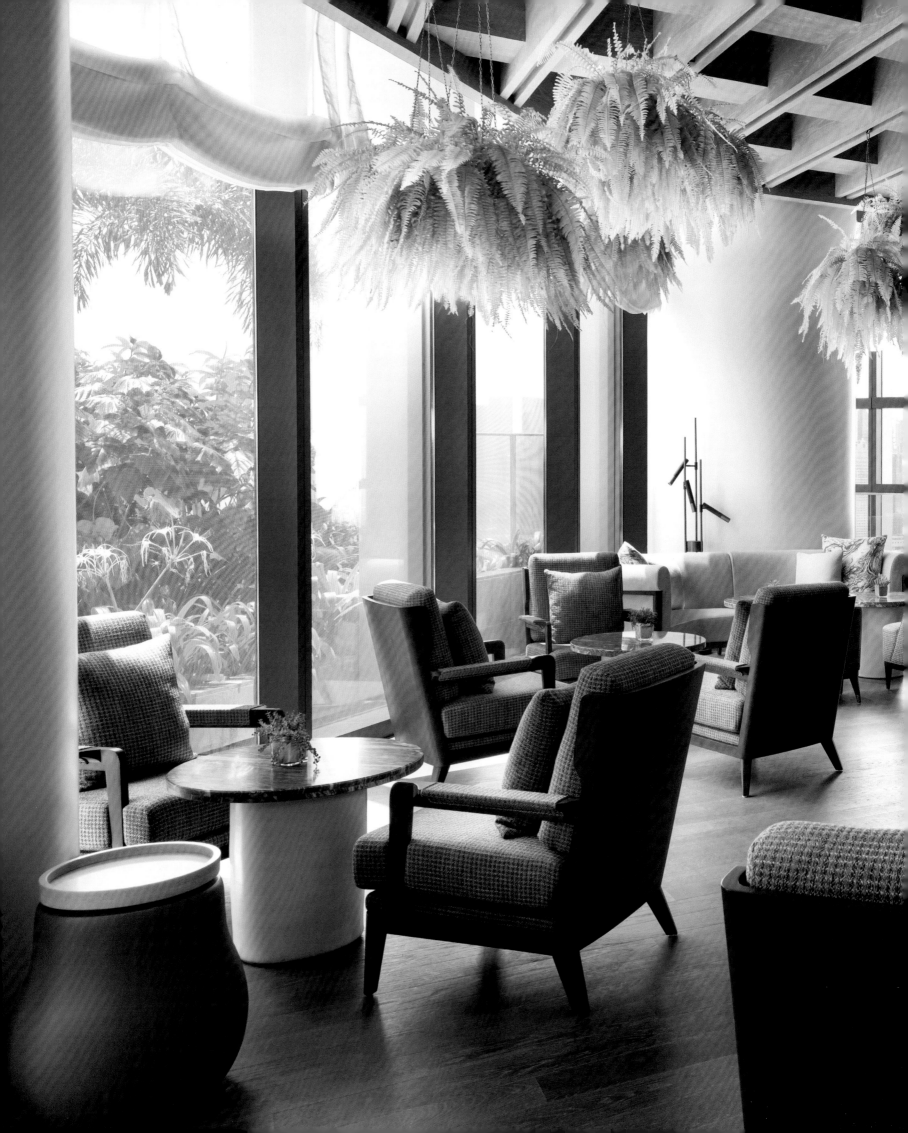

below and opposite Conceived as a casual, all-day dining area, Icehaus' light, bright palette is highlighted by copper chairs and mango-yellow accents.

left The elegant Presidential Suite, one of 342 rooms, reflects Singapore's unique culture with an understated palette embellished with shophouse-inspired doors, decorative mango-yellow accents and rich textures redolent of Singaporean culture.

pages 184–185 On the thirty-ninth floor, Mr Stork has ten teepee huts and outdoor seating in a tropical setting, and wraparound views of the city.

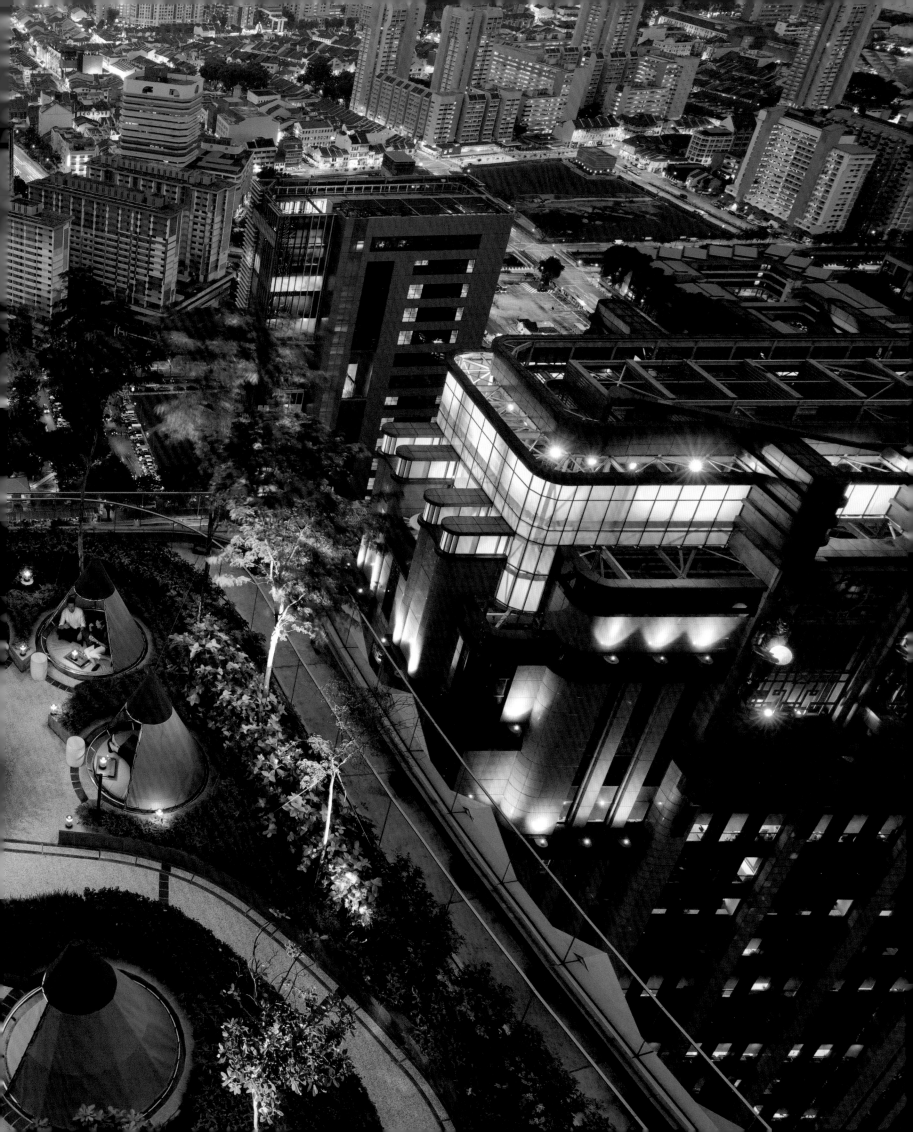

louis vuitton objets nomades hong kong

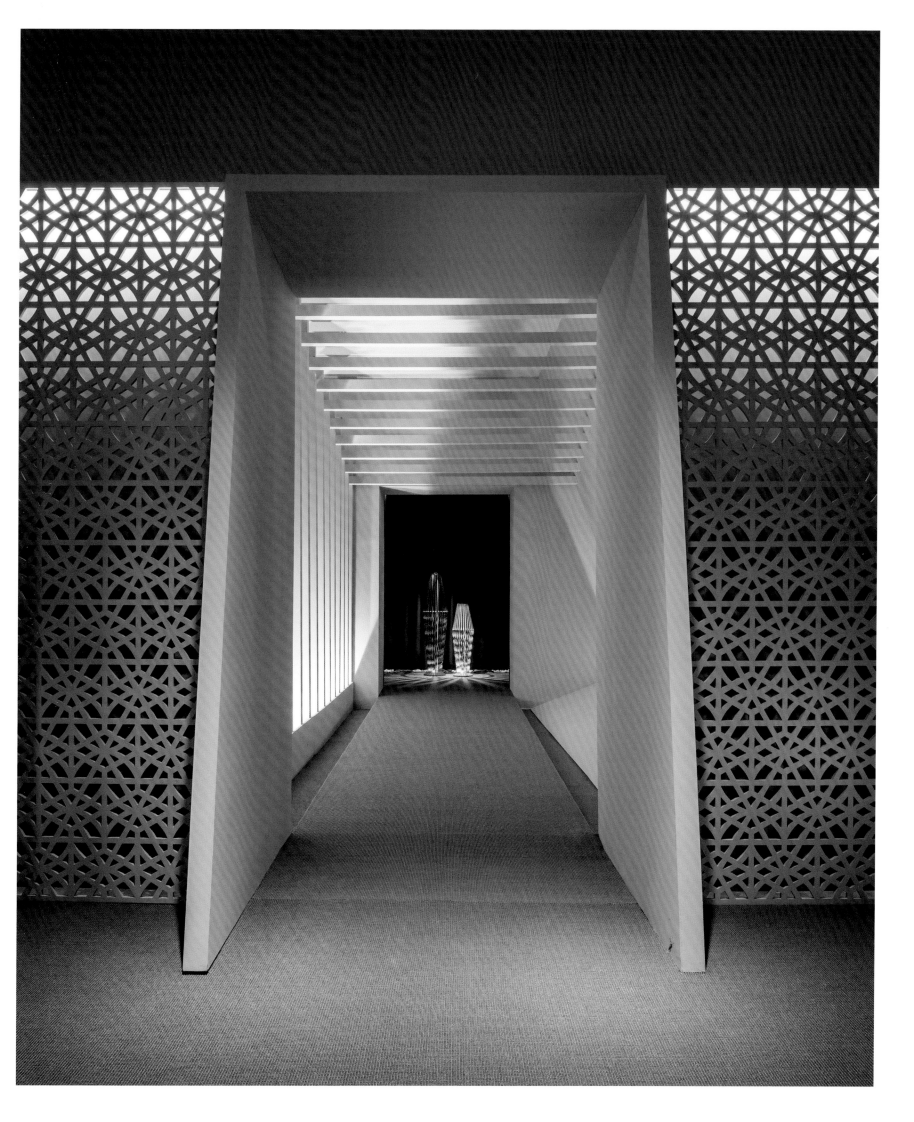

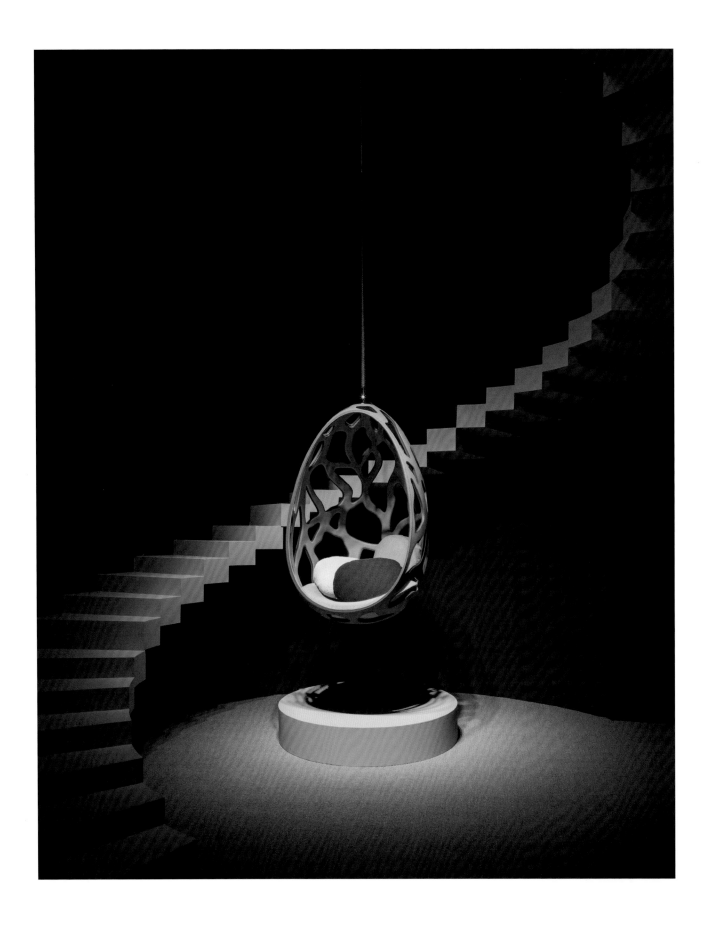

This project came about at a time when I was thinking about how I could challenge myself professionally. Installations have fewer limitations than commercial design projects, so it allowed me an opportunity to be more experimental.

It was the second pop-up installation I had created for Louis Vuitton; the first was in 2014, when I designed a 'secret' temporary Hong Kong apartment in a private members' club. That first space projected a lifestyle experience of Nicolas Ghesquière's first fashion collection. For the next spatial collaboration, the stars of the show were the experimental lighting and furniture pieces from exclusive collaborations between creative designers from around the world and Louis Vuitton.

The space was very unusual: around 465 square metres spread over the entire fifth floor of a beautiful Beaux Arts building in the middle of Central's business district, with a very special sense of place within the city.

Right from the start, I felt it was very important to avoid the temptation to design a spectacle. I wanted to create an experience that visitors could relate to on a personal level, and which juxtaposed these unique *objets* within an environment that brings a domestic dimension.

I also wanted to bring the designs together with a story, creating scenes so that they would be so much more than individual pieces. The result was a series of ten scenographies developed around the idea of a luxurious, minimalist, contemporary yet somewhat surreal home. I imagined guests walking through a softly lit entrance tunnel leading up a gentle slope into a moss midnight garden, and then through living and dining rooms where art, sculpture, architecture and form would come together in a natural way.

Each space was oriented towards the piece. In some rooms the windows were obscured with gauzy dark textiles to create a moody atmosphere, and in others I left the window completely uncovered giving a glimpse of the city outside. I find the abstract quality of architectural forms and the idea of moving between reality and illusion especially intriguing from a design perspective. A pop-up allows for a very different design intervention. In this case, it was an expressive, surreal world where visitors discovered *objets* set within a unique setting.

I felt it was essential that the installation exude a strong sense of authenticity. In my mind this quality is not about the visual 'wow' that is typical of many art and design exhibitions, where the visitor often feels removed from things and therefore remains a passive spectator. Authenticity comes from a deeper, personal experience, so my focus was much more about the power of each Objets Nomades piece and the space surrounding it. The scenography was intended to highlight the personality and character of each uniquely designed piece and allow it to be viewed in an unconventional way.

I had to account for a wide range of scales and styles because each designer is given complete creative freedom. So I had smaller pieces like Barber Osgerby's compact, portable, solar-powered Bell lamp, and larger furniture such as the Campana Brothers' cloud-inspired Bomboca sofa, which is made up of eight separate, curved cushions that fit together like a giant jigsaw puzzle.

Working with layers has always been a large part of my designs, but in this case the greatest challenge was to balance spatial and architectural experiences with the strong interplay of geometries and forms. That relationship is something I find so much more meaningful and powerful than creating a merely extravagant display.

The installation also marked the unveiling of my first piece created for the Objets Nomades collection, 'Ribbon Dance'. It is a very contemporary take on a classic conversation chair, presented as a dynamic, swooping form and inspired by the fluid movement of a ribbon. Two seats appear to float between wooden arms that are covered with incredibly soft Louis Vuitton leather.

Of course, conversation chairs are a timeless design, but I like the idea that mine responds to how people no longer communicate as they used to because they are always looking at their phones. I thought it would be interesting to design a chair with a duality that creates a place for two people to sit together and communicate on a very personal, intimate level, despite the lure of the digital world.

With this in mind I started to envision two floating cushions for a couple who are deeply engaged with each other, and a ribbon dancing around them. It became a mesmerizing image to me, but I think because of my architectural background it was not just about an *objet*; it was also a spatial concept. The simple form, however, belies the excruciatingly complex design process we went through, because I wanted to evoke a sense of energy as a lighter and more sculptural form, and this meant we had to overcome the formality of a seatback.

It was very difficult to achieve the curve on the chair. At first we hand-carved and shaved a 1:1-scale cardboard working model to create an organic and natural yet dramatic shape. Then we started to think whether we could make it more sculptural. Lighter, yet still very comfortable.

I worked very closely with Louis Vuitton's Paris design team and Italian master craftsmen to push the design to the very limits. It was like meticulously tailoring a suit, but I was driven by the imagery of two people so engaged in each other, and by expressing that in a very sculptural form.

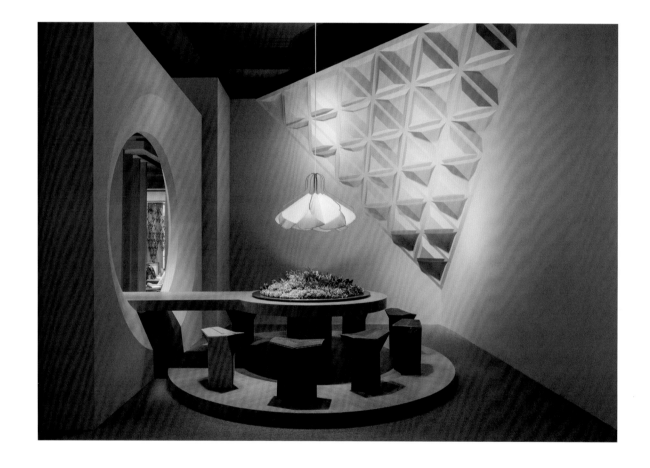

page 187 A gently sloping entrance lined with *torii* – a traditional Japanese gate usually located at the entrance of a Shinto shrine to mark the transition into a sacred space – marks the transition into Fu's surrealist world of Objets Nomades.

page 188 Each space highlights an *objet*; here, the seductive swirl of a surreal spiral staircase plays on the symmetry of 'Cocoon', an egg-shaped swing seat by the Brazilian designers Fernando and Humberto Campana.

above Fu balanced spatial and architectural encounters with a strong interplay of geometries and forms.

opposite Partitions and platforms form a complex interlocking architecture that emphasizes visual continuity.

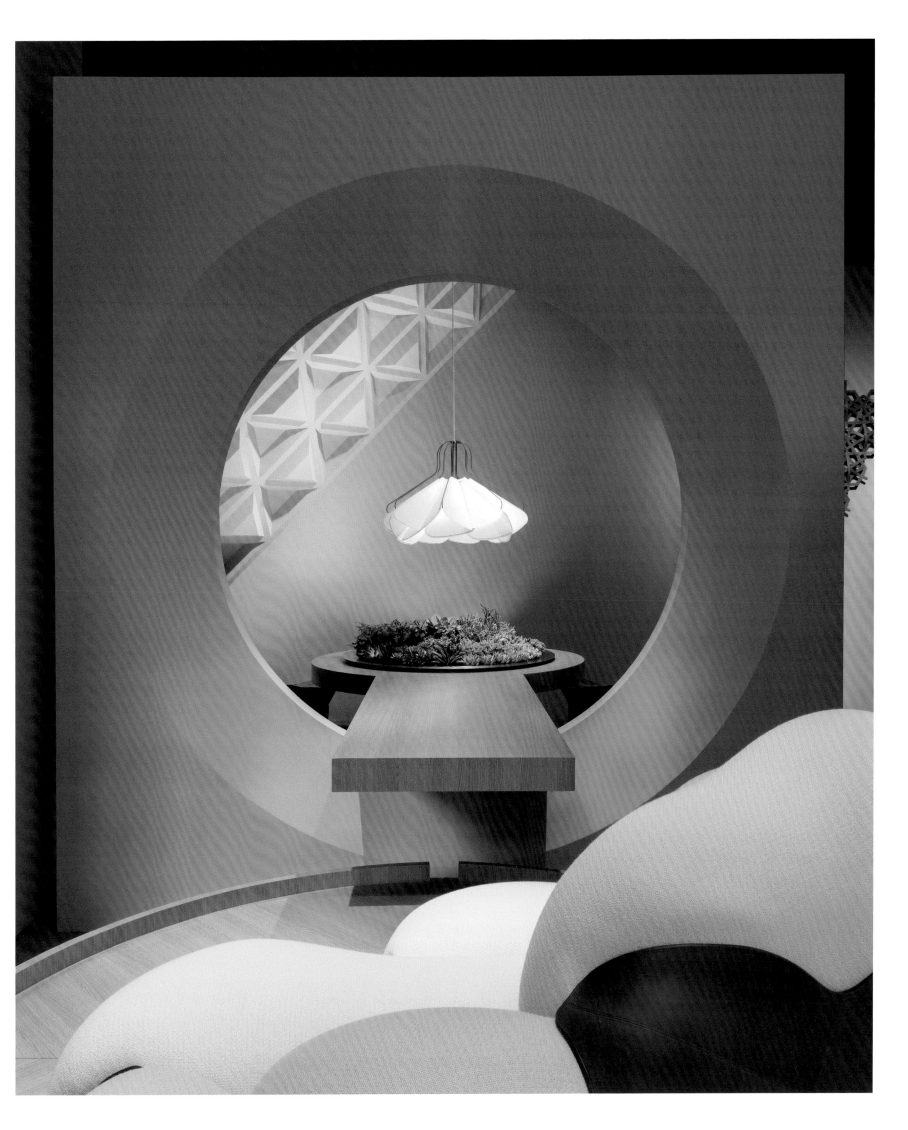

09. 02 2018.

above An original concept sketch of 'Ribbon Dance' illustrates the dynamic, calligraphic form inspired by the swooping movement of a ribbon.

opposite Channelling Fu's conceptual vision of a seat floating between dancing ribbons was technically challenging.

page 194 'Ribbon Dance' in pure white exhibited at the Louis Vuitton Objet Nomades exhibition in the neoclassical Palazzo Serbelloni during the Salone del Mobile 2019.

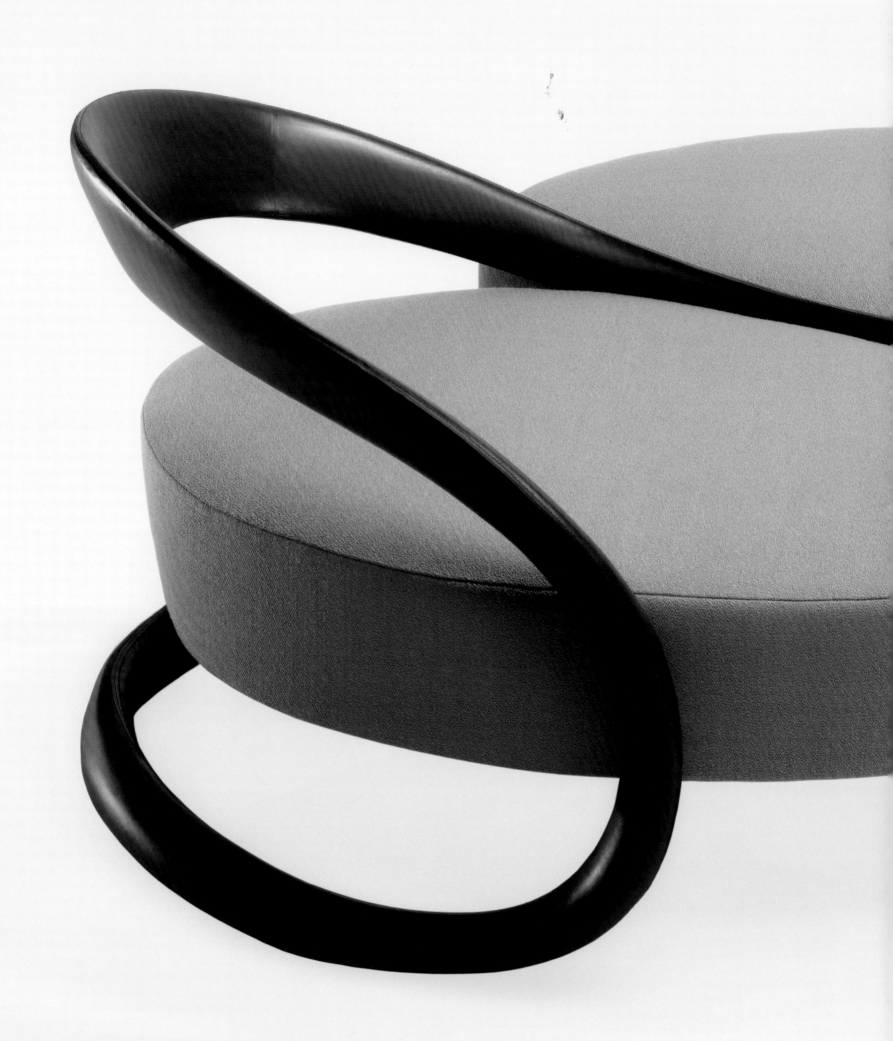

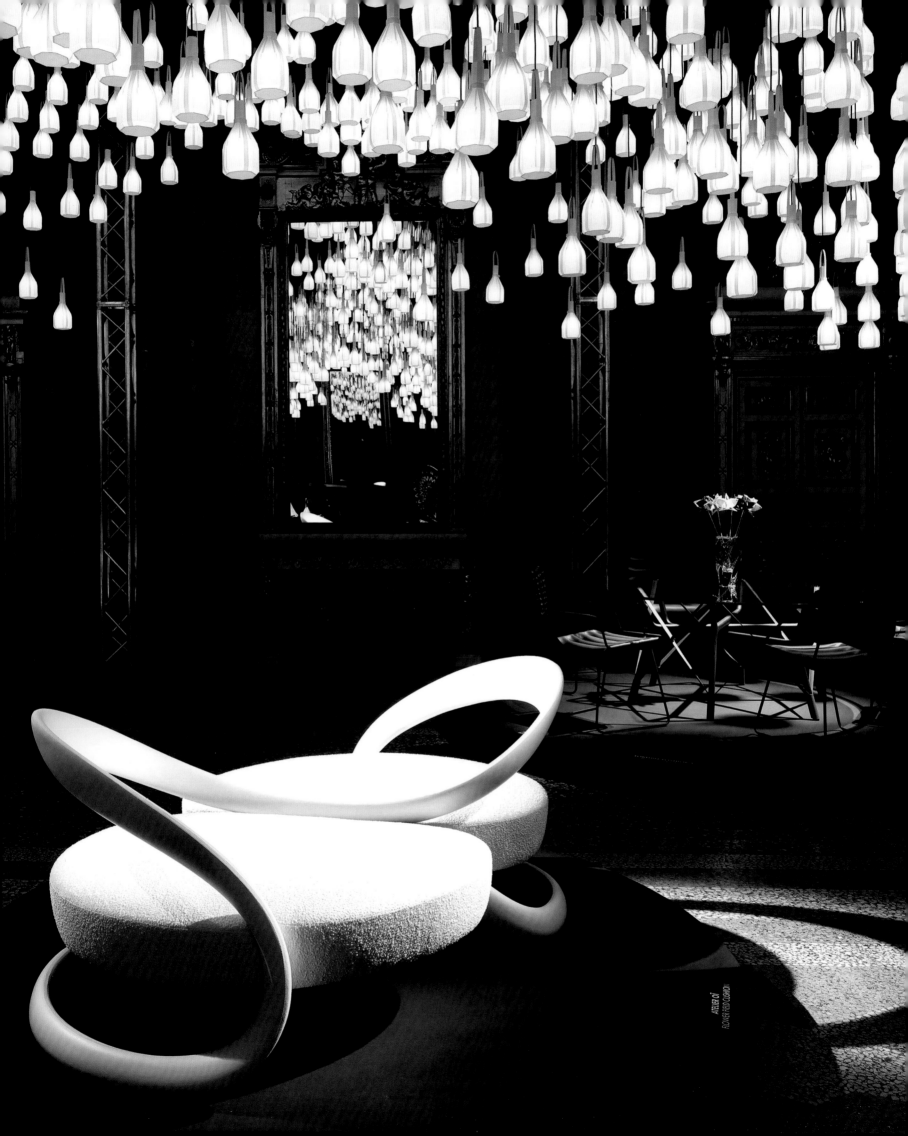

In my mind, I had the poetry of this imagery of two
people so engaged in each other, and that is what we
were trying to do – to express that in
a very sculptural form.

ANDRÉ FU

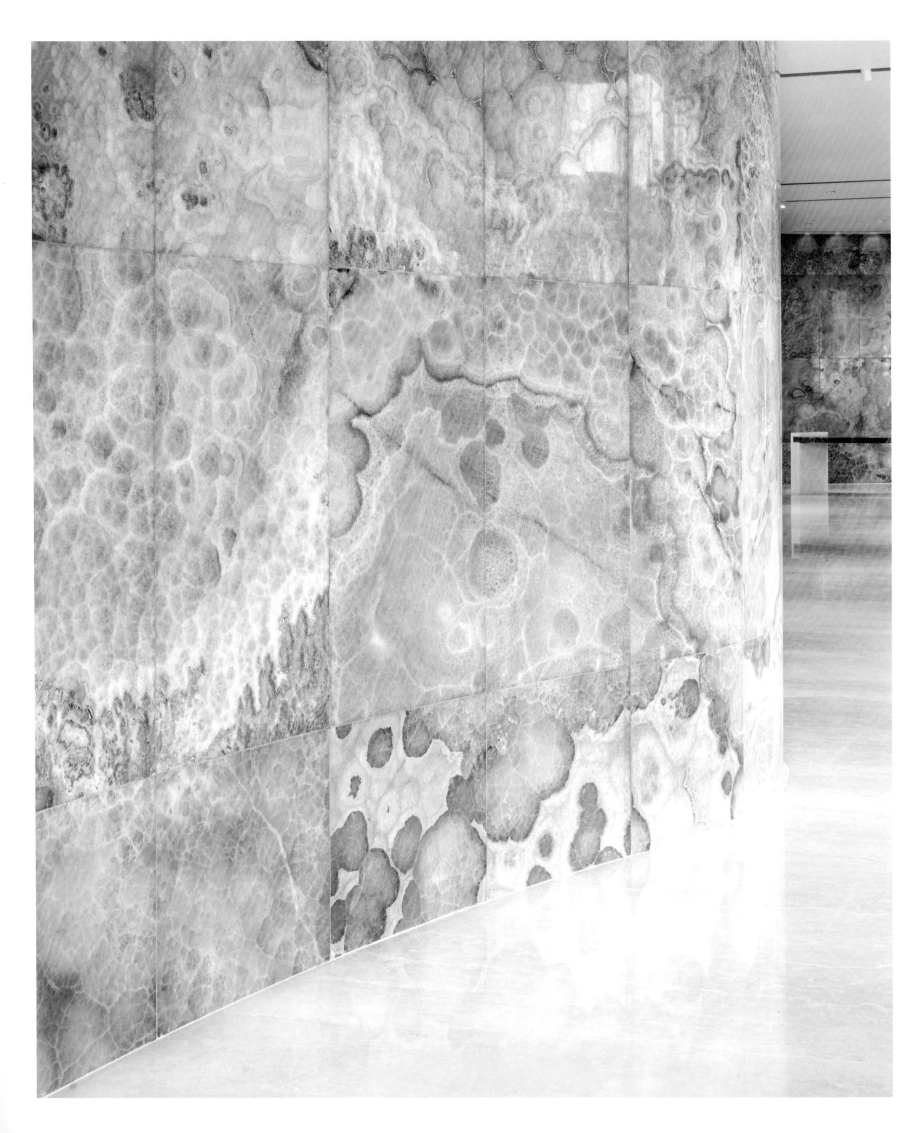

kerry hotel hong kong

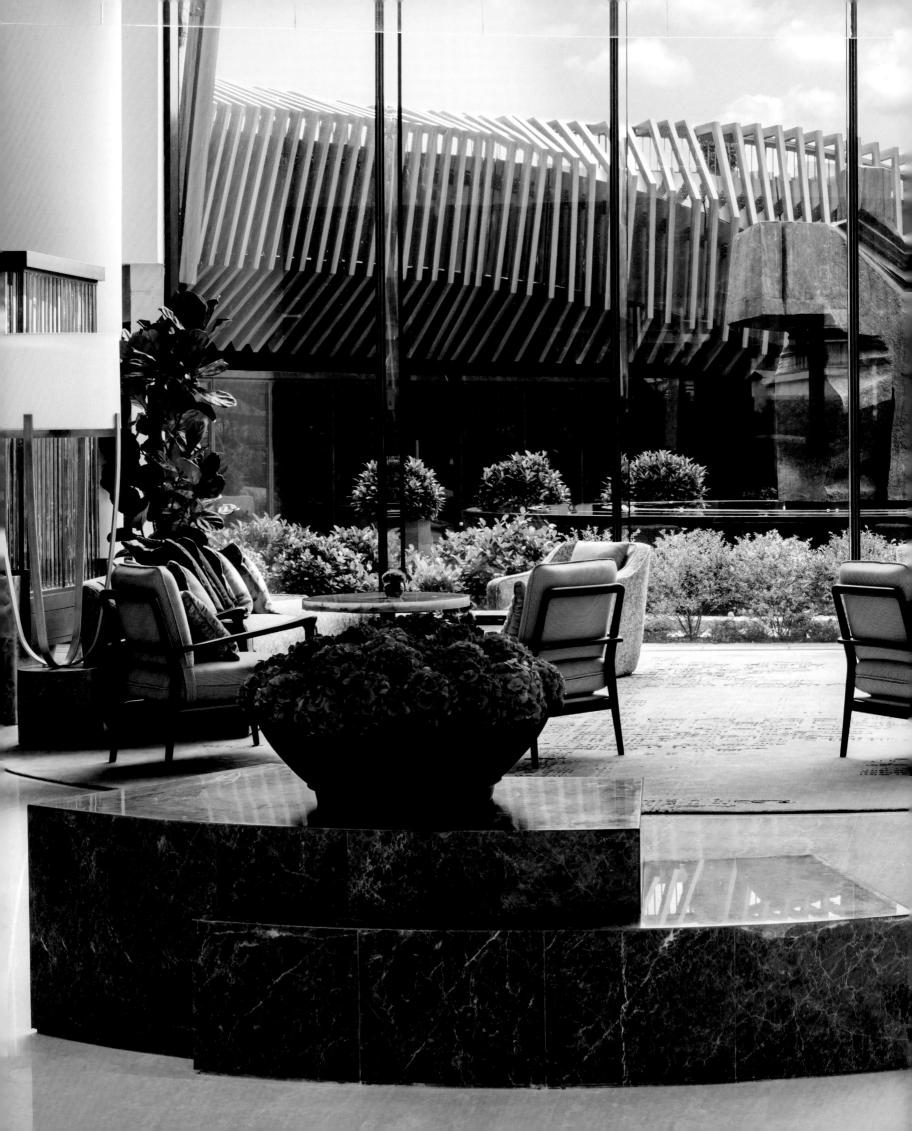

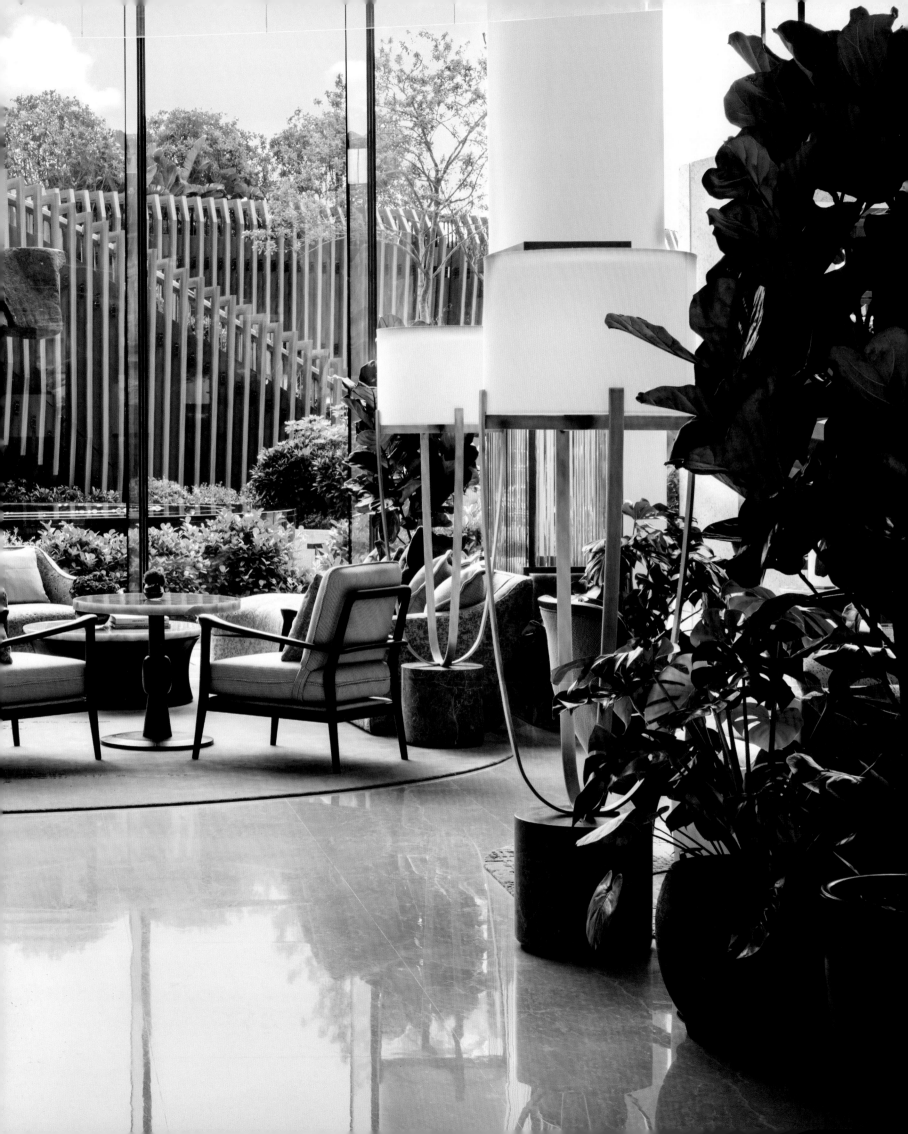

Much of my design work is on an intimate, boutique scale, but the sixteen-floor Kerry Hotel, Hong Kong, has over five hundred rooms and sprawling public spaces – including the largest ballroom in the city – and was therefore a completely different proposition. As an architect, the most interesting aspect was what I could bring to the experience of a very open, large-scale environment on the Hung Hom waterfront.

Celebrating the harbour was key to the design, and because the hotel was the first in twenty years to be built on the Kowloon waterfront, I wanted to engage both indoor and outdoor experiences throughout. The entrance lobby, for instance, has an 80-metre-wide façade of floor-to-ceiling windows, which is very unusual in Hong Kong, so I introduced a pure, minimalist interior – a world away from the chandeliers and bright colours one usually sees in Hong Kong – to allow guests' first engagement to be about observing the spectacular views. The lobby also has a very refined palette of beige Botticino Classico marble and Turkish onyx, an unusual and very special material to use because it is so precious. Here, it forms four sculptural walls whose curvilinear quality is important to the arrival impression and evokes flowing water.

Movement of water is a recurrent theme in silhouettes throughout the hotel, including laser-etched, brushed-brass screens. There are also a lot of terraces and luxuriant outdoor landscaping, and while the entrance is quite minimalist, the upper levels have a rustic sensibility, creating the feel of an urban resort. The all-day dining spaces evoke this relaxed sensibility, and, because there is such a large outdoor dining area, I could introduce a series of pavilions dedicated to different cooking techniques that create the feel of smaller spaces. The mango-yellow, terracotta and blue colours add a fresh touch, and I think it has an authentically Hong Kong feel.

The seventh-floor dining area is completely different. The entrance is marked by an abstract artwork by the Hong Kong-based artist

Adrian Wong, and there is hessian wallpaper. The granite has a carved, textured finish, and the outdoor landscape is quite wild, with grasses and trees.

There are more than a thousand works of art, including two bronze sculptures by Ju Ming on the ground floor. Although one is inside and the other on the deck, they are in dialogue with each other. I also selected pieces inspired by moving water by the Australian artist Kenny Leon and the Filipino sculptor Jinggoy Buensuceso.

The Kerry Hotel has an enormous amount of space for events – the ballroom accommodates 700 people. Here, there is an artisanal yet modernist atmosphere with Cubist touches, particularly in the hammered-bronze and rock-glass pendant lighting, again evocative of water.

It was important to create a sense of intimacy despite the scale, so we paid very close attention to tactility and engaging guests through smaller elements and rich textures, such as the hand-tufted 'Aerial' rug from my collection for Tai Ping, and beautifully crafted graphics.

We kept the guest rooms very pure and calm with a soft palette of muted shades of mauve, bronze and mineral grey, eucalyptus timber and plush carpets with subtle ripple patterns. The Presidential Suite is particularly striking and has a rich purple-blue palette. It really makes the most of the harbour view, with a very big terrace that is perfect for entertaining.

Other than the Kerry Hotel logo, I had complete design freedom over every detail throughout the hotel. Uniforms, menus and cutlery are the final layer and may seem like a small part of the overall story, but they make all the difference to an experience.

page 196 The soft silhouette of precious, Turkish onyx-clad curved walls adds a sculptural touch to the Lobby Lounge and suggests flowing water, a salute to the waterfront location.

pages 198–199 A sculpture by the Taiwanese artist Ju Ming accentuates the outdoor landscaped garden.

opposite Original, hand-drawn concept sketches showing the all-day dining space emphasize the feel of an urban waterside resort. At bottom left is the entrance to an event space; on the right, the ground-floor Gallery leads to the event spaces and has floor-to-ceiling windows that overlook the harbour.

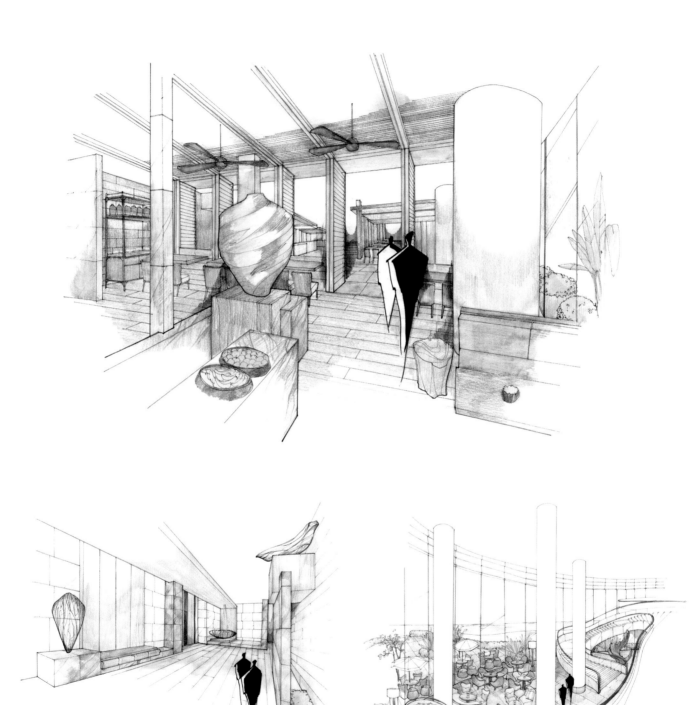

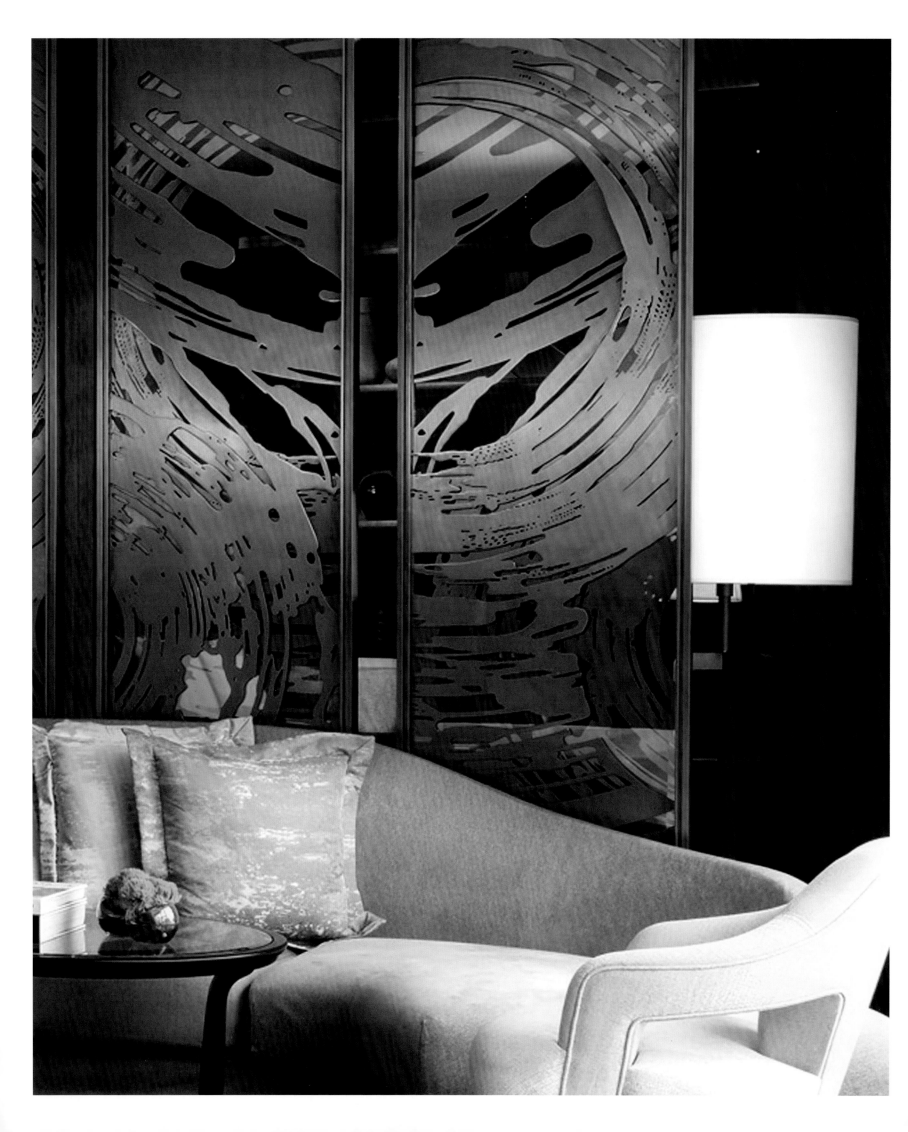

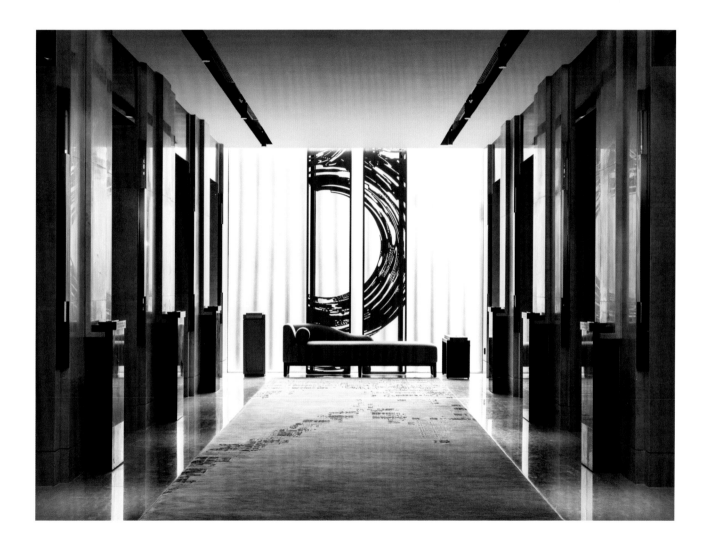

opposite Laser-cut bronze screens complement the muted, earthy palette in the Presidential Suite. The ripple pattern is a tribute to the waterfront.

above An elegant, custom-designed chaise longue and laser-cut screen provide a dramatic backdrop to the ground-floor elevator lobby.

page 205 The ground-floor lobby's grand scale retains a sense of intimacy, with seating arranged in small groups.

When I design, I always think about the essence
of the experience that I am trying to translate.
It is capturing a feeling in that moment.

ANDRÉ FU

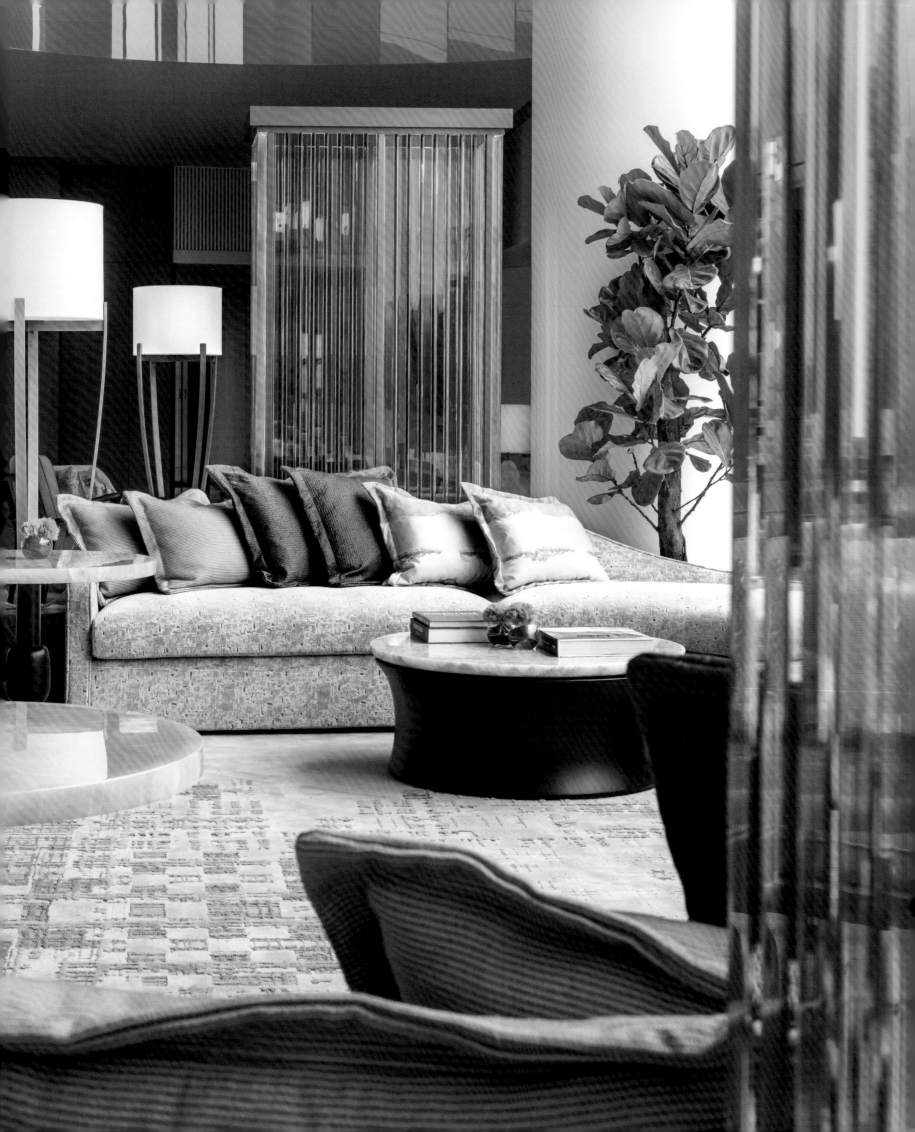

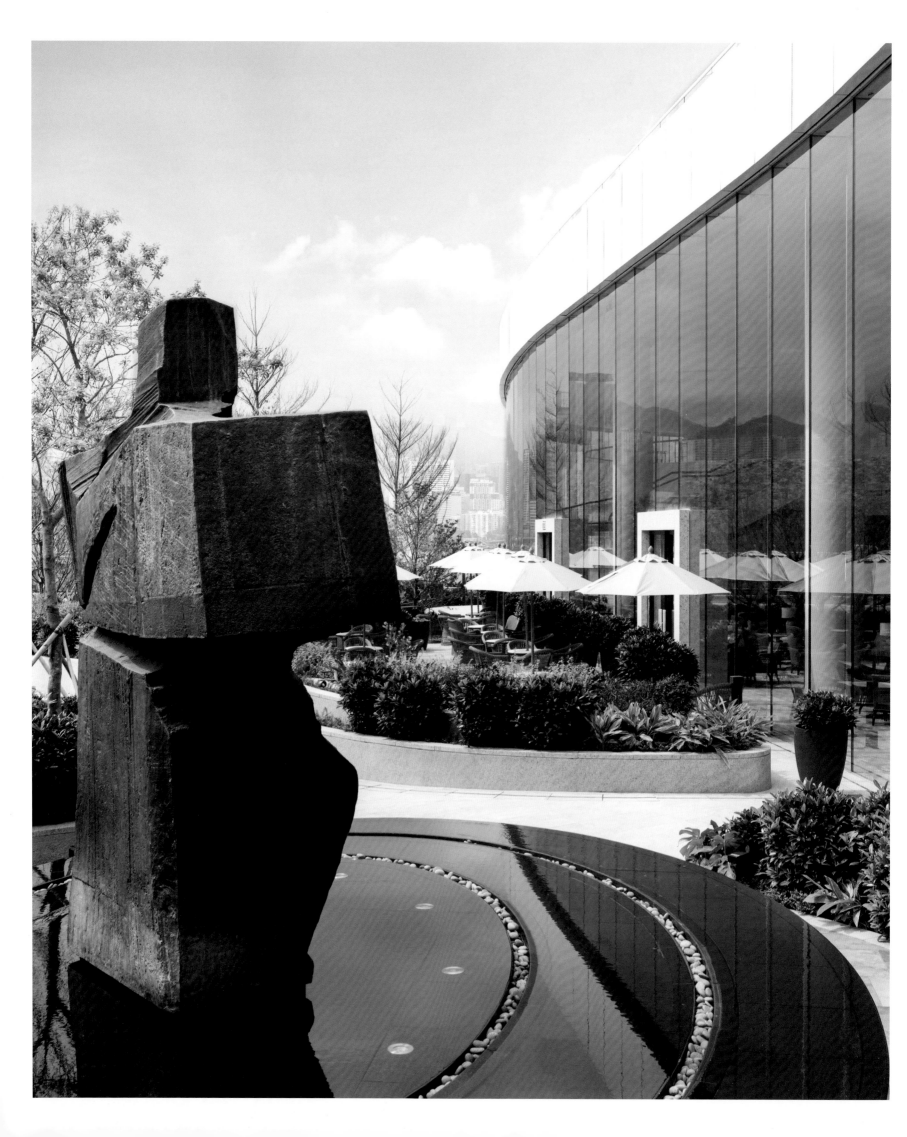

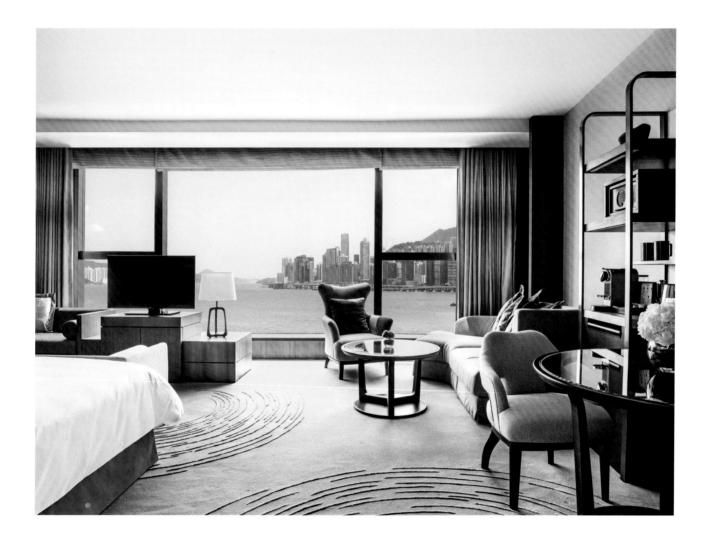

opposite An original piece from Ju Ming's 'Tai Chi' series is a minimalistic, geometric tai chi pose that creates a sense of fluidity within the sculptural landscape.

above A palette of mineral blue and ivory and a ripple-pattern rug in this open-plan guest room suggest the movement of water.

pages 208–209 The hotel celebrates its prime location on the waterfront with different al fresco settings, including the Red Sugar rooftop bar and terrace. Its wild-grass natural landscape offers a contrast to the sculptured topiary of the ground-floor's outdoor areas.

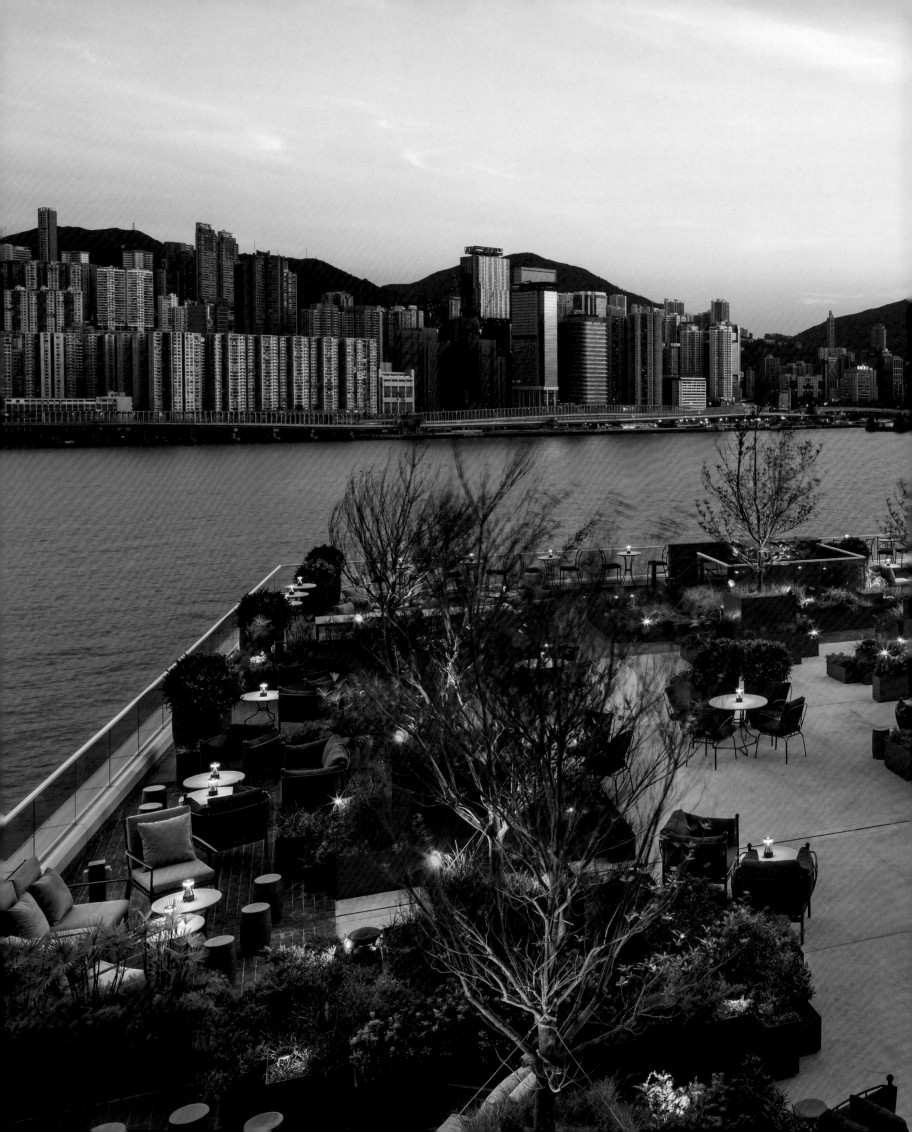

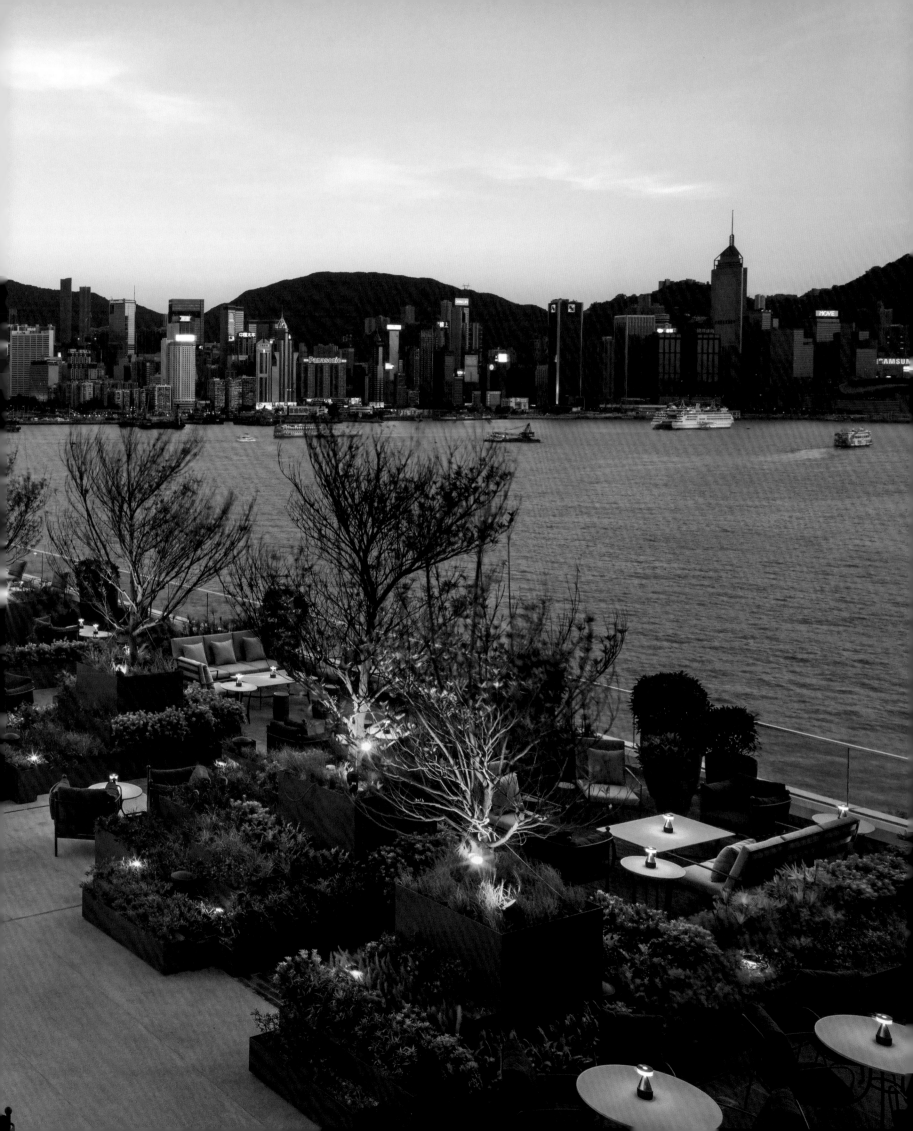

53W53 new york

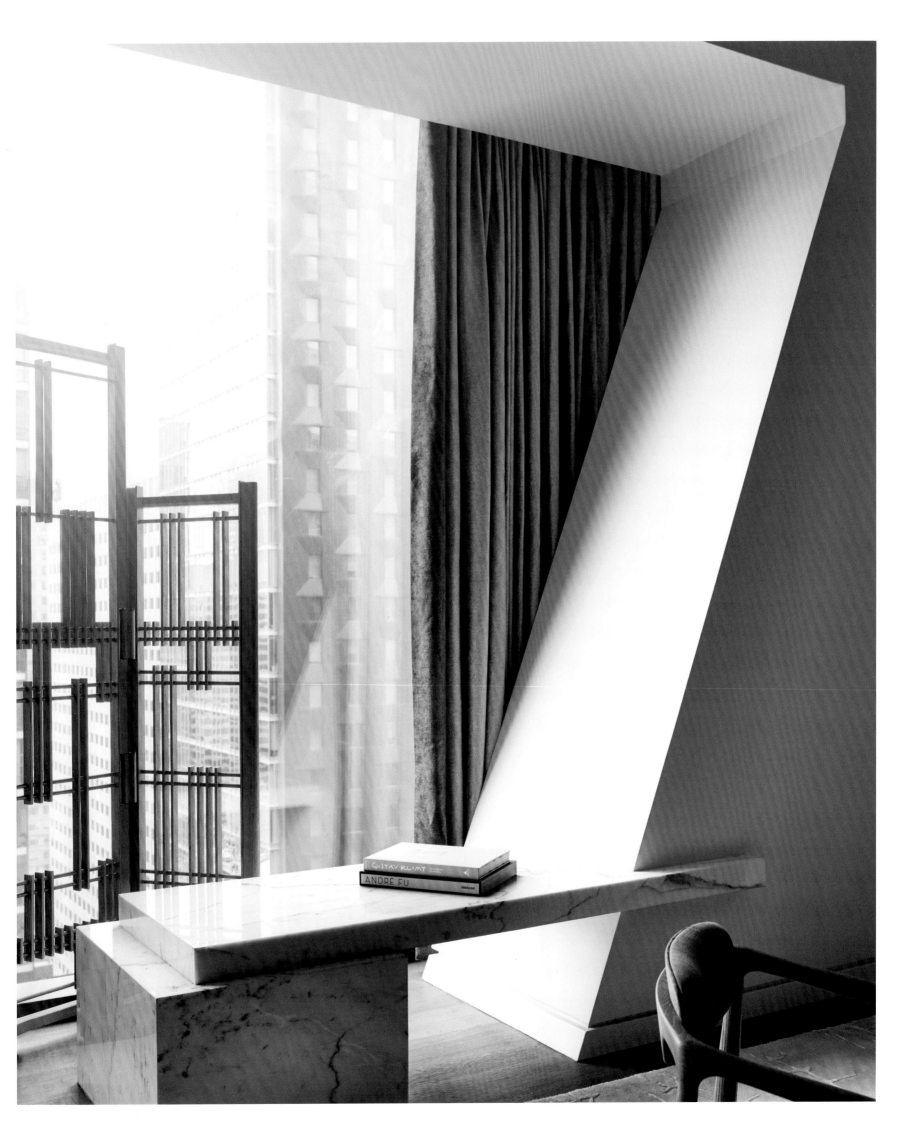

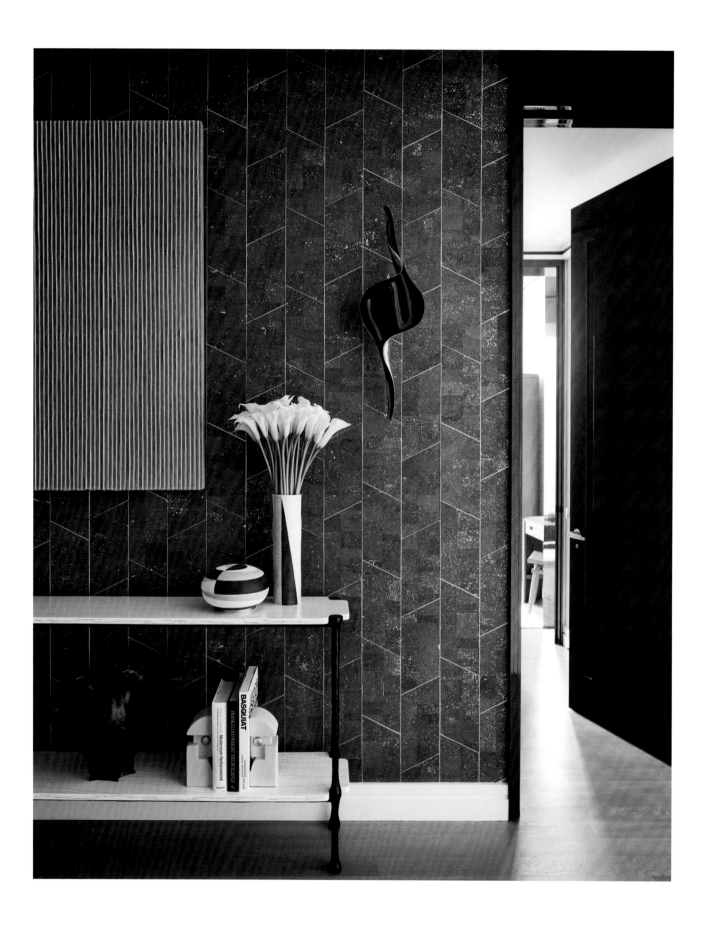

My first encounter with New York City was in the early 1990s. It was still quite rough and urban, but there was a palpable sense of the city being reinvented. I have never forgotten its powerful imagery.

New York was at the vanguard of what was happening then in art, design and architecture, and it still is. My project was a 189-square-metre, two-bedroom apartment in French architect Jean Nouvel's tallest building to date, a 320-metre-high residential skyscraper dubbed 53West53. Its great height famously makes use of air rights purchased from MoMA and other nearby buildings to give panoramic views of Central Park and across the city. The lower three floors are connected to MoMA, and there is also a lap pool, a library, a residents' lounge, a dining room, a wine vault and a private theatre. It was an incredible backdrop to my first project in the United States.

The building has a glass and exposed-steel diagrid structure that I particularly like for its powerful architectural quality. I wanted to embrace its dramatic, sloping windows and slanting columns as features of the urban landscape and not something to disguise. At the same time I imagined the apartment as a quiet haven, a world of modernist purity where one could retreat from city life and be greeted by calmness.

For me, this meant providing natural, opulent material and colour continuity throughout the apartment, achieved through a sophisticated, harmonious palette and discreet modernist touches, creating a relaxed and artisanal atmosphere.

The entrance opens on to an elegant corridor that felt quintessential New York to me. I wanted to create a sense of entrance, a spatial experience leading into the open-plan living and dining room and presenting its *pièce de résistance*: showstopper views from the floor-to-ceiling windows.

Many of the furnishings are bespoke pieces that respond to this space, including a custom ledge that integrates seamlessly into the diagrid, celebrating the strong architectural form that cuts across the windows in the living room. Key pieces include a sculptural screen in high-gloss, deep cobalt-blue piano lacquer, and low-slung, curvaceous Interlock coffee tables in oak from my André Fu Living collection. They felt like a good fit because they have a very urban sensibility and reflect a diverse take on culture, which New York embraces at every level. The master bedroom is outfitted in an understated palette of mineral blues and icy greys, which reflect the Artisan Artistry series of homewares I created in 2019, and which evoke expressive, soft brushstrokes with a handmade, textural quality.

There are other softer touches too, like oak floors with traditional tongue-and-groove detailing, a plush ivory sofa, and *soigné* home accessories by André Fu Living. The highlight of the wonderful collection of contemporary artworks curated by the French gallerist Emmanuel Perrotin is the monochromatic abstract painting by the renowned Korean contemporary artist Park Seo-Bo, which hangs in the entrance above a custom-made bronze console table. Its combination of warm hues and silhouettes offers an intriguing contrast to the iconic New York City backdrop. Other pieces include an unusual sculpture by the Japanese artist Izumi Kato, several acrylic and resin works by Bernard Frize, and three ethereal oil paintings by the American artist John Henderson.

As in all my projects, lighting is the most powerful generator of atmosphere and plays a leading role in adding warmth and clarity to the natural materials and modernist-inspired furniture. Here, the forms are sculptural and modernist, while the lamps – like my Ripple series with brushed-bronze frames and glass shades resembling a flowing waterfall – add a touch of Gotham.

page 211 Fu added an elegant marble plinth that interlocks with Jean Nouvel's dramatic diagrid architecture to honour the bold, dominant frame.

opposite A monochromatic artwork by the seminal contemporary Korean artist Park Seo-Bo in the entrance of the apartment.

pages 214–215 In the living room, Fu's custom-designed lacquer screen was inspired by New York's cityscape and architectural silhouette. The lacquer finish adds a subtle oriental touch.

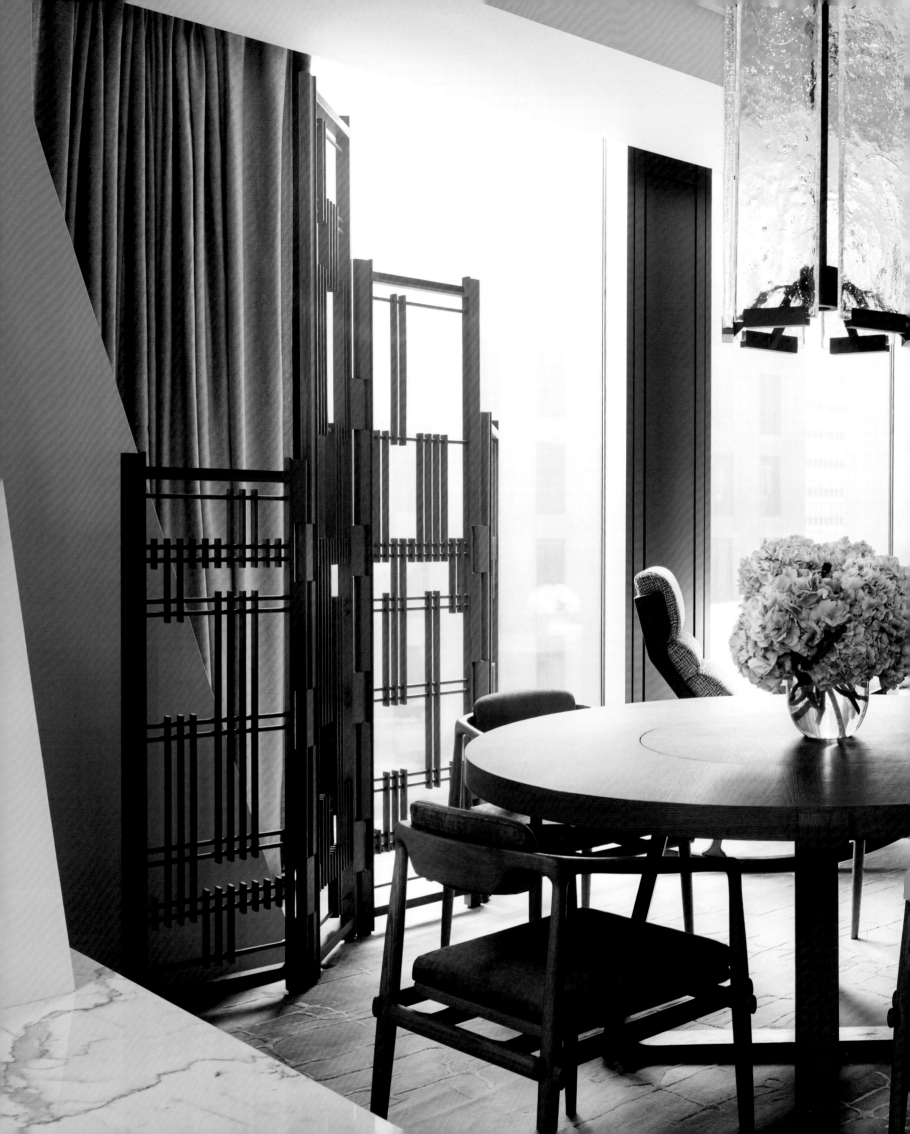

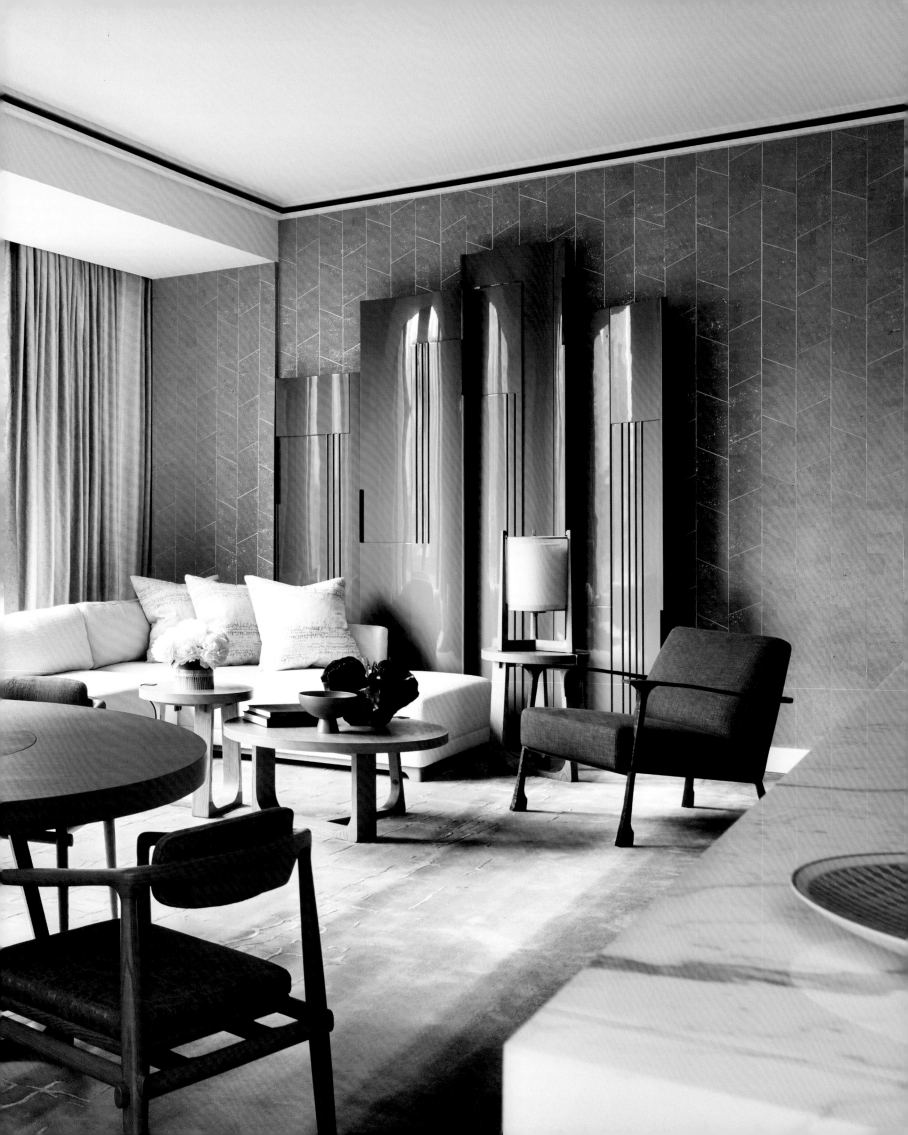

opposite The master bedroom features a hand-painted wall covering.

pages 218-219 Subtle, soft interiors relieve the powerful diagrid
visual form and cushion the masculine space.

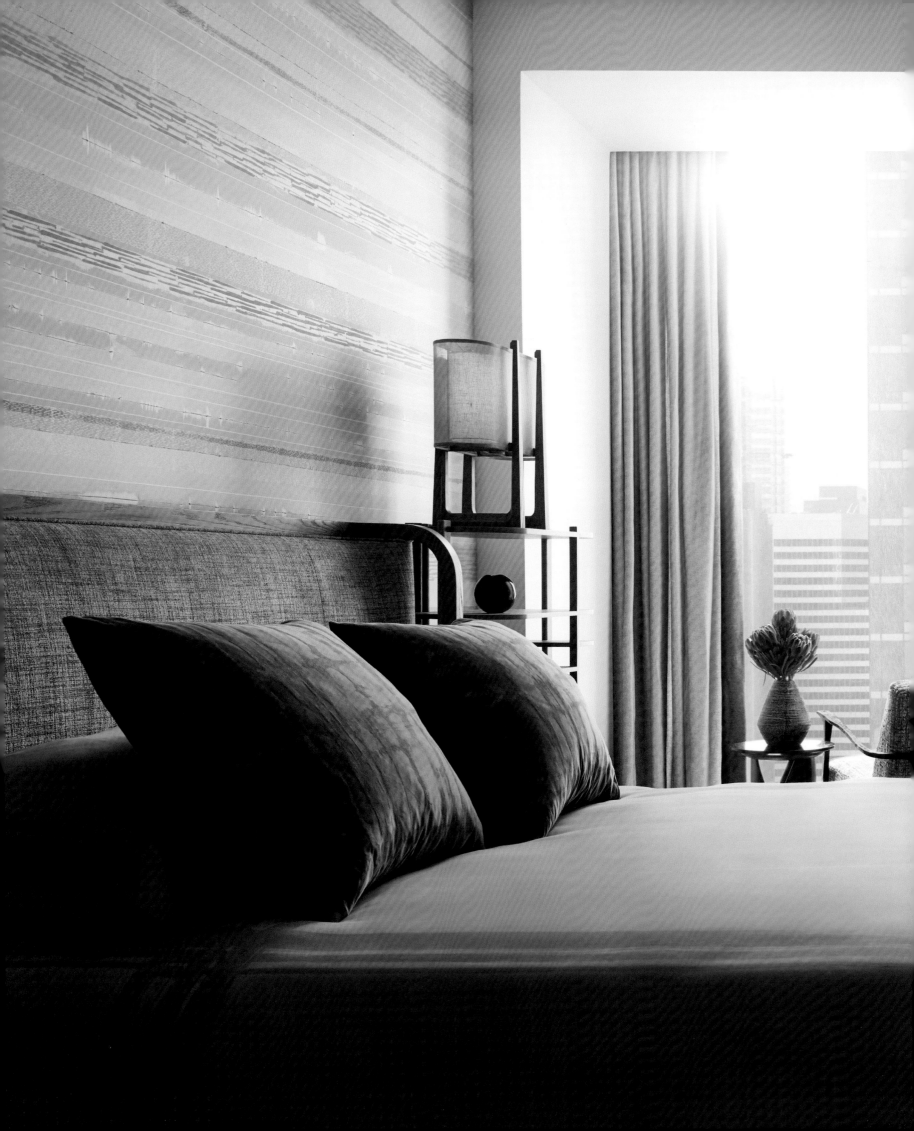

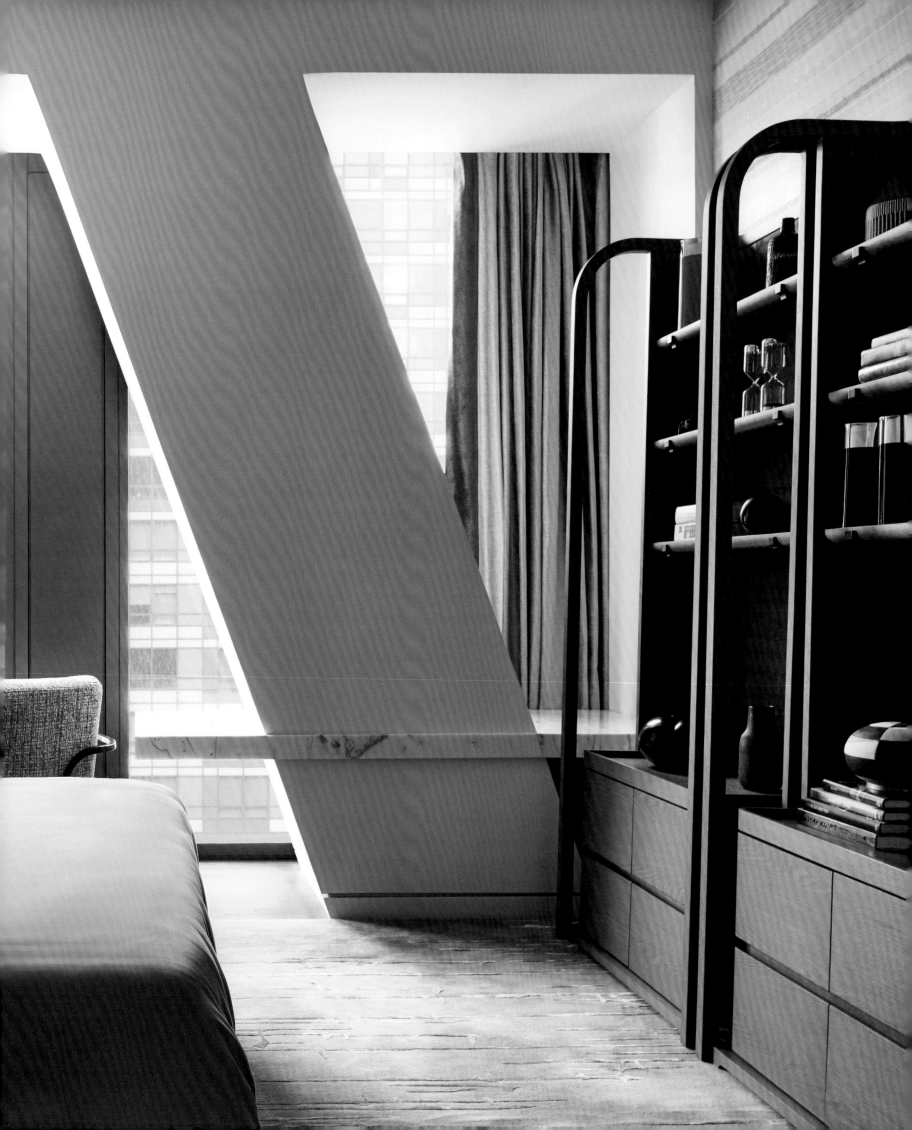

the upper house hong kong

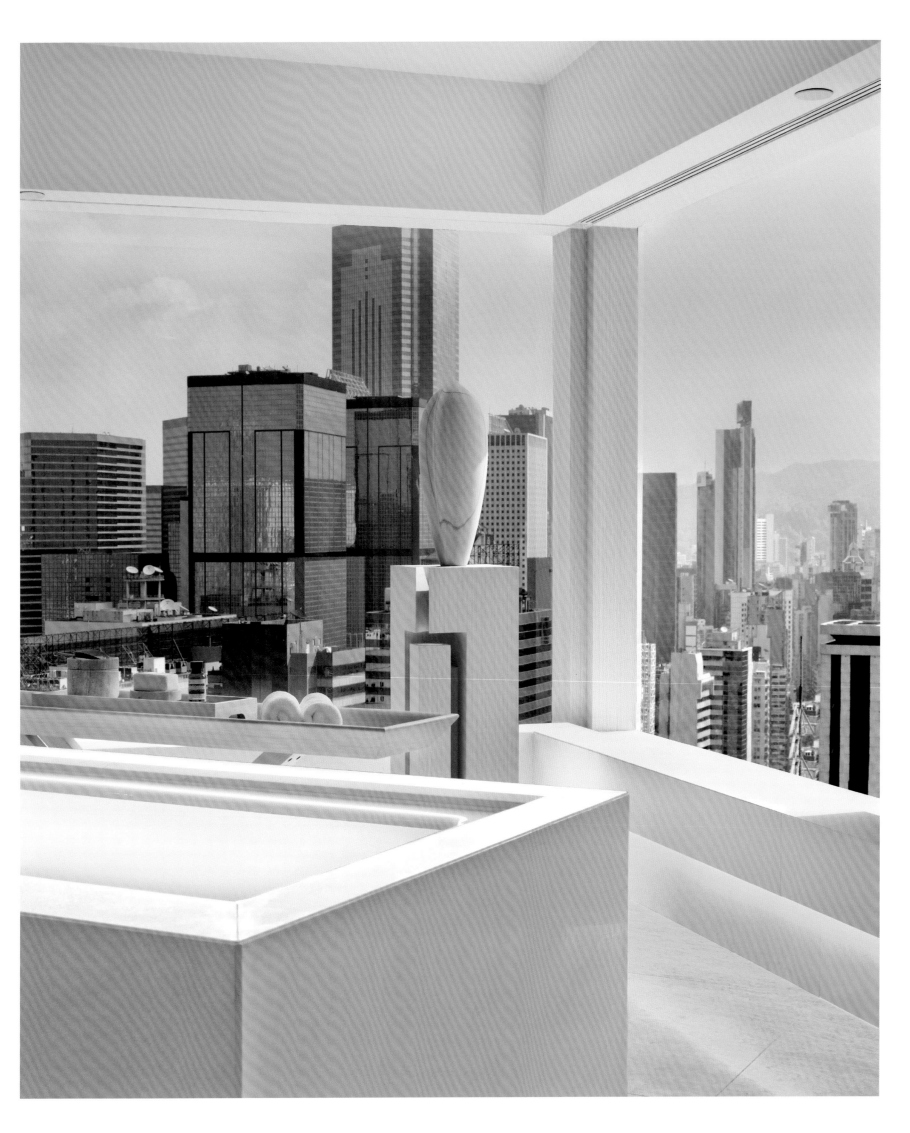

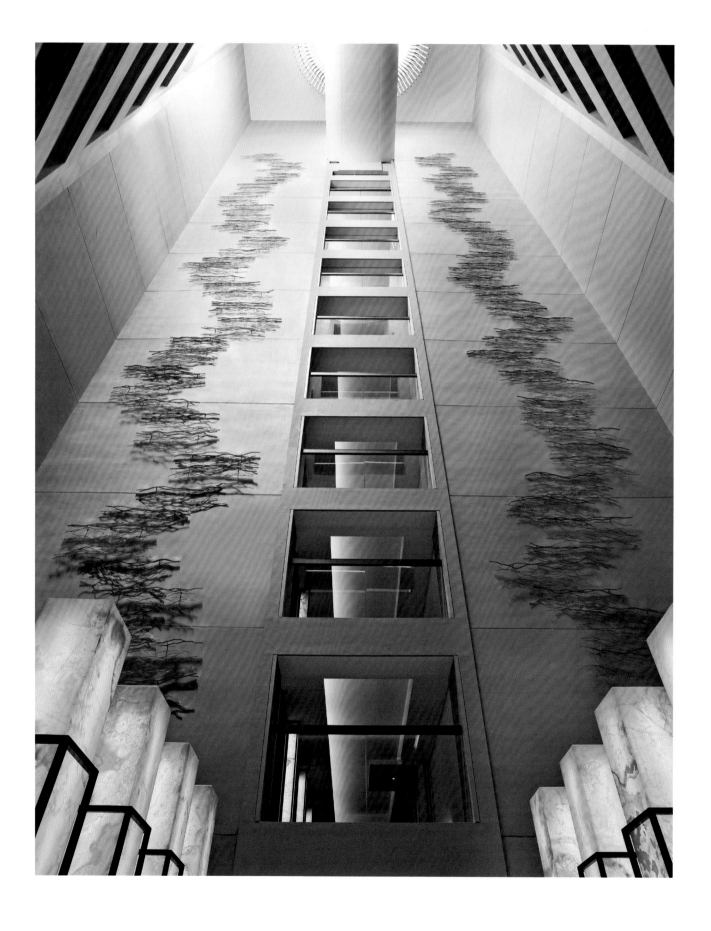

The Upper House was my very first hotel and was a remarkable proposition. I had just returned to Hong Kong after fourteen years in England and was given the opportunity to challenge the whole idea of hospitality.

The wider context is important to remember. It was a time when the Hong Kong market was saturated with what were then thought of as luxury hotels: multiple restaurants and a big lobby with chandeliers. However, the entire Pacific Place property was undergoing a major renovation led by the British designer Thomas Heatherwick, and the owner, Swire Properties, was looking for something new: a hotel with a fresh identity that would stand out.

It was quite a big risk because we decided to completely reverse the way space is allocated within a hotel by dedicating space to unusually generous guest rooms and bathrooms that would create an intimate, bespoke, quiet experience. This was a challenge because the rooms had triangular windows and relatively low ceilings, but these were the things that stimulated my thoughts on light, lanterns and how to create a spa-like bathroom experience within a guest room. It was never a question of ticking a box of hotel must-haves; it was about responding to the context and creating an experience.

This was also not about making visual statements. I knew that the project was the perfect opportunity and time to explore my natural inclination towards minimalism and wabi-sabi. I wasn't thinking of Asian aesthetics, I was thinking of purity and about creating comfort and calm. There were many places throughout the hotel where I could have made it feel more oriental, but I didn't want to do that. Where there *is* an Asian touch, it is expressed in very quiet moments, such as the lamps with double layers that evoke the soft glow of a lantern.

What really intrigued me was the challenge of creating a nuanced journey through the entrance to the rest of the hotel. It is an excellent location and has wonderful views, but the spaces were physically and visually quite disjointed and there were relatively low ceilings.

For me, the solution lay in tapping my architectural roots. The advantage of working with an existing property was that I could think about how to reinvent it not just from an aesthetic viewpoint but from the feeling you get from walking through it.

I wanted to create a very nuanced, almost subliminal journey through the spaces, always drawing the eye towards the next space without using conventional signage. A good design should naturally engage you; it should be instinctive.

The ground-floor entrance was critical in setting the scene. I envisaged it as a glowing lantern within a glass pavilion. The steep escalator ascends through a series of *torii* and lanterns so you don't see everything all at once. It is revealed very slowly.

The first thing you see as you step off the escalator is a beautiful, sculptural marble artwork by Cynthia Sah, and greenery – we punctured a wall to insert a window to bring natural light in and showcase the artwork. It is this contrast from dark to light that draws you towards something.

We also introduced a dialogue between the artworks that guide you visually through the hotel, linking spaces and allowing each pocket of space its own identity. Even at the sketching stage I was thinking about Brâncuși-like stone sculptures that would work well with the limestone palette and act as beautiful things to discover along the way.

In the upper part of the hotel we punched out an entire floor of the building to create a higher ceiling for a singular restaurant, Café Gray, which, together with a cosy lounge on the opposite side of the floor, became the ultimate interactive space for the hotel.

The outdoor space also overturned the normal way of designing. There was a big difference in level from the upper lobby and outdoors, and it would have been very easy to simply add a small, statement-making swimming pool. But in the end we decided on a very simple lawn with a crisp landscape of topiary and a secluded seating area. It was in response to Hong Kong, where there are many urban parks but they have planters and concrete. A decade on it is still rare in the city to find an outdoor space like it.

page 221 On an illuminated plinth, a custom-made, wood-grain sandstone sculpture inspired by the shapes of nuts and seeds by the Taiwanese artist Marvin Minto Fang blends into the Hong Kong landscape.

opposite *Rise*, a contemporary installation in stainless steel by the Japanese artist Hiroshi Sawada, extends the length of the atrium, conveying movement within a challenging geometric volume.

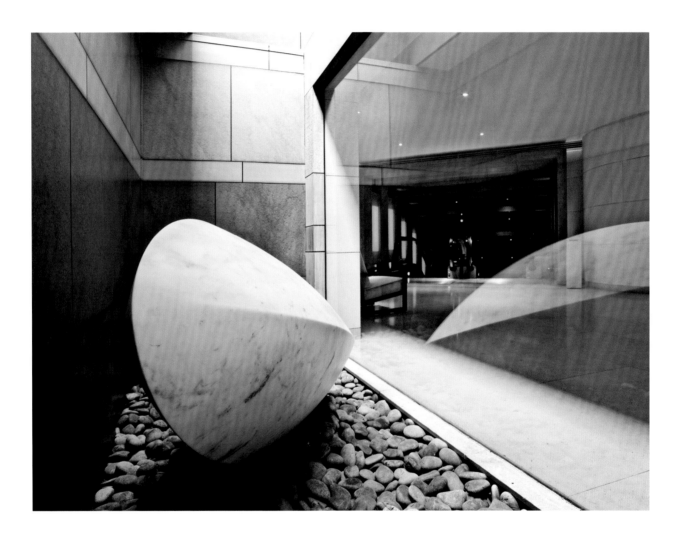

above A sculpture by the Taiwanese artist Cynthia Sah on Level 6 of the Upper House conveys the Chinese philosophy of essential equilibrium and blurs the boundaries between inside and out, as well as adding depth to the low-ceilinged space.

opposite An escalator passes through a series of contemporary *torii* interspersed with glowing lanterns, which highlight the experience of transitioning from frenetic urban life to a more serene world.

page 226 On the forty-ninth floor, Fu evokes the traditional oriental umbrella – a symbol of shelter – with an abstract suspended installation.

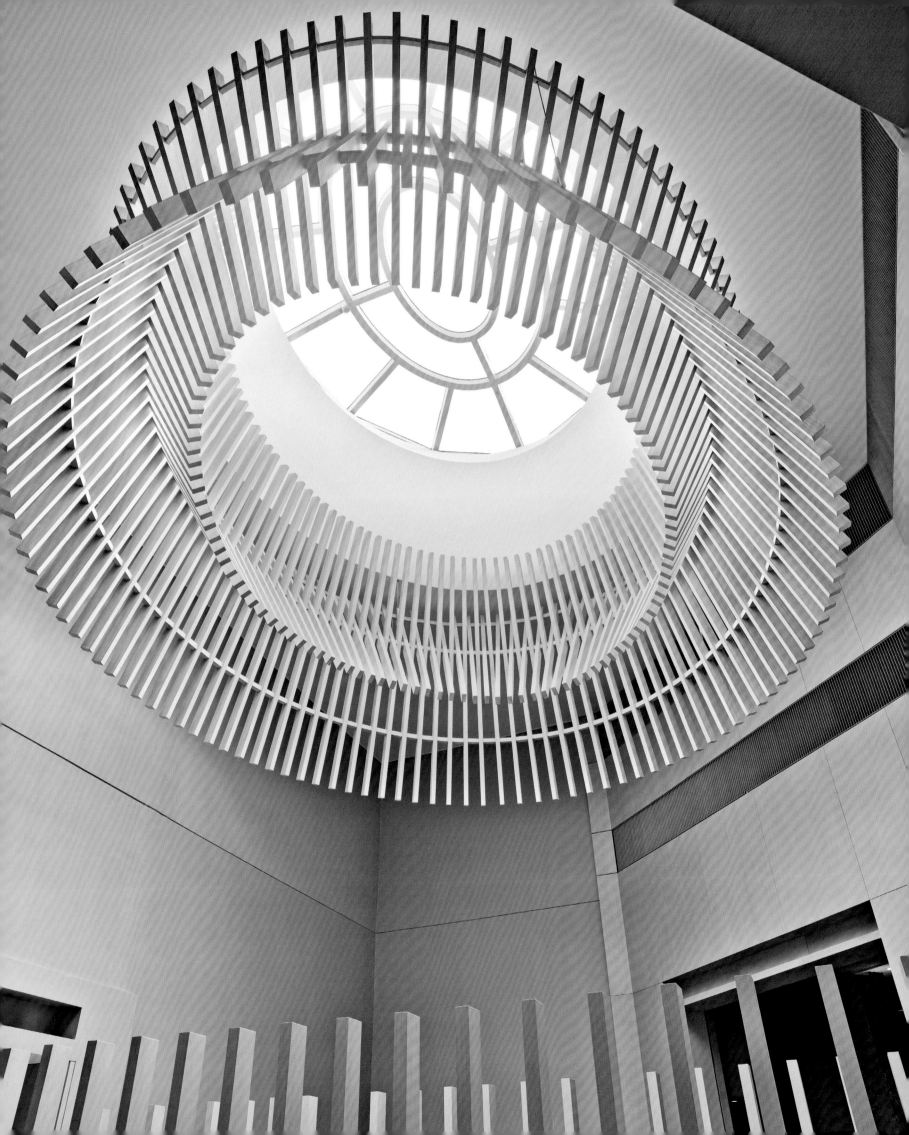

The hotel world is still very traditional,
but André has such exquisite taste that he was
able to pull off this delicate balance.
I even remember how he detailed the uniforms.
He intuitively understands proportion and
sees things that other people don't.

MARCEL THOMA
general manager of the Upper House

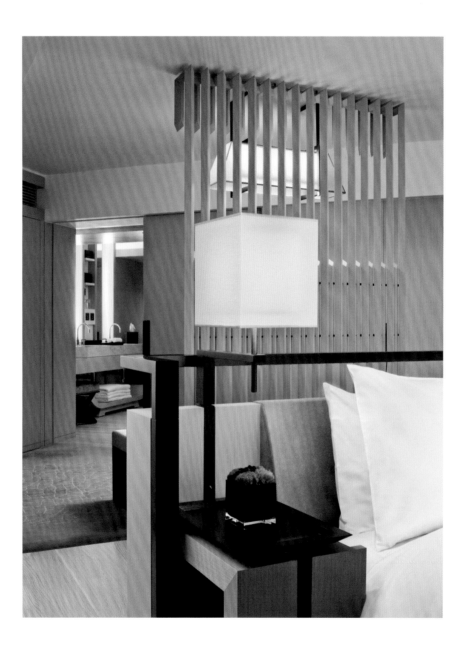

above The unusually spacious guest rooms are open plan with a palette of bamboo, solid-ash flooring, natural timber, shoji glass and limestone.

opposite A restrained palette and uncluttered, minimalist, low-slung furniture influenced by East and West in the Sky Lounge allow guests to immerse themselves in the panoramic view.

opposite Tall, onyx-lined lanterns add visual interest to a guest-room corridor while one of more than four hundred commissioned works of art is displayed on a floating shelf.

above Deep steps lined with lanterns lead outdoors to the Lawn and reinforce the sense of journey.

pages 232–233 The outdoor garden lawn is unusual in Hong Kong's urban context and highlights the Upper House experience.

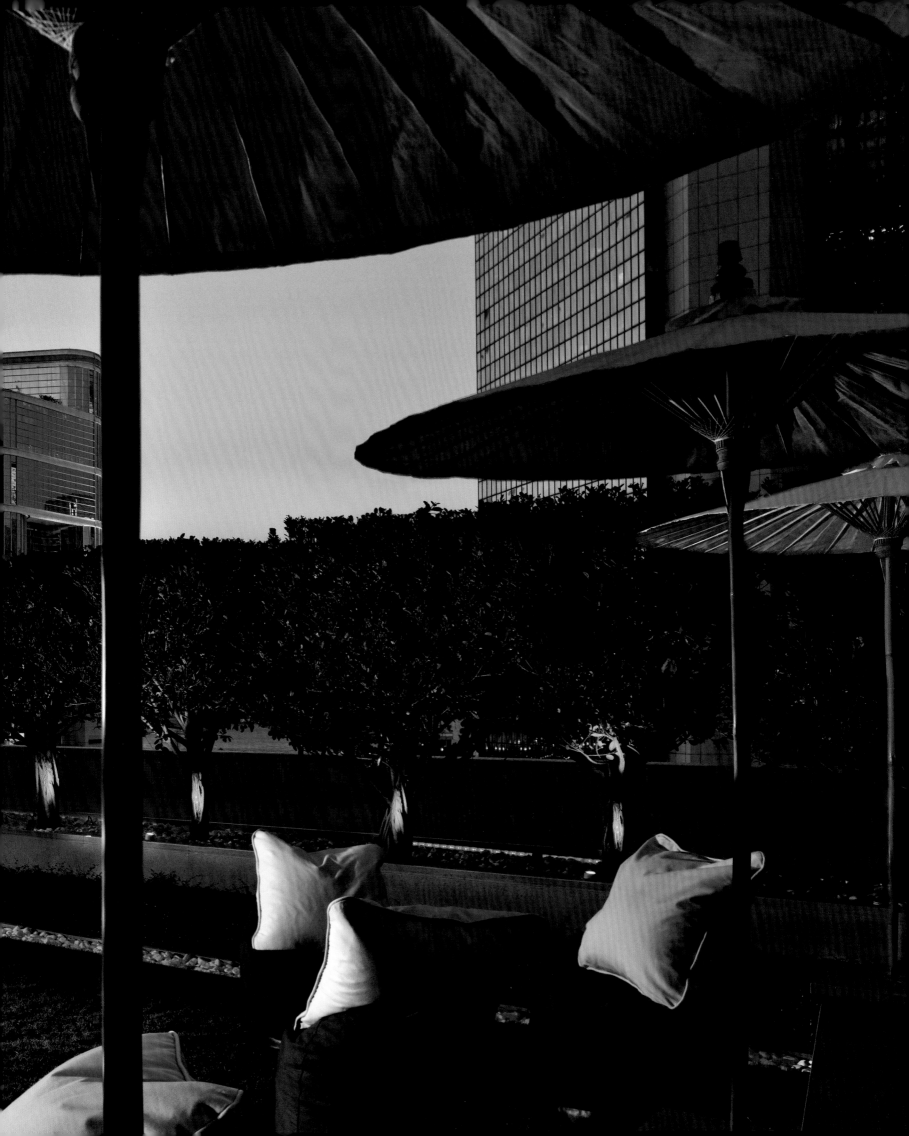

villa la coste provence

A pine forest in Provence is not where I thought I would find myself commissioned to design interiors, but this is where Paddy McKillen decided to establish Château La Coste and Villa La Coste. The first is a pioneering, open-air art and architectural museum on a 243-hectare estate with biodynamic vineyards, a winery and restaurants, while the villa is a mid-century-inspired, twenty-eight-room hotel and spa.

Most of the projects I've designed are in places that I've visited many times and so am familiar with the context, but I'd never been to Provence. It felt like a fresh encounter in terms of both my response and my design. I thought I had some idea of what Provence would be like, but in reality I found it very different when I arrived and saw the woodland, the colours of the vines and olive groves, and the scale of the chateau and its art.

I immediately knew I had to find a design language that would fit within the setting. Provence has an extraordinary light, and the texture of the stones and the olive colour of the leaves are so seductive. It is quite arid too, so you are very aware of the colour of the earth. I was also intrigued by other elements, such as traditional wrought-iron screens and matt cobblestones. The natural light and landscaping in Provence mean you almost don't want to impose anything. You don't want to fight against it. It's not like an urban scenario, where I create and provoke a narrative. In Provence there is nothing more beautiful than nature.

Villa La Coste is a very personal project for Paddy, so I was very aware that, in this case, the design was not about expressing a corporate programme or a brand. At the same time, quite a line-up of Pritzker prize-winning architects had been involved with the chateau, and this made me think very carefully about what I could bring to the project. I wanted to be sure that my design was sensitive to a place that has a life of its own. It is a very delicate and nuanced relationship.

I felt very strongly that the spaces should embrace the contemporary spirit of Château La Coste, yet at the same time integrate this with the local materials that have a traditional feel to them. Above all, it had to feel authentic. This dialogue between local materials and a place that has its own unique dynamic meant we were continually thinking about this relationship and adjusting details as the design progressed. In my mind throughout I was thinking of how to evoke modern rustic sensibility but always with a strong contemporary experience. We were not creating a classic hotel.

That spirit prevails in the spa. The upper floor is dedicated to dry treatments, and so we felt it natural to introduce beige and earthy tones. I particularly like the visual and tactile contrast between the pure stone and the raw, rustic stone basins in the treatment rooms and the classic taps and mirror suspended on a wrought-iron profile, which add a strong sense of precision. The lower floor of the spa is all about hydro rejuvenation experiences, and here I kept things very pure, minimalist and clean, in white and ivory marble.

I had designed spas before as part of a hotel, but this had a very different programme because of the focus on well-being and therapeutic experiences. One of my favourite spaces is the spa consultation room, where I created an origami screen with elegant interlocking oak panels. It is a design intervention that uses basic materials, but the way it is expressed adds an element of surprise and makes it feel special.

Paddy already liked the idea of a pavilion as a statement restaurant, and he wanted guests to use the lower ground floor as a living room, so for me the project's success centred on thinking about the sequence of the spaces and how to integrate them with the huge outdoor courtyard. I reduced the scale by creating smaller, intimate places and experiences with different personalities so that discerning guests could find a place where they would feel comfortable.

One of the challenges, especially in the dining areas, was that the art had not been curated, as would usually have been the case at a hotel. The dramatic, eclectic pieces by such artists as Tracey Emin and Louise Bourgeois are all from Paddy's personal collection, and the intention is that it will be an evolving collection where pieces change. I think that the key here was to make sure that the design did not override or dominate.

In a project like this there is always the temptation to ramp up a design but I decided to hold back. It was much more important to create something that would be quiet yet have a presence and substance of its own.

page 235 An interlocking screen in the spa's tranquil consultation area creates a feeling of privacy and evokes rustic Provençal qualities with an oriental twist.

opposite Original, hand-drawn concept sketches show a staircase descending to the lower level of the spa, where the wet treatments are. At bottom left is a relaxation area with bronze scaffolding interspersed with a sheer textile; on the right is the reception area.

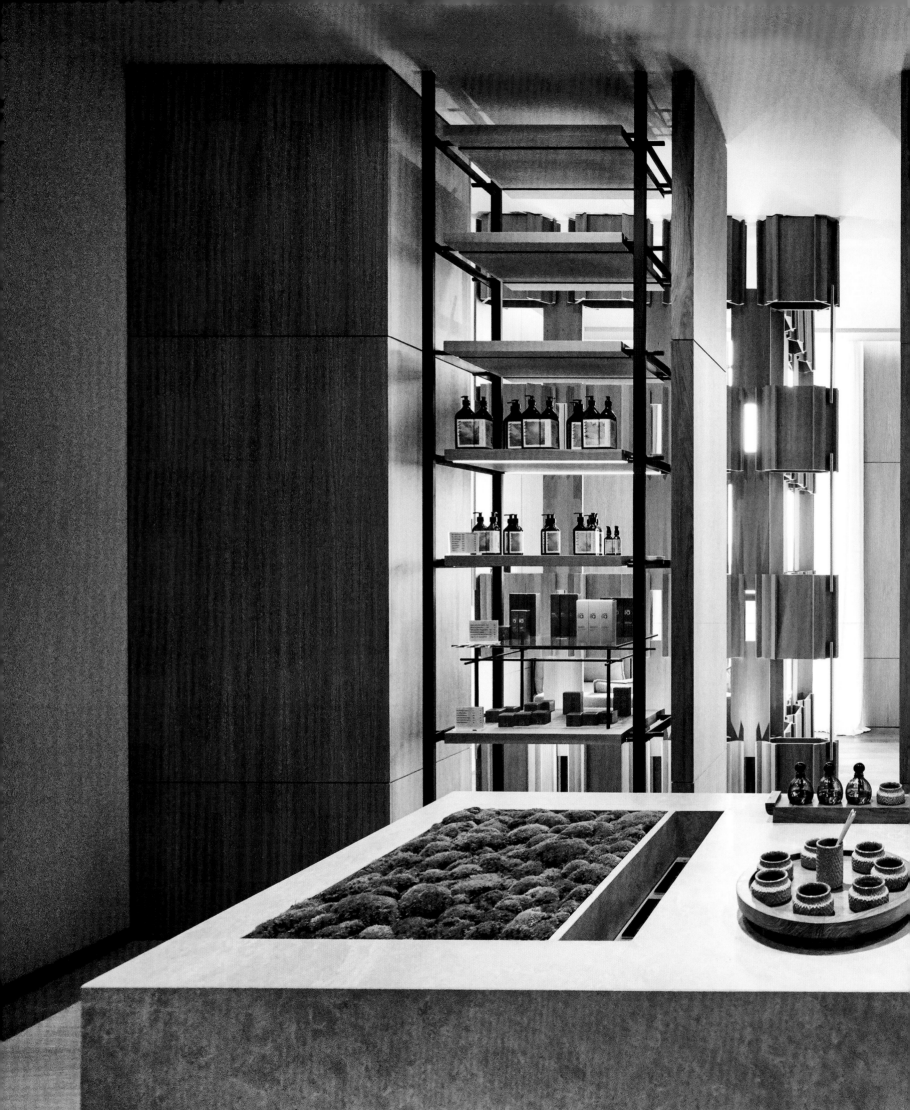

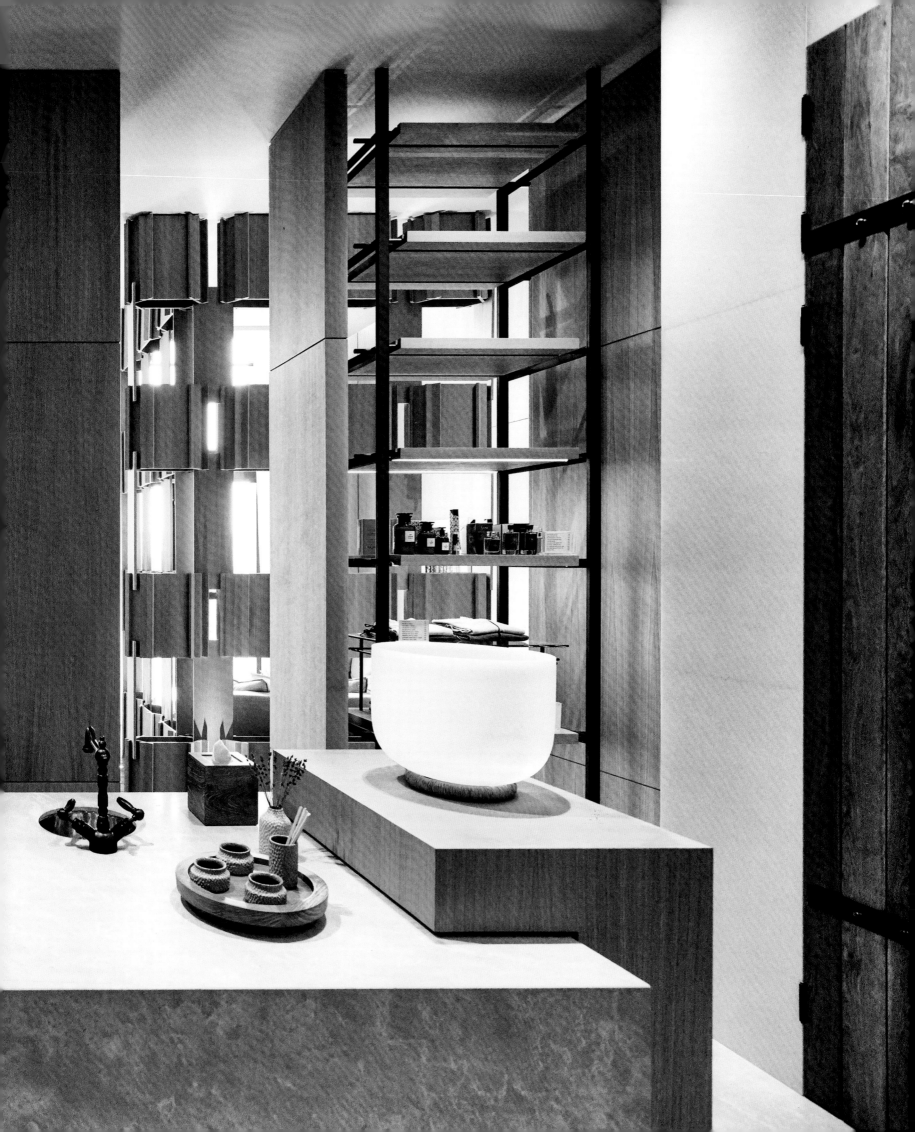

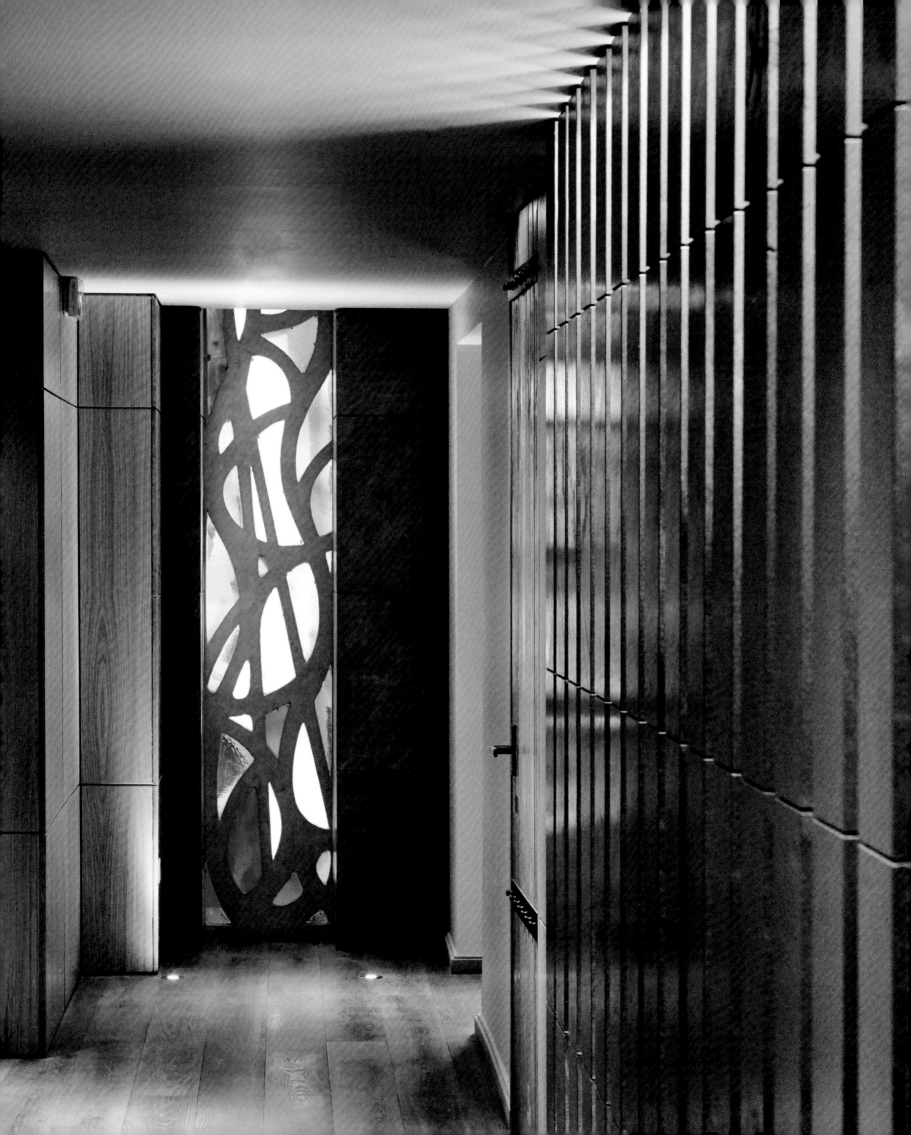

I responded to the vision Paddy has for the hotel
as an extension of the creative lifestyle at Château La Coste.
A sense of intimacy is essential, and for me that
means designing places around people,
and not purely for the spectacle.

ANDRÉ FU

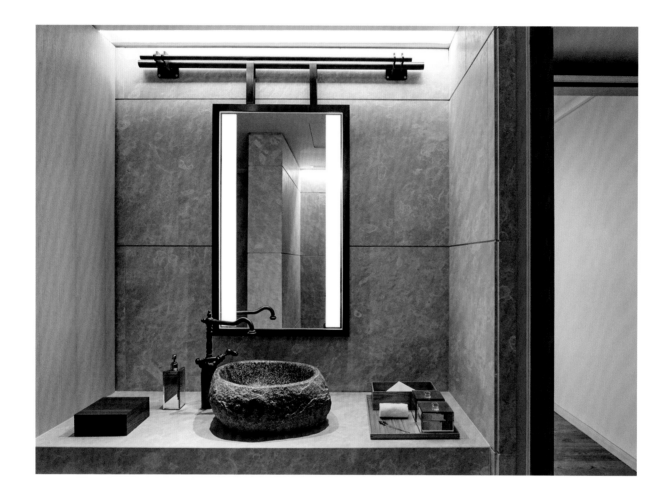

pages 238-239 An island reception desk in the spa provides an unconventional, informal greeting point. Screens add a sense of privacy yet infuse the space with daylight.

page 240 An original stained-glass window – based on the first Henri Matisse drawing Patrick McKillen acquired – provides an eye-catching visual focus at the end of a timber-panelled corridor.

above An organic stone basin, vintage-inspired hardware and a suspended brushed-brass mirror in the spa reflect refined Provençal simplicity.

opposite The sculptural staircase links two floors of the spa.

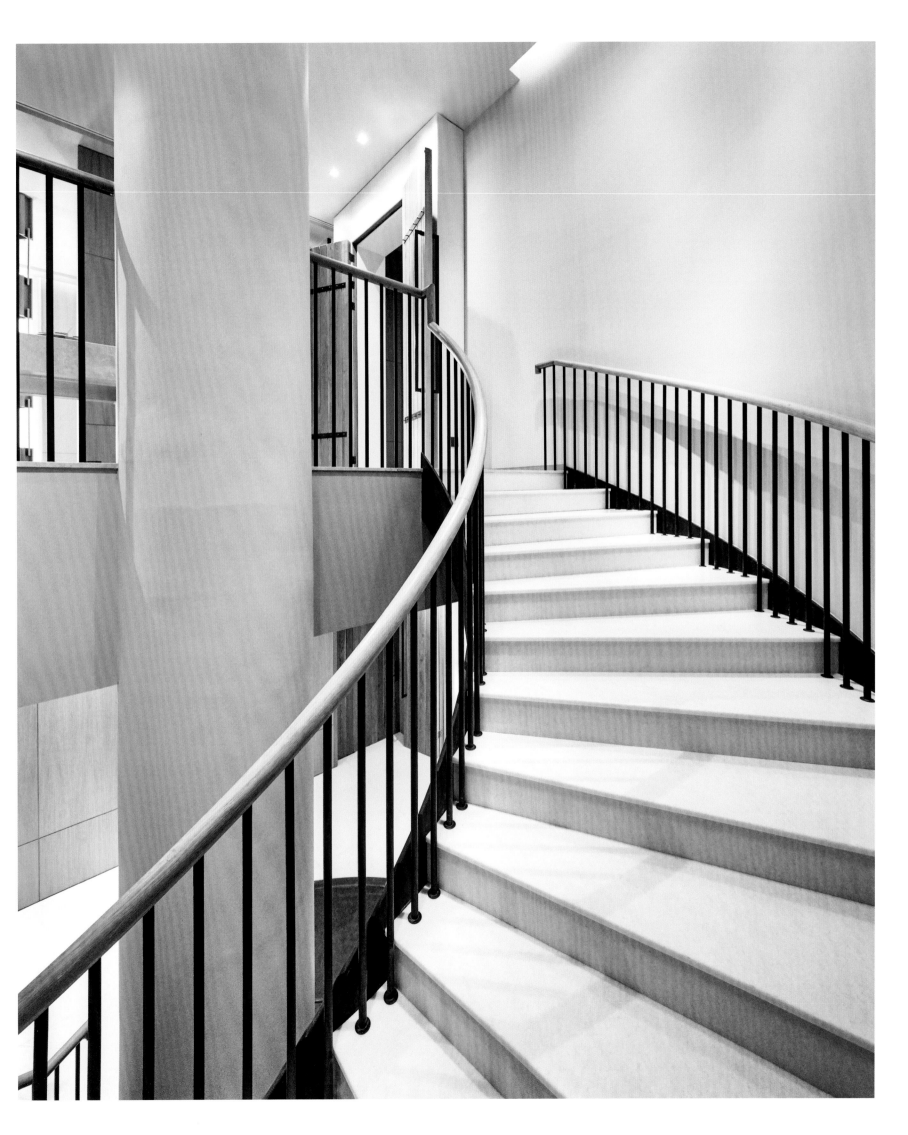

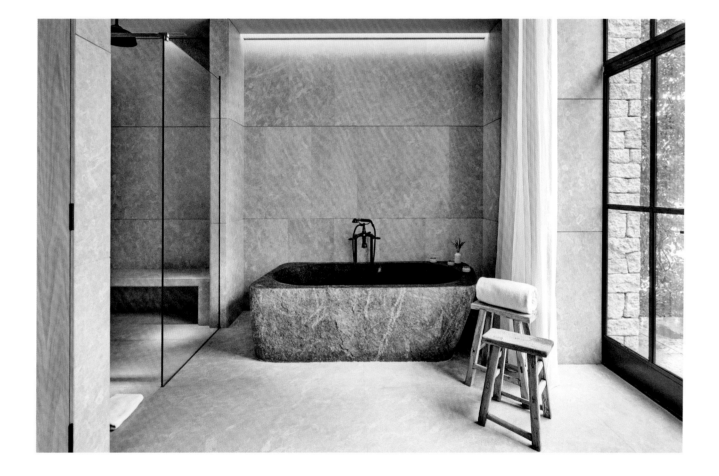

opposite Inspired by the Provençal countryside, the spa's relaxation room features a clean, graceful blend of timber and ivory linens.

above The sumptuous texture of a rustic stone bath in the spa is accented with simple earth-tones.

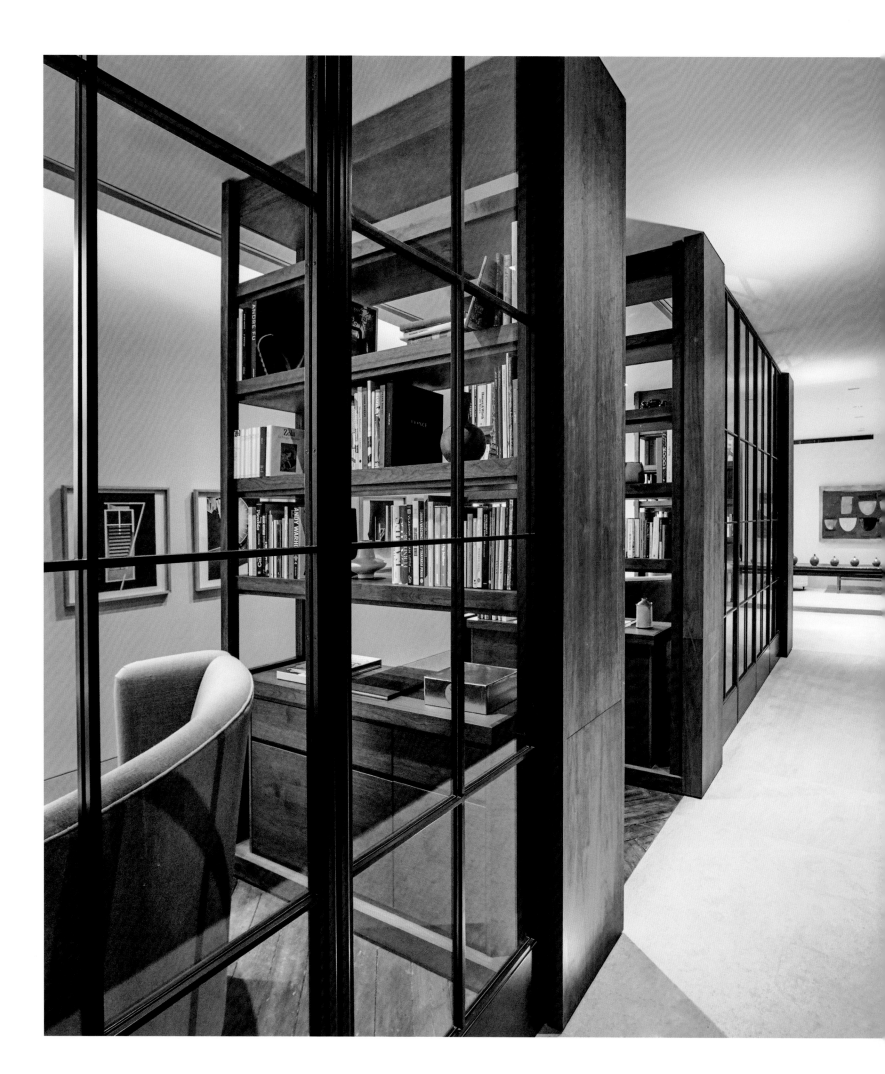

opposite and above Oak and glass partitions in the open-plan library create a sense of intimacy and privacy. The curated library contains books about the artists, architects and designers who have contributed to both Château La Coste's contemporary sculpture and architecture, and Villa La Coste. There is also a collection of unusual, decorative artefacts and a series of framed architectural drawings by the Japanese architect Tadao Ando.

pages 248–249 A collage of mirrors makes a contemporary design statement and brings depth and light into the restaurant. Custom-designed leather chairs add a simple, rustic Provençal quality.

pages 250–251 The plain, clean, elongated silhouette of *Self-Portrait with My Eyes Closed*, a sculpture by the British artist Tracey Emin, adds the finishing touch to the dark timber ceiling and Fu's signature symmetrical interiors.

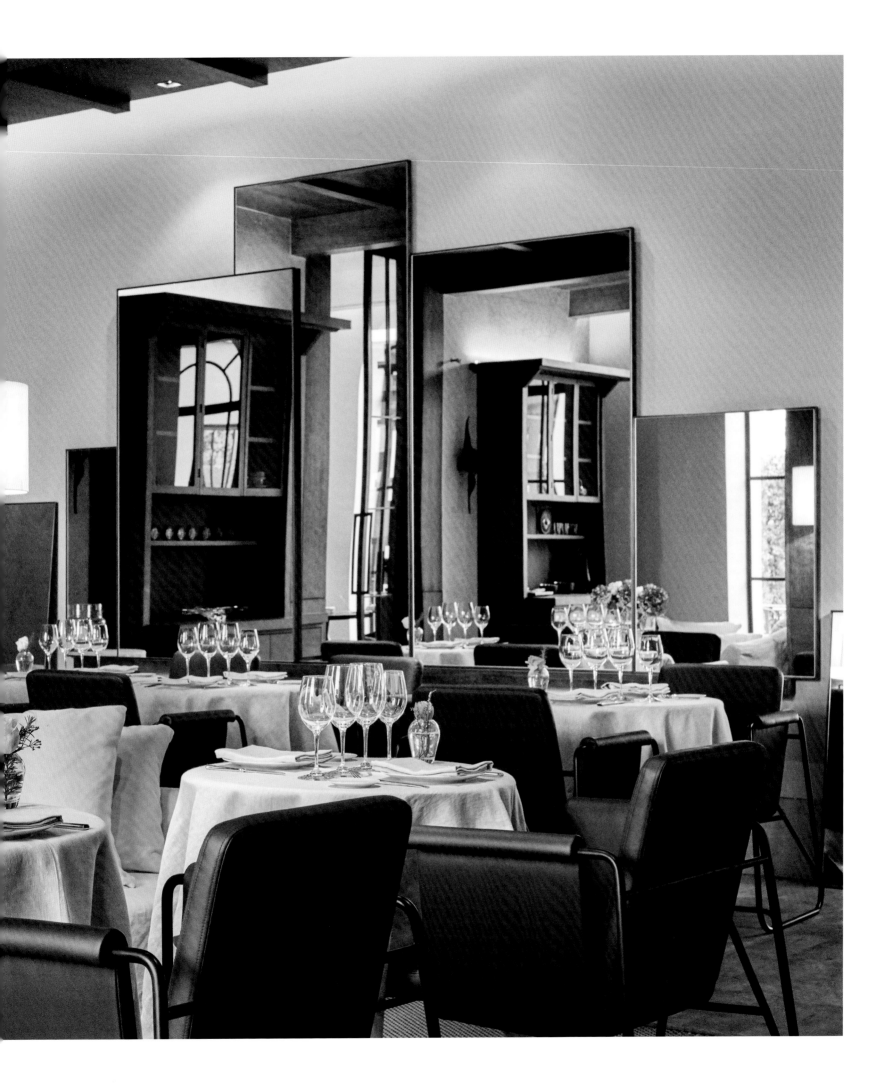

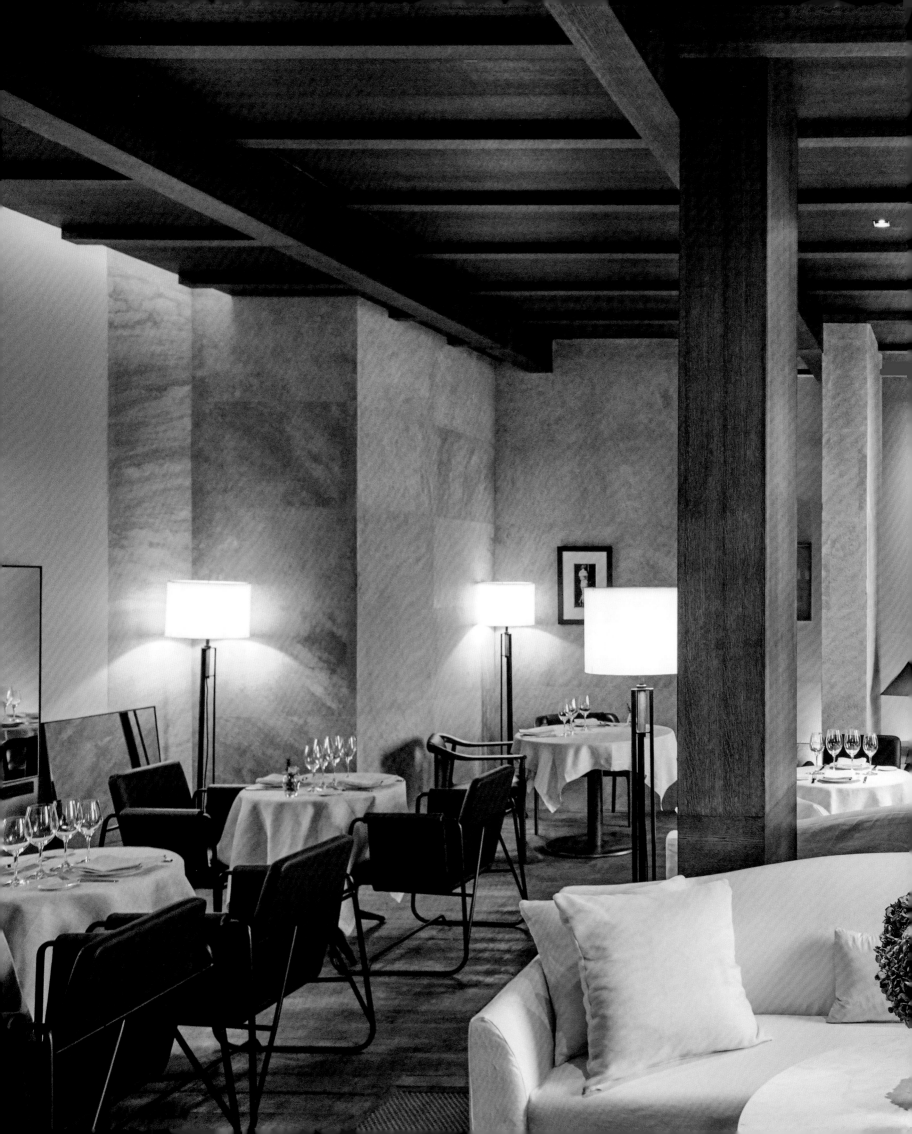

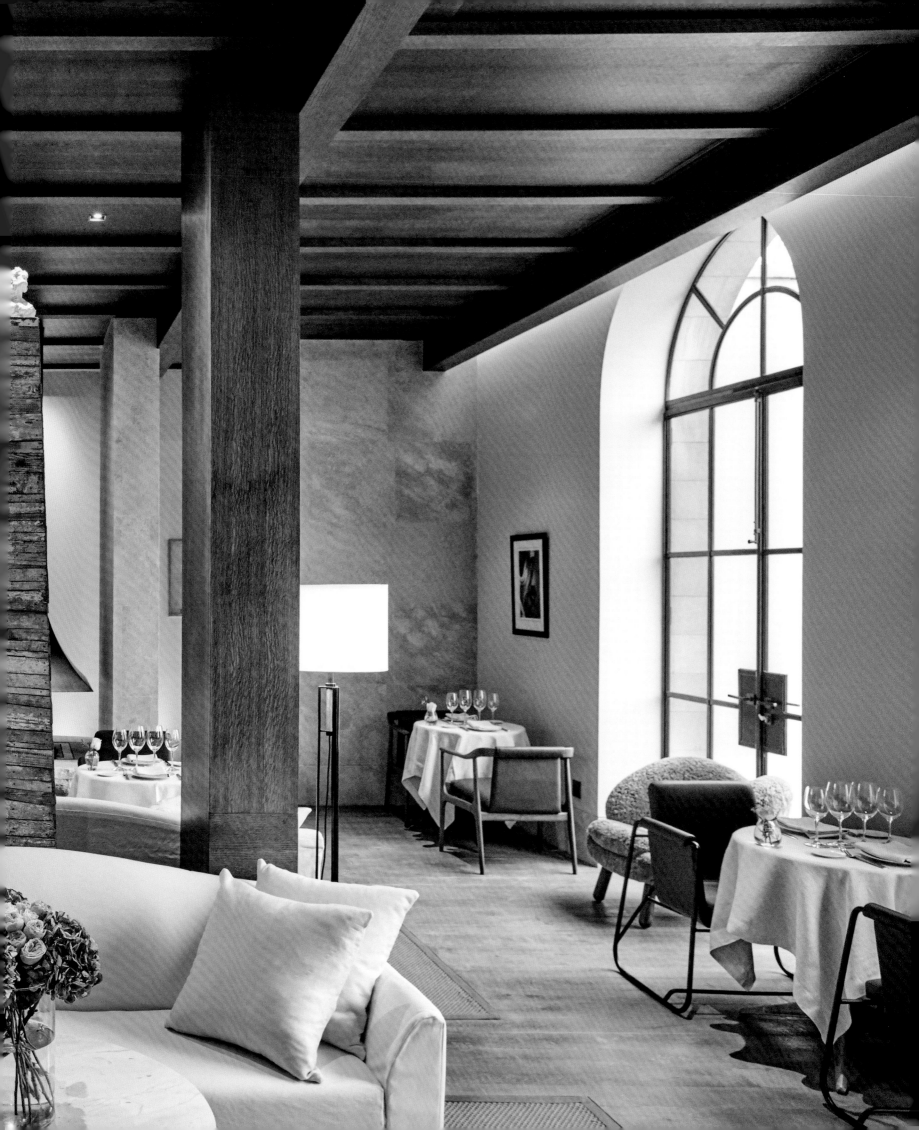

andré fu southside home

Home for me is where I can withdraw from everything. I am not alone in this – I am sure a lot of people feel the same. I enjoy being at home.

My project work is all about the client, not my own personal look or style, so in this way my home is a true reflection of myself. It may come as a surprise to some people because it is quite uncurated and not very stylized. I live with a mix of objects, including some that I inherited, such as a sculptural acrylic chair from my grandmother. I like to see the things I love so I designed a wall unit, 7 metres high and 3 metres wide, where I display an eclectic collection of things, like a tray from my grand-uncle that I remember as a child.

I also have more colour in my home, especially in my art. I have always liked sculpture, but recently I have started to appreciate different media and a strong expression of colour, and how the collision of works of art can escalate an experience.

I don't use my home as an experimental design laboratory – my homeware collection is closer to how I see people live these days. People don't just eat one cuisine, and they have limited space for storage, so they want to invest in something that is timeless.

When I launched André Fu Living in 2015, I wanted to take my studio's signature spatial-design style and create a collection of lifestyle products for the home. The first was Bamboo eau de toilette, created in collaboration with Argentina-based Julian Bedel of Fueguia 1833; more recently, in early 2019, I added a range of tableware, furniture, blankets and scarves that feel very modern and culturally informed, and which also reflect my personal appreciation for visual calm and comfort.

The design of products for the home is often driven by categories, such as bedding or furniture, but for me it is thinking about a living experience that focuses on the person, the way they live, and the places within the home where they sleep, dine or dress. It is not just about aesthetics. True luxury is in the experience.

It is quite an extensive, cross-category line of 150 pieces, but this is the only way to offer a cohesive narrative that tells the story of living well in a nuanced way. I think it would not have been as fulfilling had I focused on one product, like bed linen, for example. I think this is a different approach to design, because the multiple elements fit very naturally with each other, and you see their relationship to each other.

Everything in the collection can appear as a single object. But equally, if you want to put them all together, it works because the individual elements were conceived at the same time, and because the materials, such as oak, fine porcelain, silk and hand-painted constituents, work very naturally together. I noticed this when I first saw all the prototypes simultaneously and realized that they communicate something more because they share a quiet, understated elegance and can be used in different environments. For me, it's the small details, like an incredibly soft cashmere scarf or bed throw, that make a big difference to one's daily life. Future collections will evolve from this.

The collection spans two design languages: 'artisan artistry', inspired by artistic expression, and 'vintage modern', inspired by the geometric patterns typically found in 1960s modernist architecture. The DNA of the designs is firmly rooted in my architectural training, so you will see a touch of Bauhaus and modernist design in the interlocking details, and you will also see a hint of Asian sensibilities in the circular shapes that evoke a Chinese moon gate. Asian craft is deep in my roots, and there are subtle references in many of the objects, but my focus was on creating everyday objects that transcend cultures. The tableware in particular was designed in such a way that the shapes and patterns can cater to both Eastern and Western dining styles, because this is how we live today.

It's interesting that designing a collection of objects like this is quite different to designing a space, although some of the designs emerged from having to design practical solutions with a purpose for our studio work. The screens, for example, came out a project where we wanted to create a permeable barrier that would work in a glass pavilion structure.

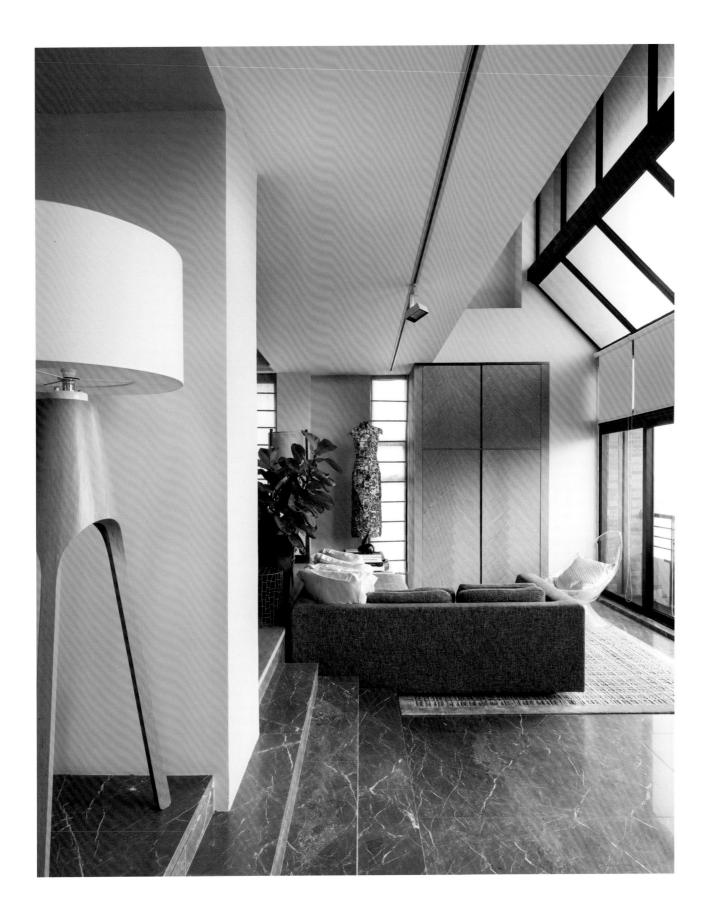

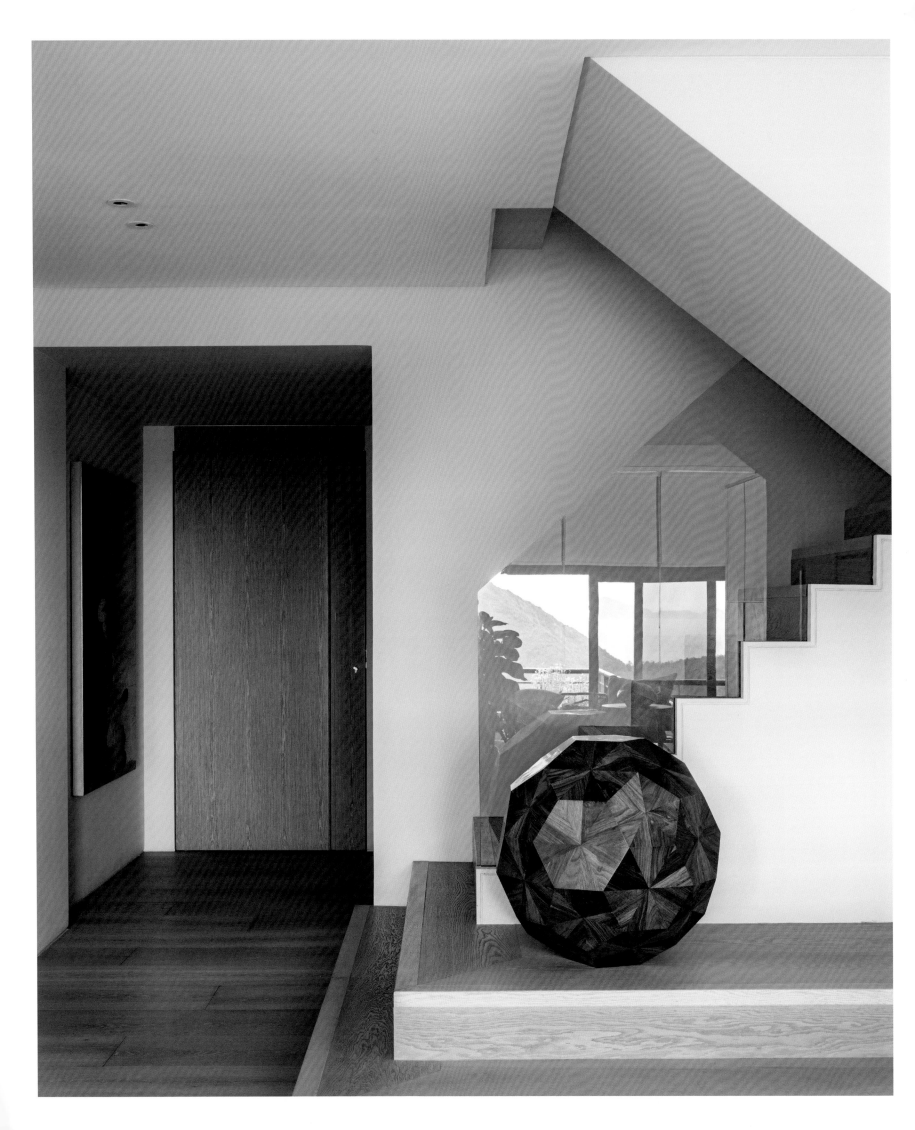

page 252 The dining table, designed by Fu, shows his preference for minimal, contemporary design. The unusual, double-height space with floor-to-ceiling windows features a custom-built shelf displaying an ever-evolving collection of Fu's favourite objects, including treasured mementos from his childhood, Le Corbusier prints, a miniature Hans Wegner chair and sketches by Fu. The dining chairs are prototypes.

page 255 The sculptural 'Arch' floor lamp was designed by Fu in 2005. The ceramic *cheongsam* sculpture is by the contemporary Chinese artist Zhang Xiaogang, while the 'Flagstone' silk tufted rug is from Fu's first collection for Tai Ping.

opposite In the entrance to the apartment a timber sculpture reflecting Fu's passion for geometry is juxtaposed with the staircase's simple yet striking form.

above The first landing, with an original Hans Wegner 'Wishbone' chair and Arne Jacobson's 'Swan' chair in front of an abstract 'Ecriture' painting by Park Seo-Bo.

above An original concept-sketch collage of the André Fu Living collection highlighting the intricate detailing of an interlocking screen.

opposite Fu's first collection of tableware reveals his signature modernist sensibilities and multicultural nuances with a *sumi-e*-style brushstroke pattern.

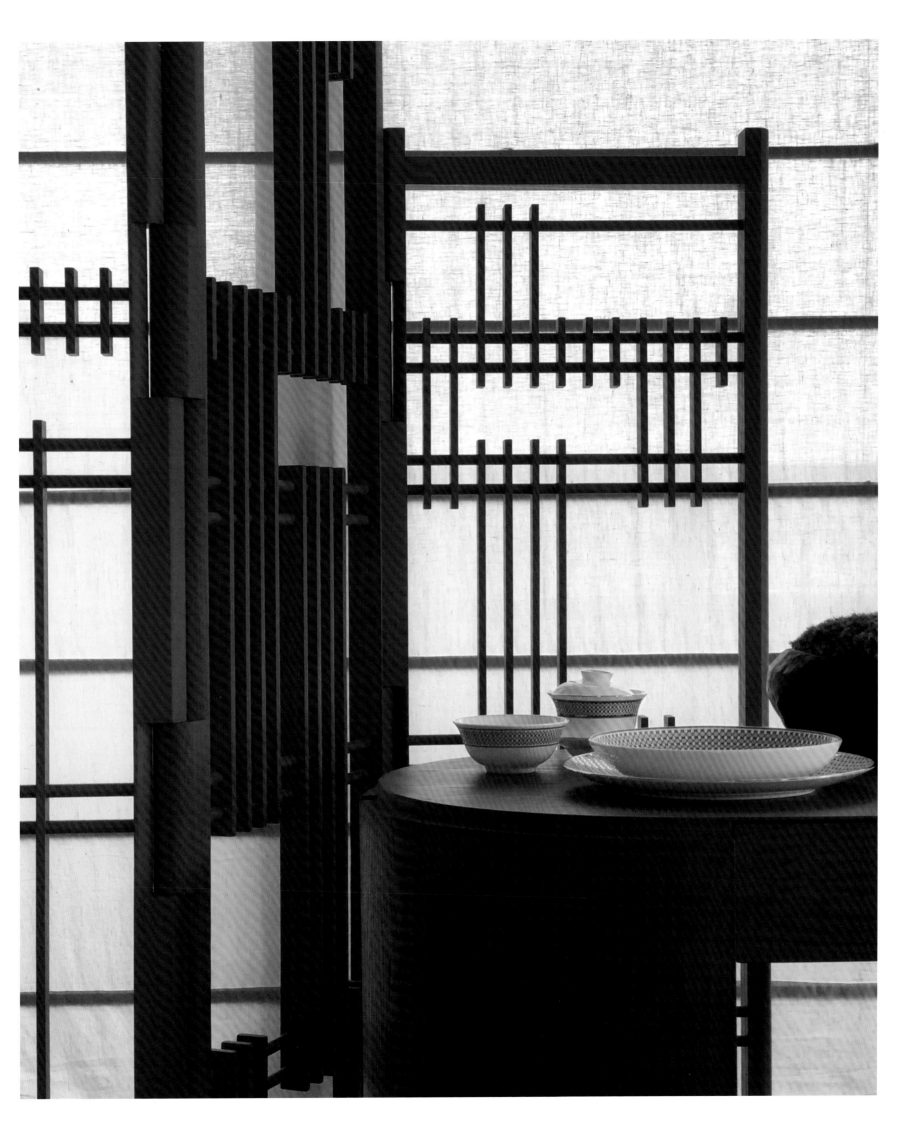

opposite and above The 'Lazy Susan' oak dining table, chairs and
tableware are from the André Fu Living collection.

page 263 Simple forms against a panoramic backdrop. Sited on a steep hill,
Fu's apartment has unrestricted views of the South China Sea.

When I come home it feels like everything stops.
I can breathe easily and take a moment to collect myself
and think things through. The dining room is where I like to sit.
It is a very personal space and not at all curated.
I keep my favourite things on a shelf and often add to them
or move things around, depending on
what I want to look at.

ANDRÉ FU

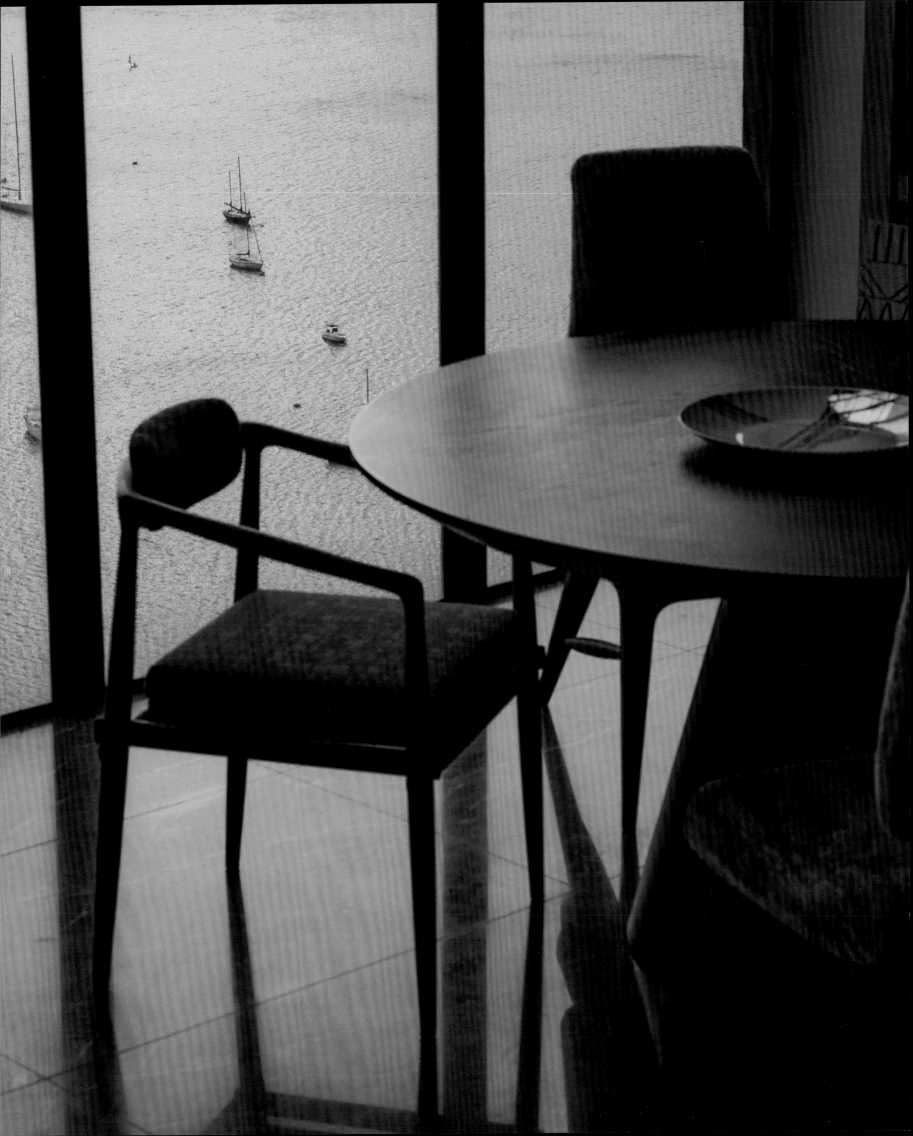

afterword

The projects presented in this book are as notable for being
beautiful spaces with elegant furnishings to enjoy as for their
unusually nuanced, fresh take on a country, city, place and culture.

That is simply how André sees things and designs; fortuitously,
it is also a perfect fit with how we live now, especially when we
travel. People want to emotionally connect with and feel part
of the creative energy of a city, and this means they look for
interesting, one-of-a-kind insights that reflect the art, design,
architecture and customs of a place.

The Shanghai-based Chinese-American writer and architecture/
design curator Aric Chen suggests that it is André's ability to
embrace and distil different cultures, and then reflect them in
a new project with a distinctive spatiality and fluency, that makes
his designs subtle, sensitive and never obvious.

'There is a powerful human desire to find comfort,' he observes.
'People tend to look for emotional reassurance in an unfamiliar
place, which is why the visual cues like those André uses in his
work are especially important.'

André's method is to immerse himself in a location, constantly
navigating between the macro and the micro elements that help
to create a compelling and authentic storyline.

'It is not a deliberate exercise,' explains André. 'I don't walk
around wondering how to express that particular context or
culture. It feels simple and almost instinctive, and probably
taps into my natural nomadic inclinations.'

opposite Rock Garden: Fu's collection of outdoor dining and lounge
furniture created in solid teak for JANUS et Cie reflects the time-honoured,
understated aesthetic, tranquillity and harmony of traditional Japanese
gardens, blending simple, sculptural, fluid silhouettes.

For instance, André thinks carefully about what people touch
and smell and how they feel as they progress through a particular
space. Design details are delicate and often interwoven with many
different cultural influences.

'It is especially important to create a fully sensory experience
when it comes to hotels because often they offer the first and last
moments that guests encounter in a new destination,' he says.

At Villa La Coste in Provence, André conveys the French
countryside's famed light, materials and textures through smooth,
rustic stone and timber surfaces. But it's as guests stroll through
the library and lounge before entering an airy glass dining pavilion
that they become aware of how he artfully conceals and reveals
details and vantage points simultaneously.

André says that Kyoto's ancient culture has been one of the most
challenging to express in a genuine, thoughtful way. 'You can't
reinvent authenticity, but I do believe that, by keeping an open
mind, a design can offer a retelling of things that are real.'

'I talked to a lot of people', he continues, 'and asked many
questions to find out what something we had proposed would feel
like to a Japanese person. The answer sometimes surprised me,
but it is all too easy to tap into clichés and local stereotypes. I am
very aware that one can study a single element of design all one's
life and still very easily make a mistake.'

It is a challenge in other locations, too. In Bangkok, for example,
André says that he and his team recently spent a lot of time

considering design cues: the smallest difference in a curve can mean a motif has been inspired by northern rather than central Thailand.

'These elements are a very important part of Thai culture,' he says, 'but at the same time our clients have come to me because they are looking for a fresh and modern perspective, so I find myself asking, who says what is modern Thai? We draw and adjust until sometimes it is reduced to just a hint. For me, the key question is whether it arouses the soul.'

André's multicultural upbringing in Hong Kong and Europe, his architectural training and peripatetic life, obviously contribute to his ability to present an informed opinion with the fresh eye of an outsider.

His approach to a contemporary Manhattan apartment at 53West53, for example, avoids traditional New York City design tropes. Instead, it creates the ambience of an international lifestyle and subtle hints of the city's architectural silhouettes through the juxtaposition of textures, materials and forms, which play off one another to produce a sense of tension within a subdued palette.

Sometimes it can mean playing with a sense of architectural proportion, as at St Regis Hong Kong, where André devised an immersive, layered visual journey as guests walk down a low, lacquer-ceilinged passageway before entering a dramatic, triple-height lobby. The tranquil interlude provided by the passageway highlights the striking contrast in proportion between the two spaces, as well as adding an element of surprise.

The hotel also shows how André is able to combine a subtle sense of both Hong Kong and the flagship St Regis New York without

allowing either to dominate or by resorting to aesthetic nostalgia, but by creating a design that people of different cultures, sensitivities and starting points can relate to.

Aric suggests that it's this 'inbuilt sense of distance' that allows André to see things in new ways and shine a light on the current cultural zeitgeist of a city. In essence, André is part of something yet also independent of it – which means that he can understand it from within but also maintain a critical distance to it. This is what enables a design to speak to and expand on a context without resorting to flashiness.

'Not that we should necessarily look to dilute a culture,' Aric warns. 'Finding and creating narratives in our physical environments can bring clarity, comfort and social connection.'

'We're always fretting about globalization and the homogeneity and sameness that it brings,' he continues. 'That is an issue, but the fact is, simply the fear of losing our identities tends to make us assert them, while, at the same time, we shouldn't underestimate the power of culture. Maybe it's not a matter of wearing Japanese yukatas versus British trench coats, but culture manages to express itself in many ways.'

Perhaps André's greatest skill is that he works meticulously from the inside out – with understanding and empathy – capturing a magic and an energy through his designs rather than applying a superficial façade. The results are engaging, offering a deeper connection to and understanding of people, place and oneself. And in the end, isn't that what design should be about?

andré fu

Born in Hong Kong and educated in England, André Fu has a BA and MA in architecture from Cambridge University. He founded his own design studio, AFSO, in 2001, and launched his André Fu Living lifestyle brand in 2015. From the outset, however, his work has focused on creating a seamless alignment of cultural and design sensibilities, modern luxury, art and craftsmanship – the themes explored in this book. His projects span a broad range of scales and typologies, bridging the gap between cultures, tradition and modernity, and range from an original collection of urban-inspired handmade carpets for Tai Ping and modernist-inspired furnishings (the latter launched at Salone del Mobile 2019) to contemporary art galleries in Hong Kong, Tokyo and Shanghai. An early commission to design the Upper House in Hong Kong for Swire Hotels has led to luxury hotels and suites for St Regis Hong Kong; Andaz Singapore; Waldorf Astoria Bangkok; The Berkeley, London; and Villa La Coste, Provence, as well as new resorts, restaurants and spas around the world. André's pure design aesthetic has been recognized with numerous awards, and he is regularly called upon to participate in international exhibitions.

catherine shaw

A critic and writer specializing in architecture, design and art, Catherine Shaw has lived in Asia for thirty years, including a decade in Tokyo, Japan. Her work focuses on urban and product design, as well as the intersection of traditional and contemporary arts and crafts, reflecting her master's degrees in urban and environmental planning. Born in Africa and now permanently resident in Hong Kong, she travels widely, writing extensively for leading magazines around the world, including *Interior Design*, *Wallpaper**, *Design Anthology* and *Vogue*, as well as such news organizations as *The Telegraph* and the *South China Morning Post*. She is also the Asia-Pacific contributing editor for New York-based *Metropolis* magazine. A popular speaker and moderator at design events, she has authored several design guides to both Tokyo and Hong Kong. She is the editor of *The Philosophy of Design* (2016), the first book in English on Japanese product designer Sori Yanagi's iconic design essays, and has contributed to a book on Hong Kong's leading designers and artists (2018). Her most recent publication is a book on Hong Kong for Assouline. She is currently researching a book on the crafts and traditional minka architecture of Japan.

project credits

St Regis Hong Kong

Location	Hong Kong
Completed	2019
Photography	Courtesy of St Regis Hong Kong
Photographer	Michael Weber

Pavilion Suites, The Berkeley

Location	London
Completed	2018
Photography	Courtesy of The Berkeley
Photographer	Jamie McGregor Smith

Waldorf Astoria Bangkok

Location	Bangkok
Completed	2018
Photography	Courtesy of Waldorf Astoria Bangkok

Lasvit, 'TAC/TILE'

Completed	2016
Photography	Courtesy of Lasvit

Perrotin Shanghai

Completed	2018

Pages 85, 88–89, 90, 93

Photography	Courtesy of Paula Cooper Gallery New York and Perrotin
Photographer	Yan Tao
Artwork	Sol Lewitt wall drawings installation view © 2019 Estate of Sol LeWitt/Artists Rights Society (ARS), New York, view of the exhibition 'Sol Lewitt: Wall Drawings' at Perrotin Shanghai. © 2019 Estate of Sol LeWitt/Artists Rights Society (ARS), New York. Photo: Yan Tao. Courtesy Paula Cooper Gallery, New York and Perrotin

Pages 86, 91, 95

Photography	Courtesy of Perrotin
Photographer	Ringo Cheung

Page 94

Photography	Courtesy of Perrotin
Photographer	Ringo Cheung
Artwork	View of Wim Delvoye's *Nautilus* © Studio Wim Delvoye, Belgium / ADAGP, Paris & SACK, Seoul 2019. Courtesy Perrotin

Louise

Location	Hong Kong
Completion	2019
Photography	Courtesy of JIA Group
Photographer	Mitch Geng

Akira Back, Four Seasons

Location	Seoul
Completion	2015

Pages 115–119

Photography	Courtesy of Four Seasons Hotels & Resorts

Pages 109, 112–113

Photographer	Michael Weber

Tai Ping, 'Scenematic'

Completed	2017
Photography	Courtesy of Tai Ping

HOTEL THE MITSUI KYOTO

Location	Kyoto
Completion	2020
Renderings	Courtesy of Mitsui Fudosan Limited

K11 ARTUS

Location	Hong Kong
Completion	2019
Photography	Courtesy of K11 ARTUS

COS, Urban Landscape

Location	Hong Kong
Completed	2015
Photography	Courtesy of COS
Photographer	Michael Weber

Andaz Singapore

Location	Singapore
Completion	2017
Photography	Courtesy of Andaz Singapore
Photographer	Geoff Lung

Louis Vuitton Objets Nomades

Location	Hong Kong
Completion	2018
Photography	Courtesy of Louis Vuitton

Kerry Hotel

Location	Hong Kong
Completion	2017
Photography	Courtesy of Shangri-La Hotels & Resorts
Photographer	Michael Weber

53W53

Location	New York City
Completion	2019
Photography	Courtesy of 53W53
Photographer	Stephen Kent Johson

Page 212

Artwork	On the wall: Park Seo-Bo, *Ecriture No.080623* (detail), 2008. Courtesy Perrotin.

The Upper House

Location	Hong Kong
Completion	2009
Photography	Courtesy of the Upper House
Photographer	Michael Weber

Villa La Coste

Location	Aix-en-Provence, France
Completion	2018
Photography	Courtesy of Villa La Coste
Photographer	Richard Haughton

André Fu, Southside Home

Location	Hong Kong
Completion	2013

Pages 252, 255–257, 263

Photographer	Michael Weber

Page 259

Photography	Courtesy of André Fu Living

Pages 260–261

Photography	Courtesy of Lane Crawford
Photographer	Stephanie Teng

project credits

acknowledgments

andré fu

I am very grateful to Thames & Hudson for offering me this tremendous opportunity to reflect on my design career to date. Also to Catherine Shaw, for her support right from the very early days of my career and her unconditional partnership in making this publication happen. I am deeply indebted to Patrick Mckillen, a genuine mentor and visionary who has entrusted me with several close collaborations and who contributed the foreword to this book; to the inimitable Joyce Ma for her belief in me; and to Adrian Cheng for challenging me to innovate. Last but by no means least, I dedicate this book to my team and to all those who have contributed to each project with genuine passion and commitment.

catherine shaw

I would like to express my sincerest thanks to André. His trust in me and willingness to explore his projects, together with our long, frank discussions on his design philosophy and personal inspirations – from ceramics, Japanese lacquer and moss-covered stones to Carlo Scarpa and Czech Cubist architecture – have made writing this book a truly memorable experience. Special thanks go to my husband, Alistair Gough, and daughters, Alexandra and Francesca, for their unwavering love, support and patience, and I am much indebted to Clare Wadsworth for her professional support and for her friendship. Many of André's clients and friends generously shared their invaluable insights with me, for which I am very grateful. I would also like to thank the dedicated Thames & Hudson team: Lucas Dietrich, Fleur Jones and Mark Ralph.

I especially appreciate André's passion and masterful attention to detail, which rise above the everyday to convey his personal sense of creativity, comfort and style. His simple, muted palette amid soaring proportions, lavish scale and luxurious materials allows objects to transfuse and live. Original, sophisticated and quietly disruptive, his work stands out in a world of formulaic interiors.

JOYCE MA
contemporary fashion pioneer and
founder of Joyce Boutique